LIFE IN THE WILD

LONDON, NEW YORK, MELBOURNE,
MUNICH, DELHI

PROJECT EDITOR Nicky Munro
SENIOR ART EDITOR Sharon Spencer
EDITOR Bob Bridle

MANAGING EDITOR Stephanie Farrow
MANAGING ART EDITOR Lee Griffiths

PRODUCTION EDITOR Joanna Byrne
PRINT PRODUCTION CONTROLLER Imogen Boase

Produced with assistance from
XAB DESIGN
39c Highbury New Park
London N5 2EN

First published in Great Britain in 2009
by Dorling Kindersley Limited
80 Strand, London WC2R 0RL

A Penguin Company

2 4 6 8 10 9 7 5 3 1

Copyright © 2009 Dorling Kindersley Limited

A CIP catalogue record for this book
is available from the British Library

ISBN: 978-1-4053-4811-9

Printed and bound in Singapore by Star Standard

See our complete catalogue at
www.dk.com

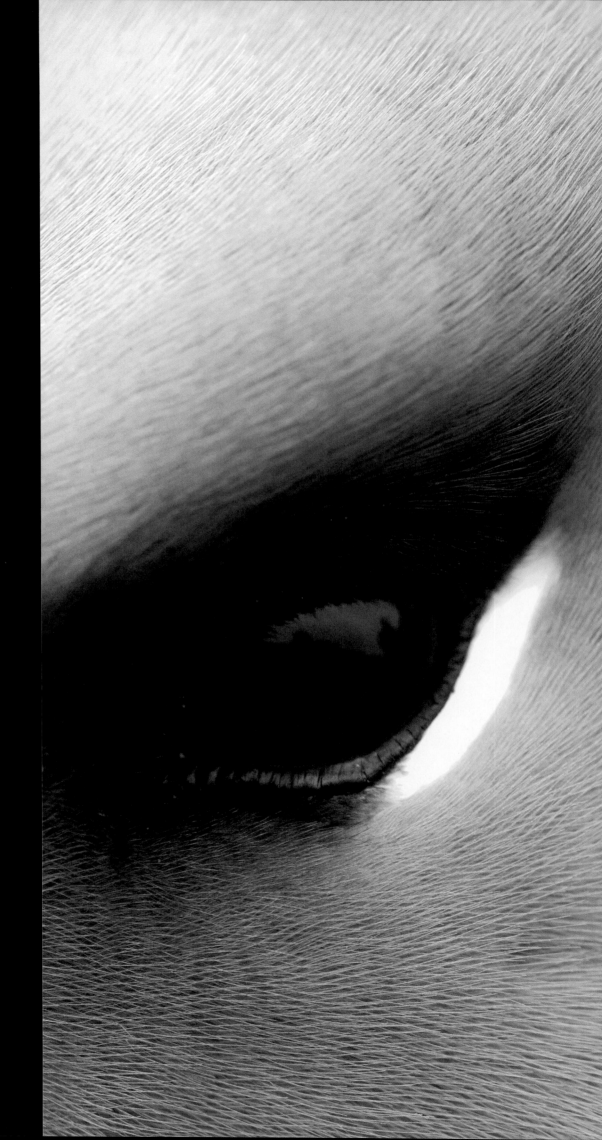

conten

Introduction

Animal life is astonishing, intriguing, and compellingly beautiful. Its sheer variety is staggering, from the sleek muscularity of a wild horse to the mechanical articulation of a scuttling crab to the mesmerizing fluidity of a jellyfish. It can inspire awe and sometimes even fear, but it is always fascinating. To watch a tiny insect hovering at a flower as it sips nectar is to see a miniature miracle of natural engineering, and to witness the deadly strike of a bird of prey is to marvel at the savage elegance of the hunter. Life in the wild might be hard, but the ruthless logic of survival against the odds has driven the evolution of animals that are all, in their diverse ways, honed to perfection.

Zoologists categorize animals into 37 groups called phyla. Of these, 36 are invertebrates, or animals without backbones, such as insects, spiders, snails, crabs, and worms. Just one phylum contains the vertebrates – the fish, amphibians, reptiles, birds, and mammals. Yet these are the animals with which we are most familiar, partly because they are the biggest, but also because they are our closest relatives. Birds alone inspire enthusiasm that can verge on the obsessive, although given their exquisite plumage and fascinating behaviour, this is not surprising.

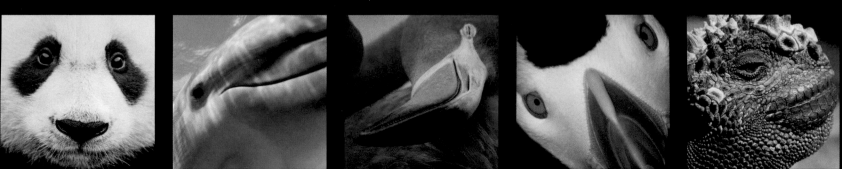

Such enthusiasm for wildlife can lead on to the kind of scientific study that has given us a deep and hugely valuable understanding of the natural world. For some, however, this type of analysis can get in the way of their instinctive appreciation of the sheer exuberance and beauty of nature. Instead of hard facts, they want the frisson of excitement that is triggered by a close encounter with a wild animal. For this, nothing can compare with physically being there – the almost tactile experience of close, personal proximity – but we can get very close to it by seeing animals through the eyes and lenses of some of the world's finest wildlife photographers. We can feel their passion, sense their excitement, and share their elation.

This book is a celebration of both animal diversity and the wildlife photographer's art. The images glow with colour and depict every detail of texture, from the scales of a butterfly's wing to the cracks in the hide of a rhinoceros. They draw you into the animal's world in a way that no description, explanation, or diagram can. You can almost smell the hot breath of the African buffalo, and hear the croak of the calling tree frog. This is nature in the raw, uncluttered by interpretation or zoological detail. It is a wildlife experience in itself.

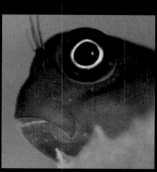
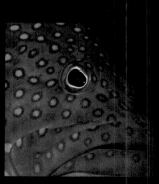
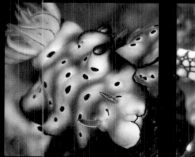

mammals

Ask a child to describe an animal, and he or she will nearly always think of a creature with four legs, fur, and a whiskery face – a mammal. Such a definition is hardly scientific, but everyone recognizes it. We know the difference between a mammal and any other type of animal without being told that all mammals are warm-blooded, air-breathing vertebrates that feed their young on milk. Some mammals are certainly a little harder to identify. A dolphin is very like a shark, which is a fish, and in the past most people assumed that dolphins were indeed fish. But most mammals – even spiny hedgehogs, winged bats, and armour-plated armadillos – are immediately recognizable as such.

This is probably because we are mammals too. Our forelegs may have become arms, we may have lost most of our fur, and we may like to think we are more intelligent, but we are still part of the family – or technically the order Mammalia. Indeed we share 96 per cent of our DNA with chimpanzees. Other mammals are our close relatives, so we relate to them.

One consequence of this is that we tend to think of mammals as more important than other animals. In reality, the 4,680 species of mammal account for less than 10 per cent of vertebrate species, and a tiny fraction – 0.25 per cent – of all known animal species. Yet while the mammals are small in numbers, they often loom large in the landscape. The African savannas teem with tiny insects, but the animals that we notice are the grazing herds of antelopes, gazelles, and zebras, and the prowling lions and hyenas that prey upon them. The largest of all land animals, the African elephant, is a mammal, and so is the blue whale – the largest animal that has ever lived. Such giants have appetites to match, and not simply because of their size. Mammals are warm-blooded creatures that use a colossal 80 per cent of their energy intake simply to maintain their body temperature. A lion must eat at least five times as much food as a cold-blooded crocodile of equal size, and this explains why big predatory mammals are relatively rare: there is

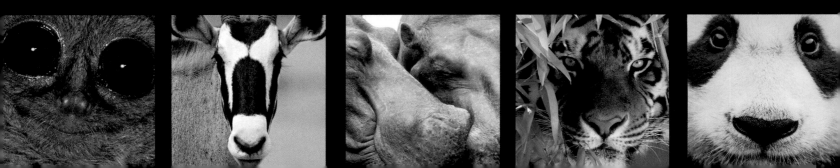

not enough prey available to support more. Small mammals have even more extreme energy requirements – a shrew must eat almost constantly to make up for the energy it loses, and if it is deprived of food for much more than an hour it will die of starvation.

The advantage of this apparently wasteful arrangement is that by regulating their own body temperature, mammals are able to live all over the planet, in all climates. Indeed a single mammal species, the grey wolf, once lived almost worldwide from the Arctic to the Arabian desert. This flexibility has enabled mammals to exploit almost

every habitat on Earth. While Weddell seals hunt beneath the sea ice off Antarctica, monkeys clamber through the tropical rainforest canopy, and desert foxes pursue gerbils over the sands of the Sahara. The demands of different habitats have brought about spectacular evolutionary adaptations, such as the giraffe's neck and the huge eyes of the nocturnal tarsier. The result is a wonderful variety of species. Some, such as the giant anteater, are specialized for particular habitats and diets. Others, such as the grey wolf, are adaptable enough to live almost anywhere, much like the most adaptable mammals of all – humans.

mammals

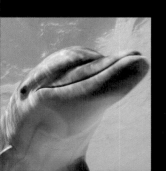
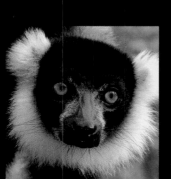
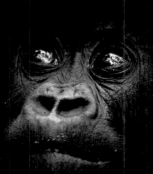

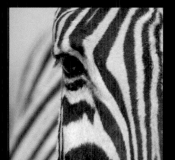

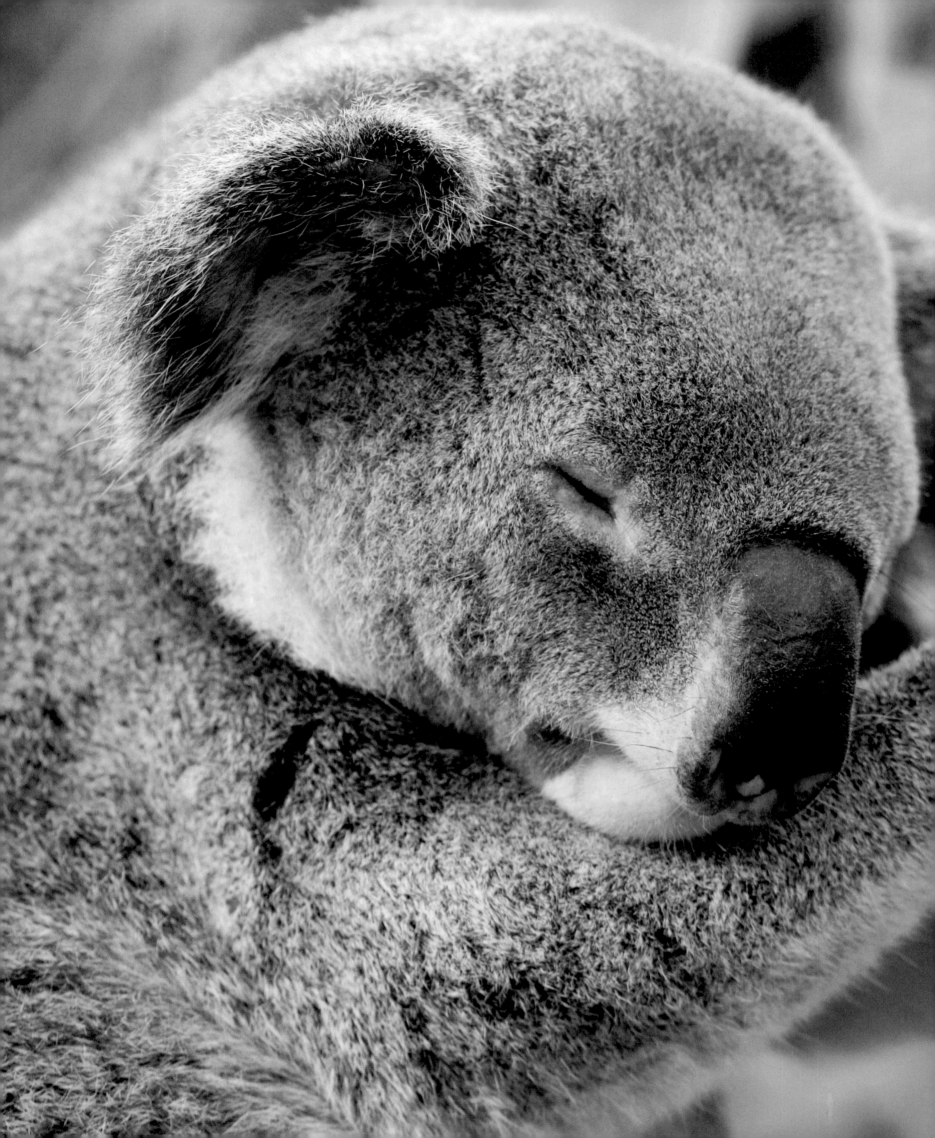

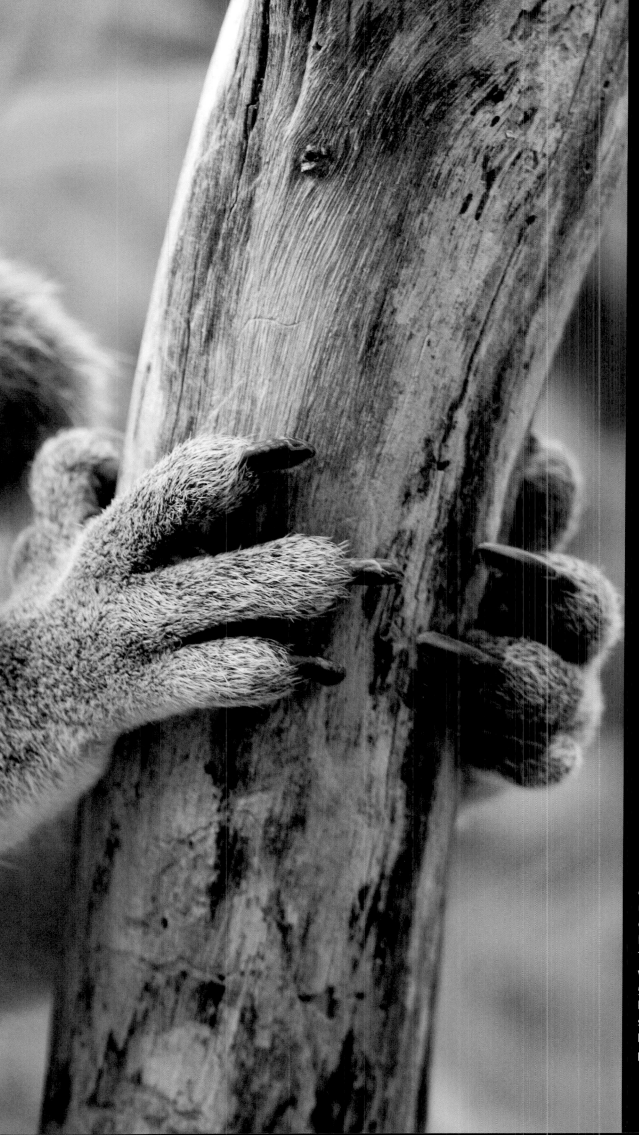

◁ Australia's koala (*Phascolarctos cinereus*) spends most of its time – up to 20 hours a day – snoozing in eucalyptus trees, gripping onto the branches with its long sharp claws. The koala is more active at night, when an adult will consume around 500g (1lb) of eucalyptus leaves. It has a very highly developed sense of smell, which helps it to differentiate between poisonous and non-poisonous leaves.

▷ The eastern grey kangaroo (*Macropus giganteus*) lives in parts of Australia and Tasmania, in small social groups known as "mobs". Typically, these include a leading male and several subordinate males, along with two or three females with young, known as "joeys". A newborn joey – no bigger than a peanut – clambers through its mother's fur to her pouch, locates a teat and remains there, safely ensconced, for up to a year before venturing out into the wider world.

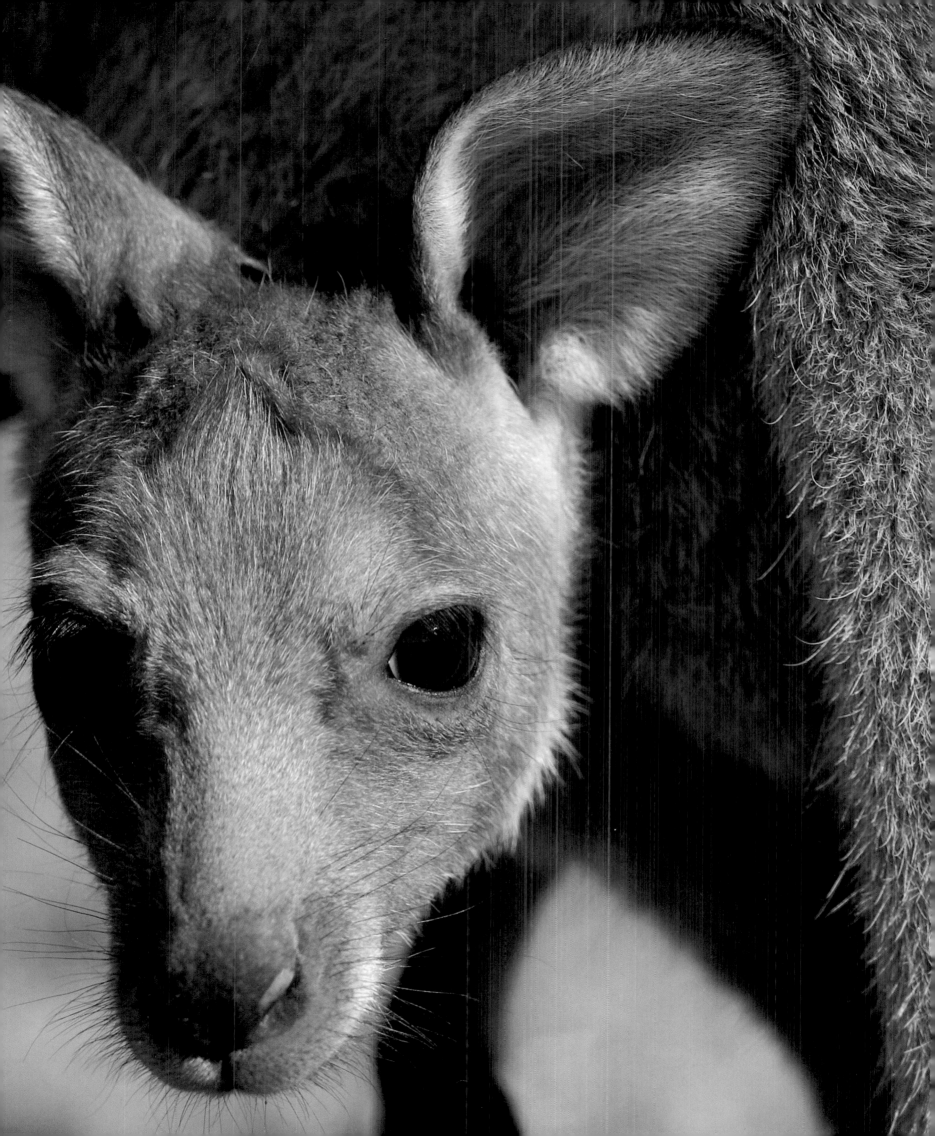

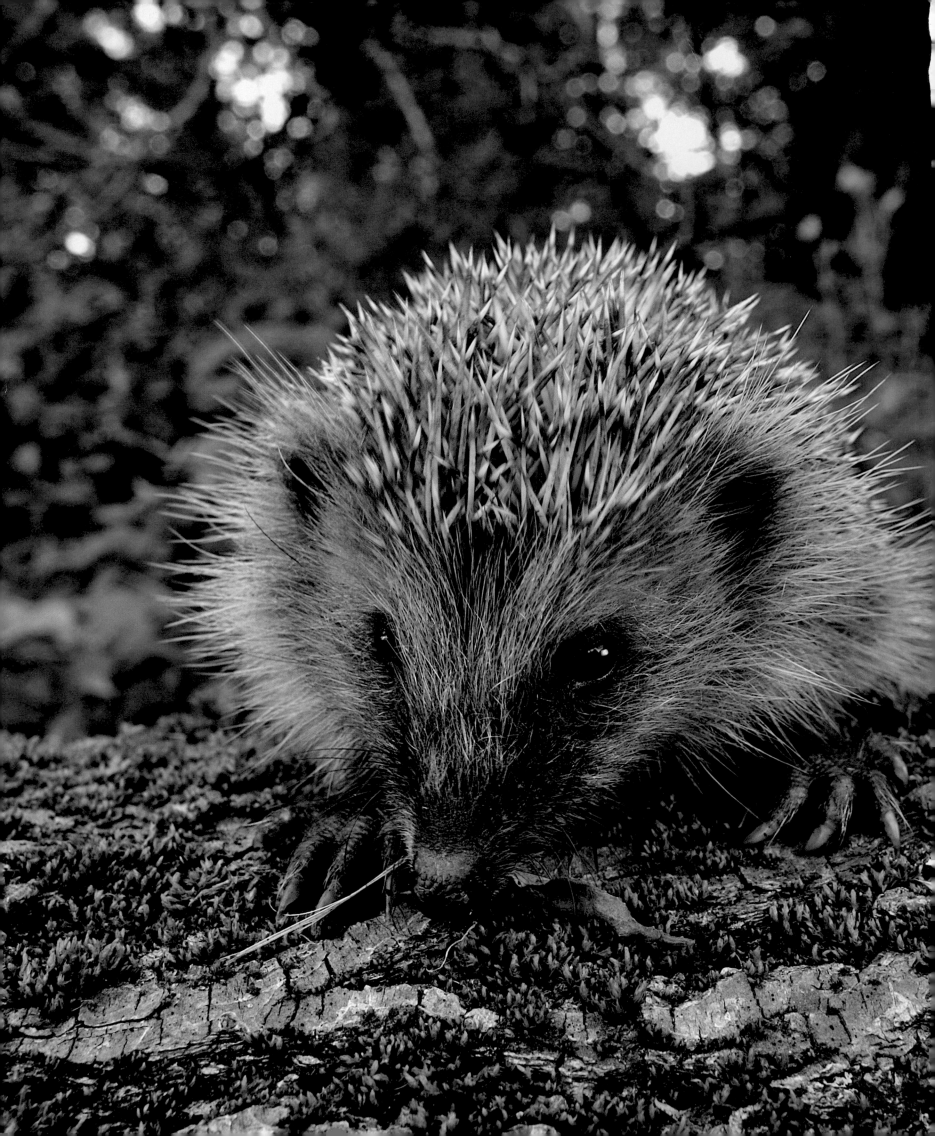

◁ The west European hedgehog (*Erinaceus europaeus*) has poor eyesight, but compensates for this with a very well-developed sense of smell, which helps it to find slugs, worms, and beetles to eat, and to detect potential threats. A hedgehog's defensive mechanism is one of the best there is. It can roll itself up into a spiny ball, and, if necessary, it will remain like this for hours, providing a very effective deterrent against most predators.

> Vampires are not just the stuff of legends. The vampire bat (*Desmodus rotundus*) lives in Central and South America and feeds on blood. Cows and horses are typical victims, although tapirs, large birds, and even humans have been known to provide the vampire with its nightly 25ml (⅘fl oz) serving. A hunting bat alights near its victim, walks up to it and uses its heat-detecting nose to find the right place for the bite. The bat then trims away any inconvenient fur and uses its razor-sharp front teeth to remove a piece of skin. Usually the victim will feel nothing. Anticoagulants in the bat's saliva keep the blood flowing as the bat laps it up.

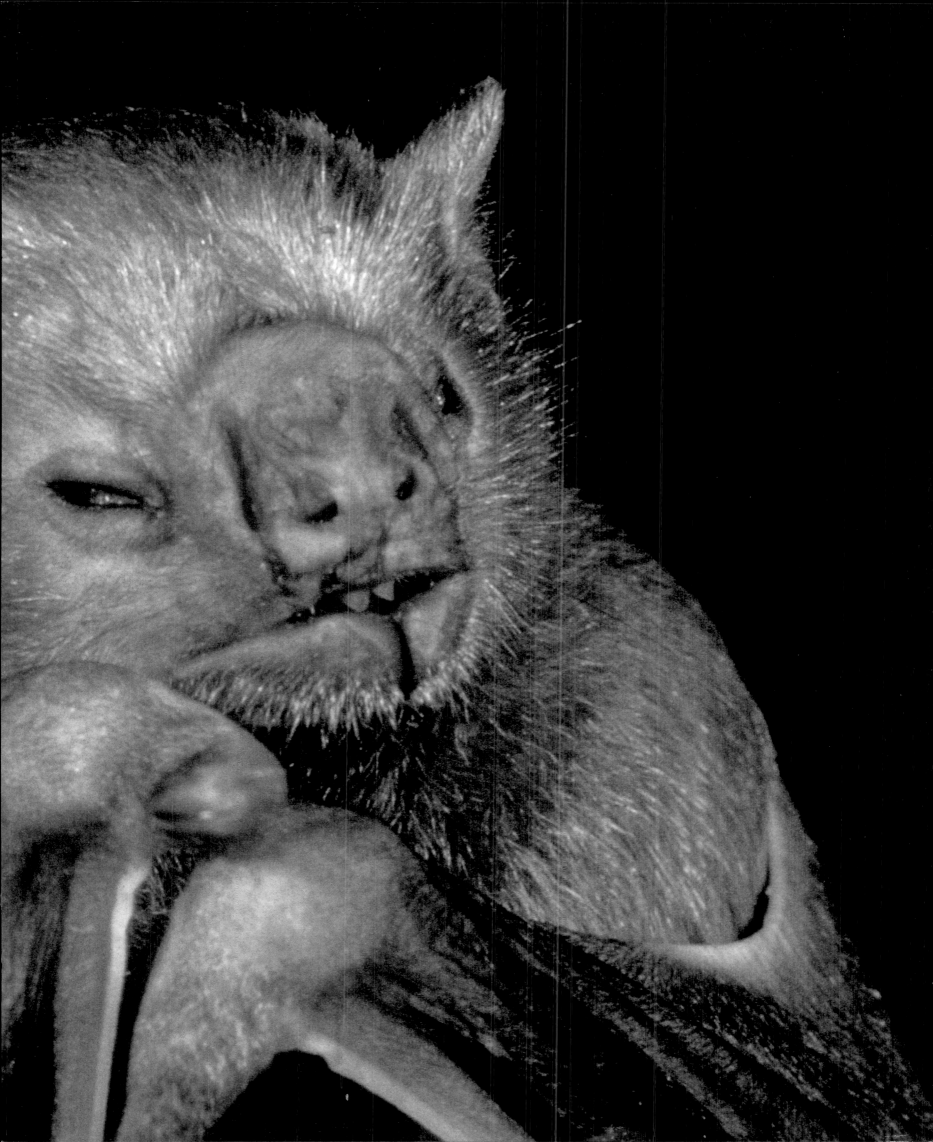

The lemur is endemic to Madagascar and neighbouring islands. Its thumbs are opposable, like a human's, and its fingers and toes are tipped with nails, rather than claws. This strikingly marked lemur is Coquerel's sifaka (*Propithecus coquereli*).

This dangling black and white ruffed lemur (*Varecia variegata*) is holding onto a branch with its feet. Lemurs use their tails to help them balance when they jump from tree to tree. At up to 4.5kg (10lb), this is one of the largest of all lemurs.

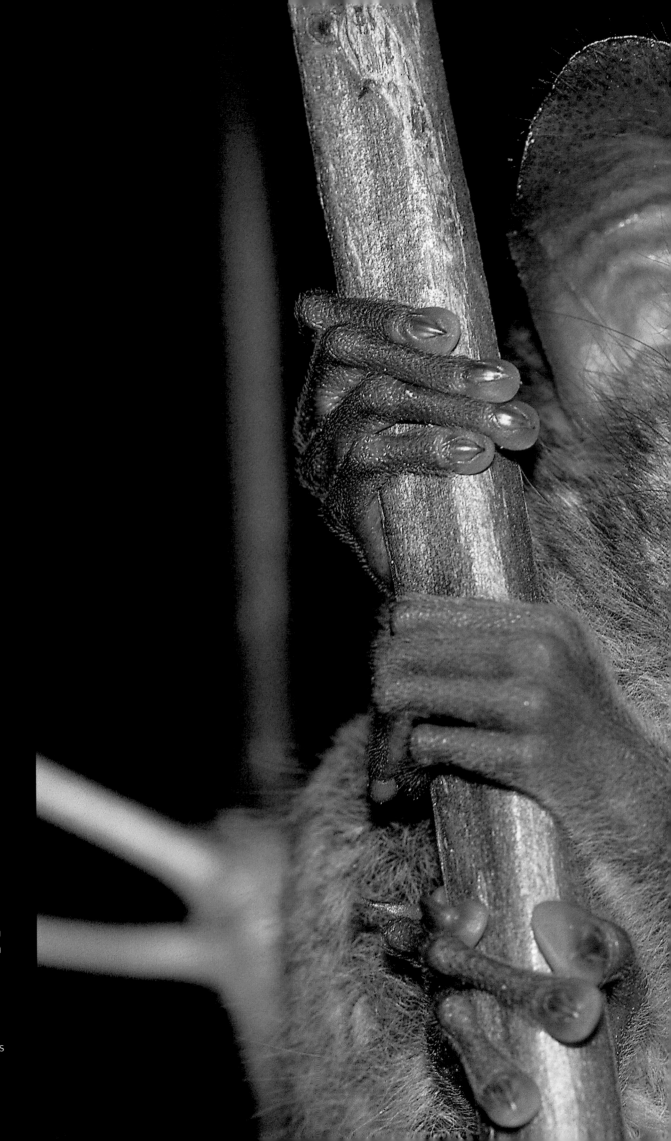

> The spectral tarsier (*Tarsius spectrum*) is a tiny, nocturnal primate found in tropical forests in Sulawesi, Indonesia. Its fingers and toes are tipped with special pads to help keep it firmly in the trees, though it frequently comes down to earth to hunt. The spectral tarsier is a ferocious insectivore, taking prey more than half its own size. It is just 11–15cm (4¼–6in) long, with an additional 24cm (9½in) of tail, and weighs just 94–132g (approximately 3½–4¾oz). The spectral tarsier cannot move its huge eyes, but can turn its head to face forwards or backwards.

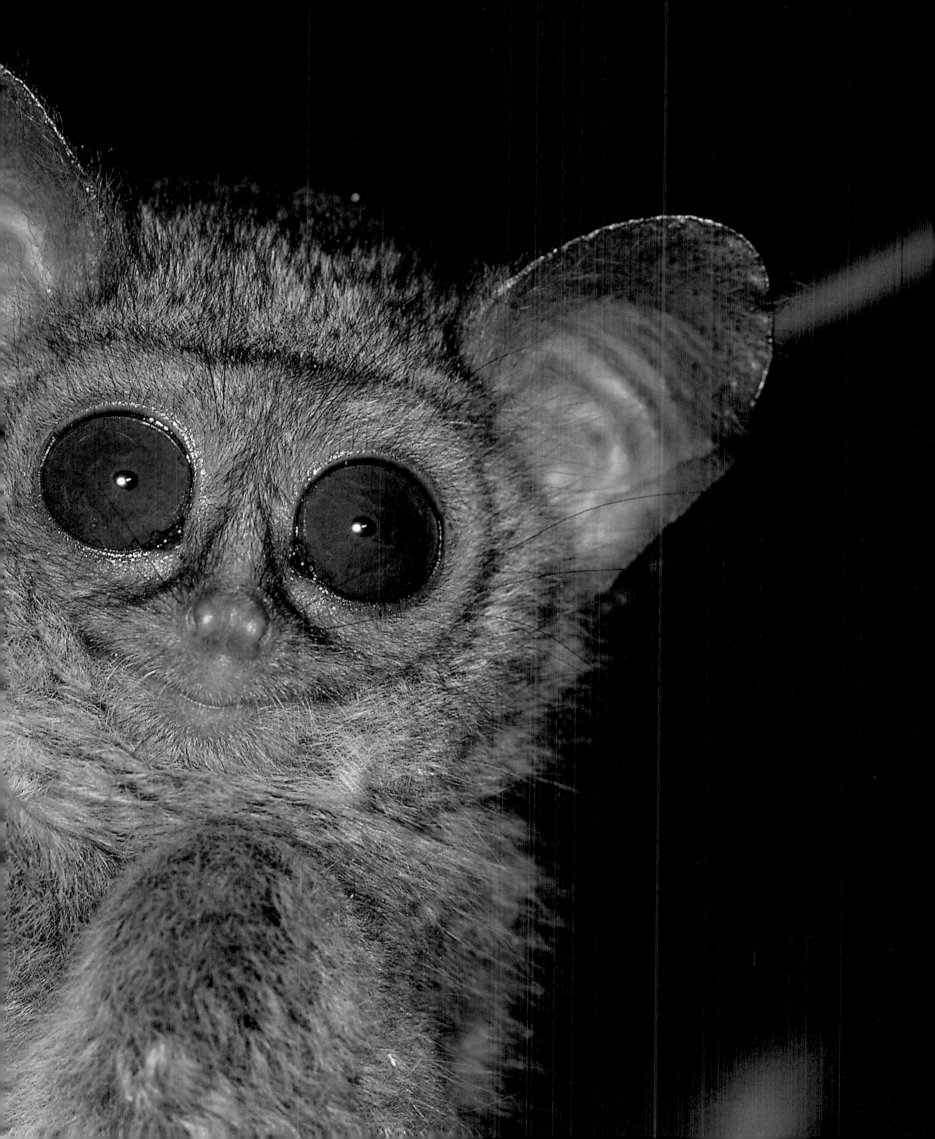

> The long-tailed macaque, or crab-eating macaque (*Macaca fascicularis*), is a native of Southeast Asia. It is a social animal that lives in a troop in which males are in the minority and both genders may be promiscuous. A youngster, such as this one, is looked after mainly by its mother and is not weaned until it is over a year old. Typically, young males leave the troop around the time they become sexually mature, while young females will stay in their natal troop. The long-tailed macaque has a varied diet that includes crabs, fruit, leaves, and insects.

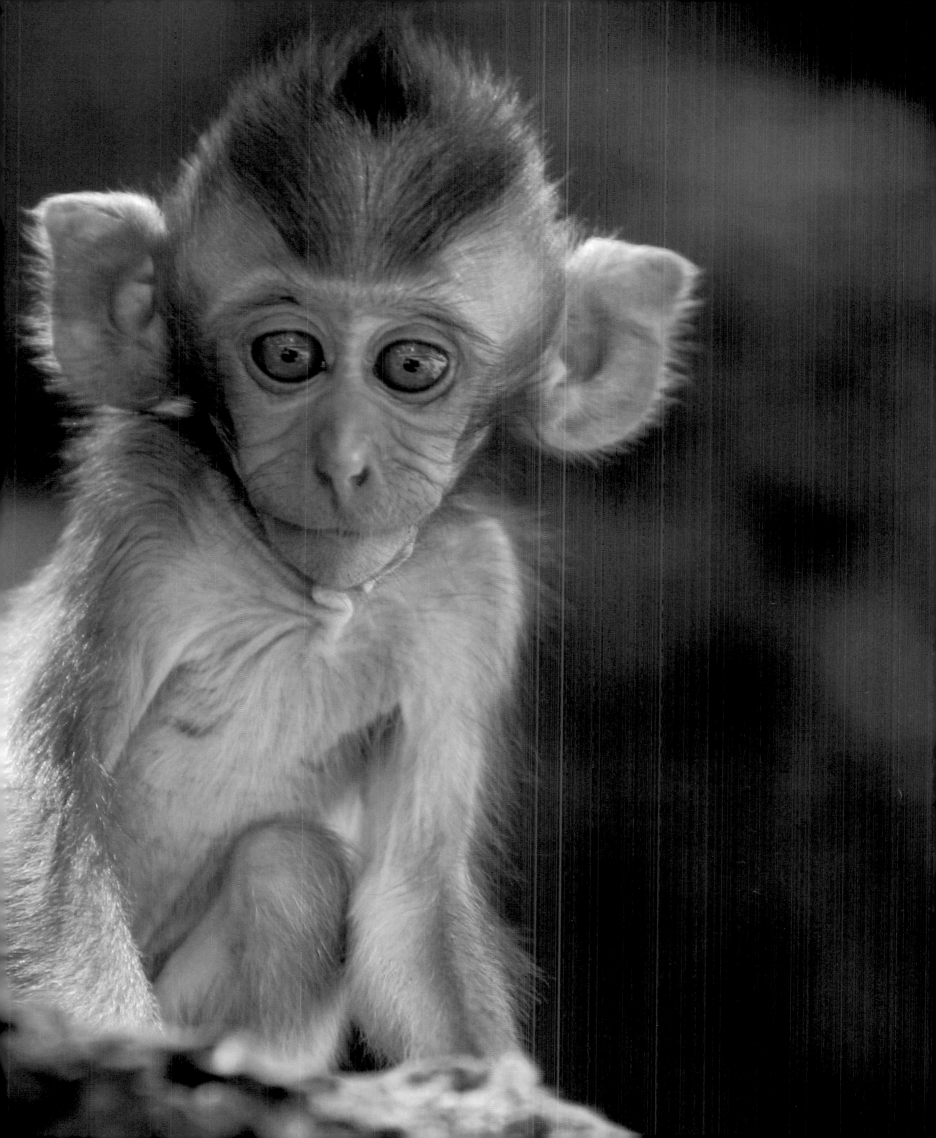

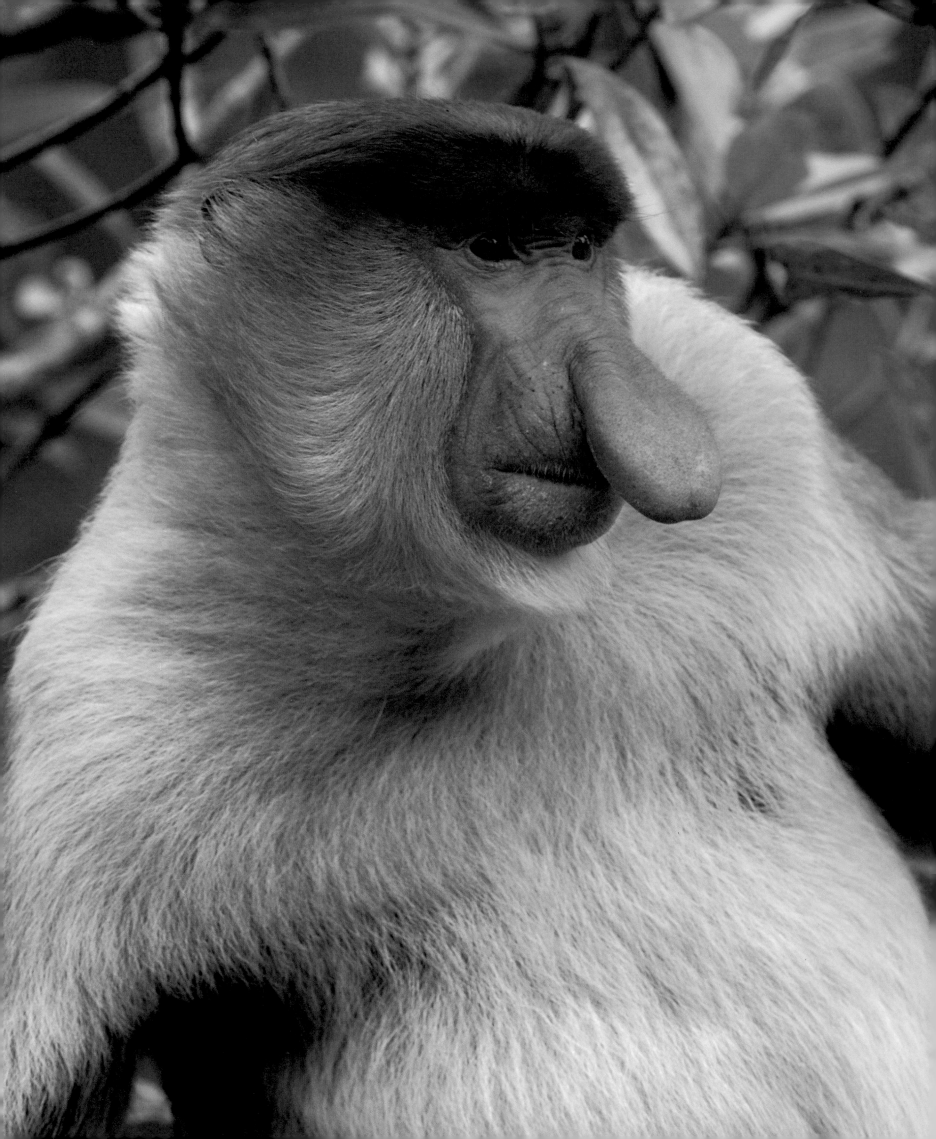

< The distinctive nose of the male proboscis monkey (Nasalis larvatus) serves a dual purpose. It attracts females and also acts as a resonating chamber to amplify warning calls. When the male is distressed, his nose becomes engorged with blood and straightens out, making his honking calls louder and more intense. Proboscis monkeys are native to Borneo.

▷ This infant mountain gorilla *(Gorilla berengei berengei)* will spend the first few months of his life in almost constant contact with his mother. Although mountain gorillas are the largest of the primates, newborns are tiny and fragile, weighing only around 1.8kg (4lb). Initially they are as helpless as human infants, but develop almost twice as quickly. At eight weeks they can crawl and at 20 weeks they can stand up, beginning to walk soon afterwards. Mountain gorillas are found only in the montane forests of the Virunga Mountains, in Central Africa.

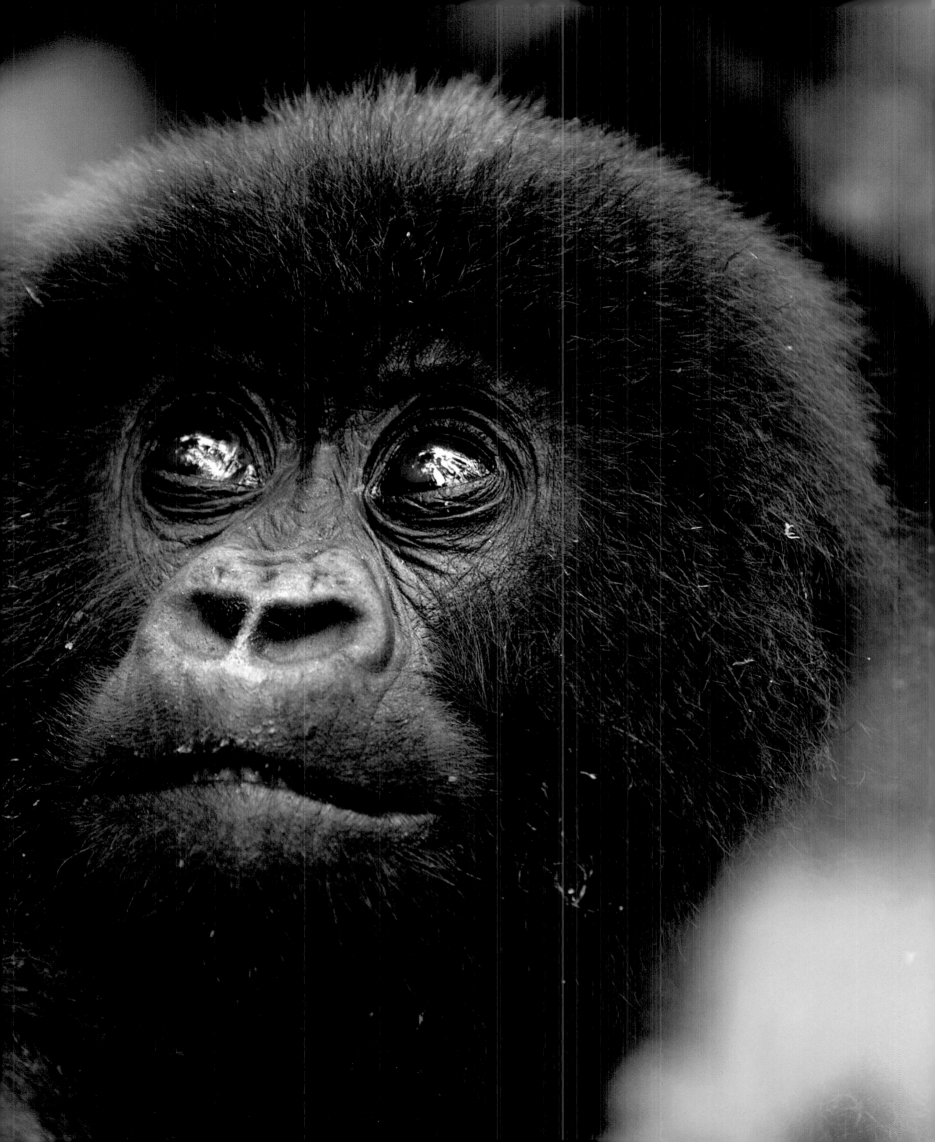

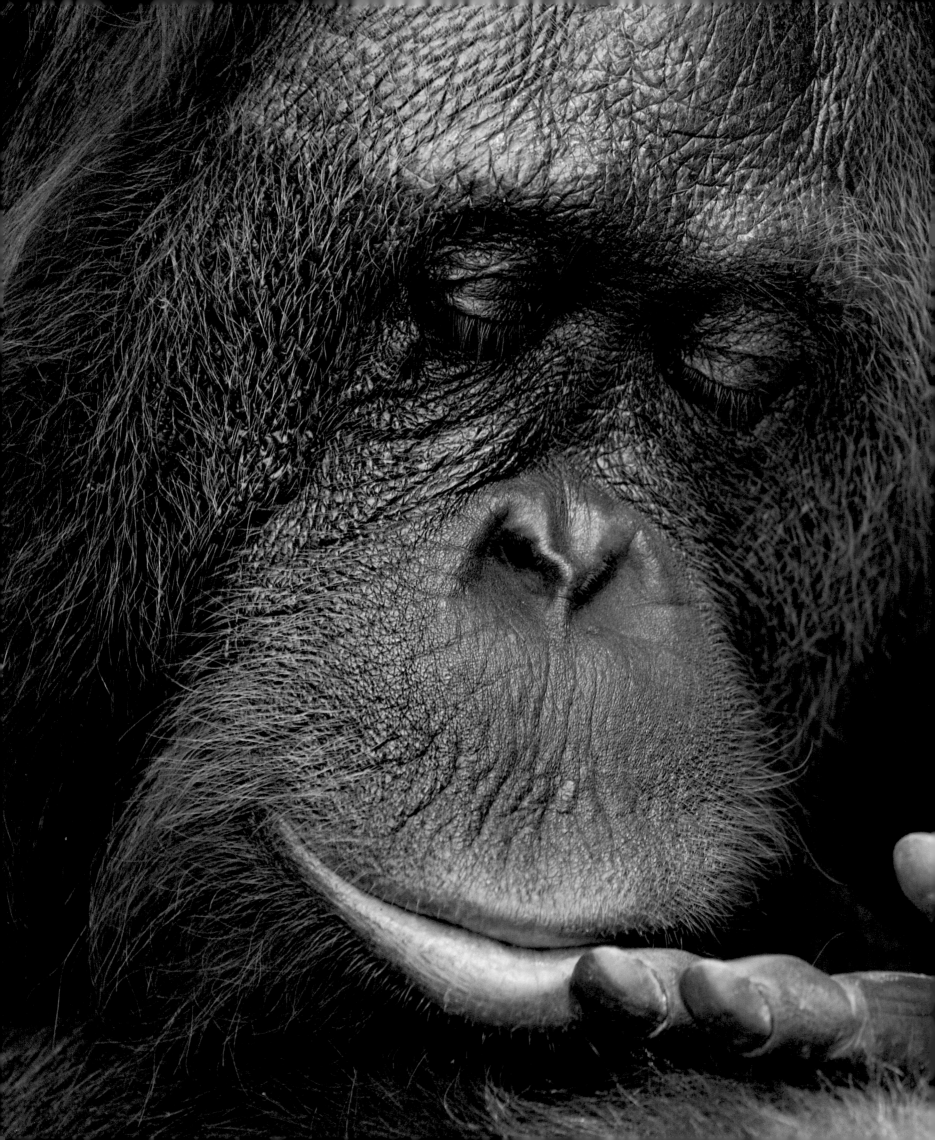

◁ The Bornean orangutan (*Pongo pygmaeus*) spends most of its life high up in forest trees, where it feeds, breeds, and constructs a platform to sleep on. The females are even more arboreal than the males, who do occasionally climb down. The orangutan's hands provide a good, firm grip as it lives out its treetop existence, aided by high-mobility hip, shoulder, and wrist joints. This great ape is found in Borneo, in southeast Asia, and the word orangutan means "person of the forest" in the Malay language

▷ The brown-throated three-toed sloth (*Bradypus variegatus*) is not known for its speed. It dwells in trees, where its slow movement may make it difficult for sharp-eyed birds of prey to spot. It comes to earth perhaps once in eight days to perform its bodily functions, and sometimes to ascend a different tree. It cannot see or hear well and probably relies largely on touch and smell to find leaves to eat. The three-toed sloth is equipped with long claws, which help it hold on to branches and are also used to discourage would-be predators. Surprisingly, perhaps, three-toed sloths swim well. This species is found in parts of Central and South America.

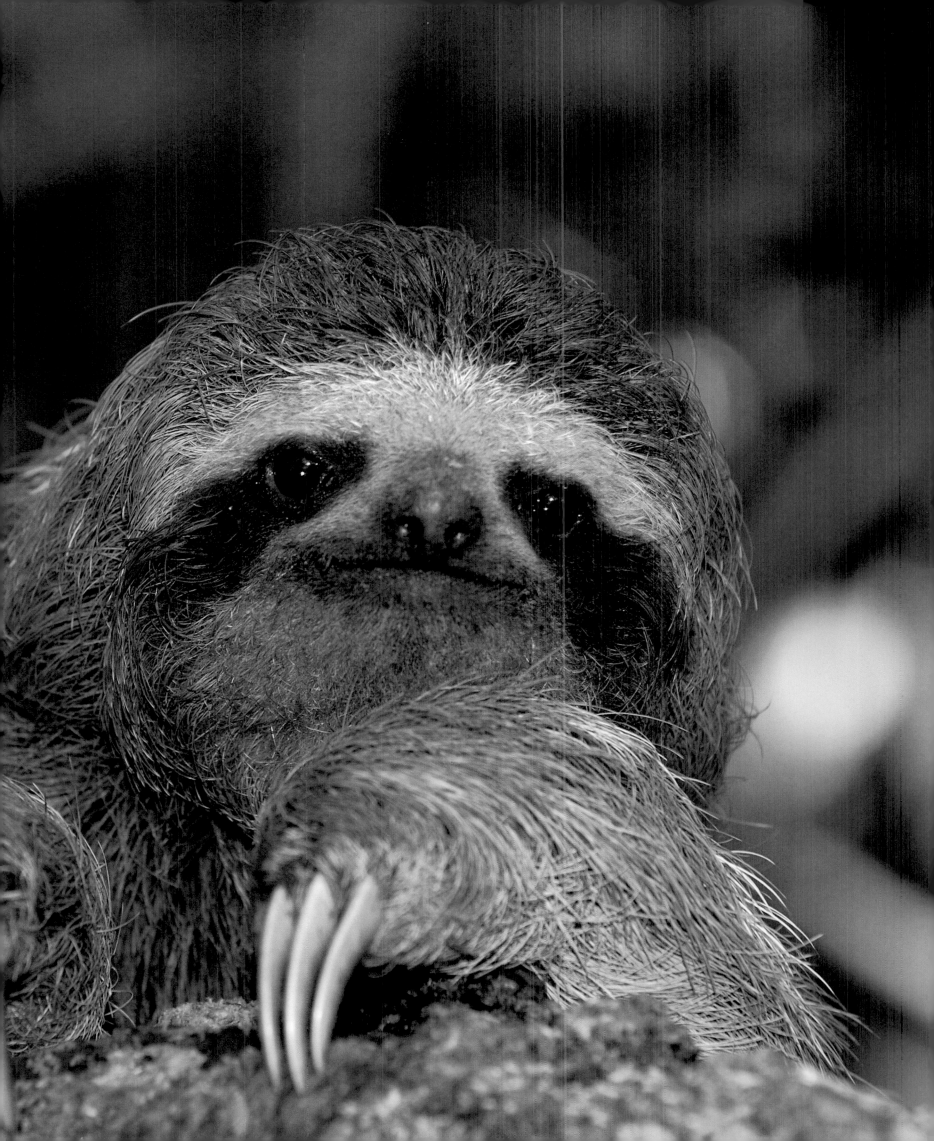

▷ The giant anteater
(*Myrmecophaga tridactyla*)
is native to Central and South
America. It is a sizeable creature,
measuring 1–2m (3¼–6½ft) in
length and weighing up to 39kg
(86lb). As well as a keen sense
of smell, the giant anteater has
two key pieces of specialist
equipment that help it to get at its
prey – oversized forelimbs armed
with large claws, and an extremely
long tongue. The claws are
effective tools for breaking into
termite mounds and ant nests,
making way for up to 60cm (2ft)
or more of long, sticky tongue,
complete with tiny spines that
point towards the snout – perfect
for extracting the exposed insects.
It can flick its tongue in and out
up to 150 times per minute.

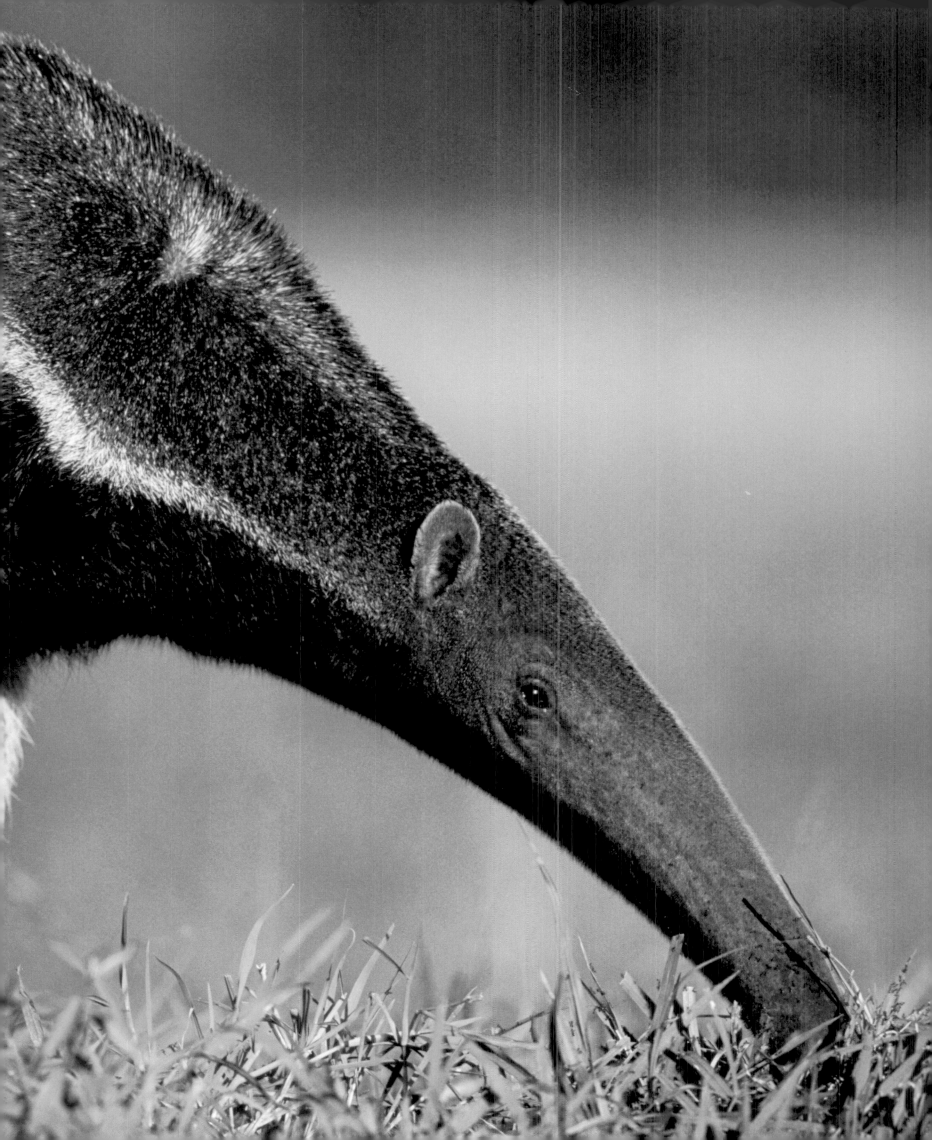

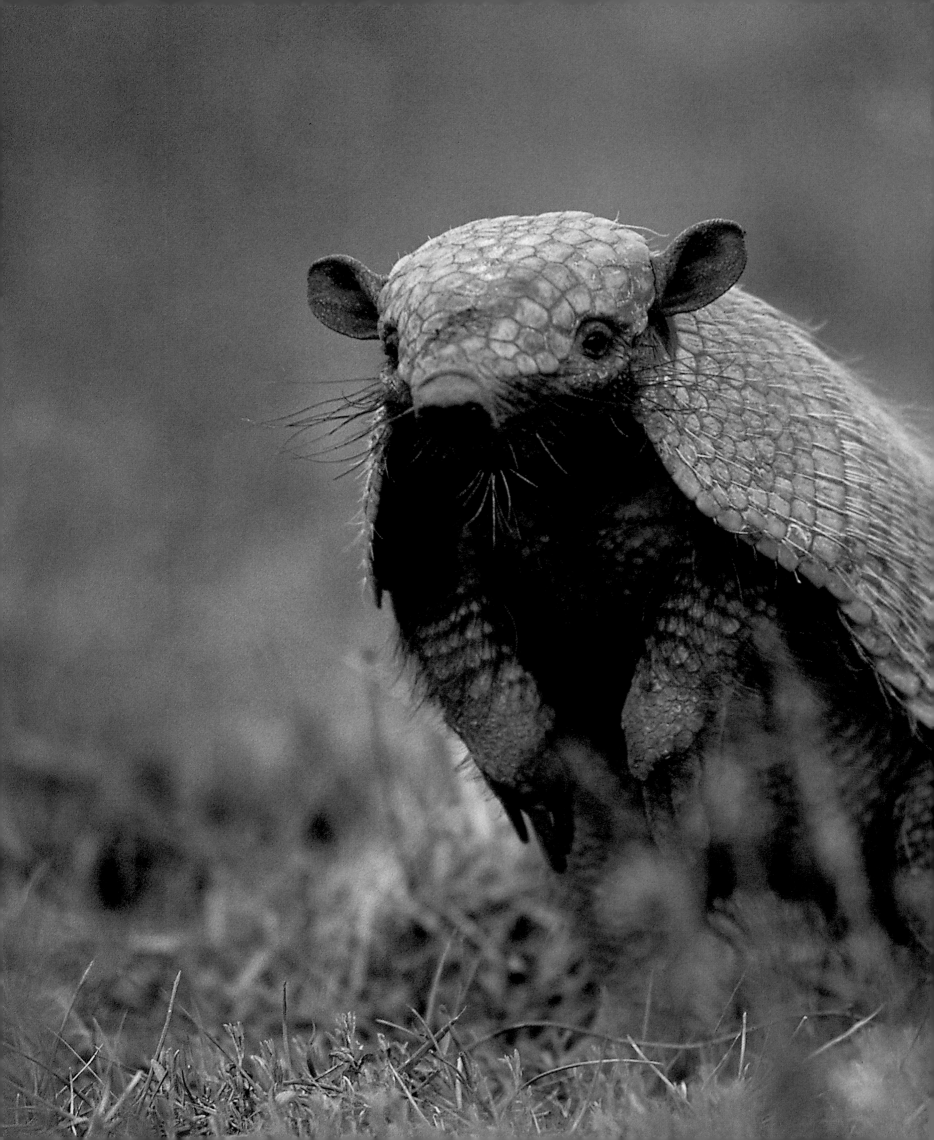

◁ Most armadillos are nocturnal, but the six-banded armadillo (*Euphractus sexcinctus*), of South America, is more active during daylight hours. This one is revealing its more vulnerable side – its soft underparts. Its upperparts are protected by an "armour" of toughened skin, which, in this species, includes between six and eight scaly bands. The claws of the six-banded armadillo are excellent digging tools, essential for a burrow dweller.

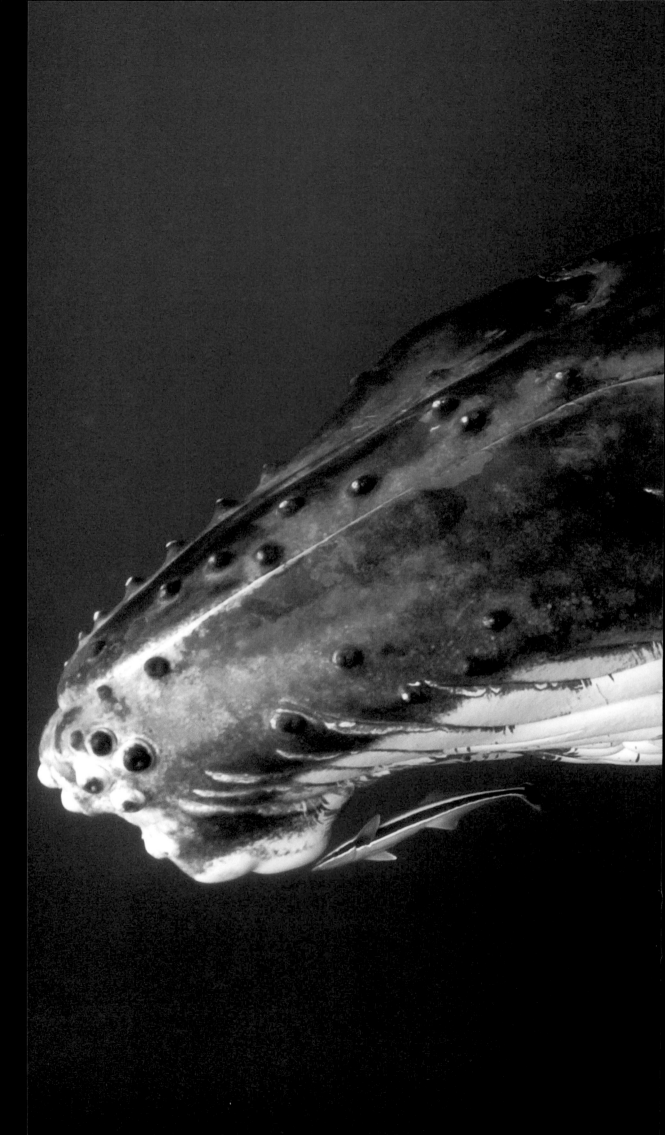

▷ The humpback whale
(Megaptera rovaeangliae) is
one of the largest living creatures.
Females can reach 15m (49ft) or
more in length – the males tend
to be smaller. A large humpback
can weigh more than 30 tonnes.
Most populations are migrants,
breeding in tropical and sub-
tropical waters and migrating
to feed in temperate and polar
regions for the rest of the year.
Their migration is thought to be
the longest of any mammal, with
humpbacks that breed in the
Pacific off Central America
travelling more than 8,000km
(around 5,000 miles) to their
Antarctic feeding areas.
Humpback whales are found
throughout the world's oceans,
although not in the Baltic,
Mediterranean, or Red Seas,
or the Arabian Gulf.

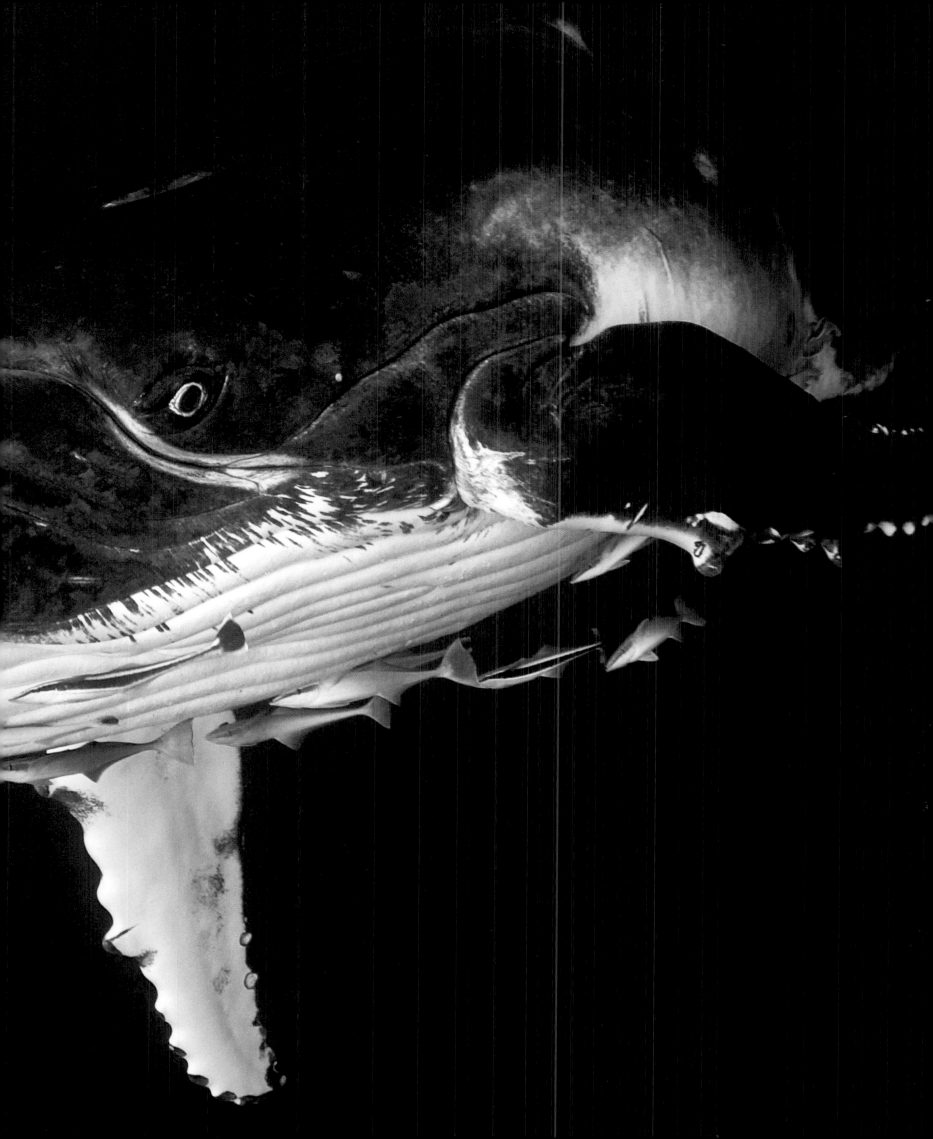

▷ This is the dolphin of marine aquaria, but its proper home is the wild sea. So named because of the shape of its "beak", the bottlenose dolphin (*Tursiops truncates*) swims in all the world's oceans, except those at extreme latitudes, and is a successful and versatile species. Those that swim around tropical coasts, such as this one in the Caribbean, are around 2m (6½ft) long – half the size of those that brave colder waters. The bottlenose dolphin's diet includes fish, crustaceans, and molluscs.

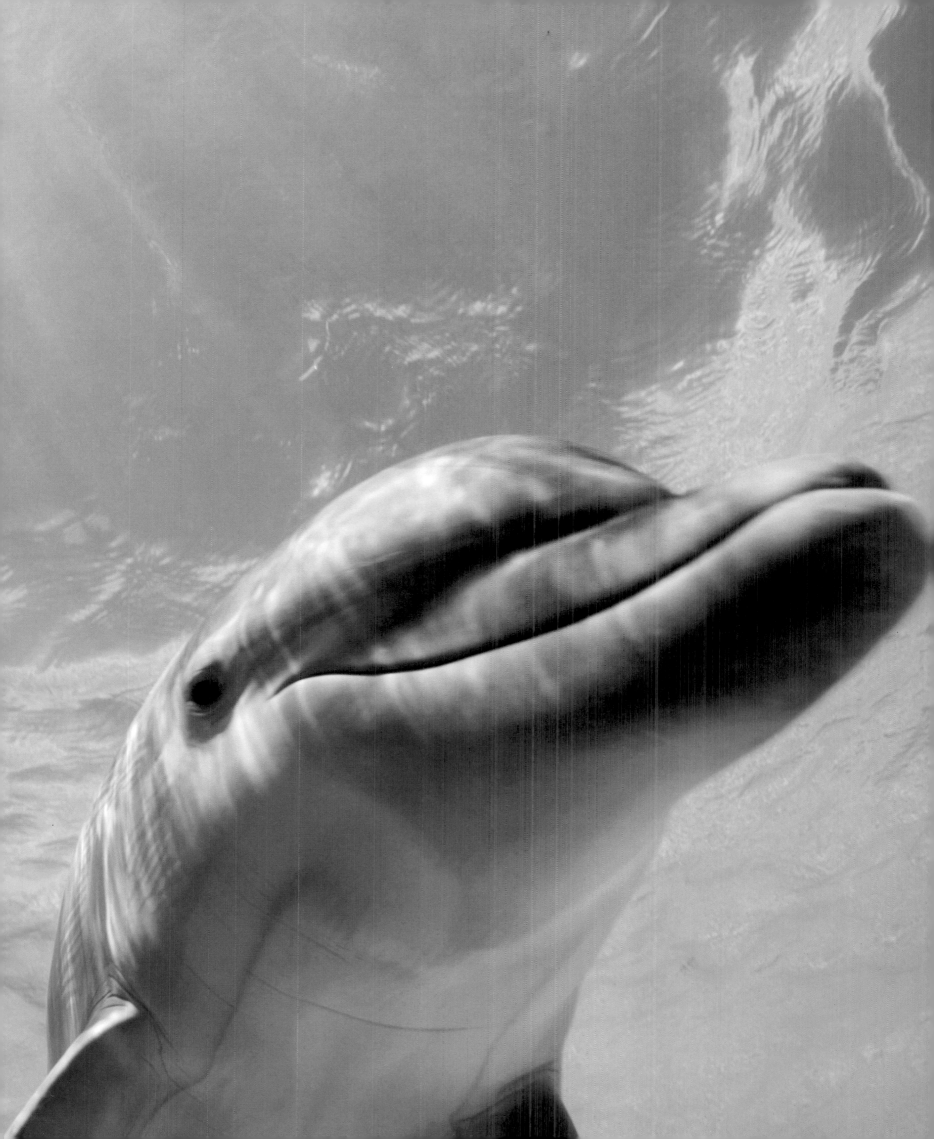

▷ At up to 60kg (130lb), the grey wolf (*Canis lupus*) is the biggest wild dog, and is the dog from which our pet canines are descended. It lives in some extreme environments, including Alaska, Greenland, and Siberia, where, when temperatures plummet, the wolf's thick fur provides good insulation. Grey wolves live in packs of around 8–12 related individuals, headed up by a dominant pair. Their teamwork puts some substantial prey items on the menu, including musk oxen, caribou, and moose. However, once the prey has been caught, the rest of the pack has to wait until the dominant pair has eaten its fill.

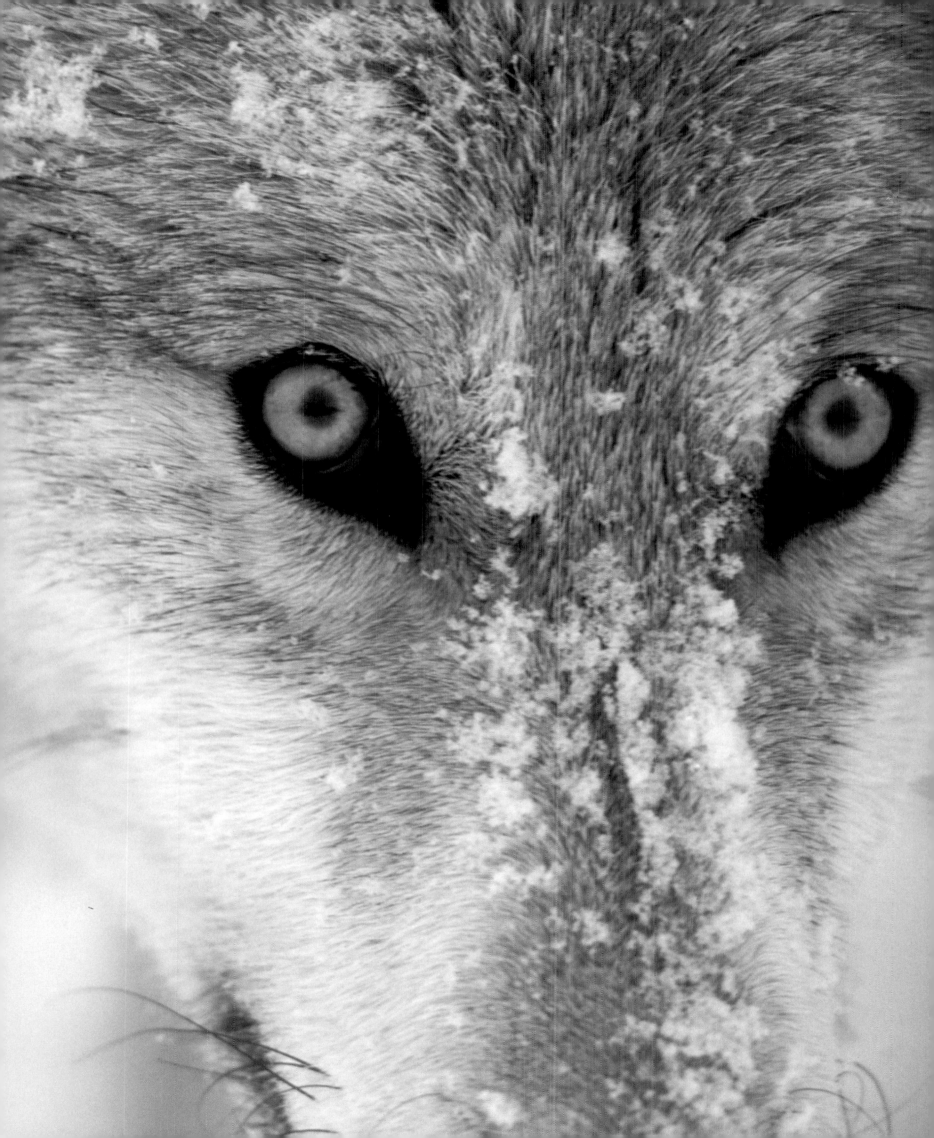

▷ A male polar bear (*Ursus maritimus*) can weigh a staggering 680kg (1500lb), perhaps twice the weight of a female. To stay warm in northern Canada and the Arctic, a polar bear has plenty of blubber and thick underfur. Its off-white coat has outer hairs rooted in black skin. The skin soaks up the warmth of the sun that travels along the hairs. Seals account for most of a polar bear's diet, which they catch either by careful stalking with a "sprint finish", or by waiting for an unfortunate individual to appear at a breathing hole. Climate change is a major threat to this beautiful animal.

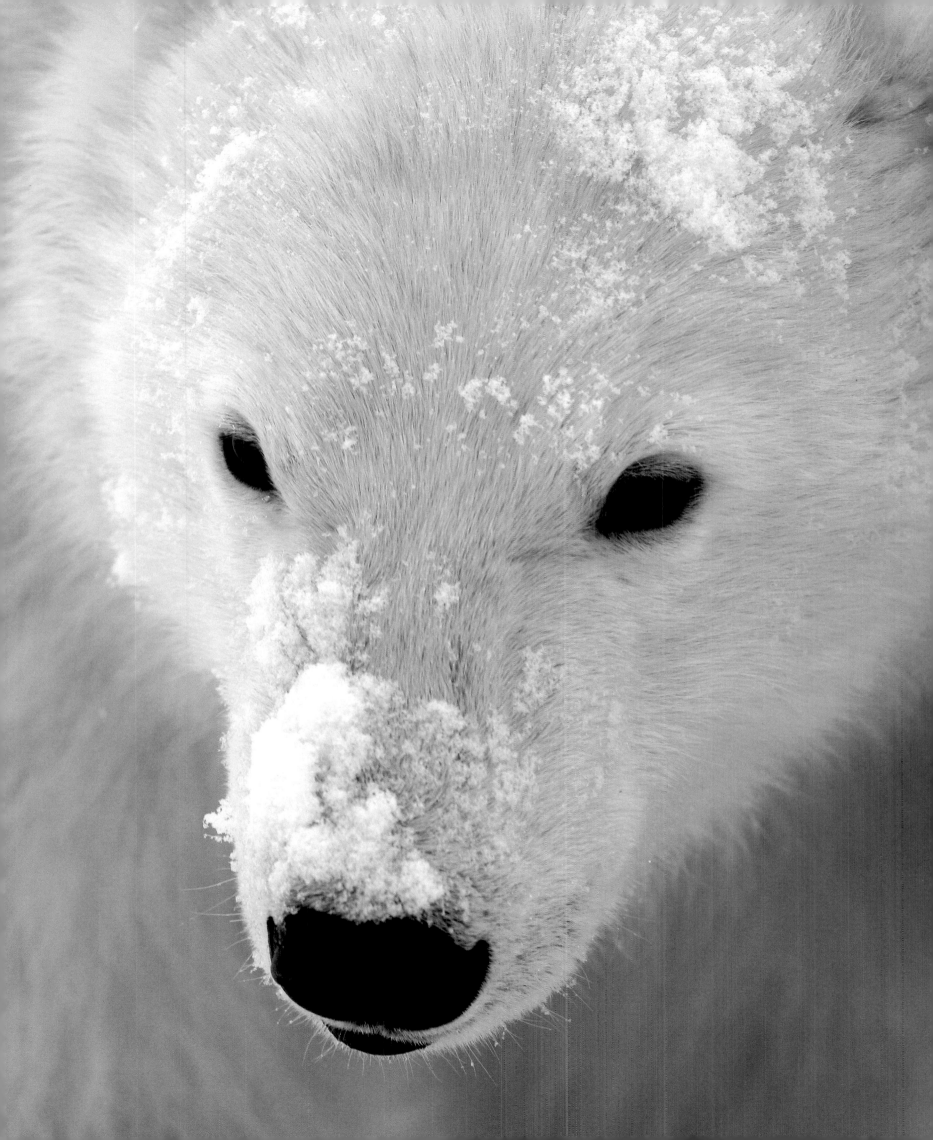

▷ The giant panda (*Ailuropoda melanoleuca*) is a species that could become extinct in the wild. This bear needs bamboos – it eats almost nothing else and sleeps amongst the cover of bamboos too – and a lack of suitable, good quality habitat is the main threat to its survival. The giant panda has what is, in effect, an extra thumb – an enlarged, projecting wrist bone with a certain degree of movement. This is used to help it manipulate its food. The giant panda is found only in parts of China.

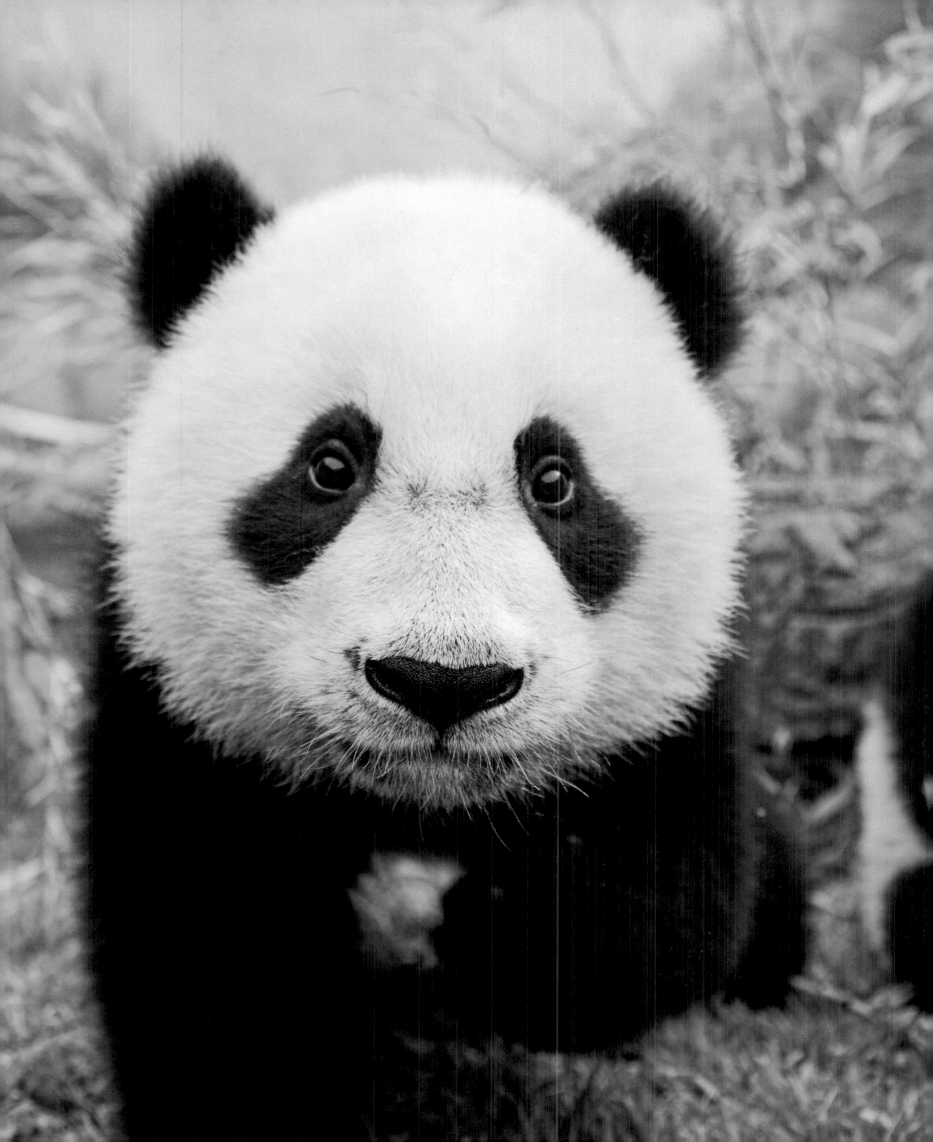

▷ Some varieties of brown bear (*Ursus arctos*) are larger than others, and these Alaskan, or Kodiak, bears are the largest. They are similar in size to polar bears, and can weigh as much as 780kg (1720lb). The Eurasian brown bear is at the other end of the scale, weighing up to 315kg (693lb). Brown bears need extensive open wilderness and are found in northern North America, Asia, and parts of Europe. Despite their sometimes fearsome reputation, brown bears will usually keep out of the way of people.

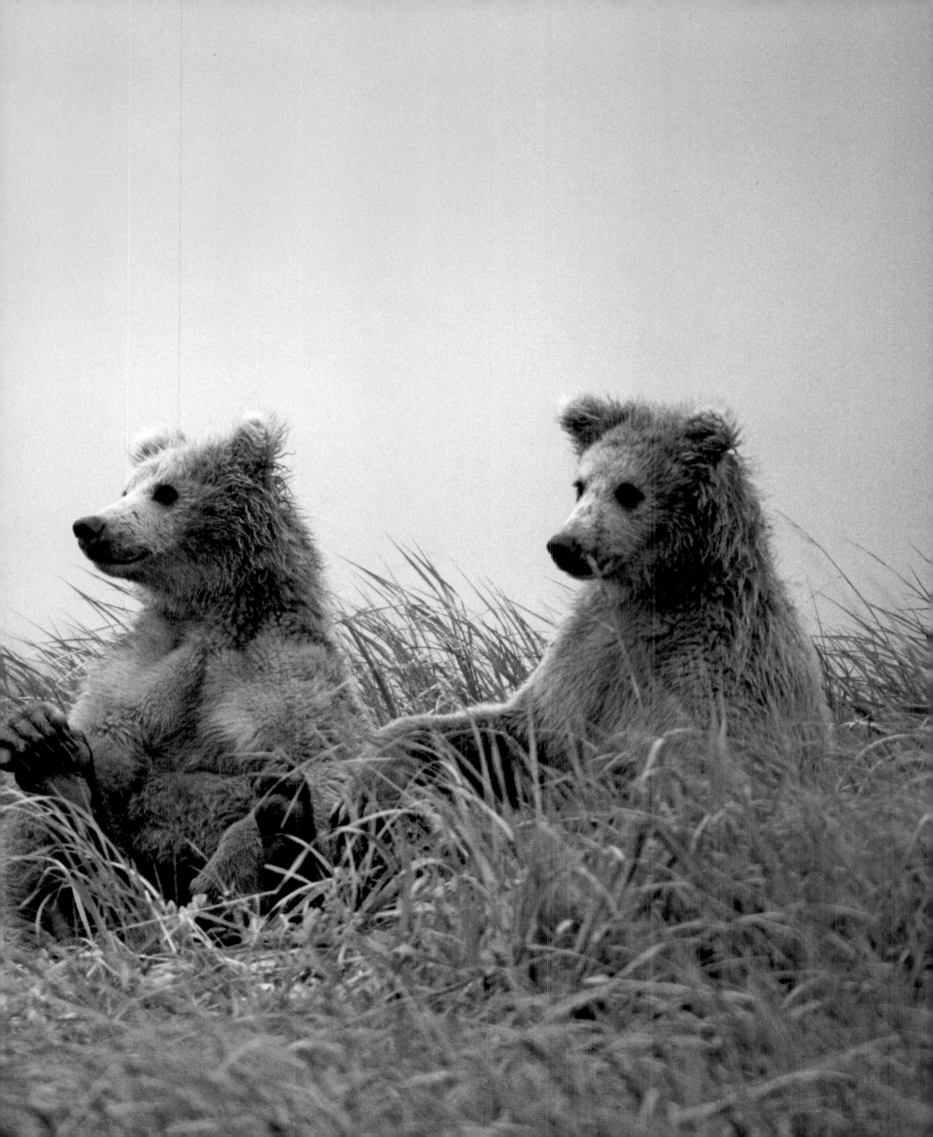

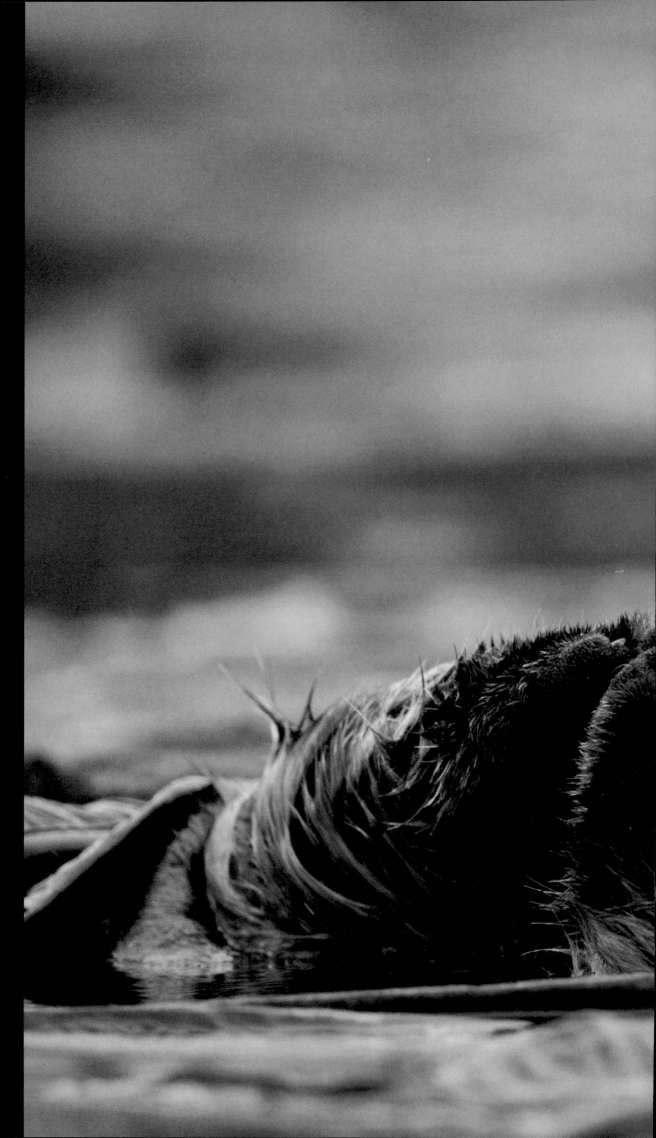

▷ The sea otter (*Enhydra lutris*) is built for a comfortable marine existence. Thick fur provides insulation and large lungs can hold enough oxygen for dives of up to four minutes, perhaps 30m (98ft) beneath the surface. Sea otters can see very well at these depths, where they hunt for crabs, clams, abalone, and sea urchins. They have very strong teeth to enable them to get into some of these seafood delicacies, but if necessary they will use a stone to assist in breaking the hard shells. Sea otters are found on both sides of the northern Pacific and can grow up to 130cm (4¼ft) long.

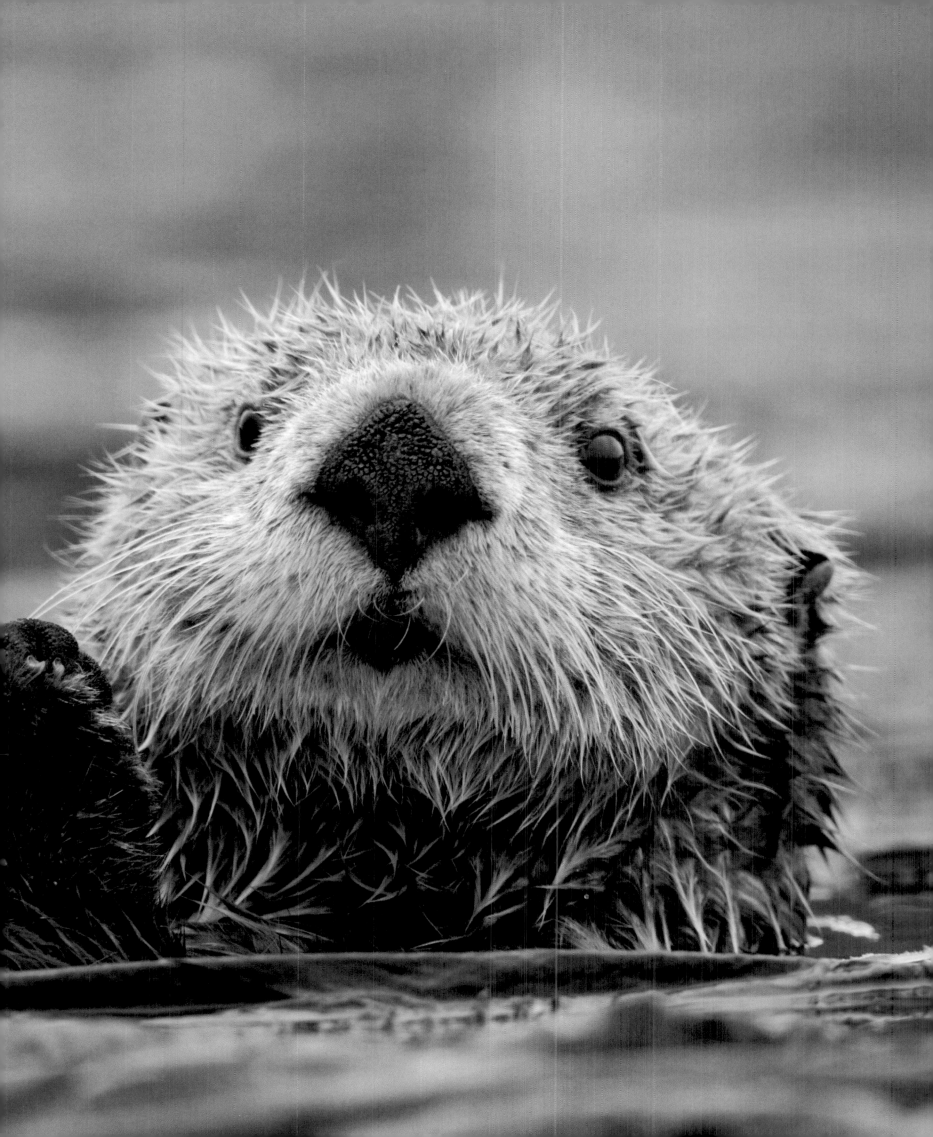

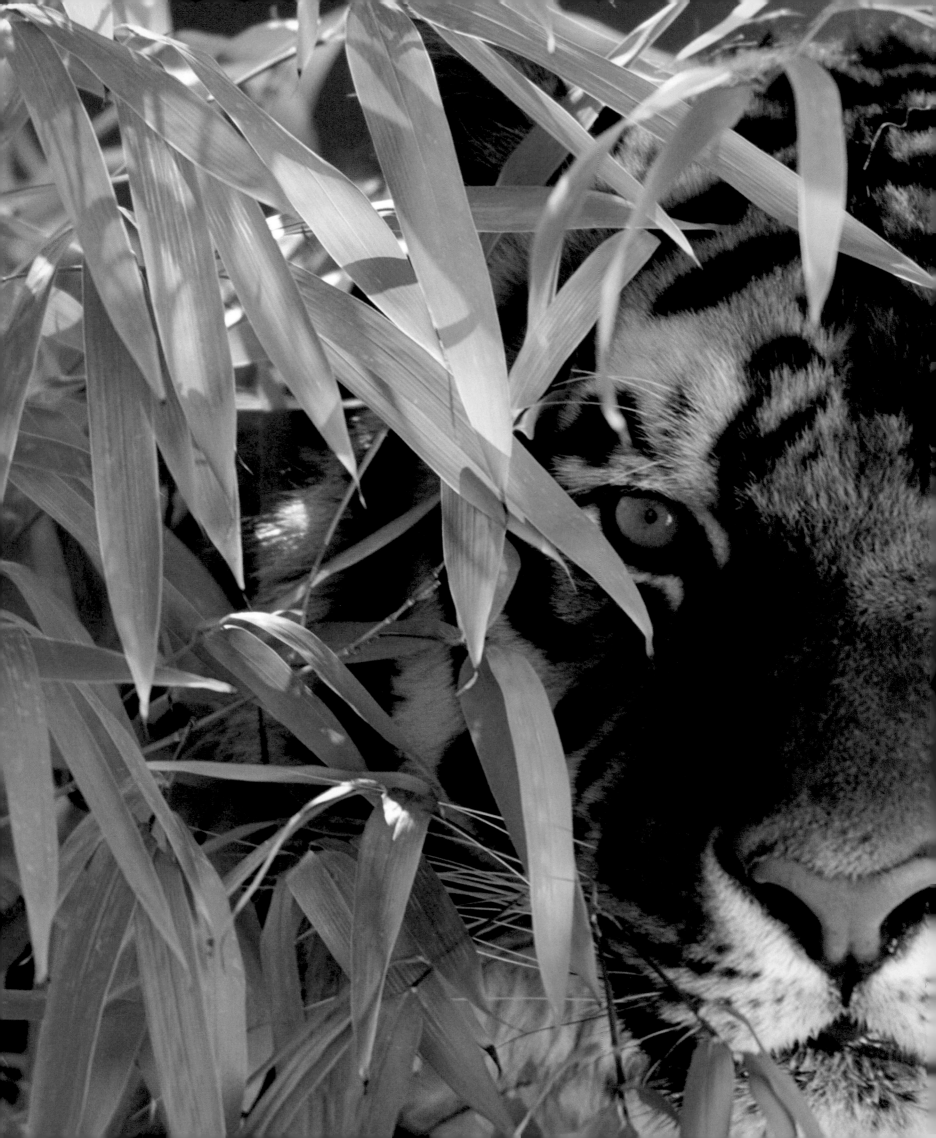

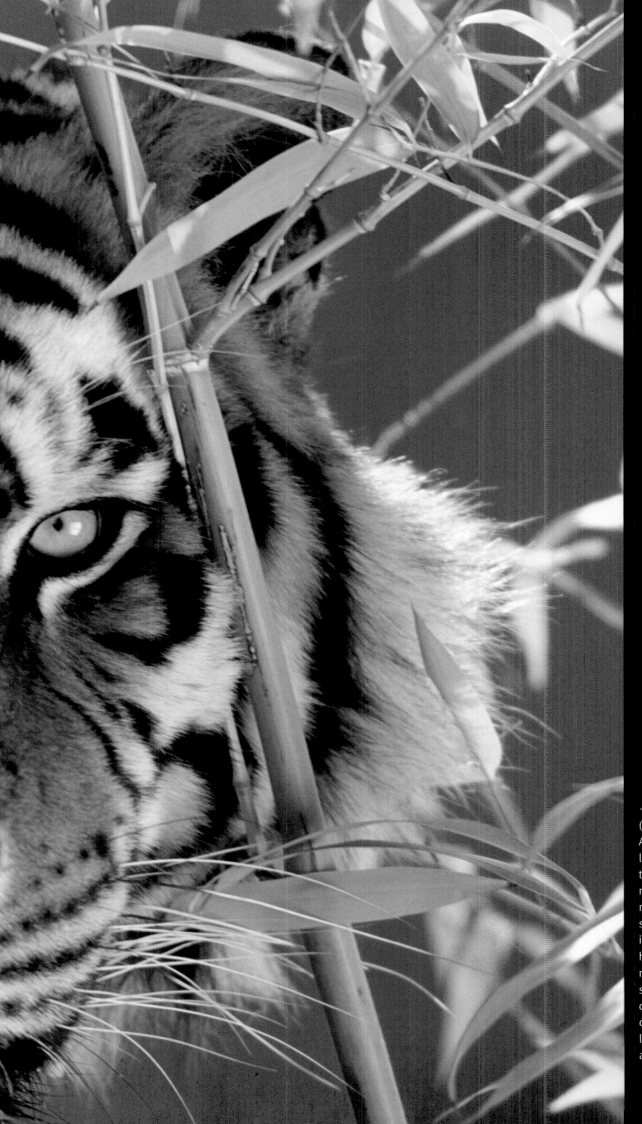

◁ Of all the big cats, the tiger (*Panthera tigris*) of south and east Asia, which can be 2.8m (9¼ft) long and weigh 300kg (660lb), is the biggest. The tiger is mainly, but not exclusively, a creature of the night. During the day, its distinctive stripes provide effective camouflage in the thick vegetation of its natural habitat. Every tiger is uniquely marked, and the stripes on one side of the body differ from those on the other. Thankfully, the demand for tiger skins has lessened, but the tiger is still an endangered species.

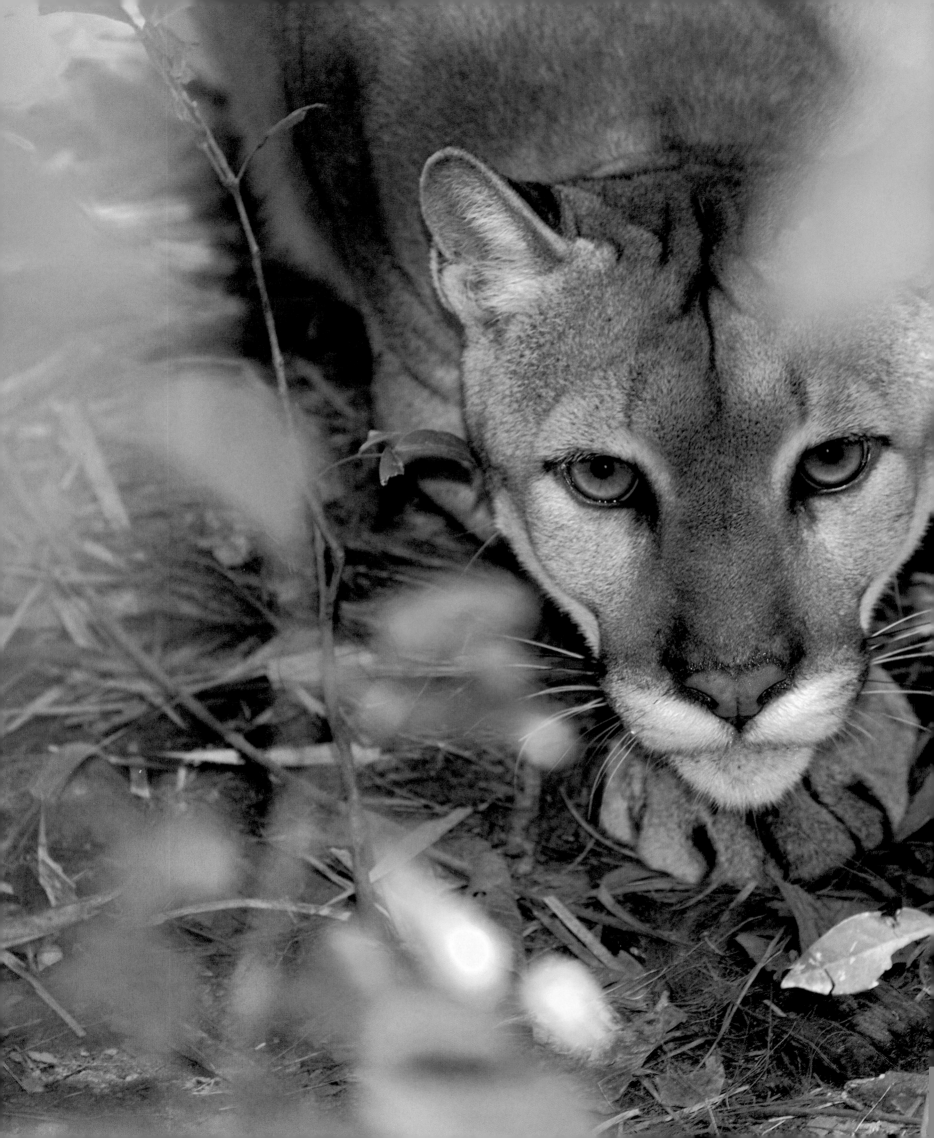

◁ The puma *(Puma concolor)* is a handsome, powerful predator. It hunts at night, its prey including moose, elk, and caribou, as well as smaller animals. To take the larger animals, a puma employs superb stalking skills, approaching to within leaping distance of its prey. A neck-breaking bite delivers the coup-de-grace. A big kill may be too much for a single sitting, and will be moved and hidden, perhaps several hundred metres away, to be revisited on subsequent nights. The puma is also known as the mountain lion or cougar. It lives in parts of North America, Central America, and South America and can weigh up to 105kg (230lb).

▷ Until recently, the black
panther was, erroneously,
regarded as a species in its own
right. "Melanism" occurs in a
number of cat species; jaguars
(*Panthera onca*) and leopards
(*Panthera pardus*) both sometimes
produce animals with much more
melanin (a dark pigment) than
normal. These black individuals
are known as black panthers.
Closer examination of their silky
skin reveals their normal markings
"underneath" the black. Most black
leopard sightings are in Asia,
rather than Africa. Black jaguars
are found in the New World.

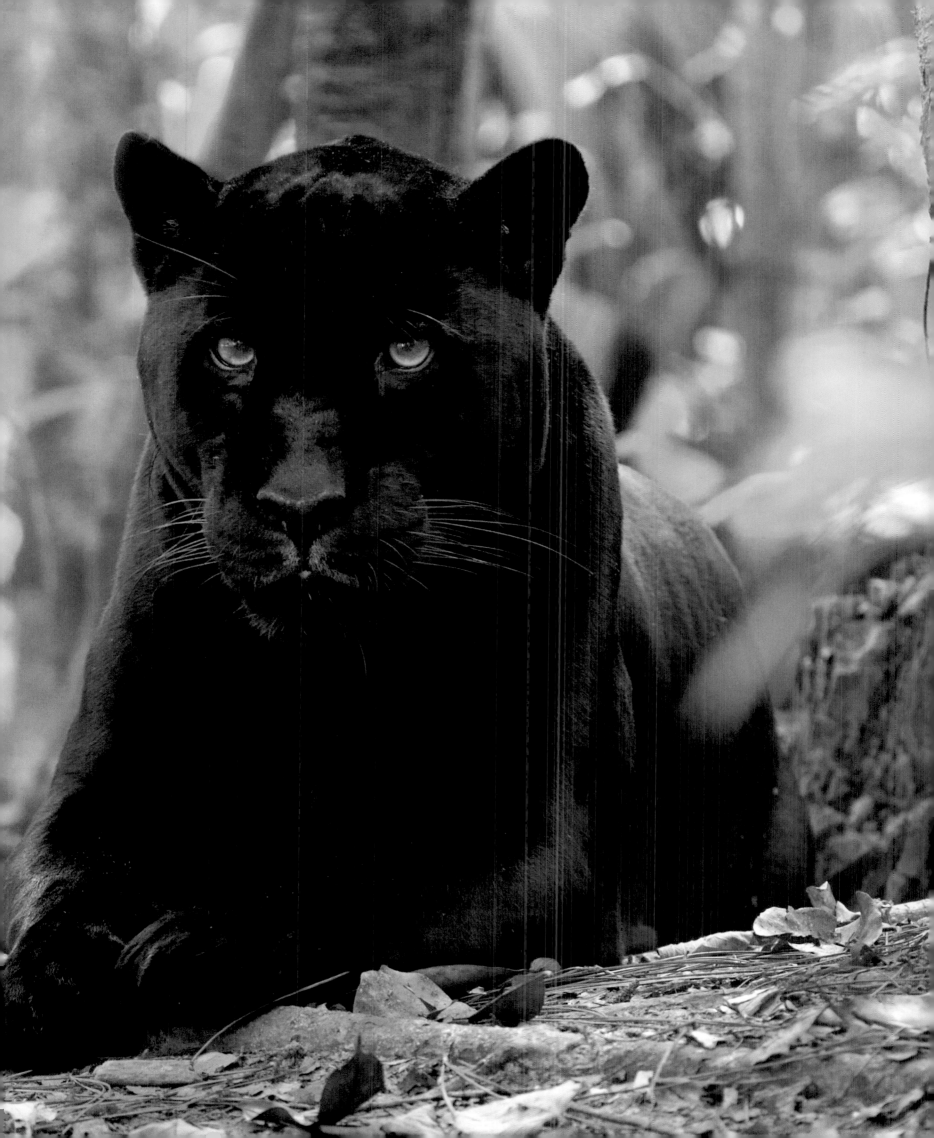

The jaguar (*Panthera onca*) is the only one of the four roaring big cats (tiger, lion, leopard, jaguar) found in the Americas. It is a powerful ambush predator, a creature of wet forests and swamps that can haul its prey while swimming and can drag it up a tree to get clear of the water.

The distinctive mane of a male lion (*Panthera leo*) makes him appear larger and provides an excellent intimidation display in confrontations with other male lions and with its main competitor for food, the spotted hyena. Lionesses favour males with the densest, darkest manes.

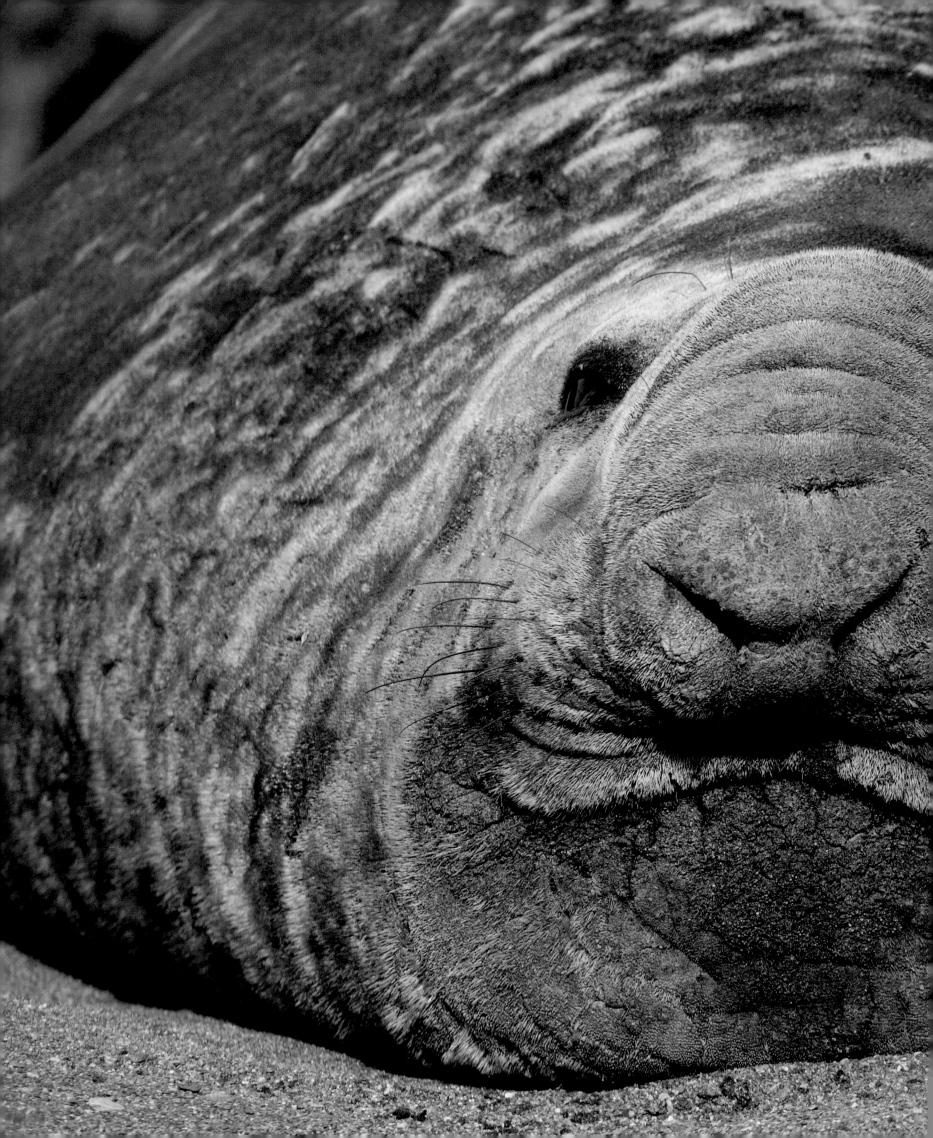

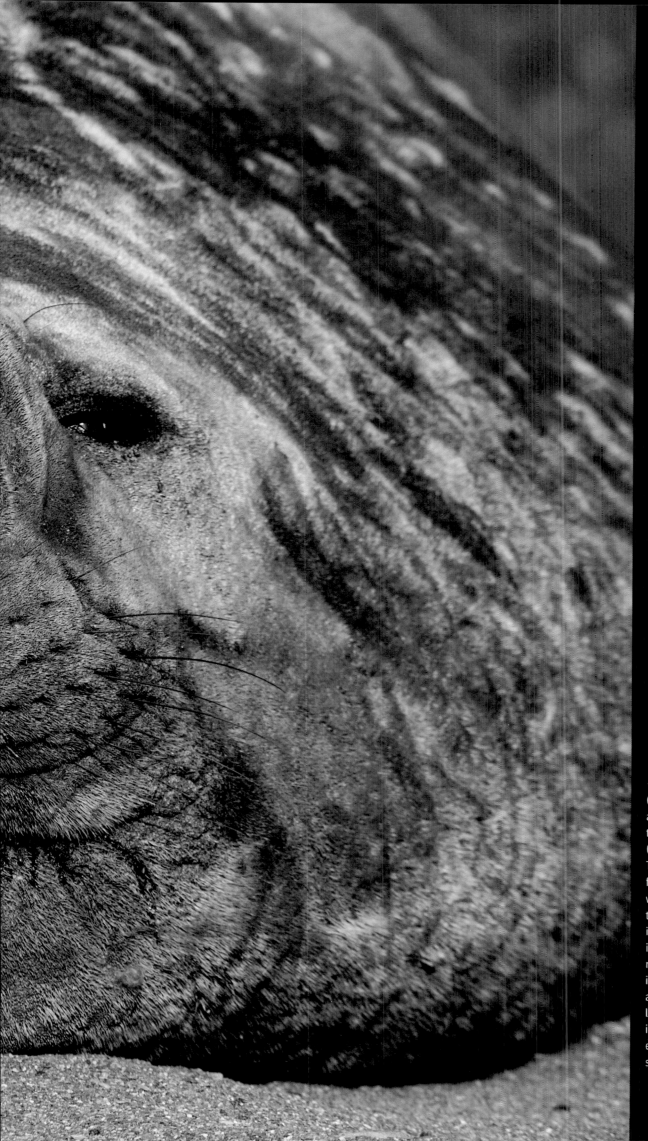

◁ The southern elephant seal
(*Mirounga leonina*) is bigger than
any other seal or sea lion – even
the walrus is smaller. At up to 6m
(20ft) long, this is a huge animal.
The male is much heavier than the
female, with the largest individuals
weighing in at a colossal five
tonnes. It is not only their size that
is elephantine – the male's nose
is trunk-like and inflatable. This
remarkable appendage generates
incredibly loud roars and, by
absorbing moisture, helps this
leviathan reduce water loss when
it breathes out. The southern
elephant seal is found around
sub-Antarctic and Antarctic oceans.

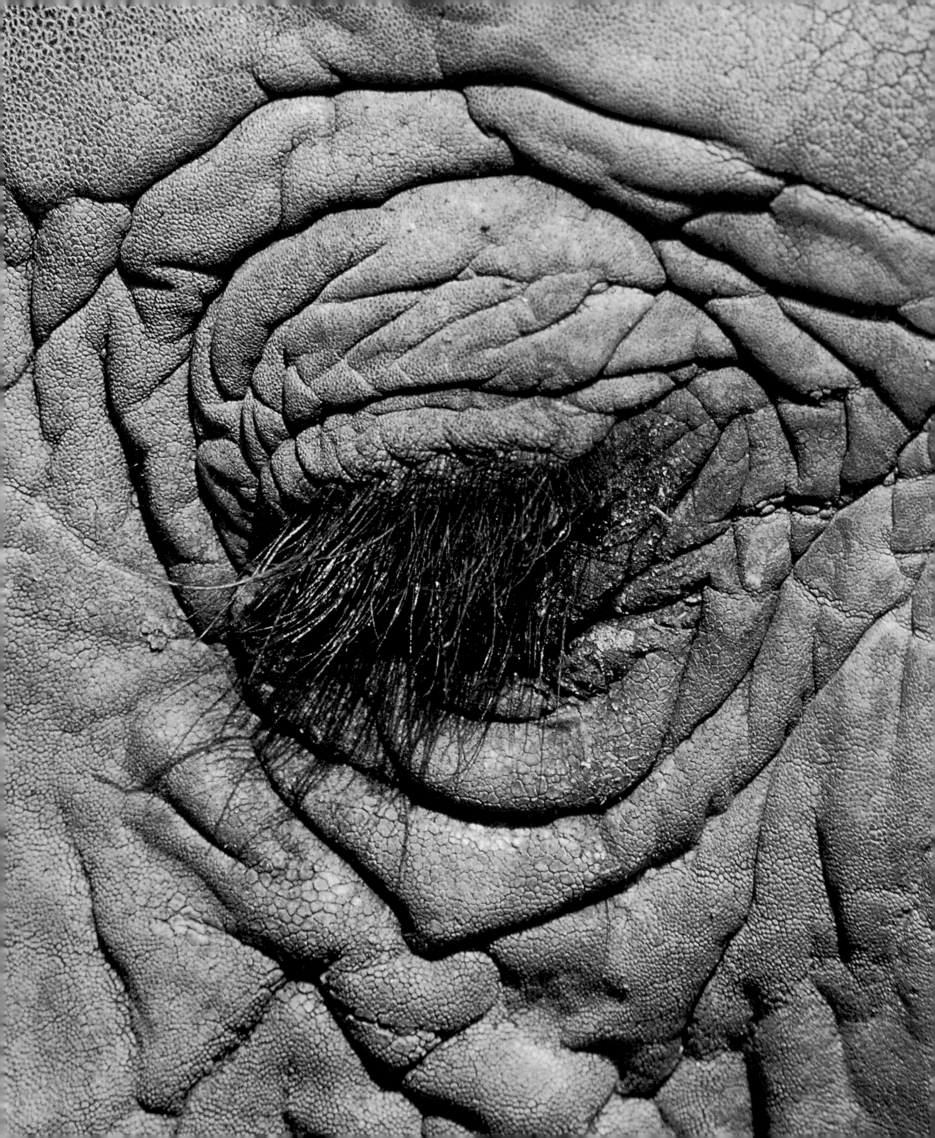

Elephants do not have good eyesight, and, proportionately, their eyes are very small. Eyelashes keep dust and some insects at bay, but the moth *Mabra elephantophila* is so small that it can breach the defence to drink the elephant's tears. The baby Sumatran elephant (*Elephas maximus sumatrensis*) above is just two days old.

▷ Camargue horses (*Equus caballus*) live in the Camargue wetlands of the south of France. They are resilient creatures, able to withstand the fierce heat of a Mediterranean summer as well as the surprisingly low winter temperatures. At birth, Camargue horses are black or brown, but they become paler with age. Their diet includes goosefoot, samphire, and reed shoots, and if food is thin on the ground a hungry horse might devote as much as 22 hours of its day to grazing.

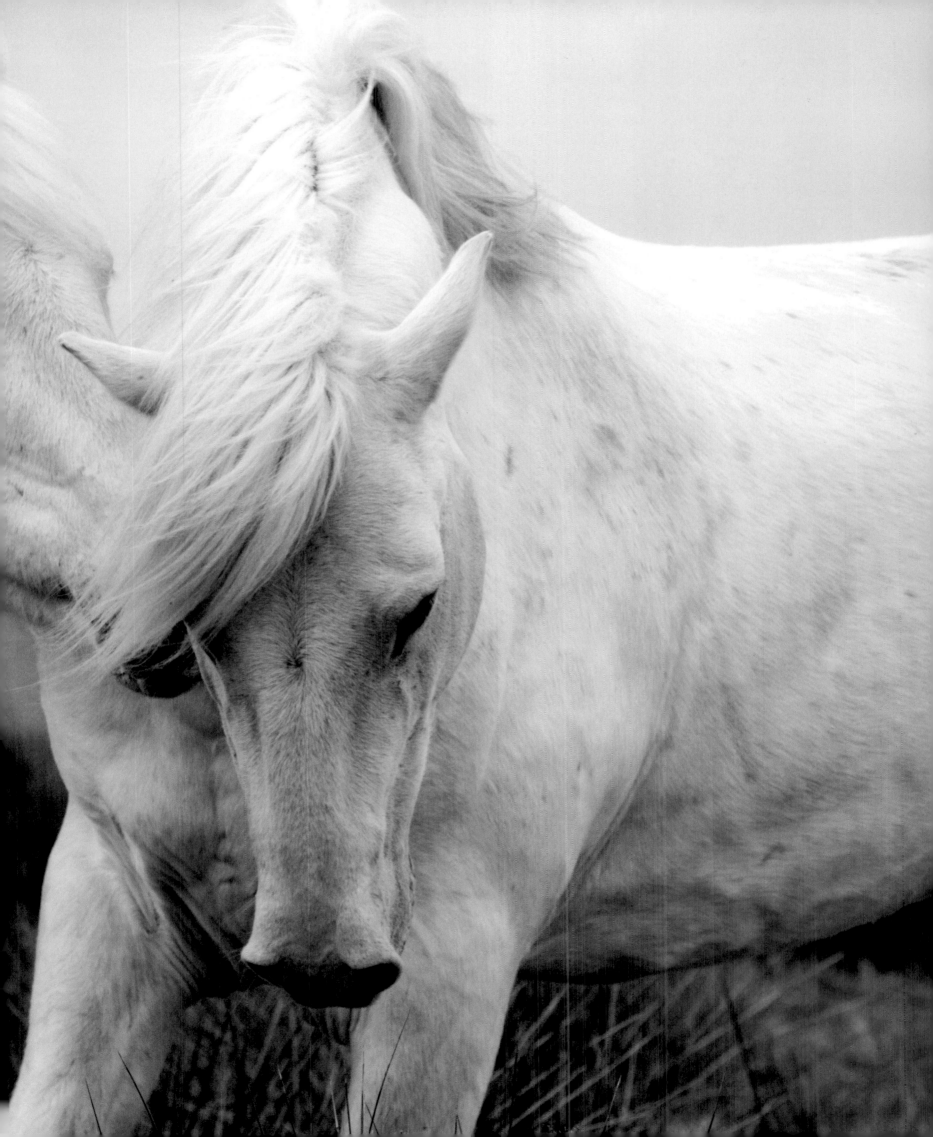

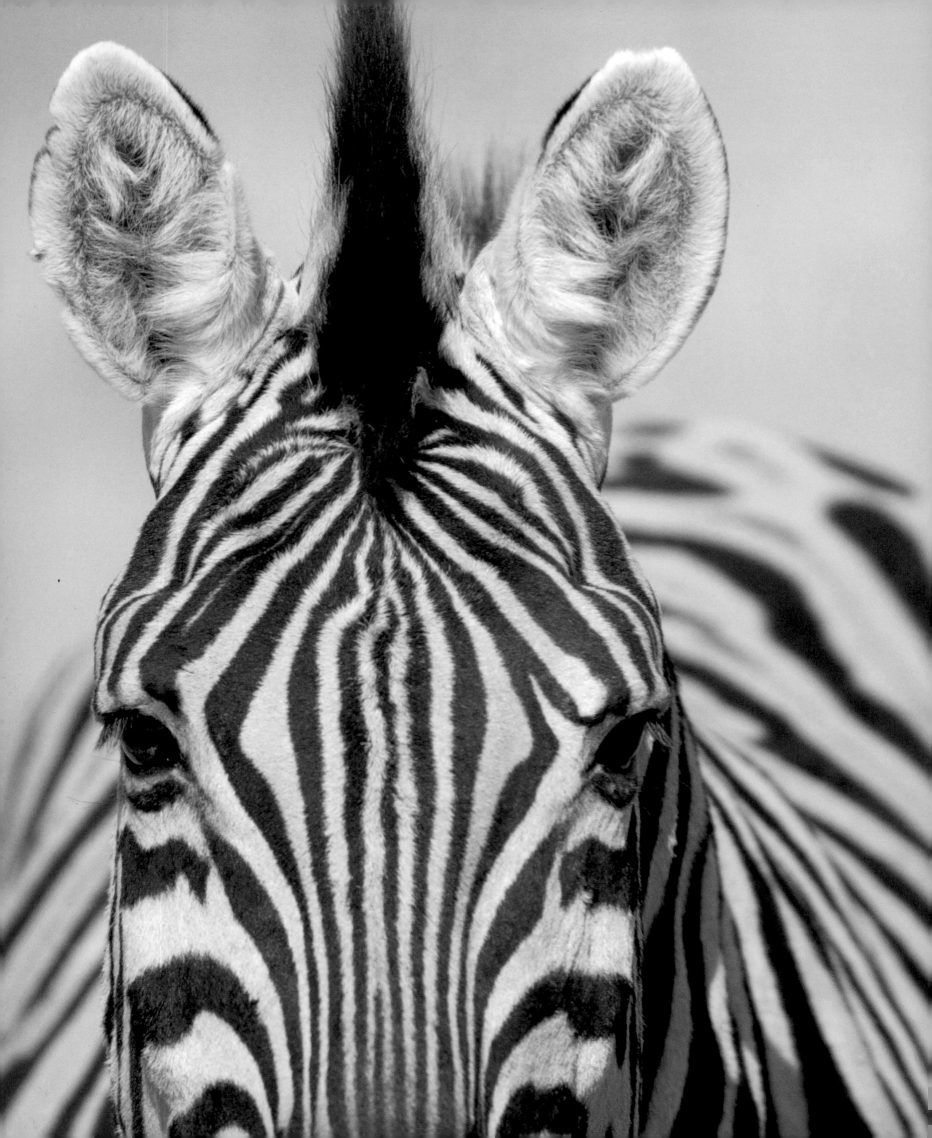

◁ This is a Burchell's zebra (*Equus burchelli*), found in southern and eastern Africa. Various ideas have been put forward to explain why zebras have their stripes, the exact pattern of which varies from one individual to the next. Suggestions include providing camouflage from predators by breaking up the zebra's outline, assisting with thermoregulation, and acting as an insect repellent by reducing bites from insects that seek blocks of unbroken colour.

With its prehistoric looks, a large Indian rhinoceros (*Rhinoceros unicornis*) is two tonnes or more of poorly-sighted herbivore. The deep creases in its armour-like skin harbour parasites, which are helpfully extracted by egrets.

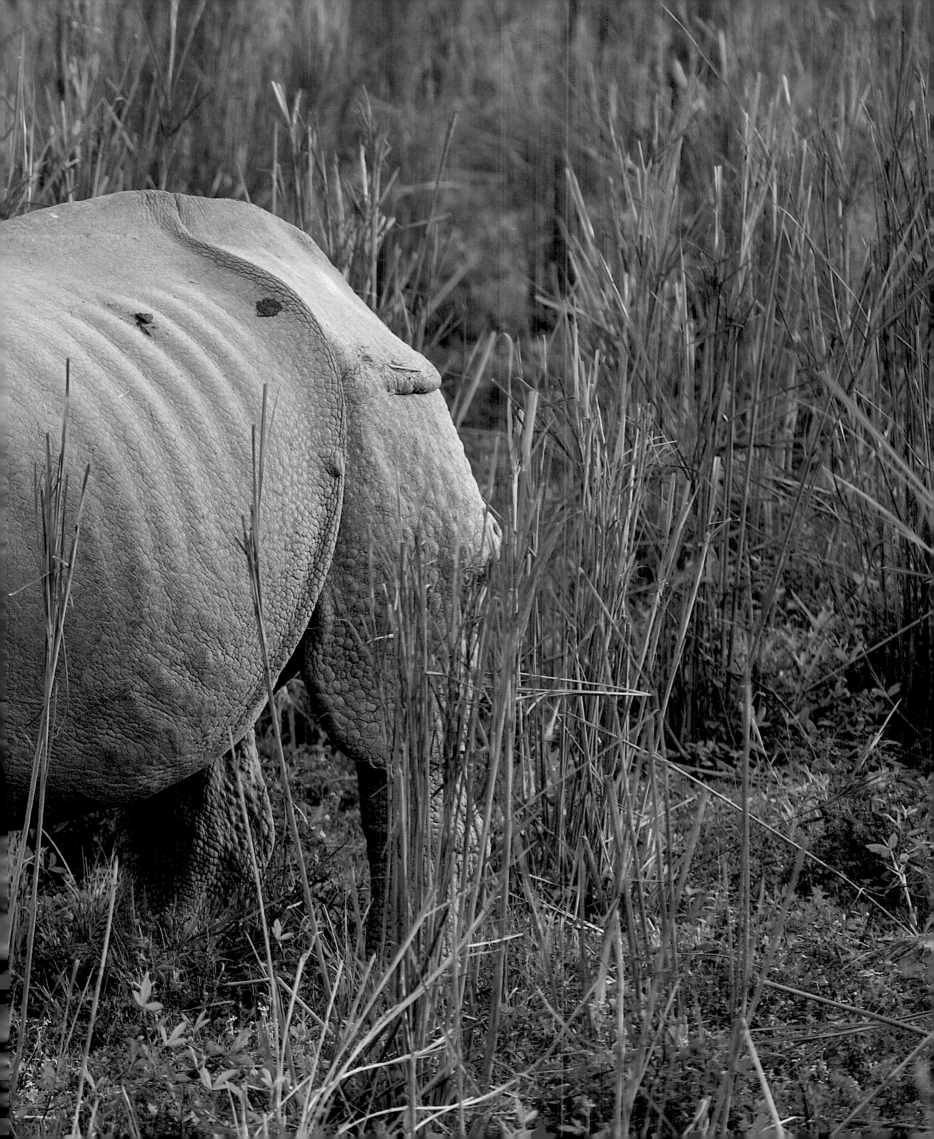

▷ Despite a fearsome reputation, there is a sensitive side to the hippopotamus (*Hippopotamus amphibus*) – its skin. The top layer is thin and needs to be protected from biting insects and the sun. The skin produces a moisturising mucus, and the hippo tops this up with frequent visits to mud or water holes – in effect, the mud coating acts as a kind of sunscreen. The hippo is an amphibious behemoth – with nostrils, eyes, and ears well placed for loafing just beneath the surface of the water, and its nose and ears can be sealed shut when submerged. Hippos are common in parts of Africa, reaching 2.7m (9ft) in length and 1.5 tonnes in weight.

▷ Its remarkable height – a male can measure up to 5.5m (18ft) tall – and striking skin pattern make the giraffe (*Giraffa camelopardalis*) easy to recognize. Its long neck enables high-level browsing but has no more vertebrae than a human's. A giraffe's vertebrae are larger than those of a human, and complex ball and socket joints increase the neck's flexibility. The giraffe is found in various parts of Africa and different subspecies have different skin patterns – this is a Rothschild's giraffe (*G.c.rothschildi*).

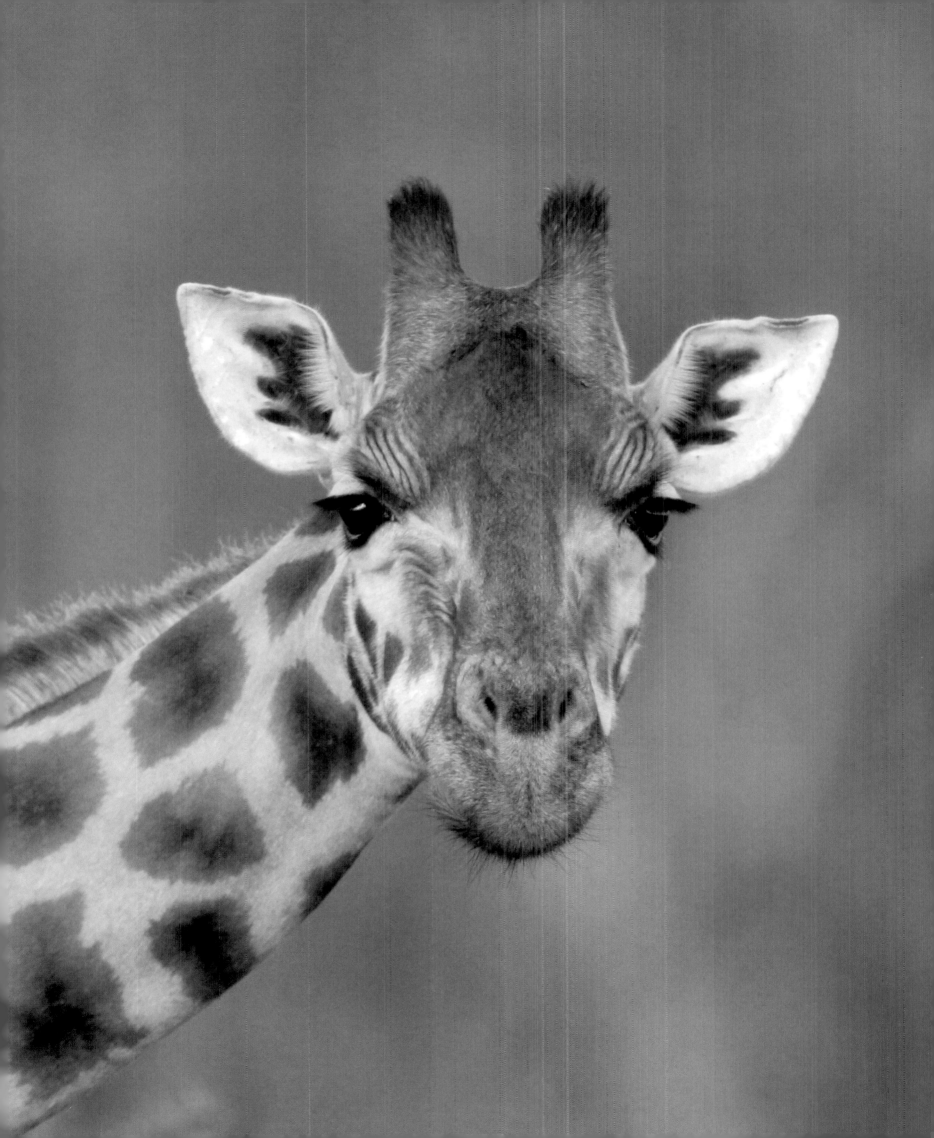

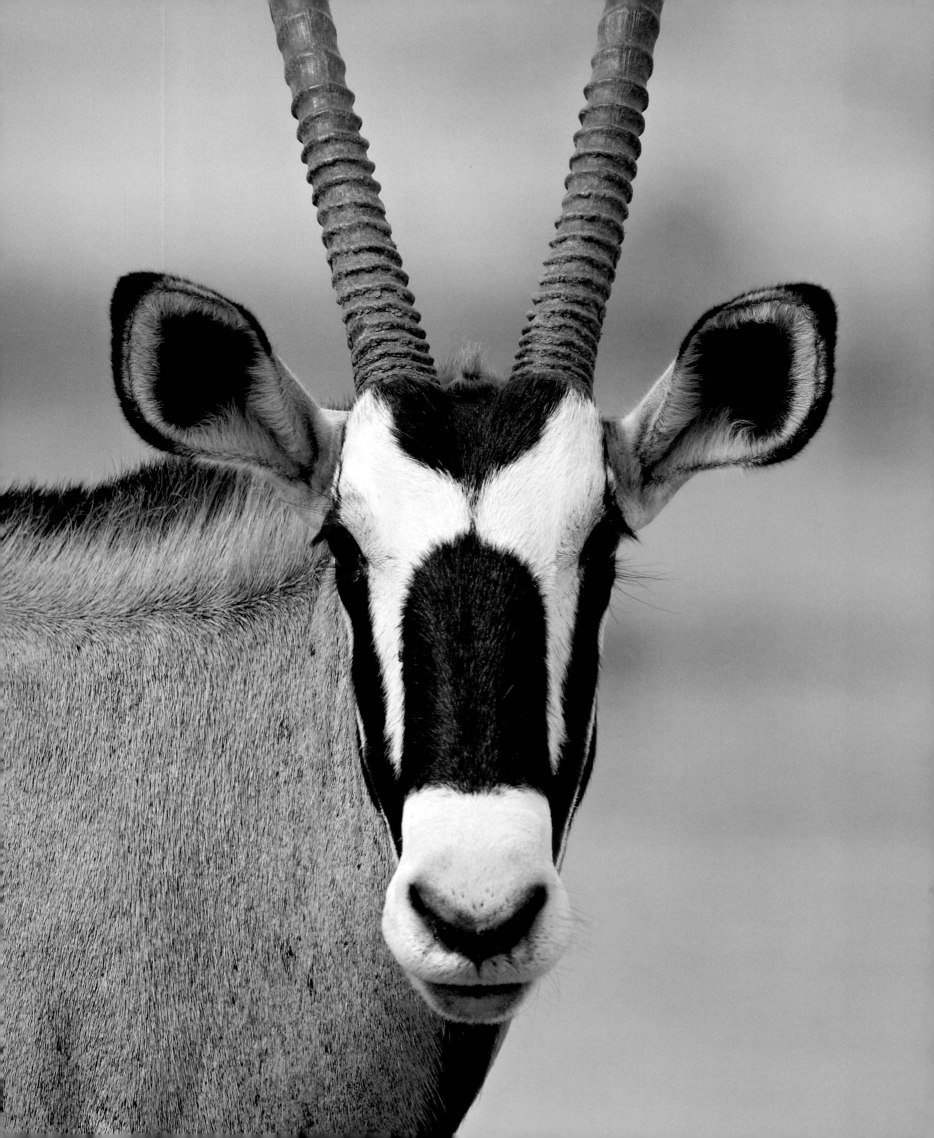

Gemsbok (*Oryx gazella*) live in herds in some very arid places in southwest Africa. Their impressive horns serve to keep unwelcome newcomers away. Posturing, rather than fighting, settles issues of seniority in the herd.

▷ The gaur (*Bos gaurus*) of south and southeast Asia is one of the world's largest wild cattle, measuring up to 3.3m (11ft) in length and weighing around 1000kg (2210lb). Also known as the Indian bison or seladang, the gaur is adorned with impressive horns up to 1.1m (3½ft) in length. During the rut, a male makes his presence known with calls that can be heard from as far as 1.5km (1 mile) away.

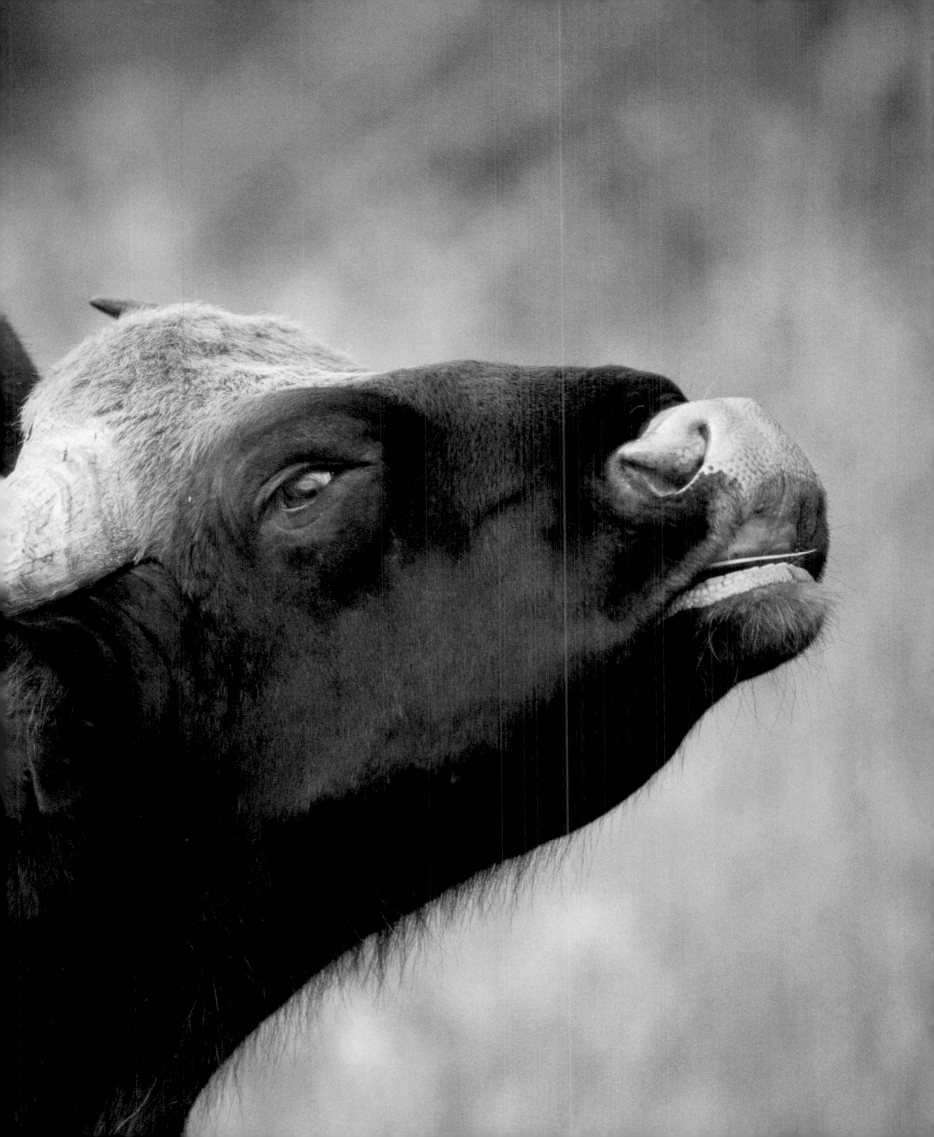

birds

Some people have a passion for birds. This is understandable, for many birds, especially those from the tropics, are spectacularly beautiful creatures, adorned with glorious plumes that shimmer with vibrant colour. The finches and tits that visit our garden birdfeeders may be less flamboyant, but they are still vividly coloured compared with most other animals. Even those birds that have opted for camouflage rather than dazzling display are marked with rich, subtle patterns of marvellous intricacy.

Some birds are also superbly musical, the males singing to proclaim their ownership of territories and to attract mates. To hear a nightingale in full song on a warm summer evening is a truly memorable experience, and the dawn chorus of songbirds in spring is one of the miracles of nature.

However, our enjoyment of birds is more than superficially aesthetic. It is almost as if we share the same enthusiasms. They are attracted by colour, pattern, and music, and so are we. Most are active by day, like us, and find their food by

sight, just as we do – or did. We understand them. When we watch a heron as it stalks a fish we can almost see it thinking, and that is a powerful bond.

Indeed some birds are remarkably intelligent. The expression "bird-brained" is an unfair slur, because some species, such as the parrot and crow families, are at least as intelligent as dogs and even rival many primates. They can remember people and places, solve problems, and make tools – a skill that was once thought unique to humankind.

Another feature of birds that we find so immensely appealing is that they fly. We envy and admire the casual ease with which they launch themselves into the air and soar high into the sky. Some birds such as the vulture and albatross seem to fly almost effortlessly, barely beating their huge wings. Others are capable of extraordinary aerial feats, such as the peregrine, which may dive on its prey at 200kph (124mph) or more, and the common swift, which is able stay airborne for months, or even years, without landing, and even sleeps on the wing.

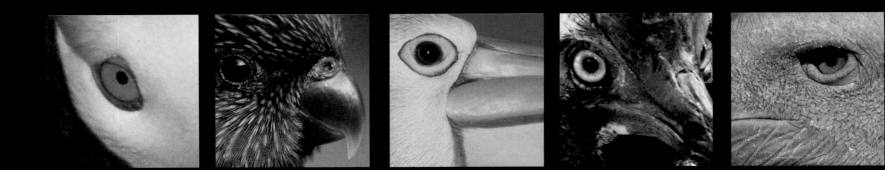

> **"** Exquisite plumage, enchanting songs, and intriguing behaviour give birds a charm that is always highly appealing. **"**

Flight is the most demanding way for an animal to travel. It involves a combination of weight reduction, aerodynamic efficiency, strength, and stamina that has pushed the evolution of the basic vertebrate body plan to extremes. As a result, the anatomy of birds is virtually defined by their conquest of the air. Even flightless birds such as the cassowary and ostrich share most of these adaptations, inherited from their flying ancestors.

The most obvious of these adaptations are wings and feathers. It is likely that feathers evolved first, because they provide excellent insulation for warm-blooded animals that must conserve as much heat as possible. Recent fossil discoveries show that feathers were first evolved by meat-eating, warm-blooded, bipedal dinosaurs such as the agile, fast-moving Velociraptor. The skeletons of these animals are almost identical to those of Archaeopteryx, the first known bird, so it is almost certain that the birds we so admire today are directly descended from the dinosaurs that died out 65 million years ago.

It may be hard to connect a gorgeous, balletic flamingo or a delicate, iridescent sunbird with a monstrous prehistoric beast like Tyrannosaurus rex, but it certainly adds an extra dimension to our appreciation of these captivating creatures.

birds

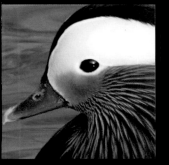

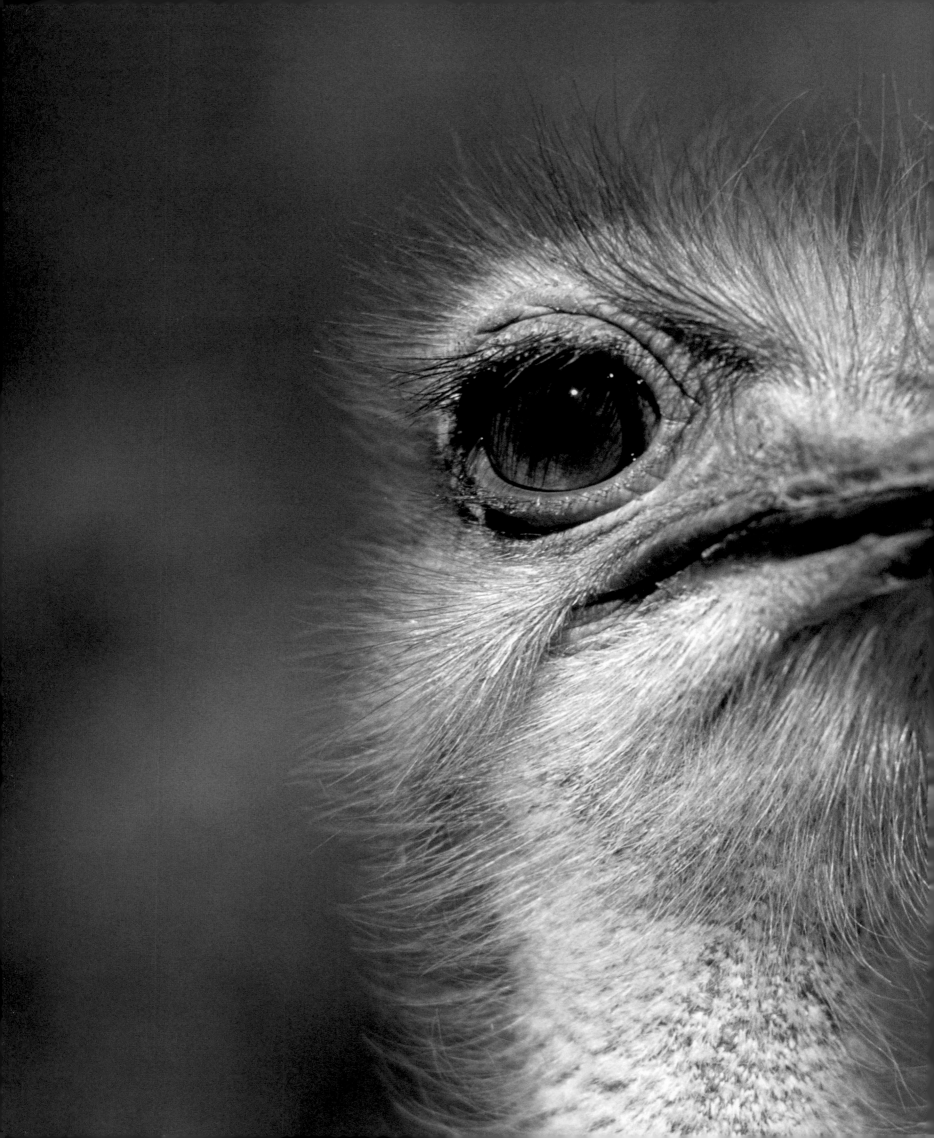

◁ A male common ostrich (*Struthio camelus*) grows to 2.75m (around 9ft) tall, giving him an excellent view over the open African plains. Females are smaller but, growing up to 1.9m (about 6ft) in height, they still have an elevated view of the world. The ostrich has a small head, but its eyes are 5cm (2in) in diameter – a record among the land-based birds and mammals. Not surprisingly, this bird has very good eyesight, essential for looking out for would-be predators, and for finding other ostriches. An ostrich can weigh 150kg (330lbs) and is the world's heaviest bird.

The bright colours on the head and neck of the northern cassowary (*Casuarius unappendiculatus*) enable it to find potential mates in its dense forest habitat. The purpose of its horny "helmet" is unclear. The bird may use it to push through forest growth, or as a "spade" for finding food. It could also be a sign of a bird's seniority.

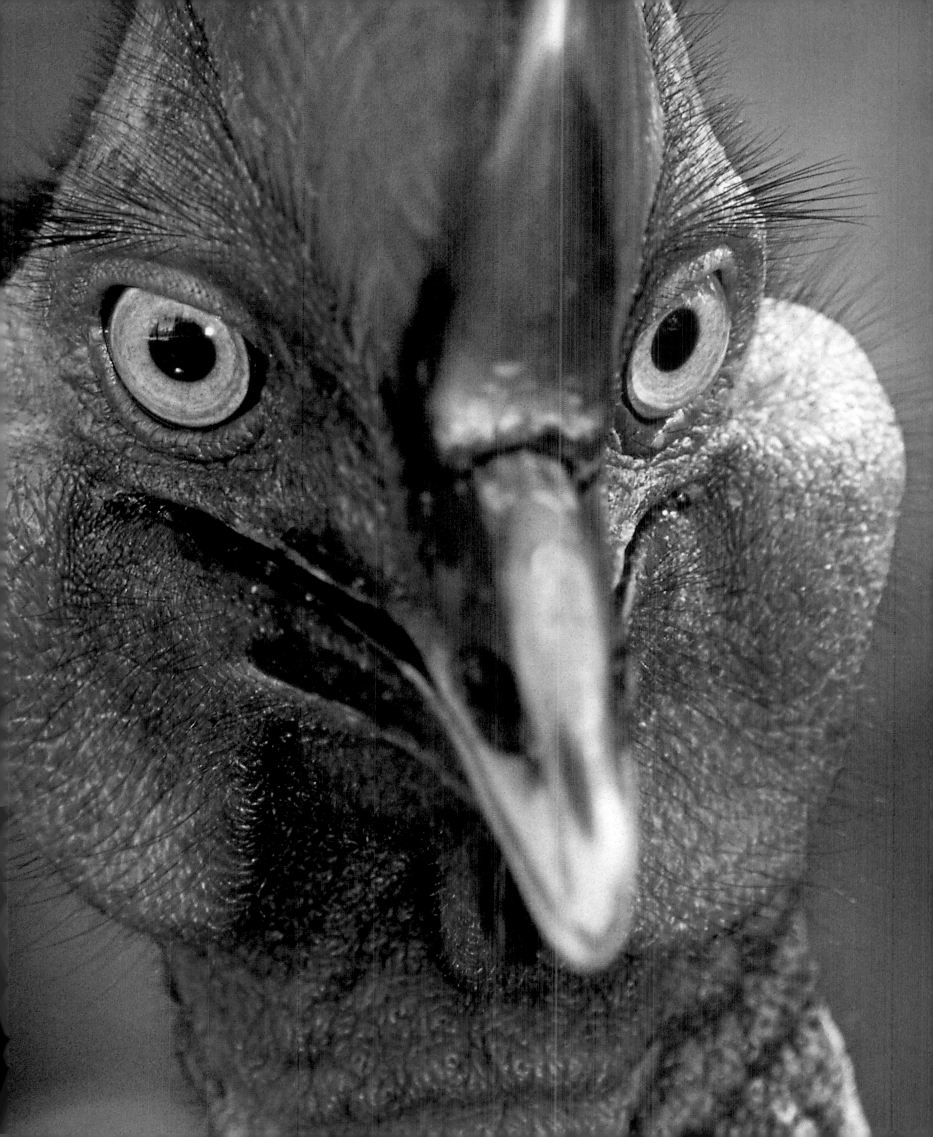

▷ The king penguin (*Aptenodytes patagonicus*) lives on sub-Antarctic islands, where its thick plumage helps to keep out wind and water and provides effective insulation. All adult penguins have dark backs and pale bellies. The dark parts function as passive solar heaters, soaking up the warmth of the sun, and this contrasting plumage pattern makes a swimming bird harder to see from both above and below. A bird's bill is designed for its diet – the long, relatively fine bill of the penguin is an effective tool for catching and eating fish. King penguins are around 95cm (3ft) tall and weigh up to 15kg (33lb).

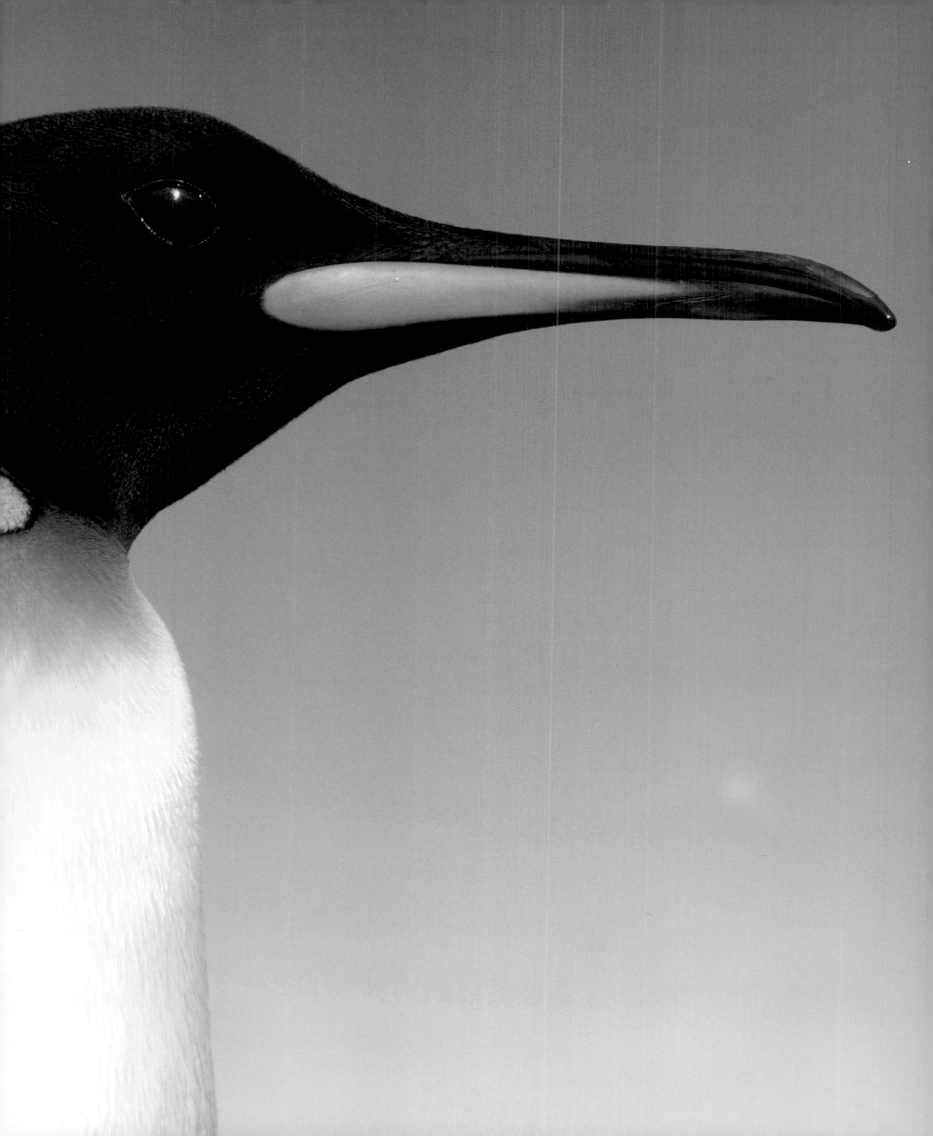

These black-browed albatross (*Diomedea melanophris*) chicks grow up in a colony but must be at their own nest site if they are to be fed when a parent returns with food. The "black brow" of the adult (right) protects the eyes from sunlight, helping it to see better.

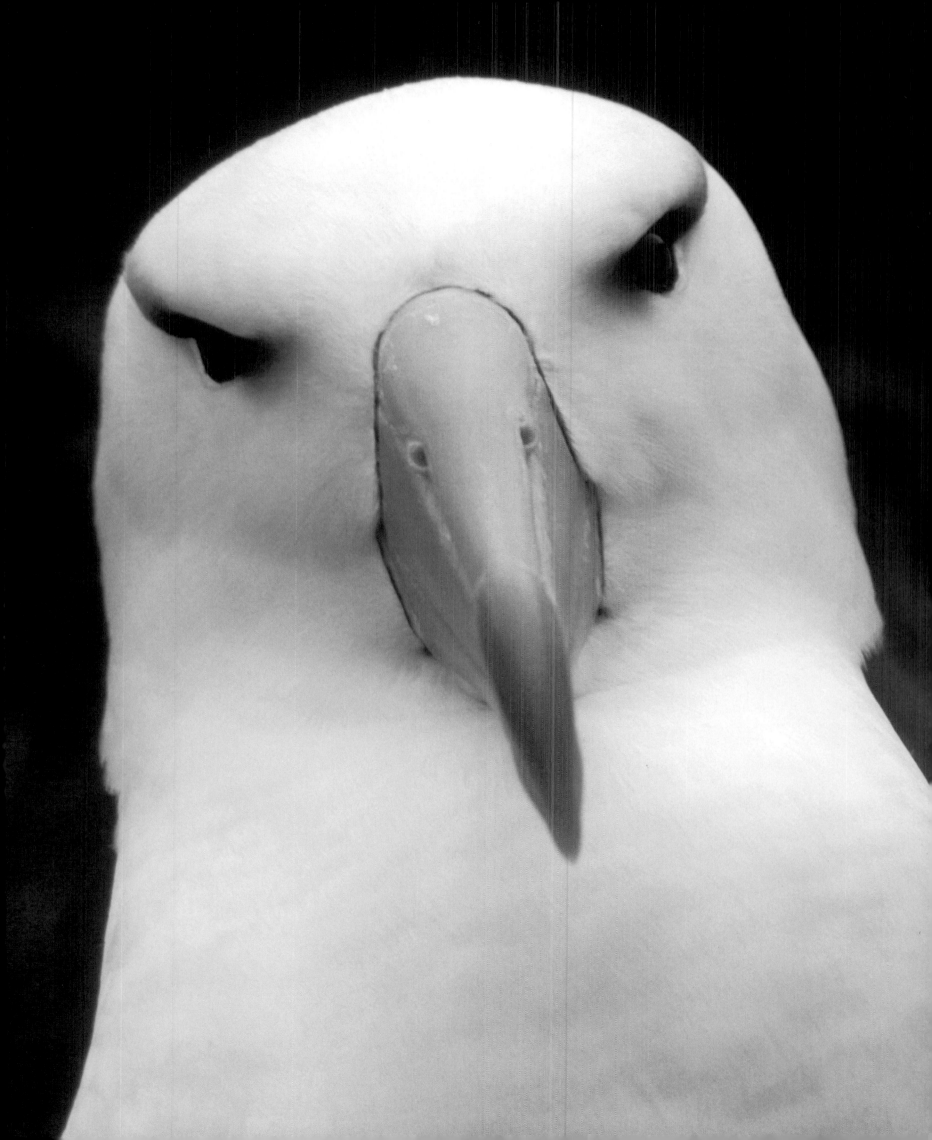

▷ Like all pelicans, this Australian pelican (*Pelecanus conspicillatus*) has a remarkable and highly distinctive bill. The lower half is very flexible and forms the upper rim of a large, distendable, skin bag, which functions as the bird's fishing net. A pelican's bill is more than a simple mechanical device and can sense the presence of fish even when they can't be seen. The bag can also play a part in temperature control, giving cut heat during the hotter parts of the day.

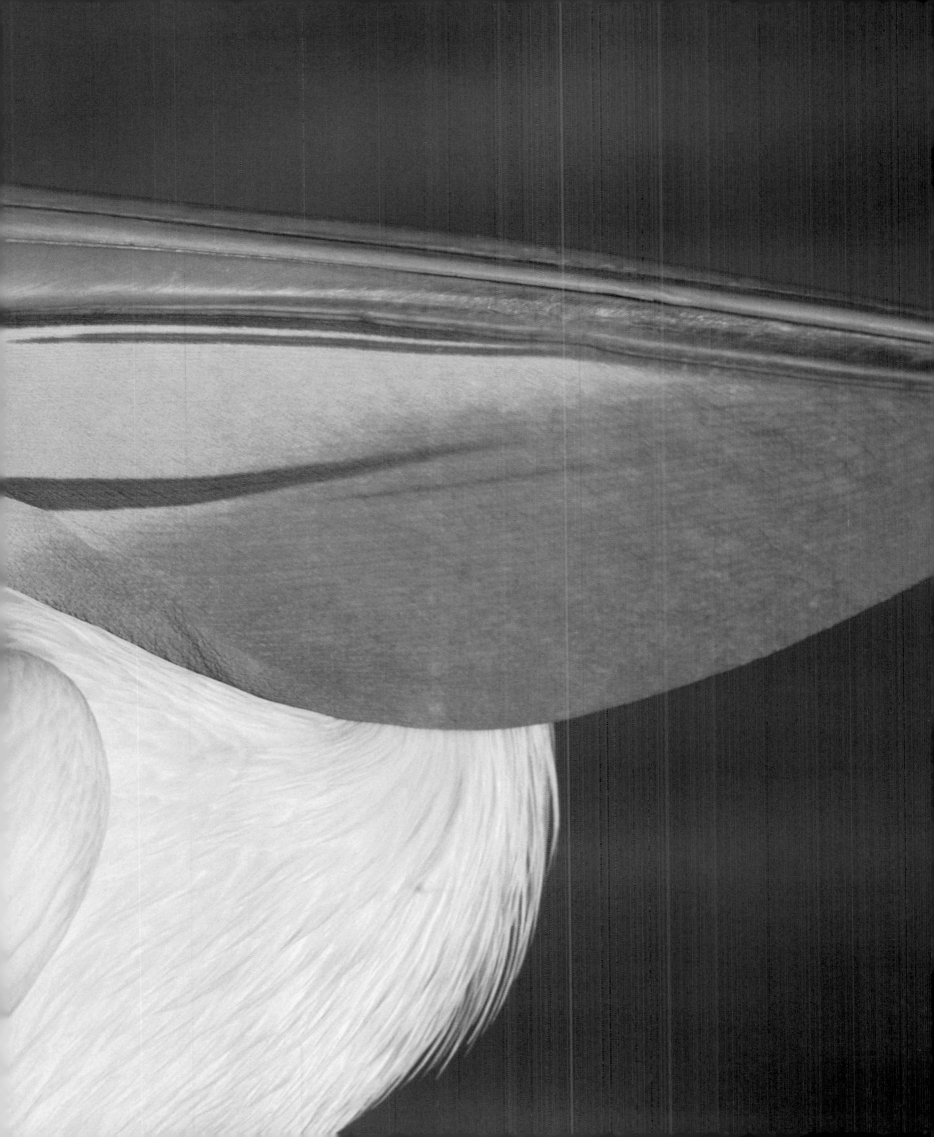

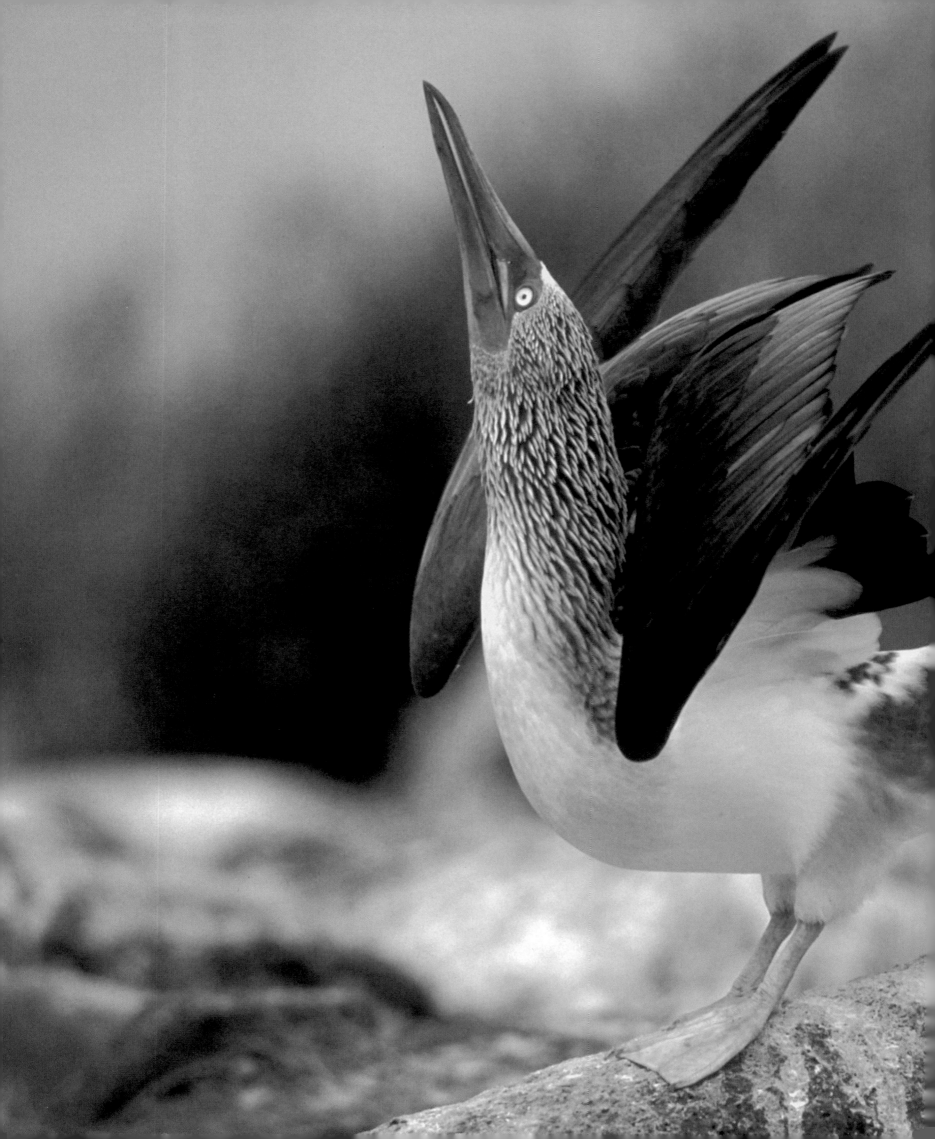

◁ This blue-footed booby (*Sula nebouxii*) is "sky-pointing", a display that strengthens the pair bond between male and female. To woo a potential partner, a male booby displays his wares with stomping feet and open wings, and the bluer his feet are the more likely he is to be successful. Blue-footed boobies nest on rocky shorelines. They use their feet to incubate their eggs, with the eggs taking the full weight of the adult bird. This species is found mostly around tropical waters off the west coast of the Americas.

BIRDS

▷ Anhingas (*Anhinga anhinga*) are found around wetlands in the Americas. The wings and tail of this prehistoric-looking bird are waterproof, but the feathers on its body are not, so after every dive the anhinga perches with outstretched wings so that it can dry off. A submerged anhinga waits for prey to come within reach with its long snake-like neck held in an "s-shape". When the prey is within striking distance, the head shoots forward, spearing its victim with a sharp dagger-like bill. Fish make up most of its diet, but other animals are taken too, including baby alligators.

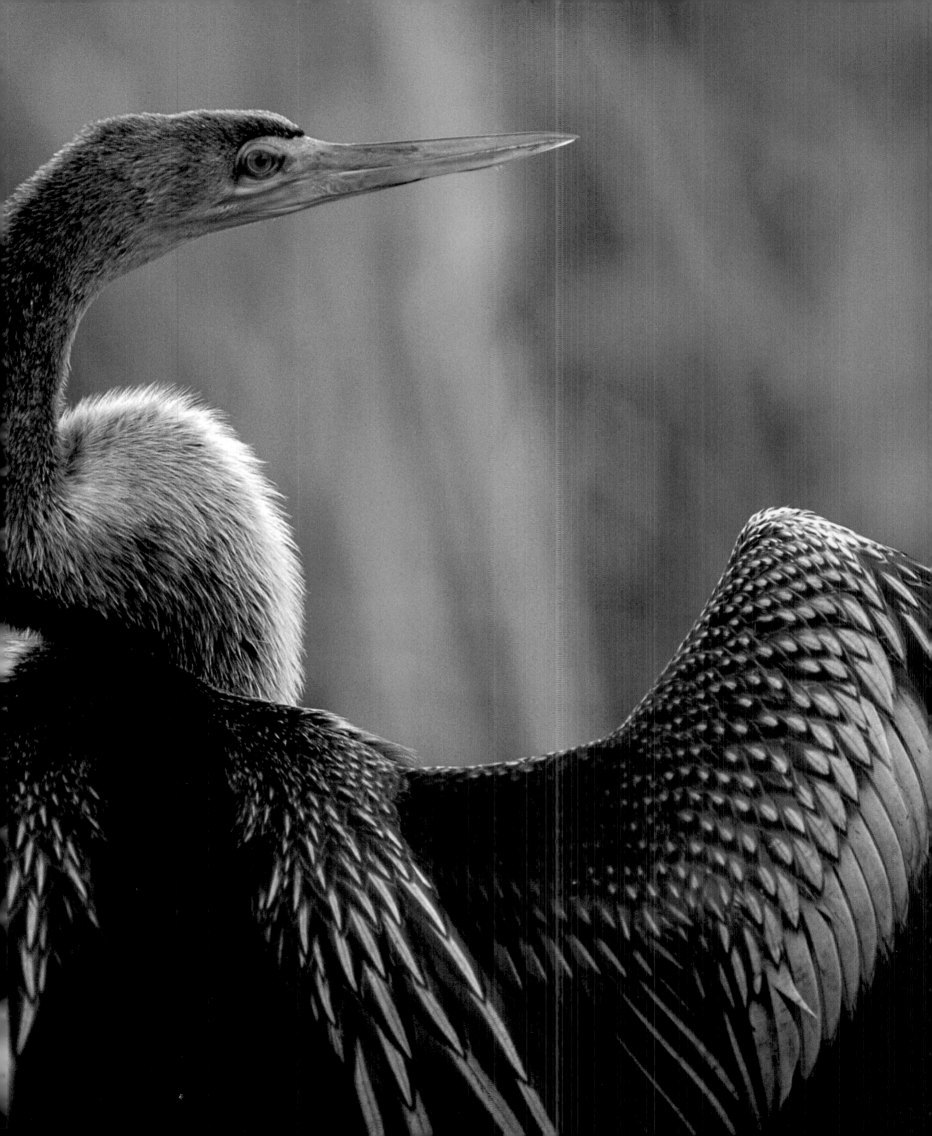

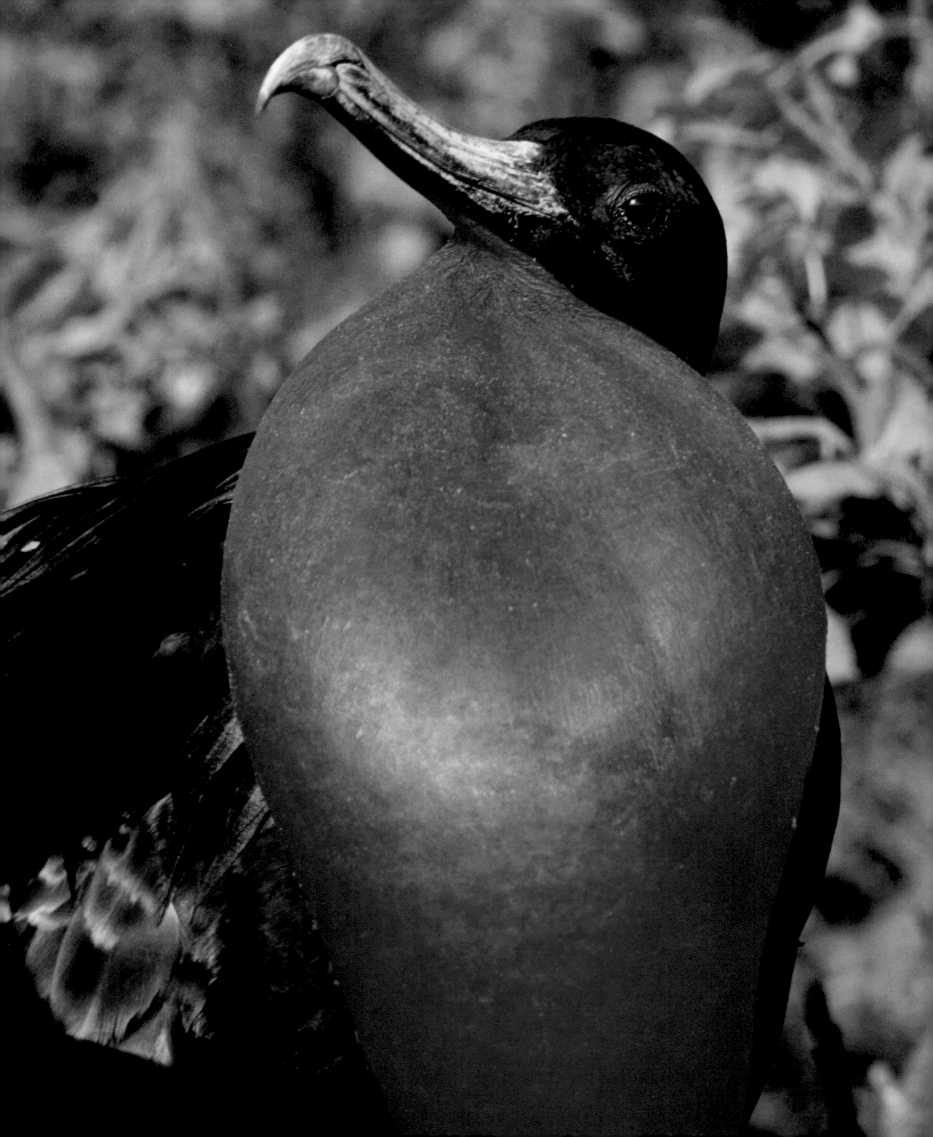

Only the male great frigatebird (*Fregata minor*), left, has the impressive red throat-pouch. By inflating it, he makes himself more visible to the female, right. His display also includes using the air-filled pouch as a drum, with his beak acting as a drumstick.

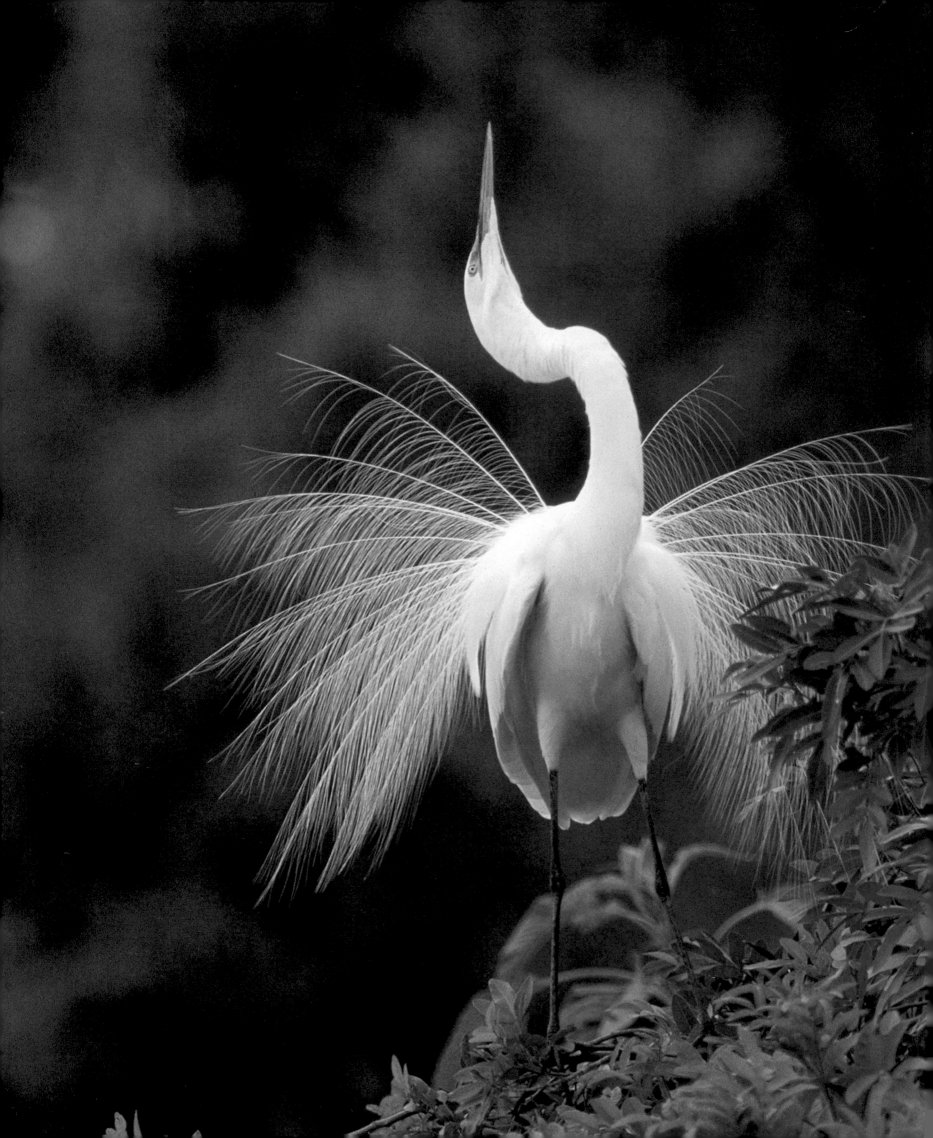

◁ This displaying great eg
(*Casmerodius alba*) points
to the heavens and shows
"aigrettes", delicate feath
are present only when the
in its breeding plumage. T
feathers used to be much
demand by milliners and l
the great egret's near exti
19th-century North Americ
to save the species led to
featured on the logo of the
Audubon Society, whose m
is to conserve and restore
ecosystems. Today great e
found in the Americas, Afr
and Australia, building the
in trees, bushes, or reeds.

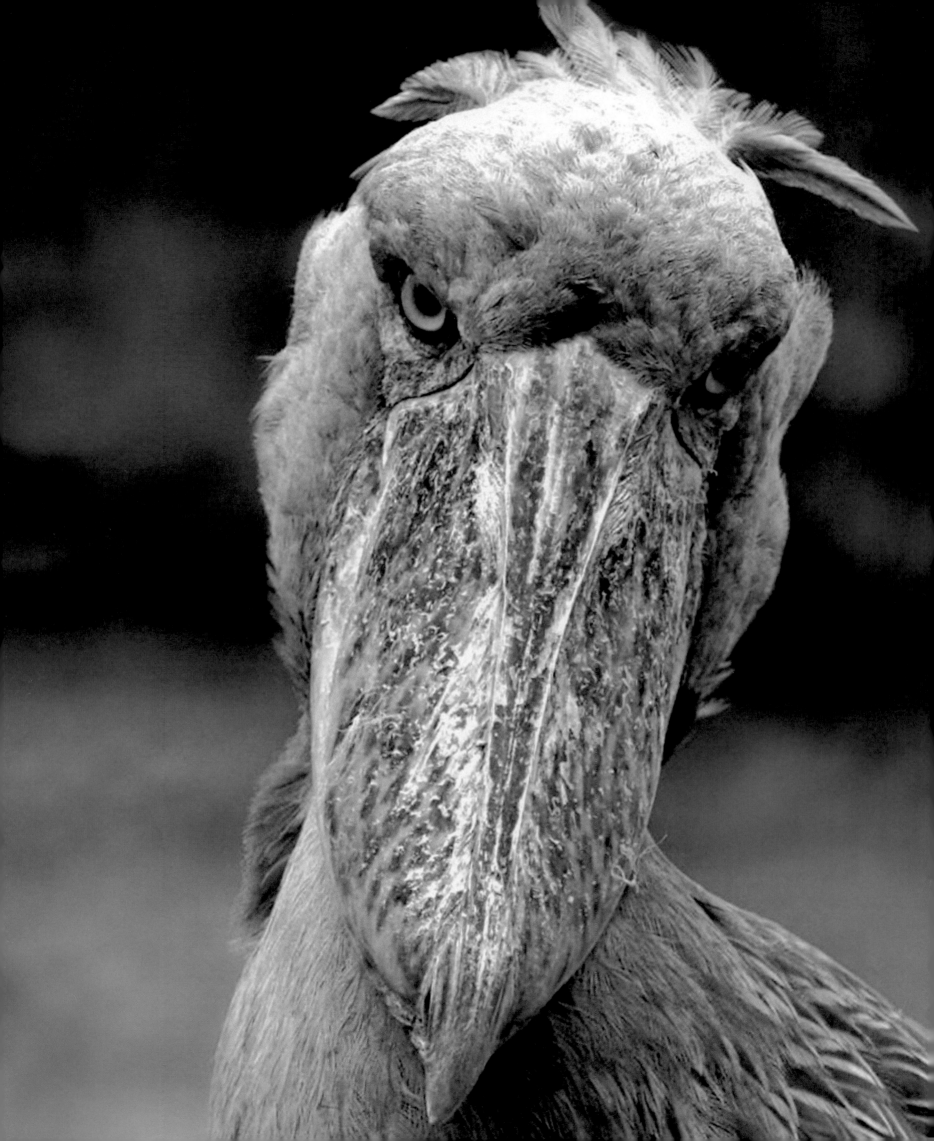

The strange-looking bill of the shoebill (*Balaeniceps rex*) can be used for carrying water to pour over overheating eggs or chicks. It is very strong with sharp edges for decapitating prey, including young crocodiles. Shoebills live in east and central African swamps.

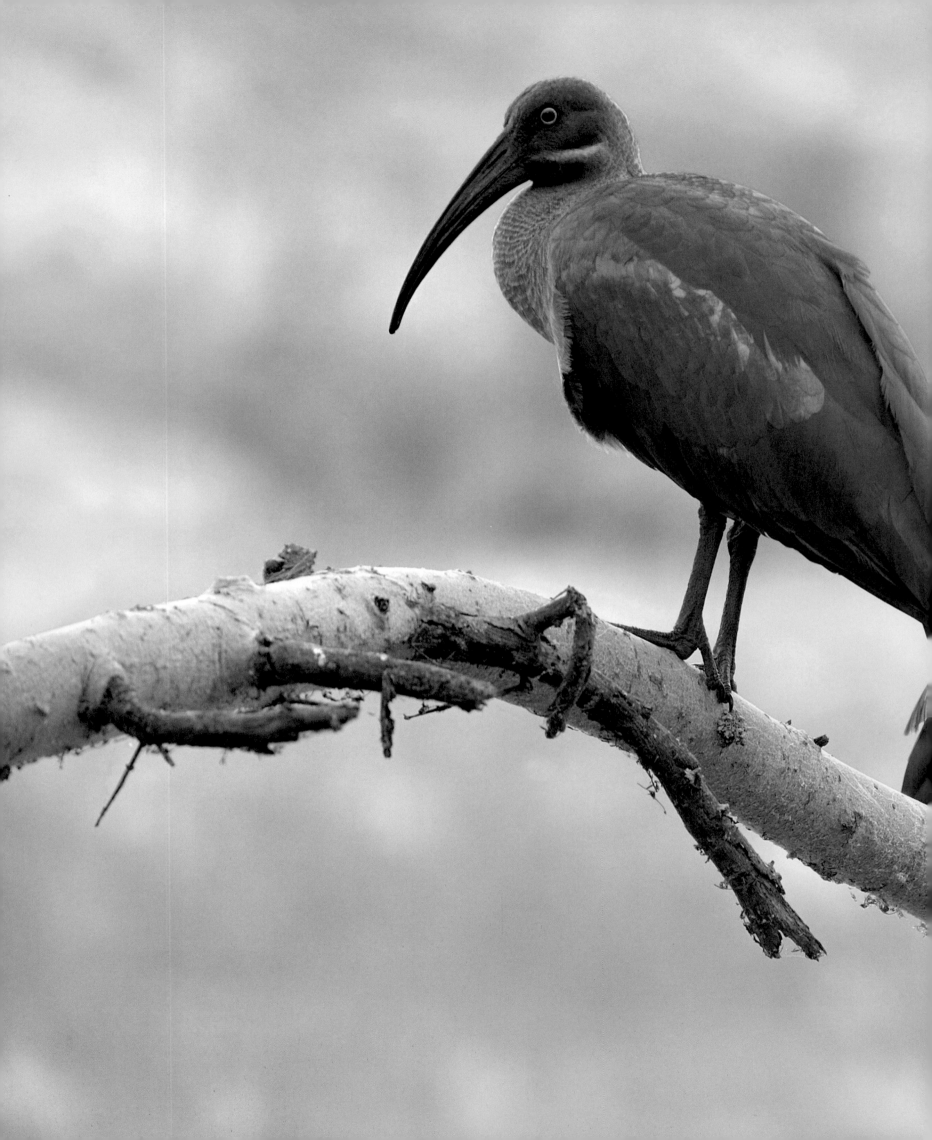

Africa's hadada ibis (*Bostrychia hagedash*), so named because of its call, has a distinctive curved bill that it uses to find insects on and in the soil. Flies and beetle larvae are among its favourite foods.

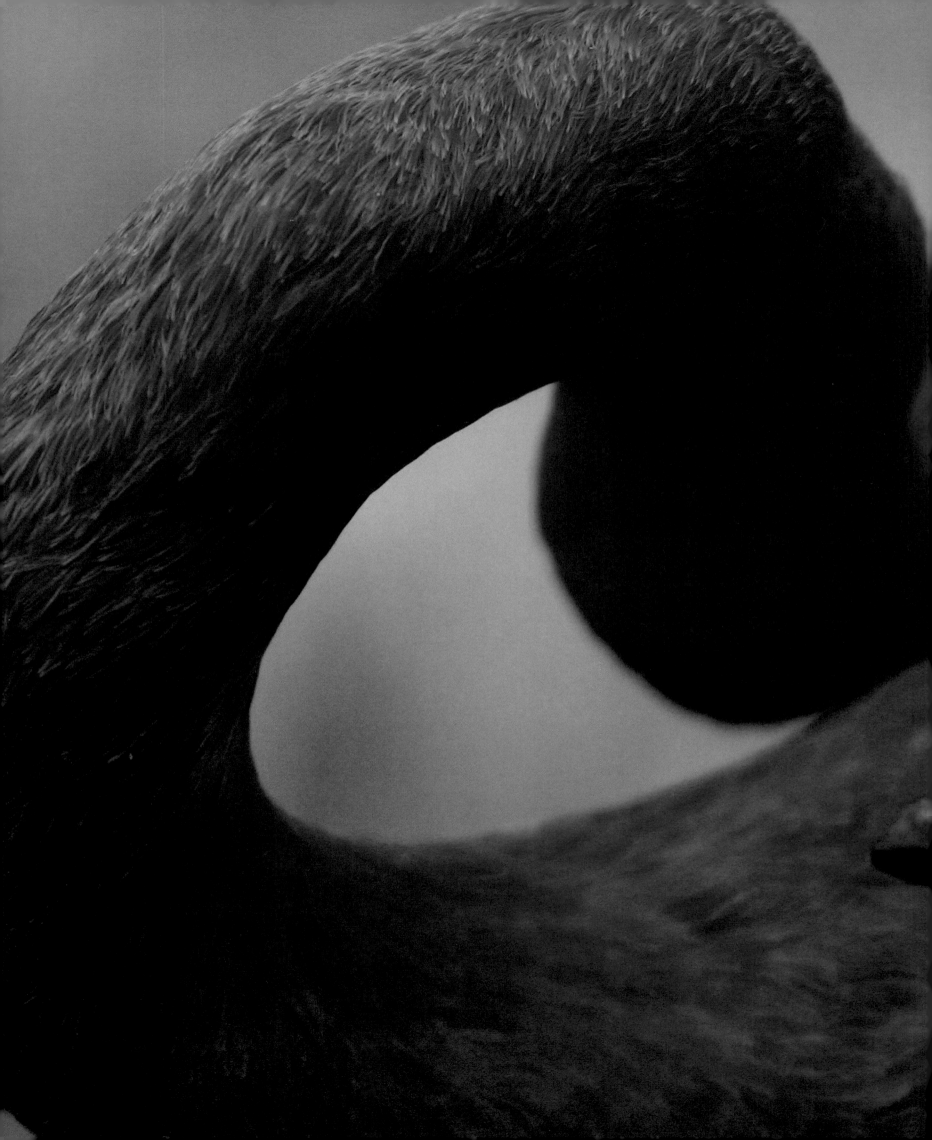

The pigments that give this greater flamingo (*Phoenicopterus ruber*) its stunning colour are made by organisms that form part of its diet. The flamingo's bill contains a finely honed filtering mechanism that enables it to extract these organisms from the water.

▷ The mute swan (*Cygnus olor*) has a massive wingspan of 2.4m (8ft) and weighs up to 15kg (33lbs). This puts it among the world's heaviest flying birds. Using the water as a runway for take-offs and landings, it needs a considerable distance and plenty of energy to get airborne. Once aloft, the swan must continue to flap its wings, only switching to a glide as it descends at the end of the flight, with its webbed feet forward and splayed to act as brakes during the dramatic landing.

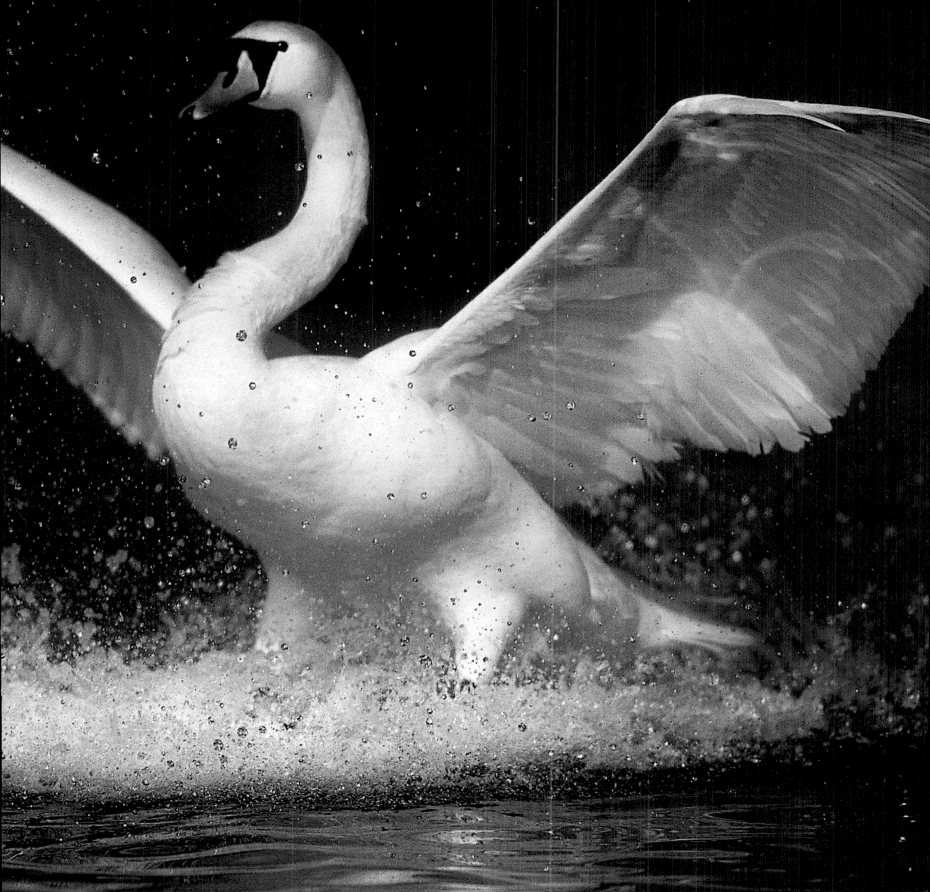

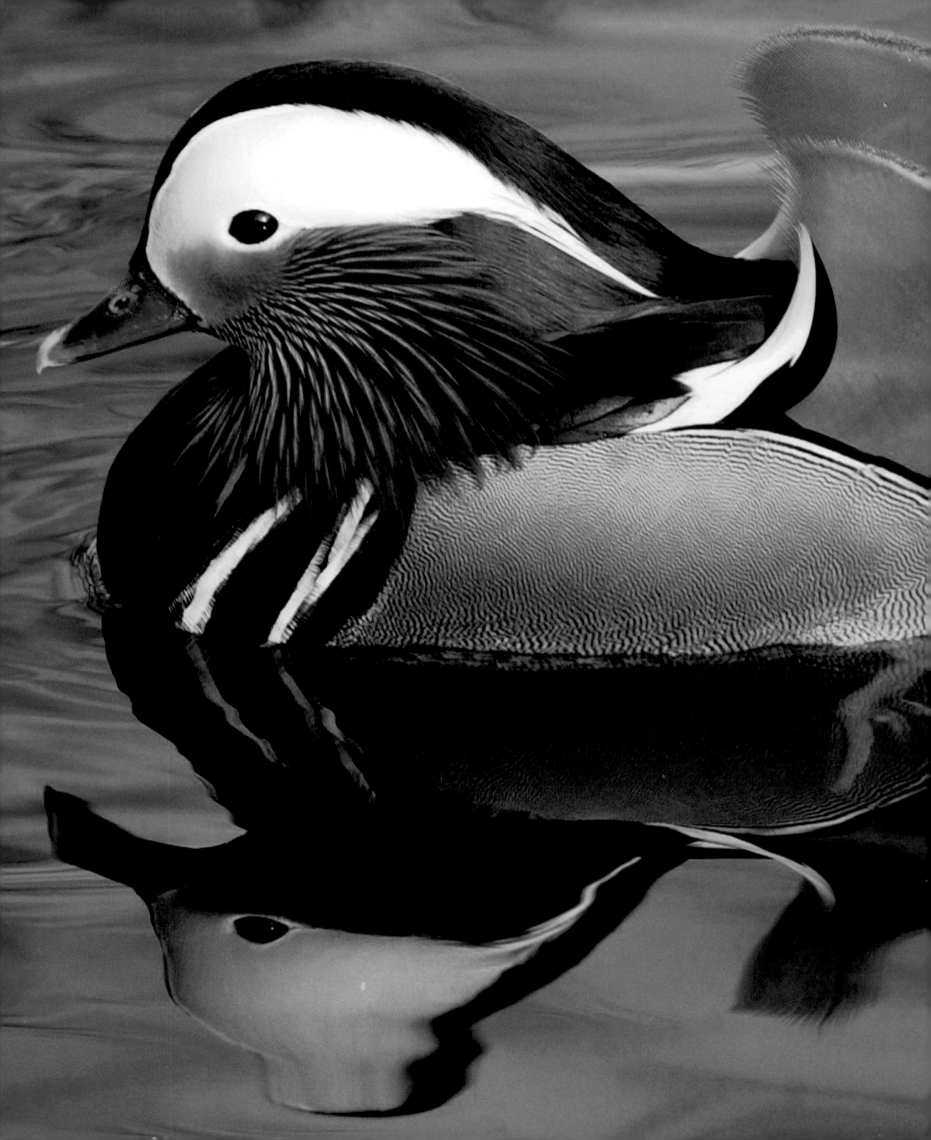

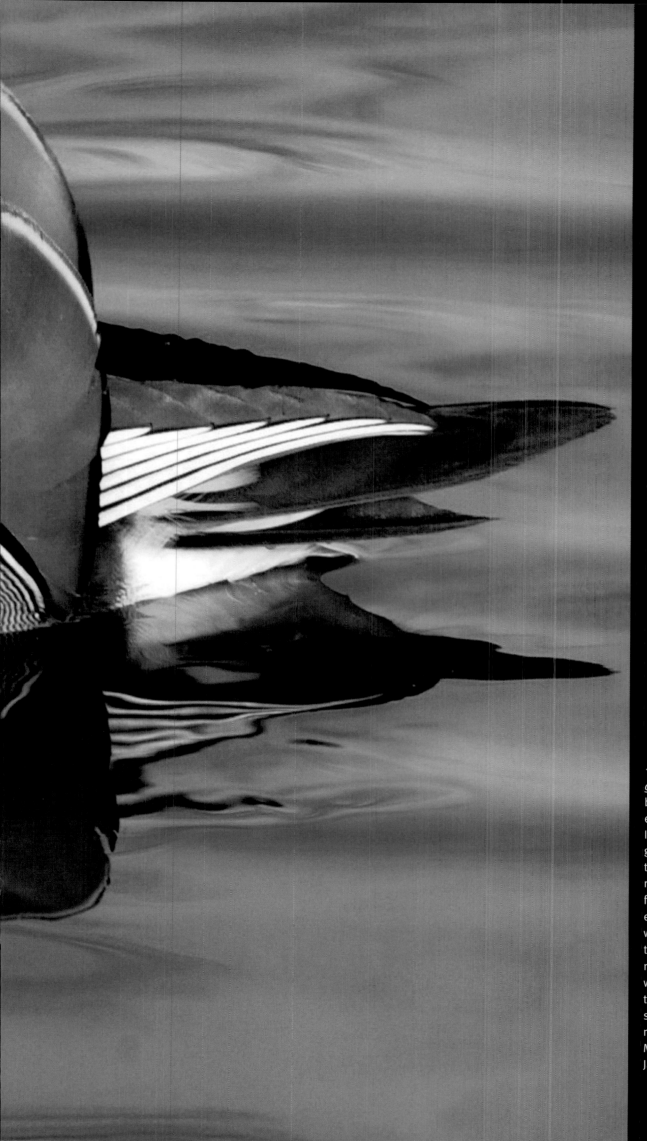

◁ A male mandarin (*Aix galericulata*) in its unmistakeable breeding plumage is a most extravagantly patterned duck. Its fine looks are put to particularly good use when there is a mate to win. A number of males gather, raising their large inner wing feathers ("sails") and crests, each trying to persuade a watching female that they are the best choice of mate. Female mandarins are fairly drab with white "spectacles" (circles around their eyes), and males adopt a similar plumage during their moult after the breeding season. Mandarins are native to China, Japan, and Russia.

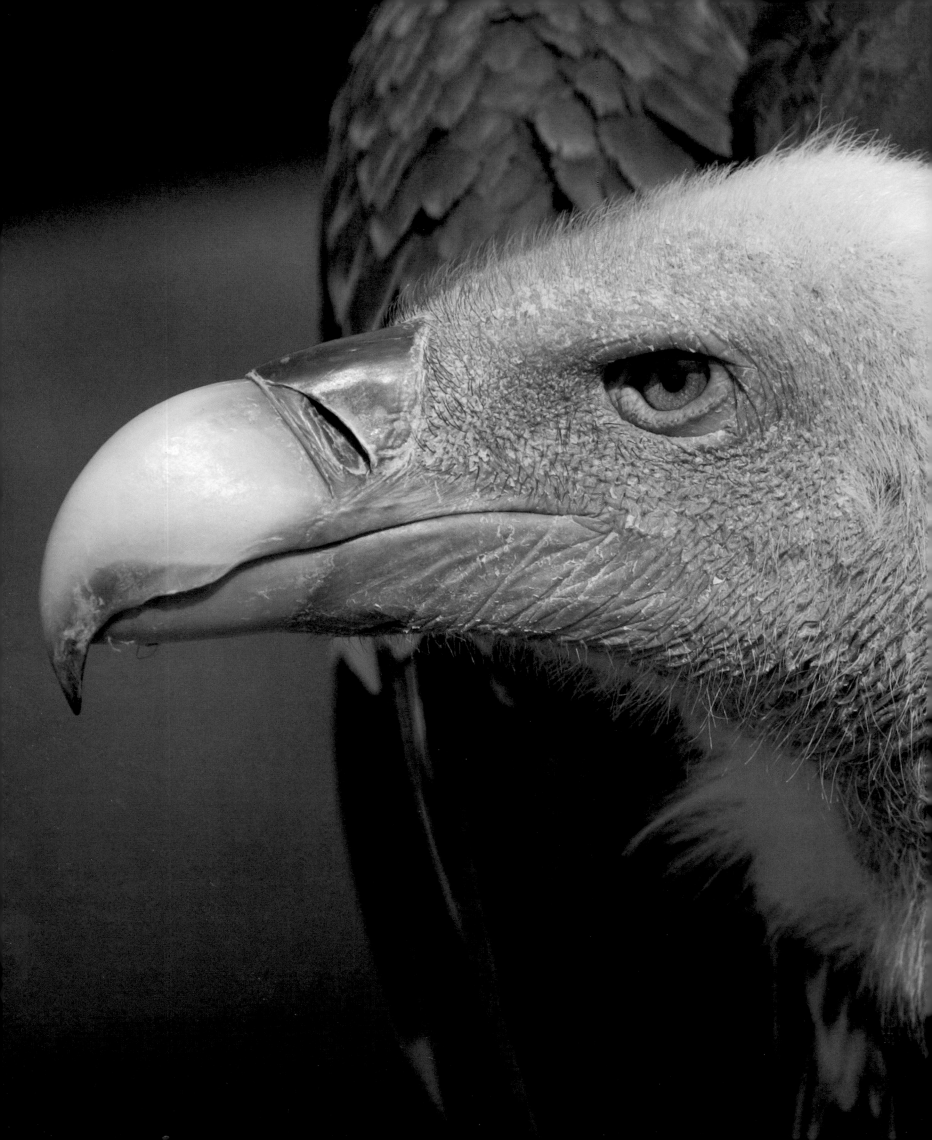

< Vultures are not pretty birds, but they do essential work. The Ruppell's griffon vulture (*Gyps rueppellii*) helps to keep Africa's grasslands and steppes clean and tidy. Feeding on carrion can be a messy business, and this vulture will go right inside a carcass to find meat. If it had feathers on its head and neck they would become heavily soiled and very difficult to clean, so its baldness is an asset. The strong beak copes well with the tugging and ripping that are a vital part of the job.

▷ Despite its name, North America's bald eagle (*Haliaeetus leucocephalus*) is not bald. This is an adult bald eagle, so named because of the whiteness of the head and neck against the dark colour of the wings and body. This "eagle-eyed" bird can see extremely well. Its eyes have two foveae (the point at which an image is at the sharpest focus), one pointing sideways and the other to the front. This means the eagle has an excellent ability to spot movement and calculate distance.

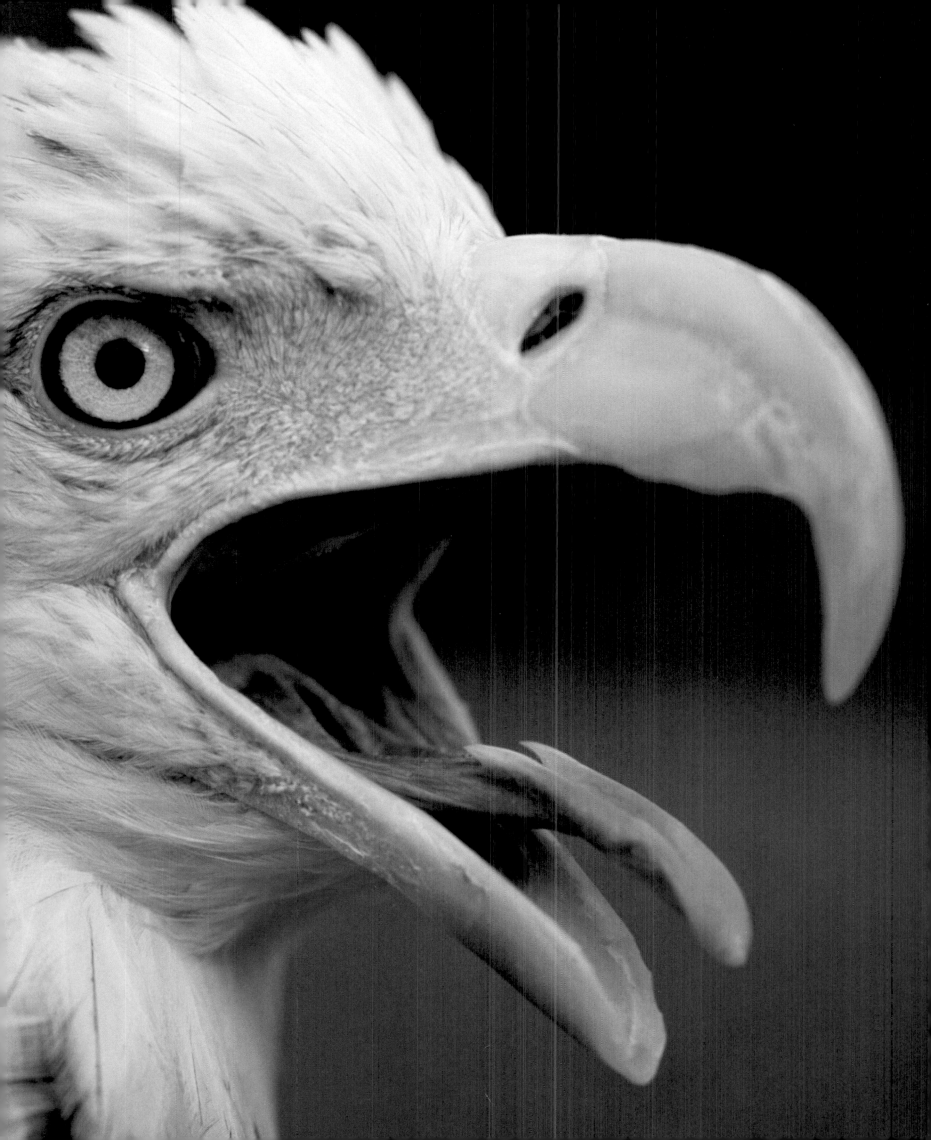

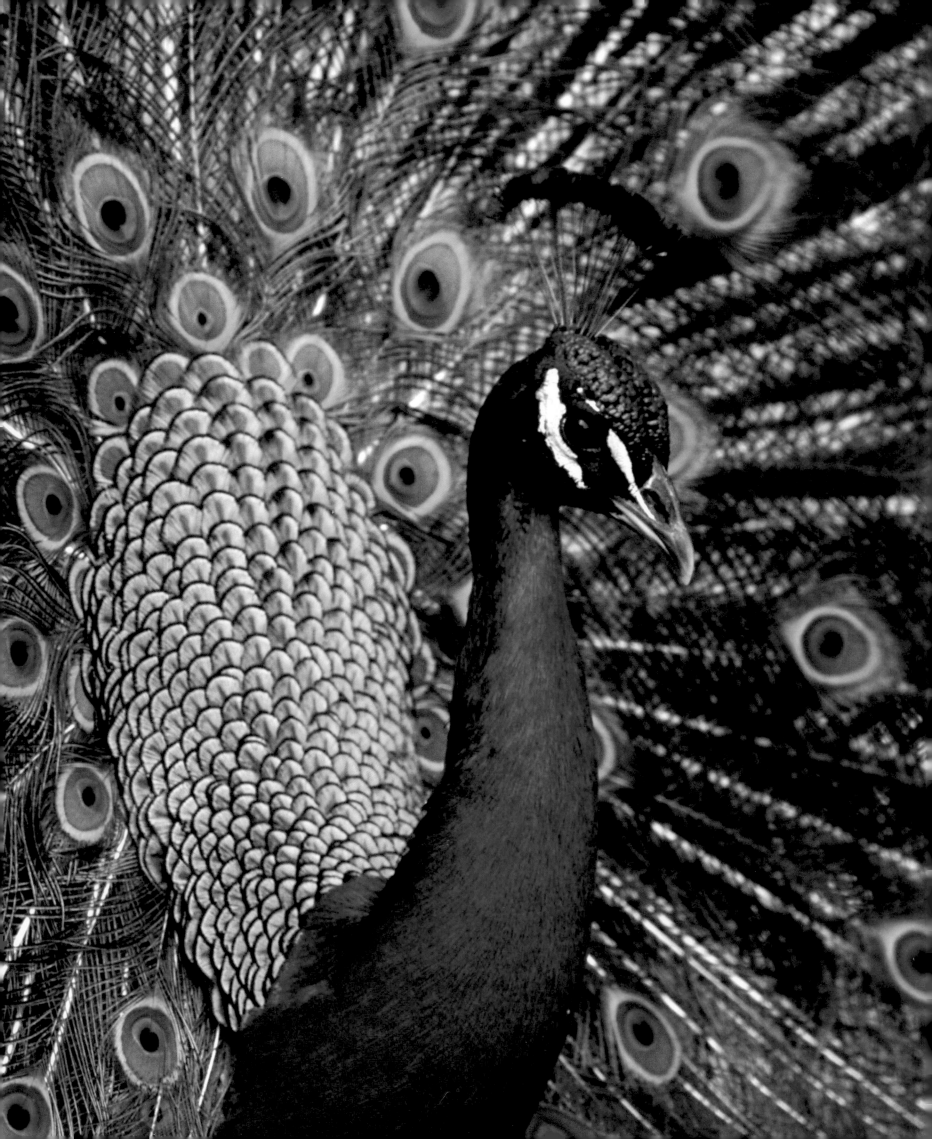

The common peafowl (*Pavo cristatus*) is native to India, Pakistan, and Sri Lanka. Its glorious tail is, in fact, a series of elongated uppertail coverts (feathers that cover the base of the tail on its upper side). The true tail sits beneath these coverts and raises them for display.

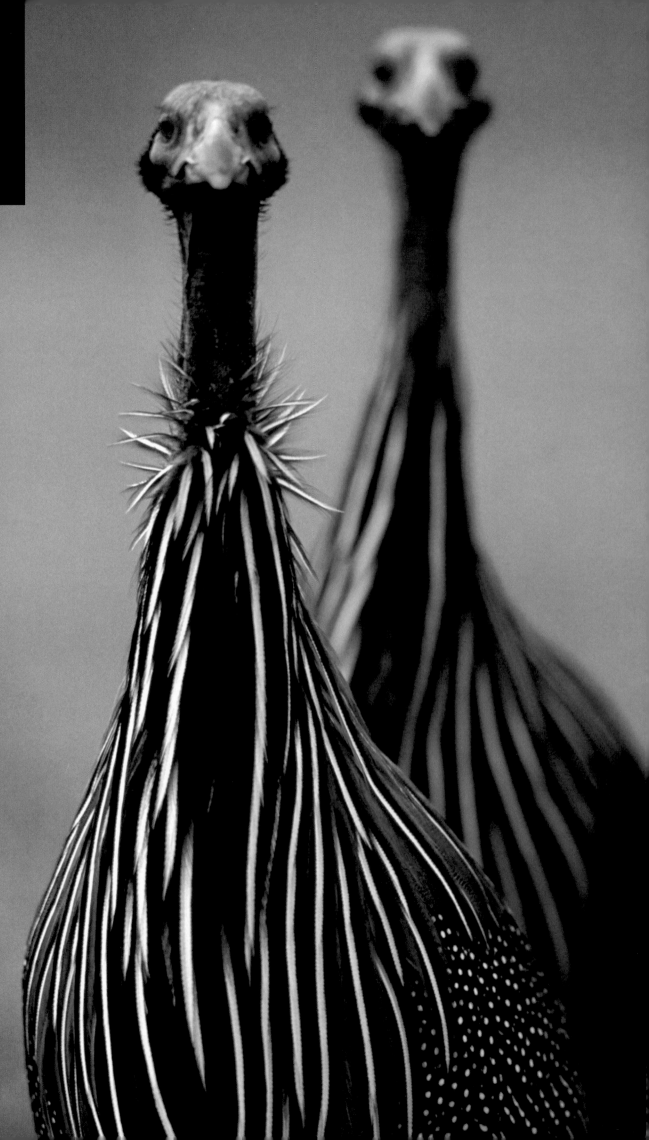

The elongated neck feathers of the vulturine guineafowl (*Acryllium vulturinum*), of northeast Africa, are particularly striking. The neck and head are largely bald, which is thought to help with temperature control.

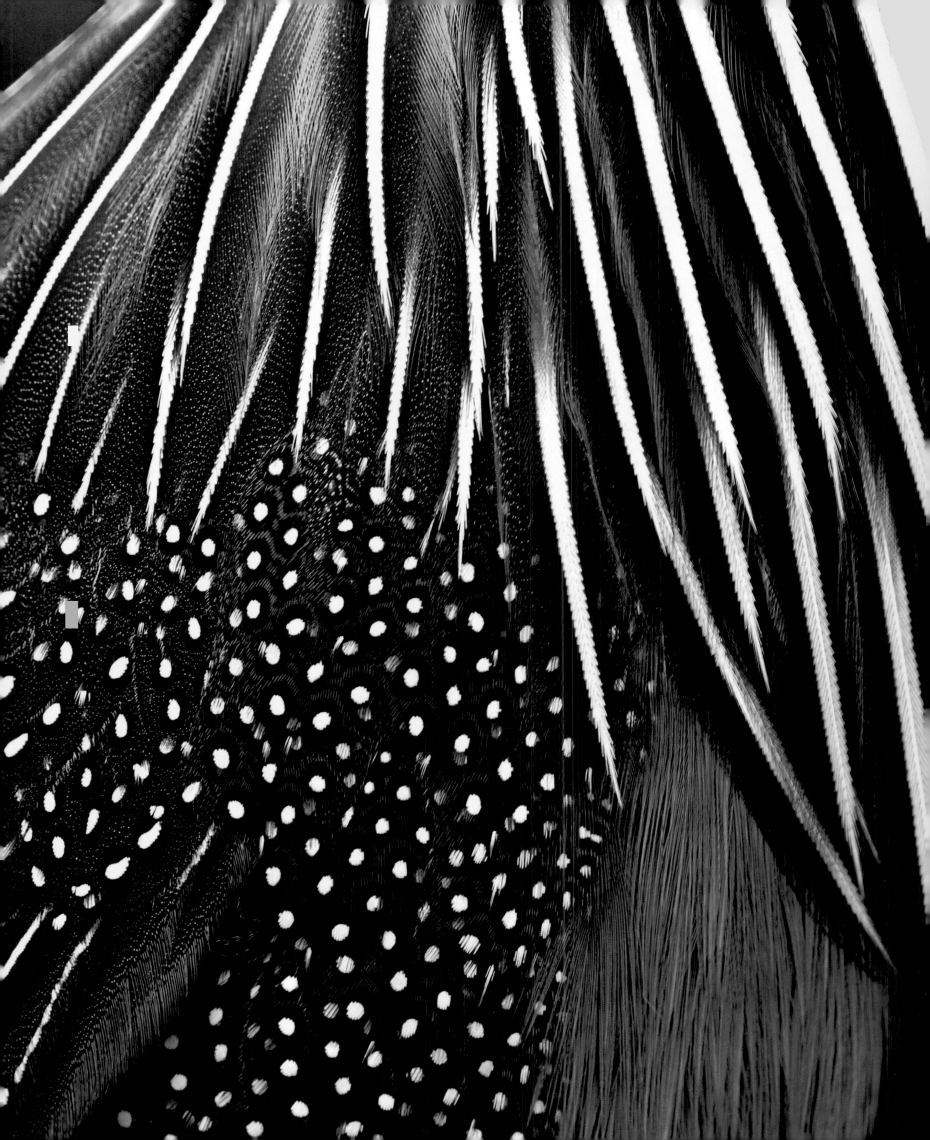

▷ The long-billed curlew
(*Numenius americanus*) probes
the mud for shrimps or crabs in their
burrows, and also takes prey from
the surface. Its unwieldy-looking
bill is more capable than it might
appear. The tip of the bill is loaded
with sensitive receptors, making it
possible for the bird to find food by
touch. Once prey has been found,
its manipulation is made easier
by the curlew's ability to raise the
tip of the upper part of its bill
independently, a phenomenon
known as "rhynchokinesis".

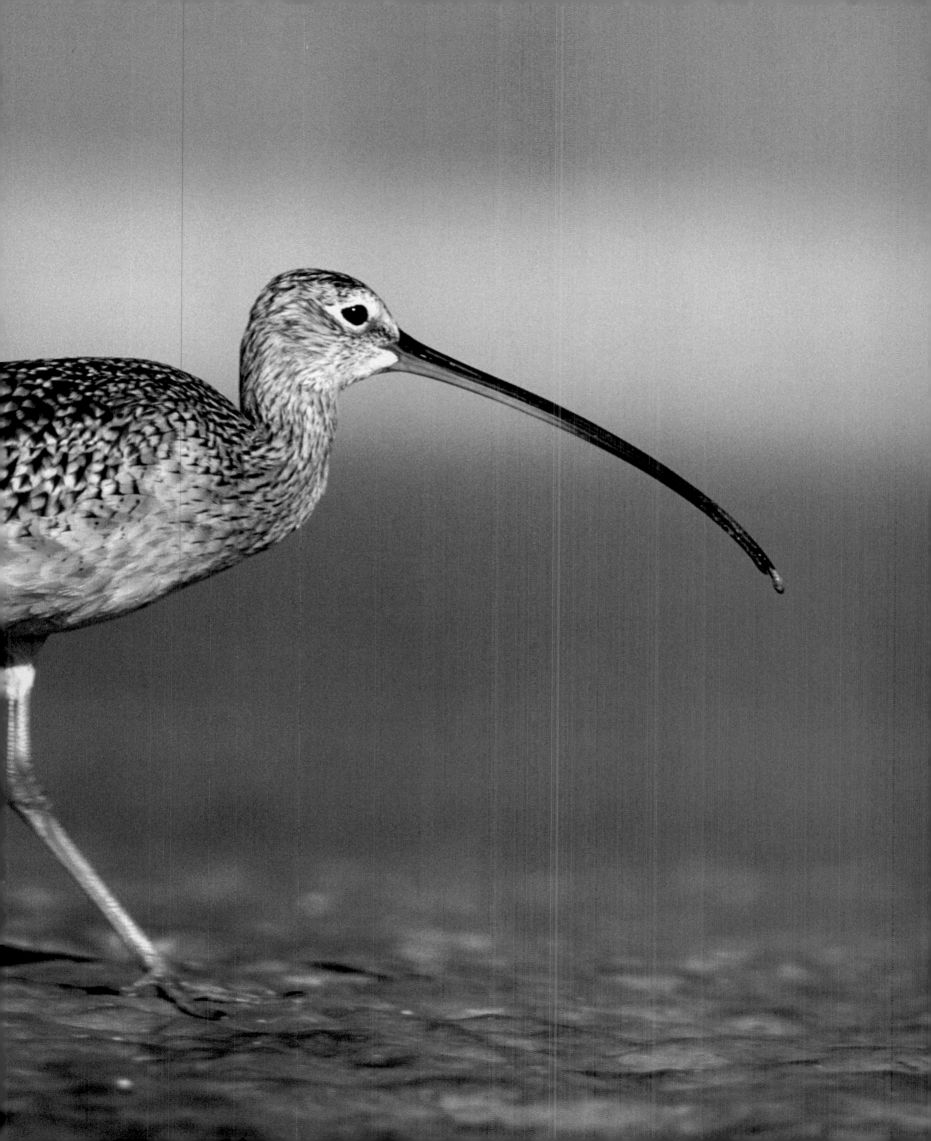

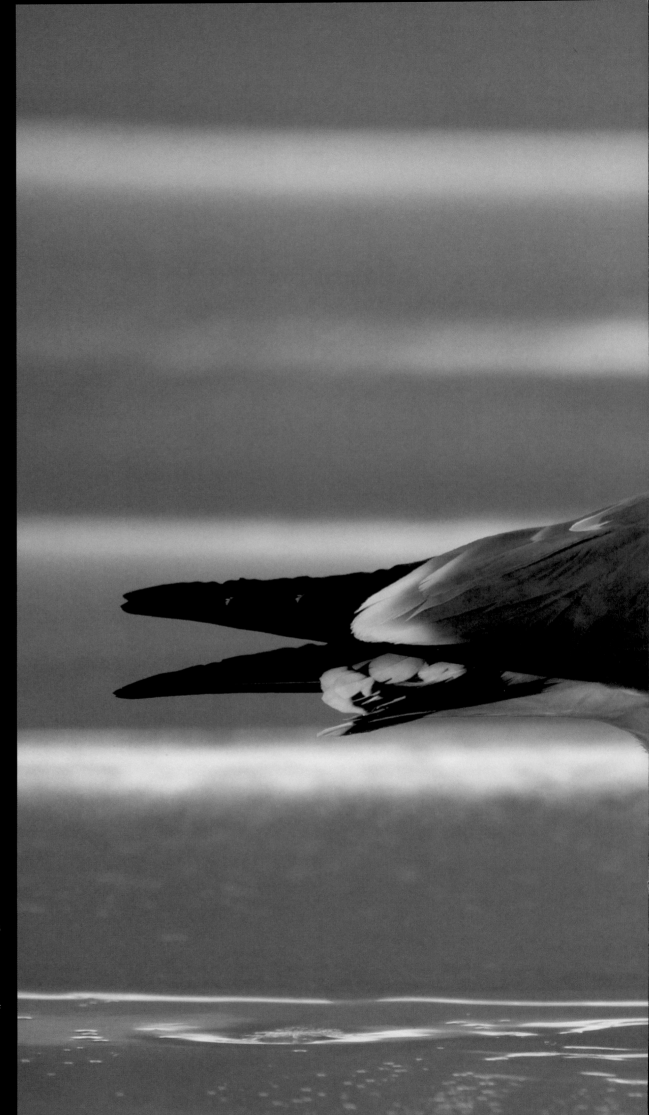

▷ The benign appearance of this
Heermann's gull (*Larus heermanni*)
disguises its true character. This
bird is a thief and a bully, snatching
fish from the bill of a brown pelican
when it surfaces with its catch, for
example, or harassing other species
and forcing them to let go of their
food. Like most gulls, their wingtips
are black. The black pigment
strengthens the feather, providing
protection from the wear and tear of
a gull's life. Heermann's gulls live
on the west coast of North America
and Mexico.

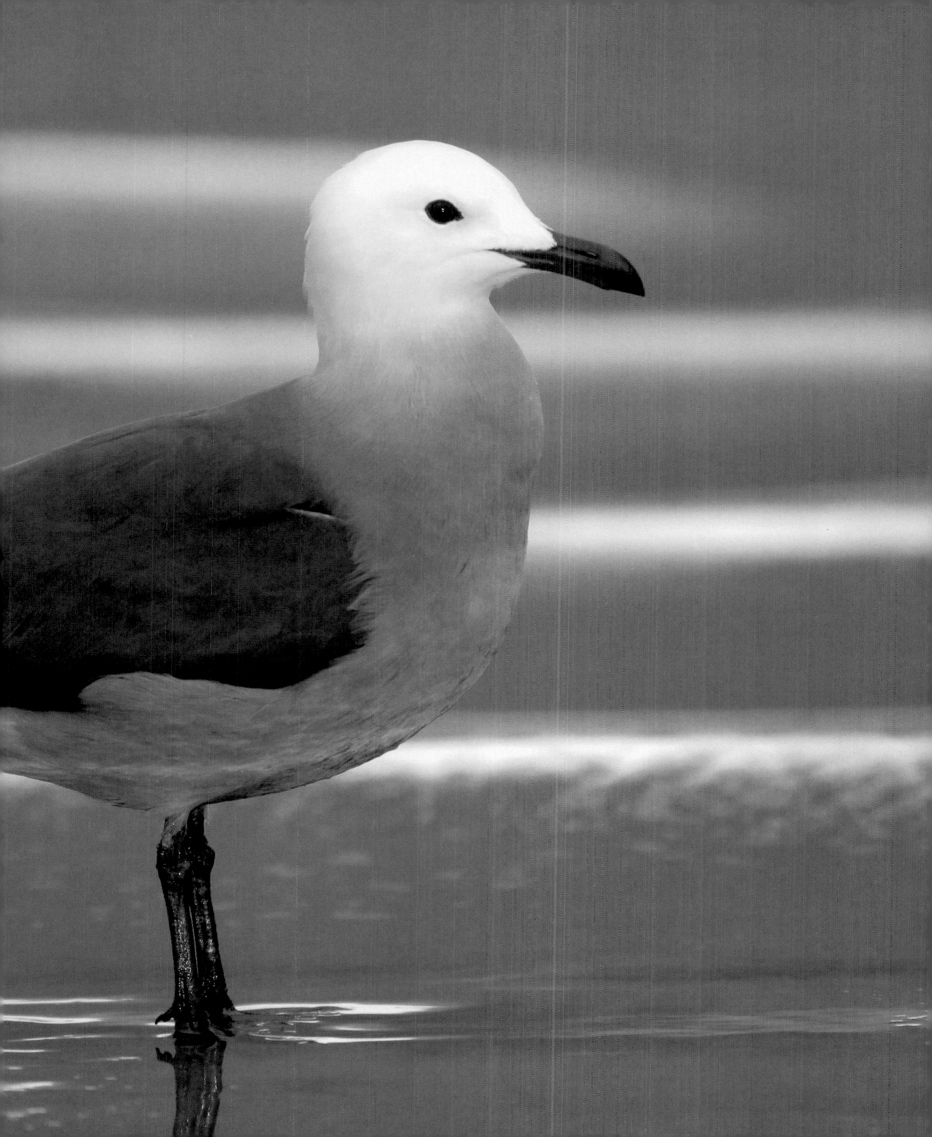

▷ It is obvious why this bird
is called a rhinoceros auklet
(*Cerorhinca monocerata*), with a
horn on its bill that can be up to
25mm (1in) long. The horn grows
as part of the bird's breeding
"plumage", and is moulted later
in the year. However, its precise
function is a mystery. The shape
of the bill itself equips the auklet
for a diet of both plankton and fish,
versatility that is denied to some
other auks, which specialize in
either one or the other. Rhinoceros
auklets are found around the
northern Pacific.

▷ In its breeding plumage the
tufted puffin (*Fratercula cirrhata*)
has long, swept back ear-tufts.
In winter, however, it looks quite
different. The ear-tufts and large
greenish "cere" at the base of the
upper mandible are gone and the
white face is dark. The tufted puffin
has an oversized bill, which can be
used to determine the age of the
bird. There are grooves on the bill
that, over the years, become more
obvious and more numerous. One

BIRDS

▷ With its long neck hackles and iridescent green feathers, the Nicobar pigeon (*Caloenas nicobarica*) is one of the world's most colourful species of pigeon. Its real curiosity may be less obvious, however – it has been suggested that this species is the closest living relative of the now extinct dodo. The Nicobar pigeon lives on small islands off southeast Asia, Indonesia, and New Guinea but is unfortunately in decline. Its good looks may be contributing to its downfall – many are trapped in the wild and sold as pets.

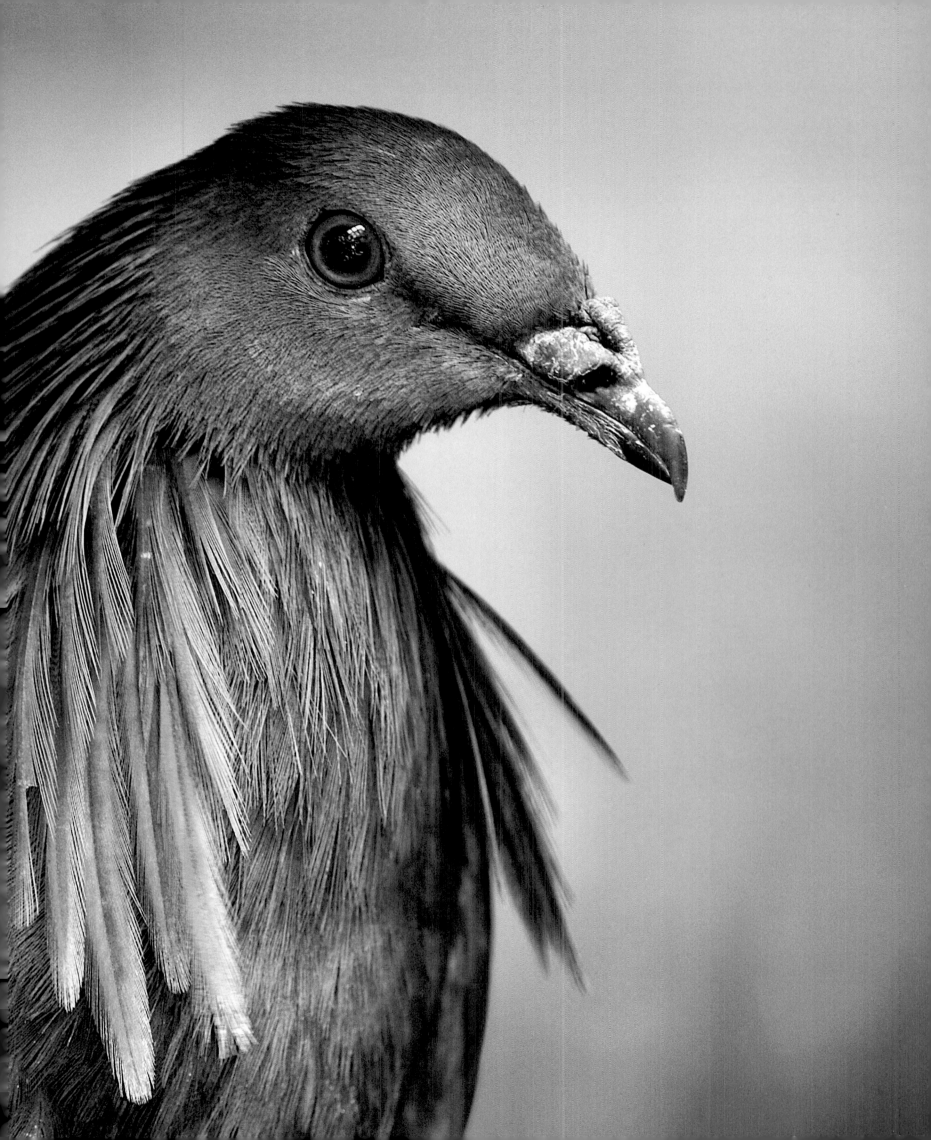

Despite its bright colours, the rainbow lorikeet (*Trichoglossus haematodus*) can be surprisingly hard to see when feeding on nectar, pollen, and fruit high up in the canopy. They mate for life and tend to travel in pairs – although they will sometimes gather in huge flocks.

When alarmed, a palm cockatoo (*Probosciger aterrimus*) raises its crest and its red cheeks become even redder. It is equipped with a large, strong bill for breaking into palm nuts and other similarly tough nuts and seeds.

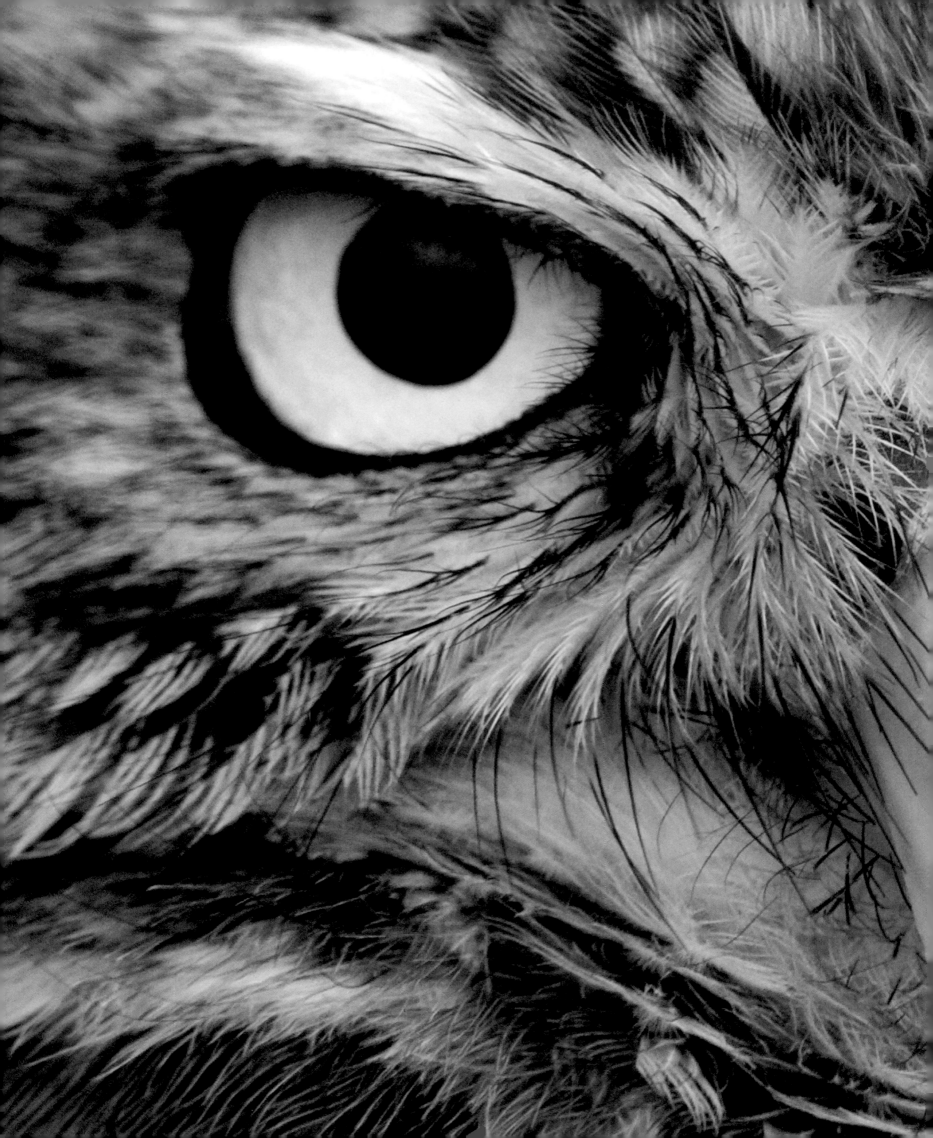

The forward-facing eyes of this little owl (*Athene noctua*) help it to detect movement and judge distance. Owls are unable to move their eyes in their sockets, but their necks are highly flexible, allowing them to turn their heads 270 degrees horizontally and 90 degrees vertically.

▷ There are more than 300 species of hummingbird in the world, all found in the Americas and the Caribbean. Weighing only 3.9–4.6g (around ³⁄₂₀oz), this tiny bird is the purple-crowned woodnymph (*Thalurania colombica*). It is plundering the nectar store of a heliconia in Costa Rica. Hummingbirds have amazing aerial abilities – they hover by flowers, can fly backwards, sideways, and even upside down. The end of the tongue is split into two channels that take nectar from the flower by capillary action, with the tongue moving in and out between three and 13 times per second.

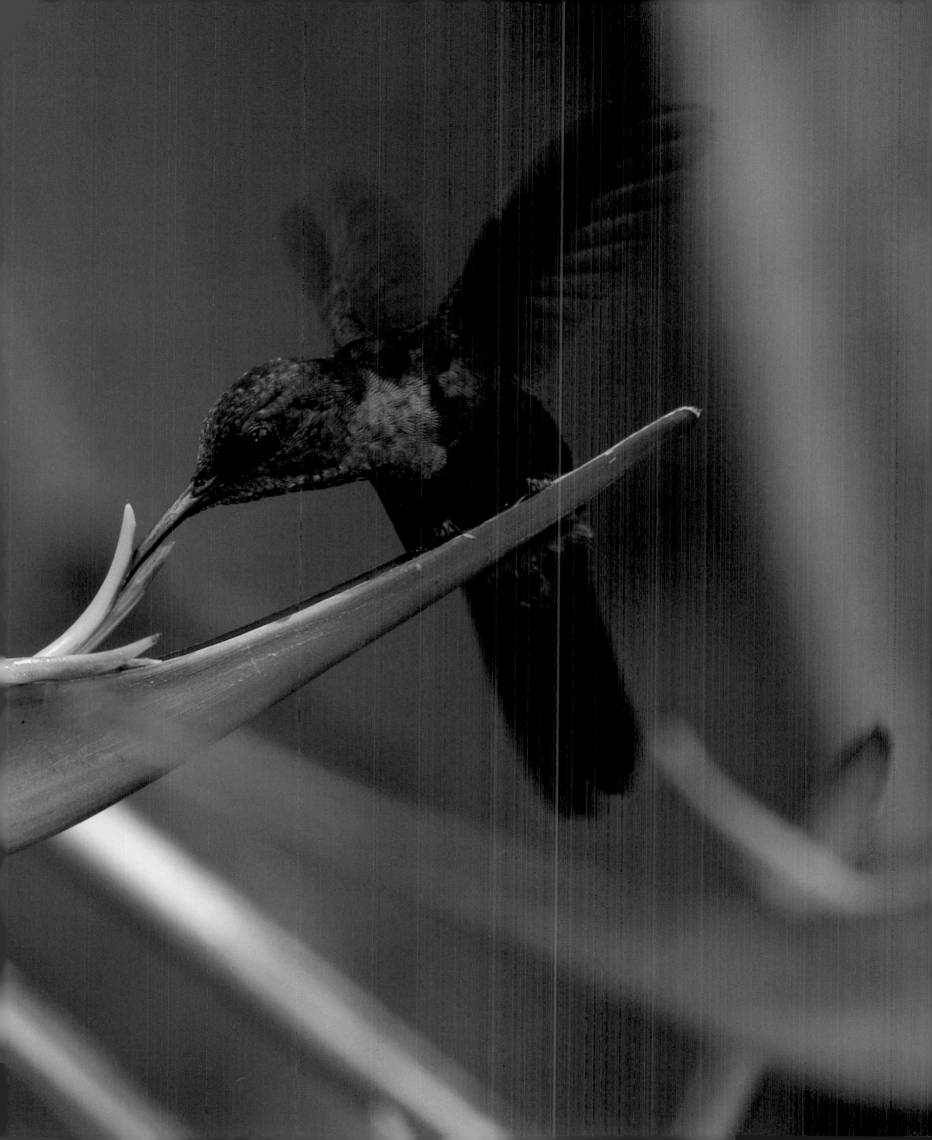

▷ The African malachite kingfisher
(*Alcedo cristata*) is very similar to
the kingfisher of Europe. This
sparkling blue and orange bird
watches the water carefully from
its perch. Like the bald eagle, it has
two foveae (the point at which an
image is at the sharpest focus) per
eye, one pointing to the side and
one pointing forwards. When the
bird spots movement to the side it
moves its head so that the potential
prey is focused in its forward-
pointing foveae, where its position
can be pinpointed. There is a
lightning-quick dive, and then,
usually, the kingfisher is back on
its perch with a fish in its bill.

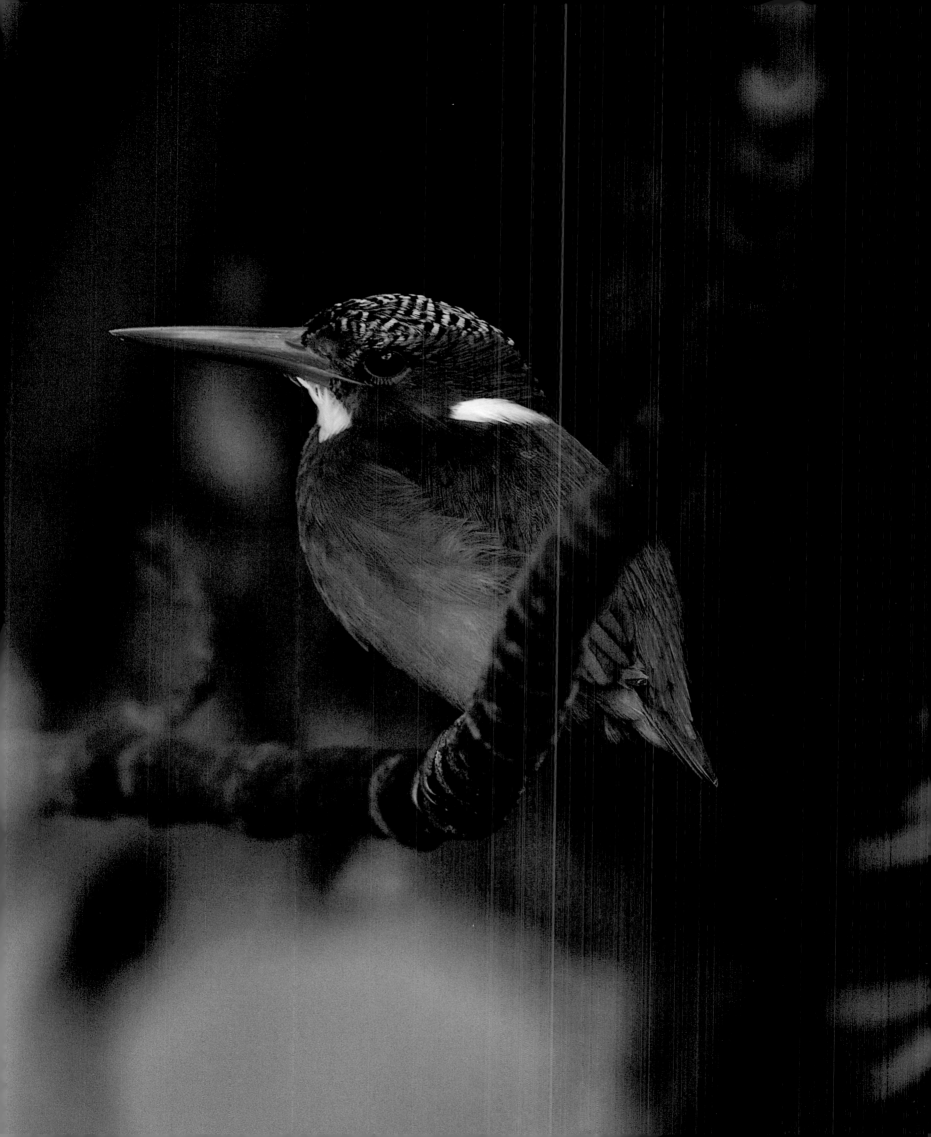

▷ The gorgeously coloured lilac-breasted roller (*Coracias caudatus*) is usually seen perched at a high vantage point, such as the top of a tree or a pole, from where it can easily spot its next meal on the ground, be it a beetle, grasshopper, snail, scorpion, or even a small mammal or bird. The lilac-breasted roller is common in much of sub-Saharan Africa, where it makes the most of bush fires, seizing small creatures as they flee the flames.

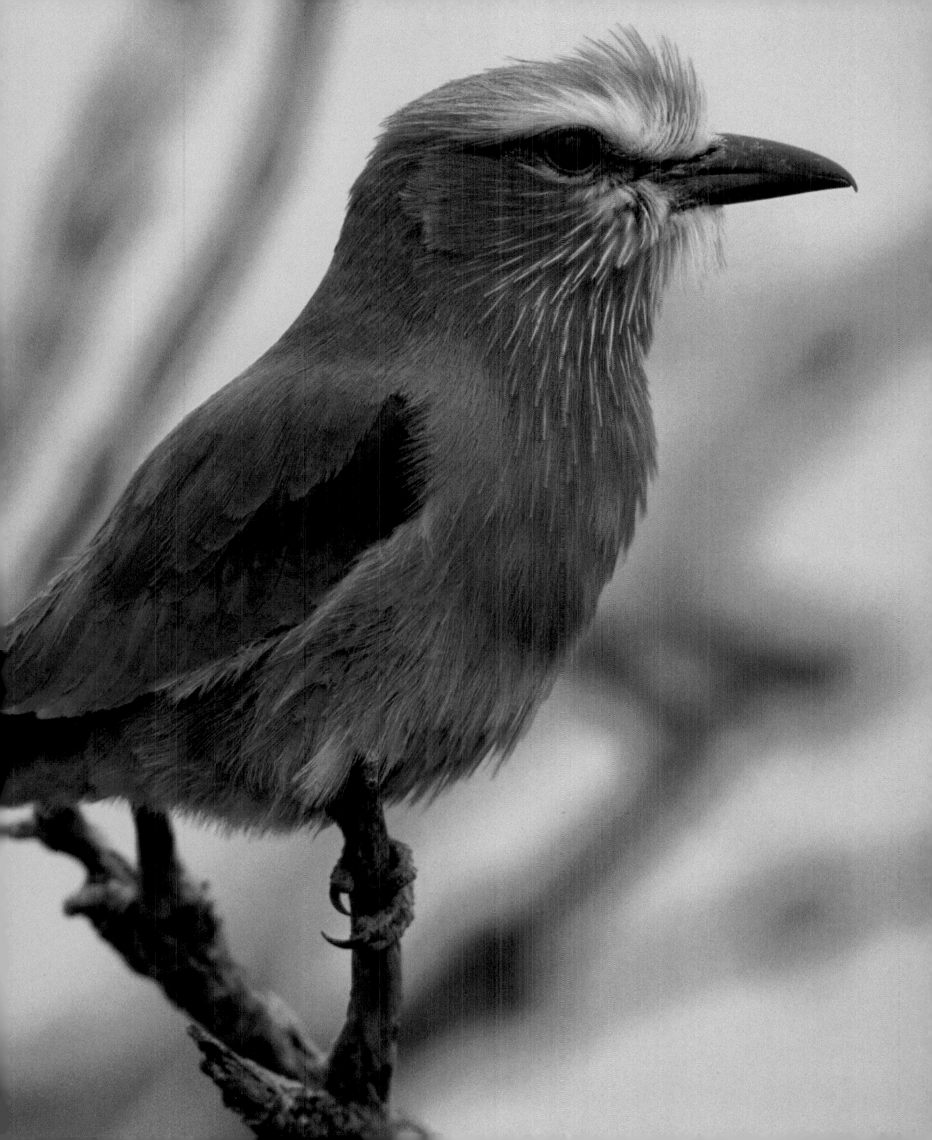

◁ The most remarkable feature of the great Indian hornbill (*Buceros bicornis*) is the huge enlargement, known as a "casque", on top of its already very sizeable bill. The function of the hollow casque is uncertain: the bird may use it to knock fruit out of trees, or it may play some kind of territorial role – very rarely, two males have been seen "casque-clashing". The feathers around this bird's face are not naturally yellow; the colour comes from the hornbill's preen oil, which it uses to keep its plumage in good condition.

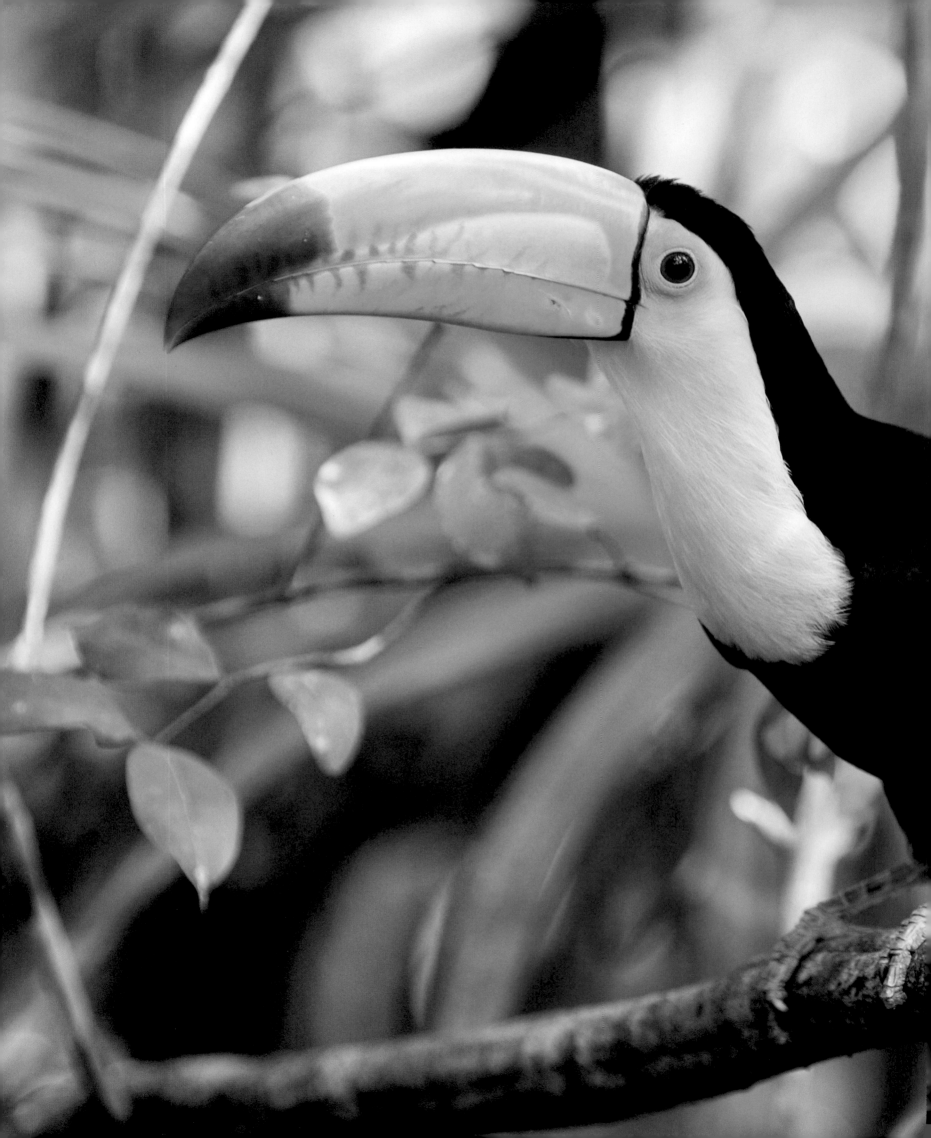

◁ The keel-billed toucan
(*Ramphastos sulfuratus*) of
South America is also known
as the rainbow-billed toucan
and the sulphur-breasted toucan.
It has a long, lightweight,
colourful bill that provides the
bird with a number of advantages.
Its bill enables the toucan to reach
fruits borne on parts of a tree that
could not take its weight, and is
used in threat displays against
other fruit-eating birds. As well as
fruit, the toucan also eats insects,
lizards, and tree frogs, and will
even take the eggs and fledgelings
of smaller birds, using its bill to
frighten the parent birds away
from their nest.

▷ Sunbirds of the *Nectariniidae* family are the Old World equivalent of the hummingbirds of the Americas, but they are not closely related. This beautiful sunbird is feeding at flowers in Rwanda. Most male sunbirds have iridescent feathers, and, like hummingbirds, a bill and tongue that can collect nectar, though they normally perch rather than hover when feeding. Many sunbirds also eat spiders and other small invertebrates, which are picked off flowers and foliage, or taken in mid-air.

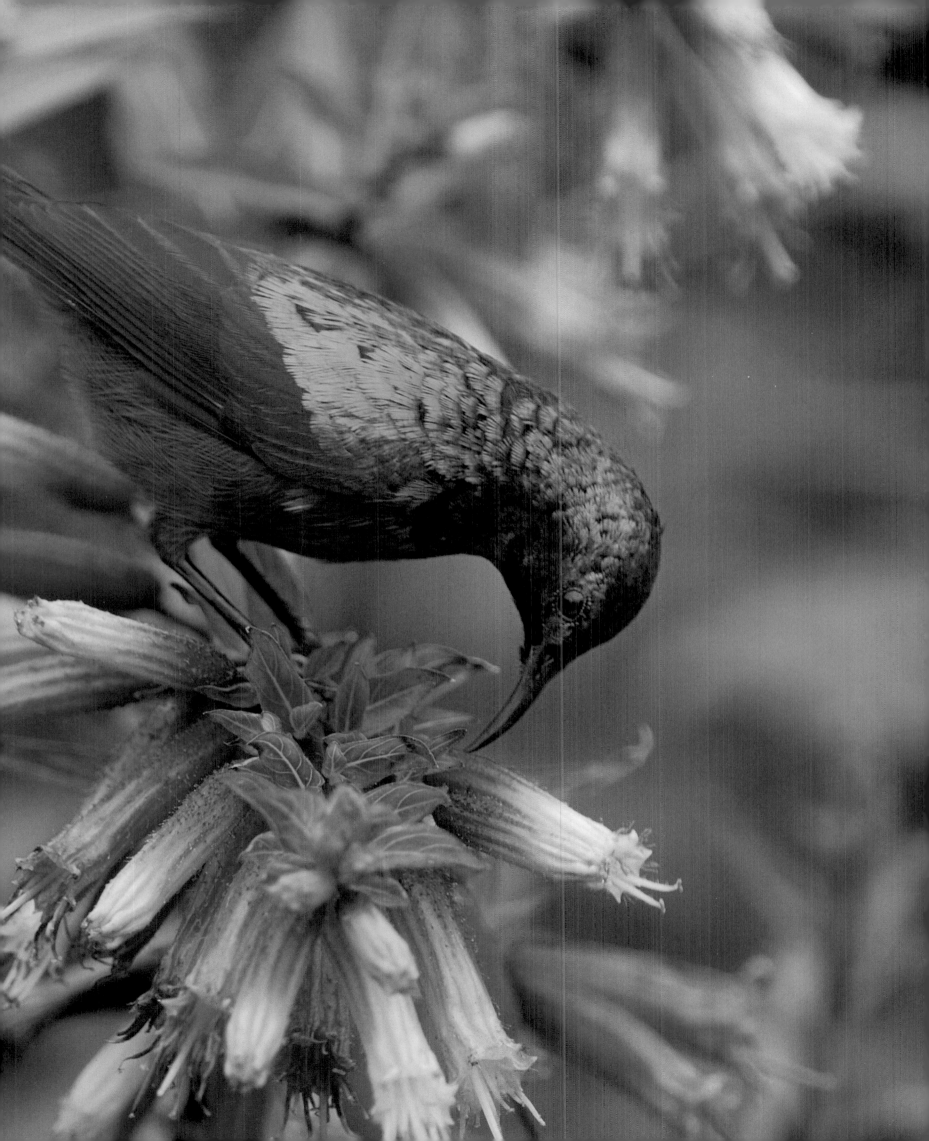

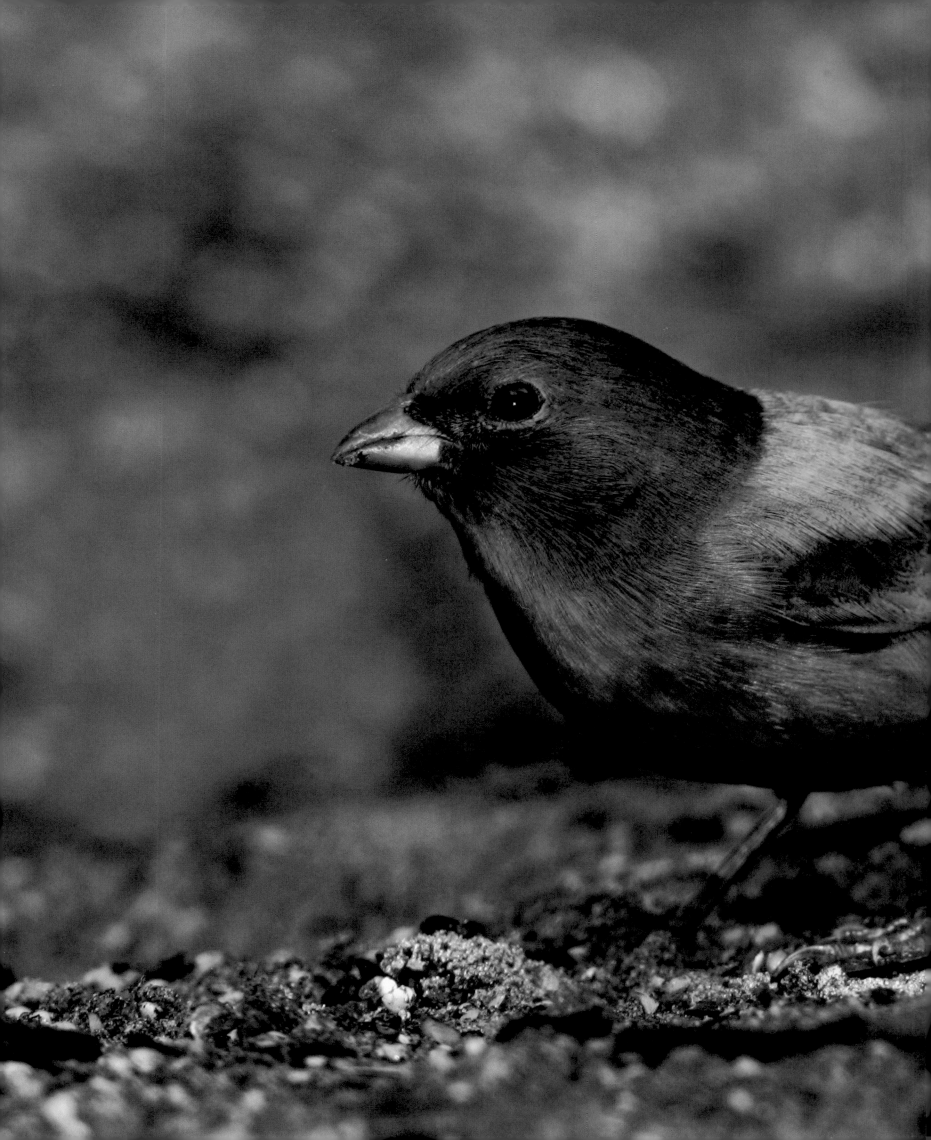

◁ The vivid red, green, and blue of this male painted bunting (*Passerina ciris*) make it one of North America's most colourful birds. However, it isn't always easy to spot, often remaining obscured by vegetation and denying hopeful observers a view. The female is a greenish colour and looks very different to the male. It is not surprising that a bird as beautiful as this is sought after by the cagebird industry, and trade in painted buntings is one of the main threats facing the species.

▷ The crow family (*Corvidae*) is renowned for its intelligence and the common raven, with one of the biggest brains of any bird, is no exception. Like some other birds, this species hides food and comes back to it later. It keeps an eye on other ravens, making a mental note of where they hide their food, with the intention of plundering their food caches. To protect its own food, a common raven will try to find the most secure spot it can, and may even fake food storing in an attempt to outwit the thieves.

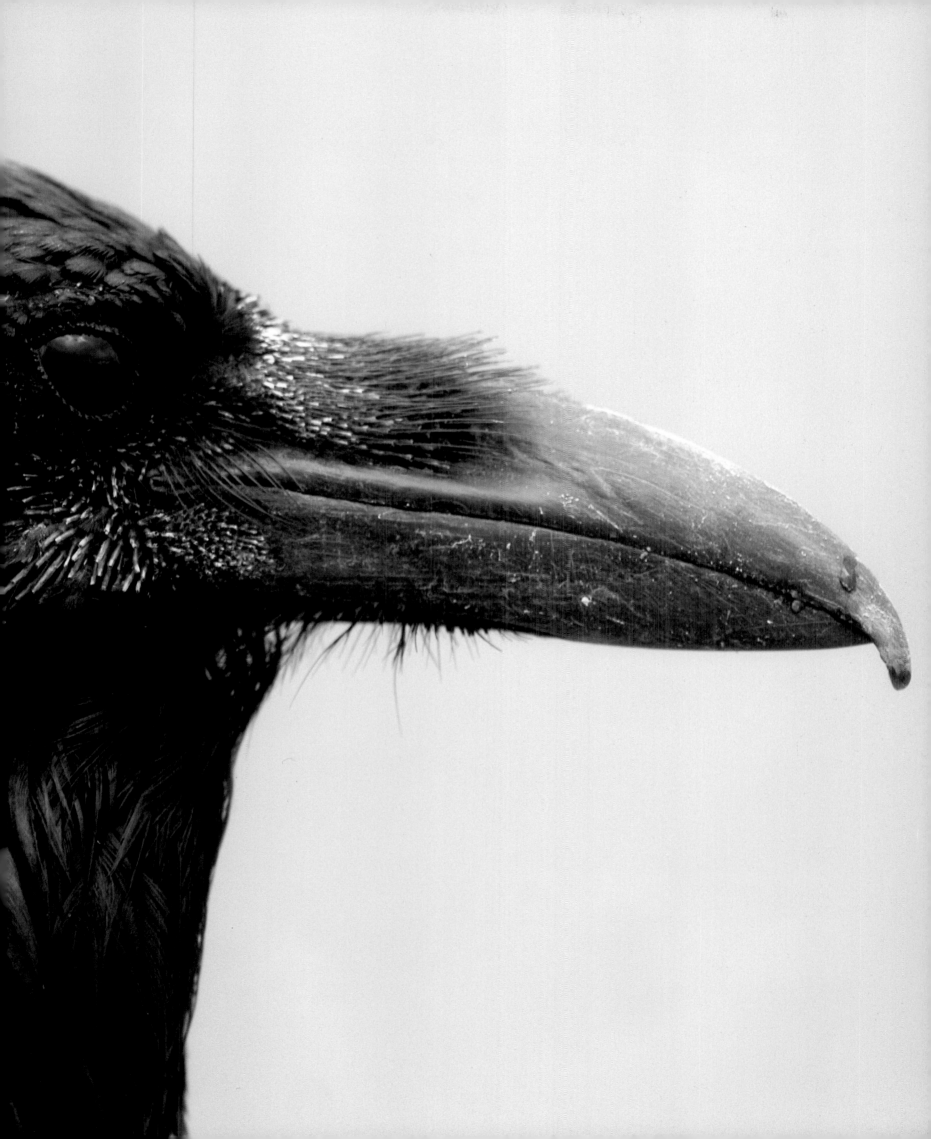

Reptiles and amphibians are creatures of bad reputation. Newts, toads, lizards, snakes, and crocodiles – the very names conjure up images of cold-blooded, creeping, slimy, or scaly creatures with lethal venom or terrifying teeth. It is certainly true that some are among the most dangerous animals on the planet. You do not trifle with creatures like the king cobra or the Nile crocodile. But most reptiles and amphibians pose no threat at all. A few are hugely popular, such as the snakes that some people keep as pets, or the frogs that spawn in garden ponds. Indeed, raising tadpoles and watching them turn into frogs is, for many, a fascinating insight into the wonders of the natural world.

This is because the amphibians – which include frogs, as well as toads, salamanders, and newts – are among the most intriguing of the vertebrates. These were the first creatures to live on land, having evolved from fish that had developed the ability to breathe air. However, they have not entirely broken their link with the water: their thin skins lose moisture easily, forcing them to live in damp environments. Most species must also breed in pools or moist places because their eggs and young resemble those of fish.

Yet many amphibians have found ways around these restrictions. Some frogs and toads survive desert droughts by absorbing water during rare rainstorms and then burrowing underground. Many live among the shady, damp foliage of trees, especially in tropical rainforests, and some breed in tiny pools that form on leaves high up in the canopy. Some African tree frogs lay their eggs in "nests" made of wet foam, and European midwife toads carry their eggs on their backs so they can dunk them in water every so often to keep them moist.

The thin skin of amphibians is also less of a handicap than it might seem, because it has the ability to absorb oxygen from water or, if it is kept moist, from the air. This enables the largest family of salamanders to do without lungs altogether. It also explains why many amphibians are slimy – the slime retains the moisture that enables them to breathe.

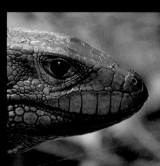
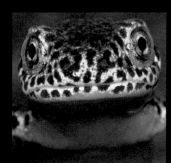
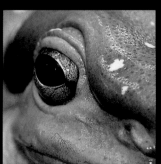
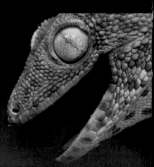

> **Disturbingly alien, yet often strangely beautiful, reptiles and amphibians are among the most intriguing of all animals.**

By contrast, a reptile such as a lizard or snake has a waterproof, typically scaly skin. This equips many reptiles to colonize arid habitats without resorting to extreme measures such as living underground for months on end. Most lay eggs with waterproof shells, and some species retain their eggs in their bodies until these hatch as tiny versions of their parents – for unlike most amphibians, all reptiles start life as they mean to go on.

Reptiles can also thrive in dry, hostile habitats because they do not need to eat much. Being "cold-blooded" means that, rather than turning food into heat, they rely on the sun's warmth to raise their body temperature. This saves a huge amount of energy, allowing them to survive on very little food – a python can get by on just one big meal a year. So while reptiles might seem alien, alarming creatures, their very strangeness is fascinating.

reptiles and amphibians

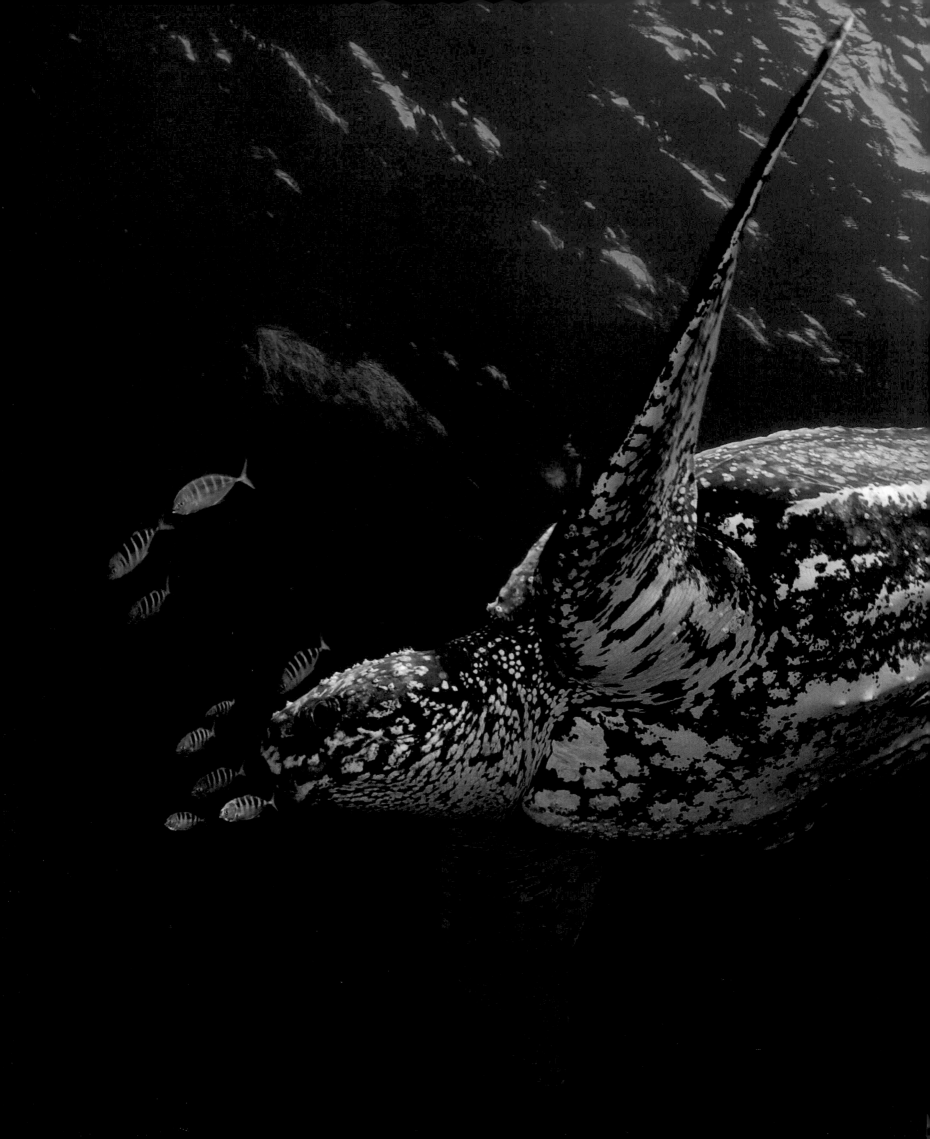

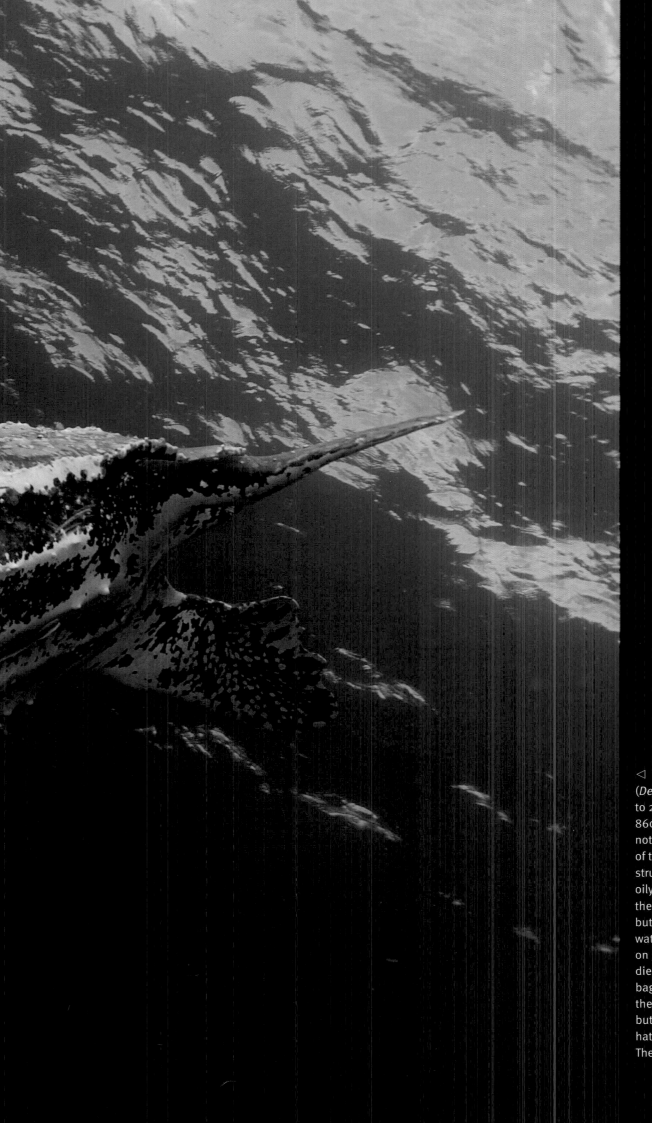

◁ The colossal leatherback turtle (*Dermochelys coriacea*) can grow to 2.4m (8ft) long and weigh up to 860kg (1,900lb). Its "shell" does not have the horny plates typical of turtles, but is a ridged, bony structure with a covering of thick, oily skin. The leatherback cruises the warmer oceans of the world, but penetrates deep into cooler waters in summer. It feeds mainly on jellyfish, and many leatherbacks die after eating floating plastic bags by mistake. The females lay their eggs on tropical beaches, but fewer than one in a thousand hatchlings survive to adulthood. The species is critically endangered.

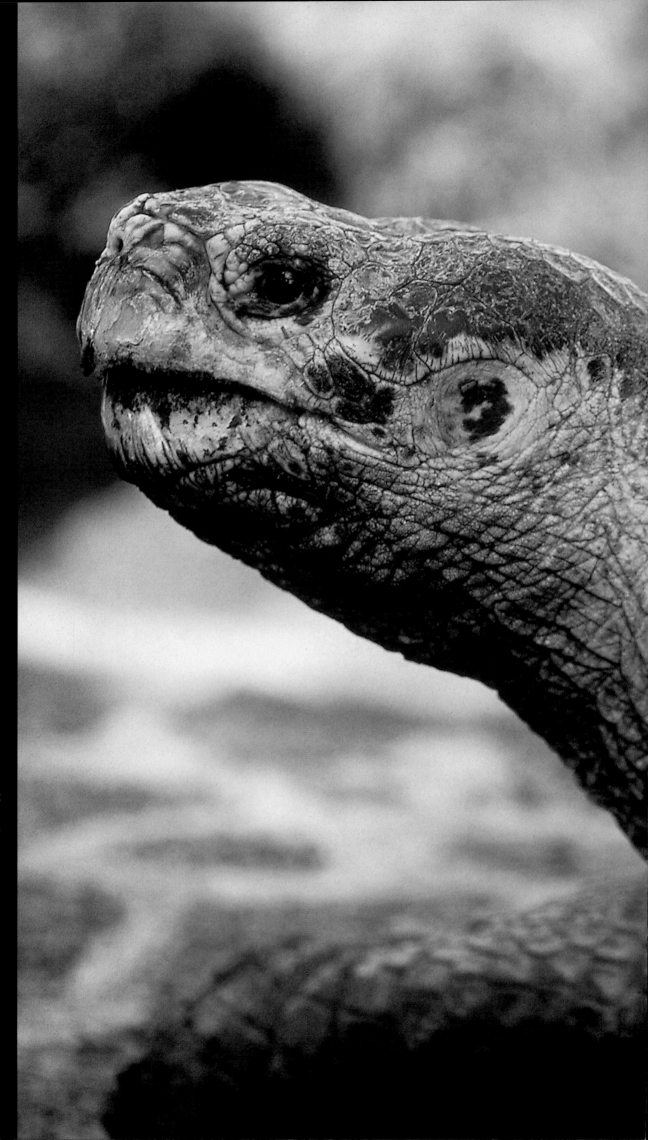

REPTILES AND AMPHIBIANS

▷ The Galapagos islands off
Ecuador are famous for their giant
tortoises – magnificent animals that
can weigh up to 300kg (660lb) and
live for well over a century. Although
they are all classified as one
species, *Geochelone nigra*, there
were originally 12 island races, of
which 10 remain. Each has its own
shell shape adapted to suit the
feeding opportunities on its island.
The shell of this tortoise is low at
the front, but the shells of other
races are higher, allowing them
to stretch up to pluck leaves from
bushes. The variation was one
of the features of the Galapagos
wildlife that helped Charles Darwin
develop his ideas on evolution.

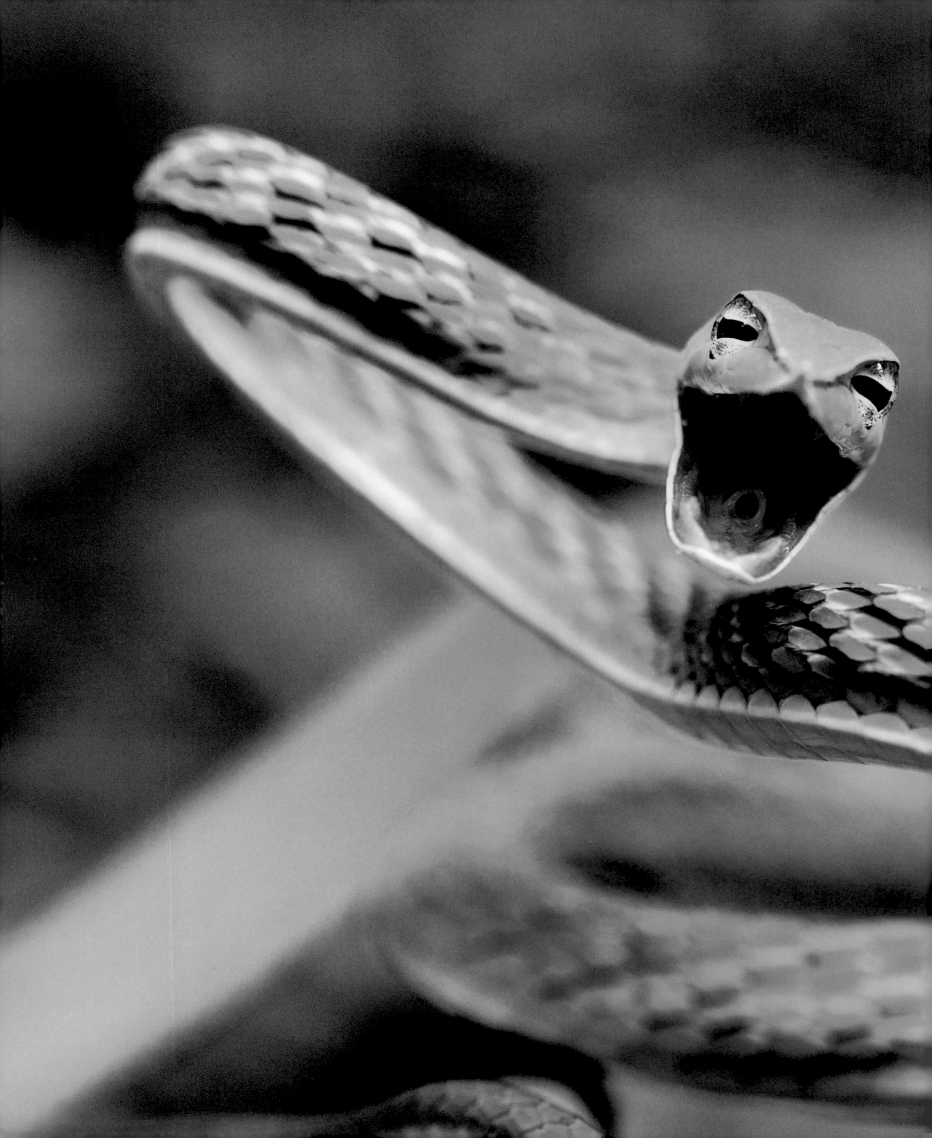

◁ Many snakes are able to climb trees, but few are as specialized for life in the forest canopy as the long-nosed vine snake *(Ahaetulla prasina)*. One of eight species that live in southern and southeast Asia, it is a very slender snake that resembles a vine stem, and has short venomous fangs that it uses to subdue tree-dwelling lizards. The eyes of this snake are almost unique in having horizontal, slot-shaped pupils that improve its binocular vision, so it can judge distances accurately and seize its agile prey with a single well-aimed strike.

By resembling the venomous coral snake, the false coral snake (*Rhinobothryum bovalli*) of tropical America enjoys immunity from its enemies.

The largest of all venomous snakes, the Asian king cobra (*Ophiophagus hannah*) can grow to more than 5m (16½ft) long. It is not particularly aggressive, but if cornered it may rear up, flatten its neck in a threat display, and strike. Its venom is lethal unless treated very rapidly.

Dwarfed by the body of an adult, this young Wagler's pit viper (*Tropidolaemus wagleri*) from Borneo will change colour as it grows. This venomous snake hunts lizards, birds, and small mammals in the trees.

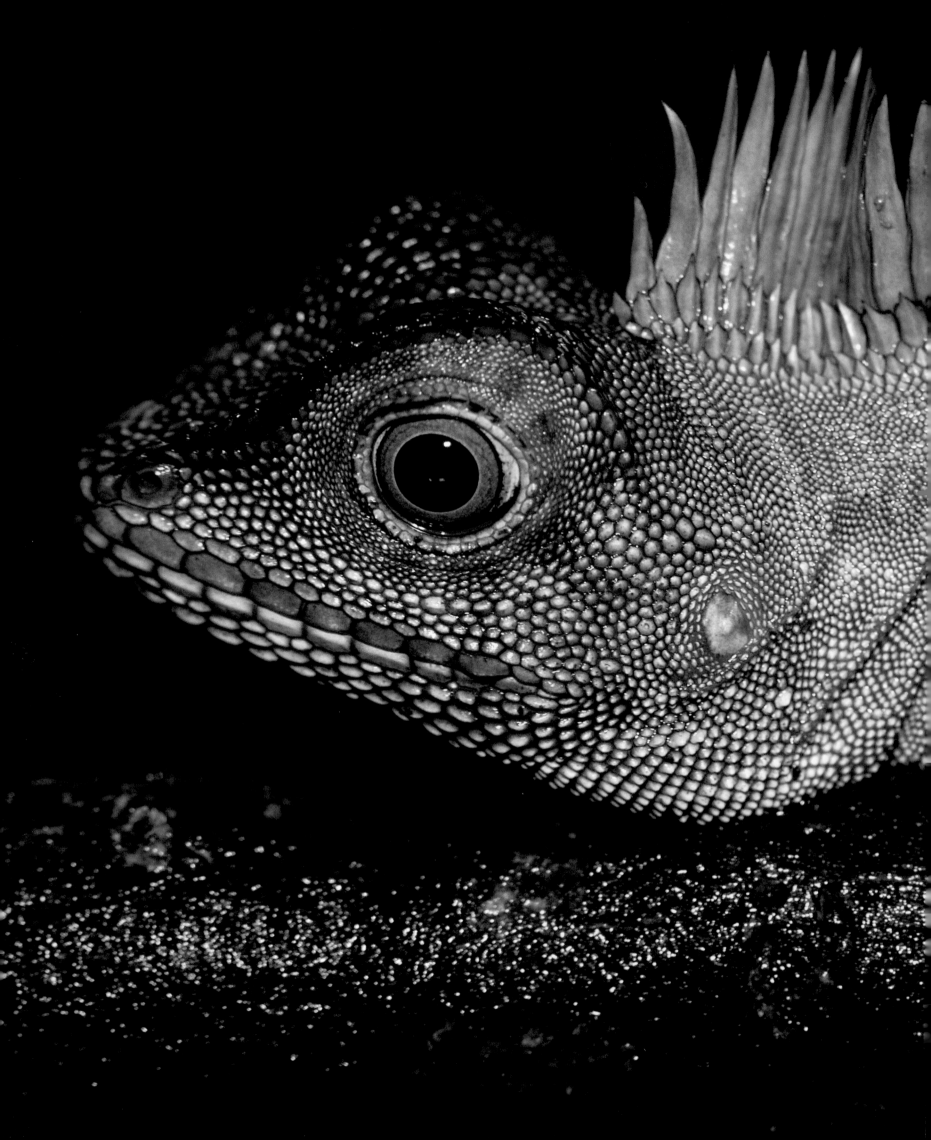

◁ One of the large family of chisel-teeth lizards, or agamids, this comb-crested forest lizard (*Gonocephalus liogaster*) is so named because of the crest of long, sharp spines extending down its back. It lives in the forests of Borneo, Indonesia, usually near water, where it is typically found clinging to the trunks and branches of tall forest trees. It preys on insects and other small animals, and may grow to a length of 30cm (12in).

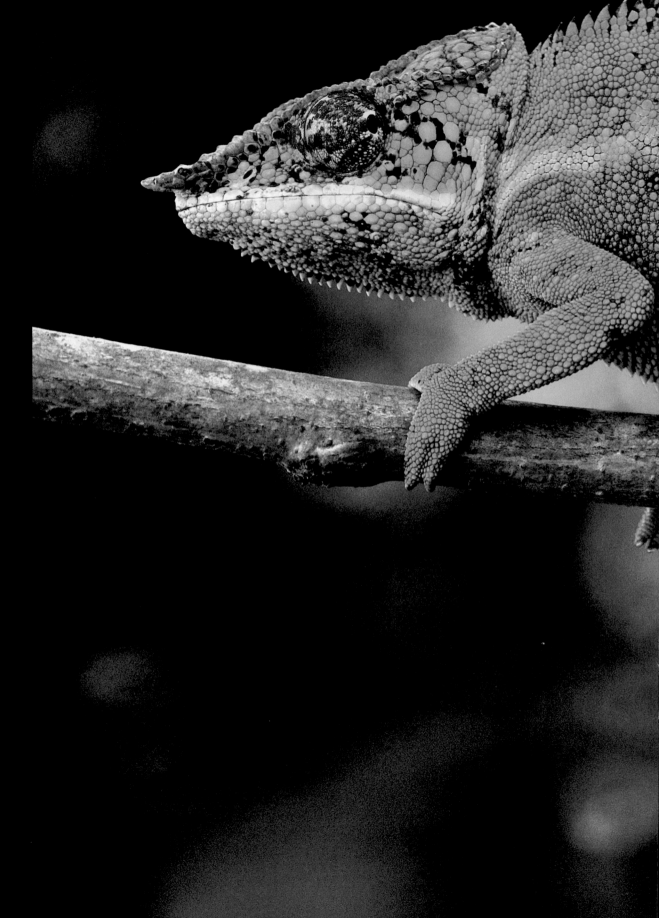

▷ Chameleons are tree-living lizards, famous for the way they change colour as pigment cells in their skin expand or contract under the control of hormones carried in the blood. If this male panther chameleon (*Furcifer pardalis*) from Madagascar gets excited by a potential mate, the flush of hormones will make him glow with the much brighter colours seen around his eyes. Yet if he has to retreat from a rival, he may fade to a submissive ashy grey. The toes of all chameleons are fused into two opposing hooks to give a firm grip on slender branches, and they have muscular prehensile tails.

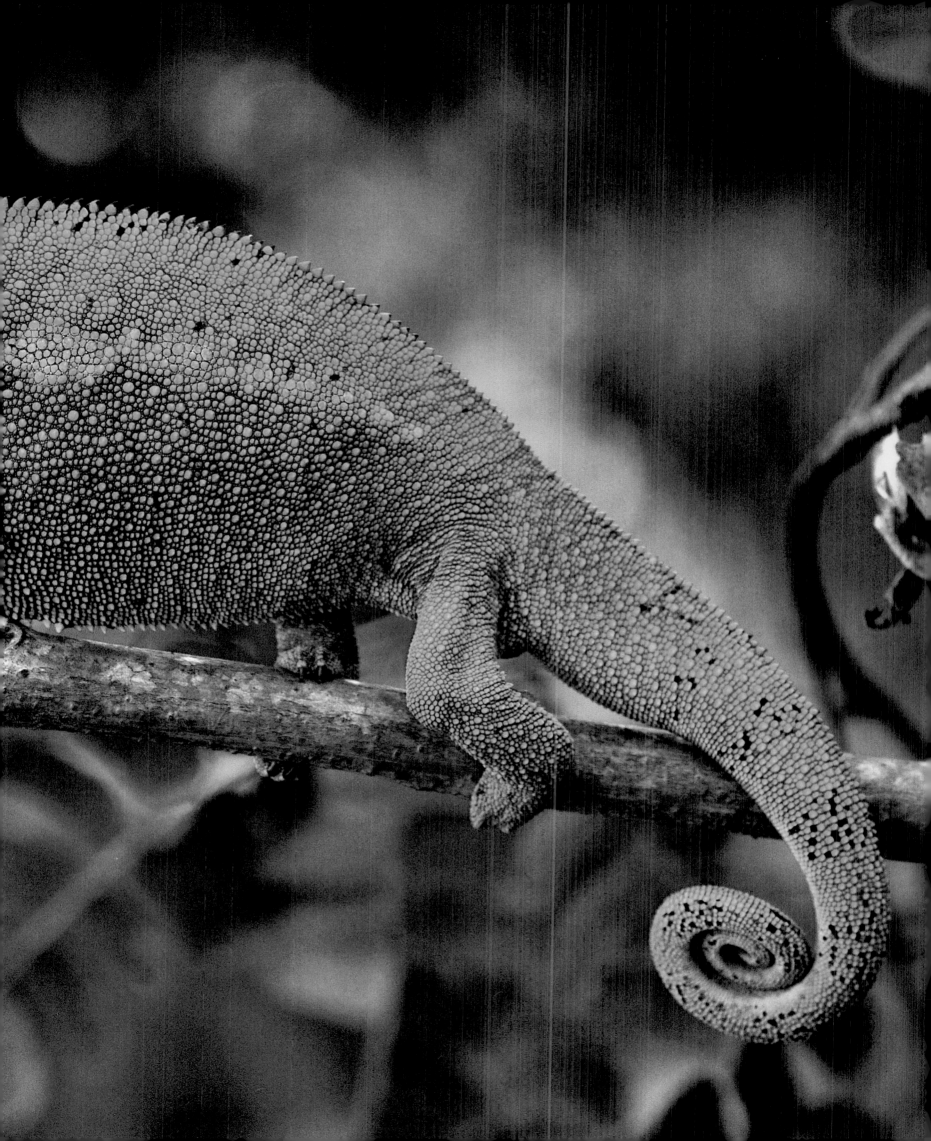

▷ All chameleons have very
mobile eyes that can swivel
independently to focus on two
things at once. This gives them
the ability to stalk prey while
watching for danger at the same
time. They move very slowly,
creeping up on insects and
capturing them by flicking out
their extremely long telescopic
tongues – an action that takes just
a fraction of a second. This is
Furcifer willsii, a species that
grows to some 14cm (5½in) long.
It lives in Madagascar, which is
home to half of the world's 135
species. These range from the
pygmy stump-tailed chameleon,
barely longer than a thumbnail, to
the cat-sized Parson's chameleon.

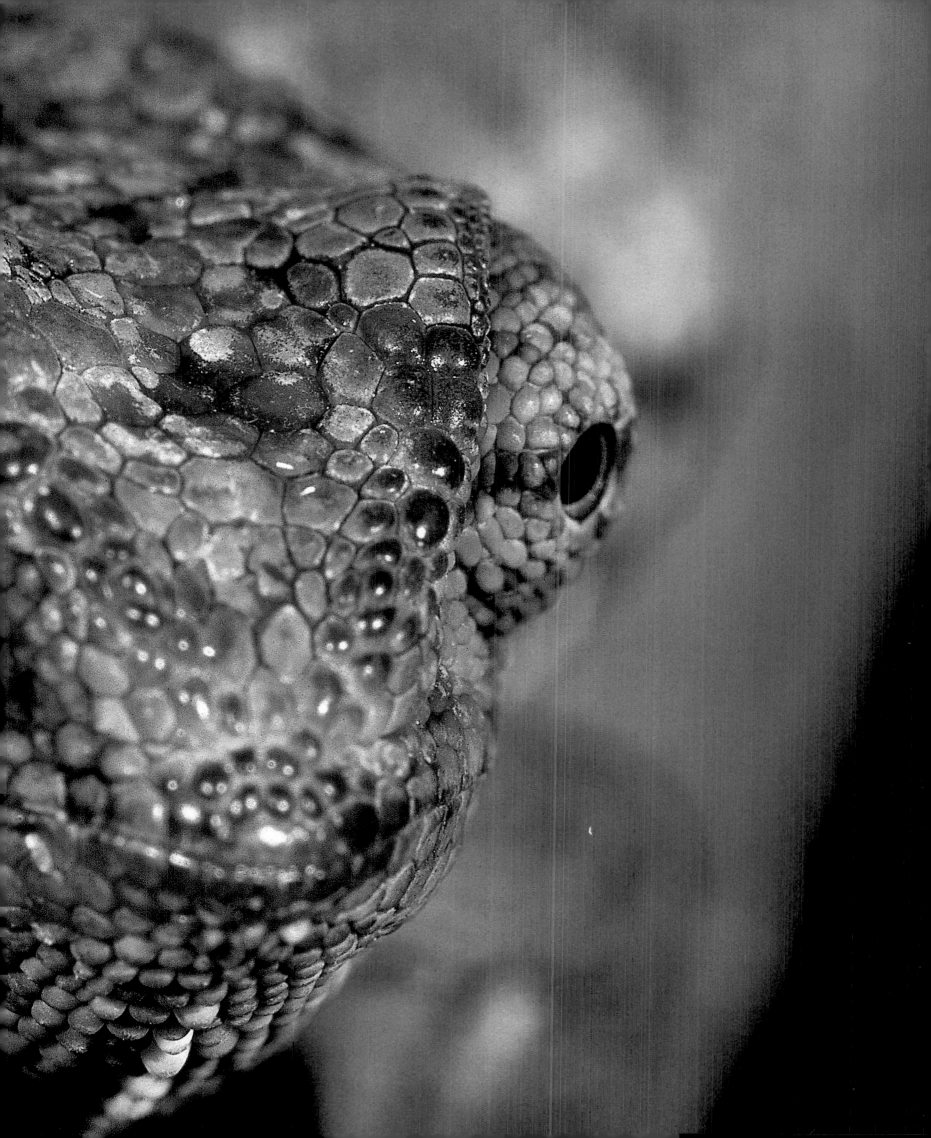

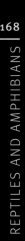

REPTILES AND AMPHIBIANS

▷ The Galapagos islands are home to many unique species that have become adapted to unusual environments. One of the oddest is the marine iguana (*Amblyrhynchus cristatus*). The only truly aquatic lizard, it dives into the cold ocean surrounding the islands to graze on seaweed on the sea bed. In the process it gets so cold that it has to spend hours basking on the hot, black, volcanic rocks of the islands to warm up again. The marine iguana also ingests a lot of salt, which it eliminates from its body by excreting it through special salt glands in its nostrils.

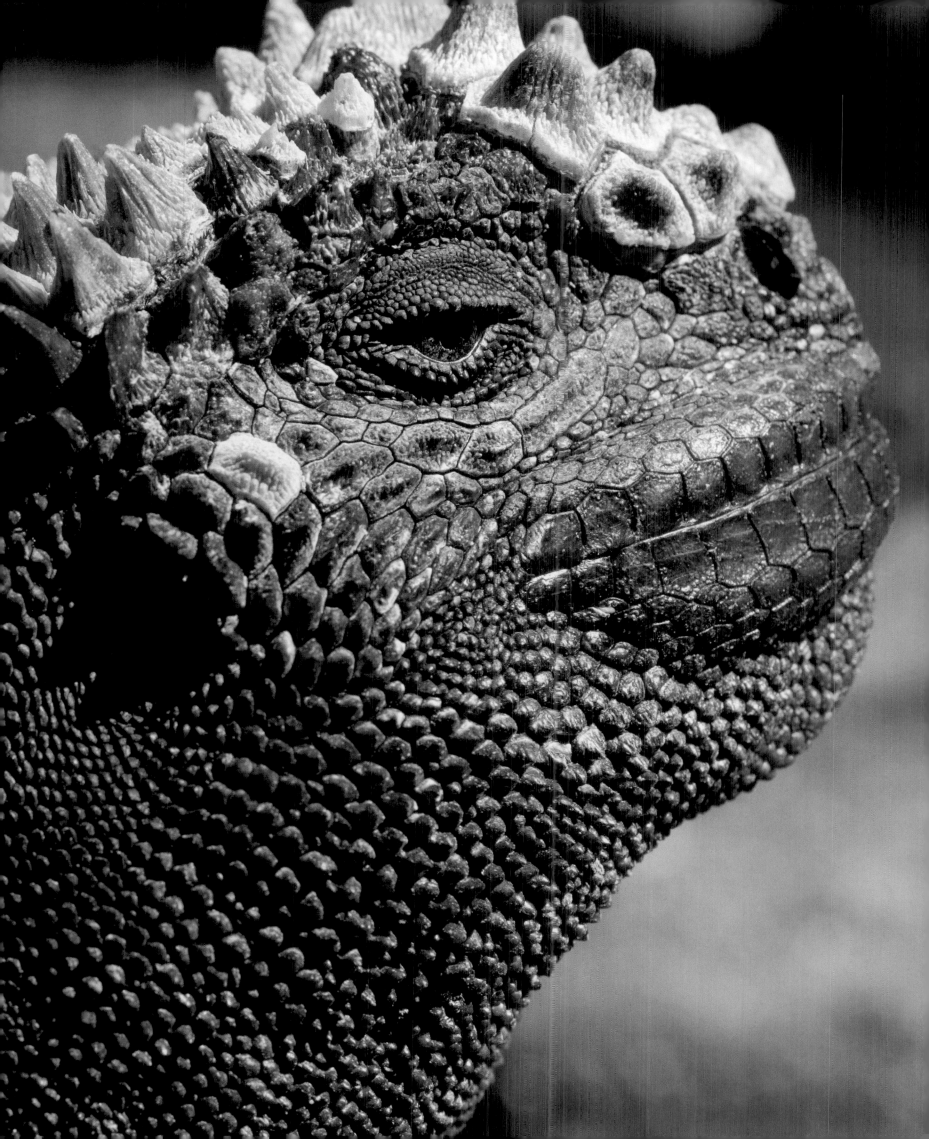

The small iguanas known as anoles are among the most successful of all lizards. This neotropical green anole (*Anolis biporcatus*) from Costa Rica is one of nearly 400 species that live in various habitats in Central and South America.

▷ Geckos are mainly tree-living lizards, famous for their amazing climbing abilities. Their feet are equipped with broad discs covered with hundreds of thousands of microscopic "hairs" that stick to almost any surface, including glass. The tokay gecko (*Gekko gecko*) of southern and southeast Asia is one of the largest, growing to 35cm (14in). It runs up walls and even across ceilings inside houses, where it is a welcome visitor because of its appetite for cockroaches and other pests. However, the tokay gecko has a powerful bite if cornered, and may cling on for several hours (although it can be dislodged by being submerged in water).

Veined and twisted like a dead leaf, the fantastic leaf-tailed gecko (*Uroplatus phantasticus*) is almost invisible among the leaf litter on the forest floor of its native Madagascar. It is most active at night when it emerges to hunt insects.

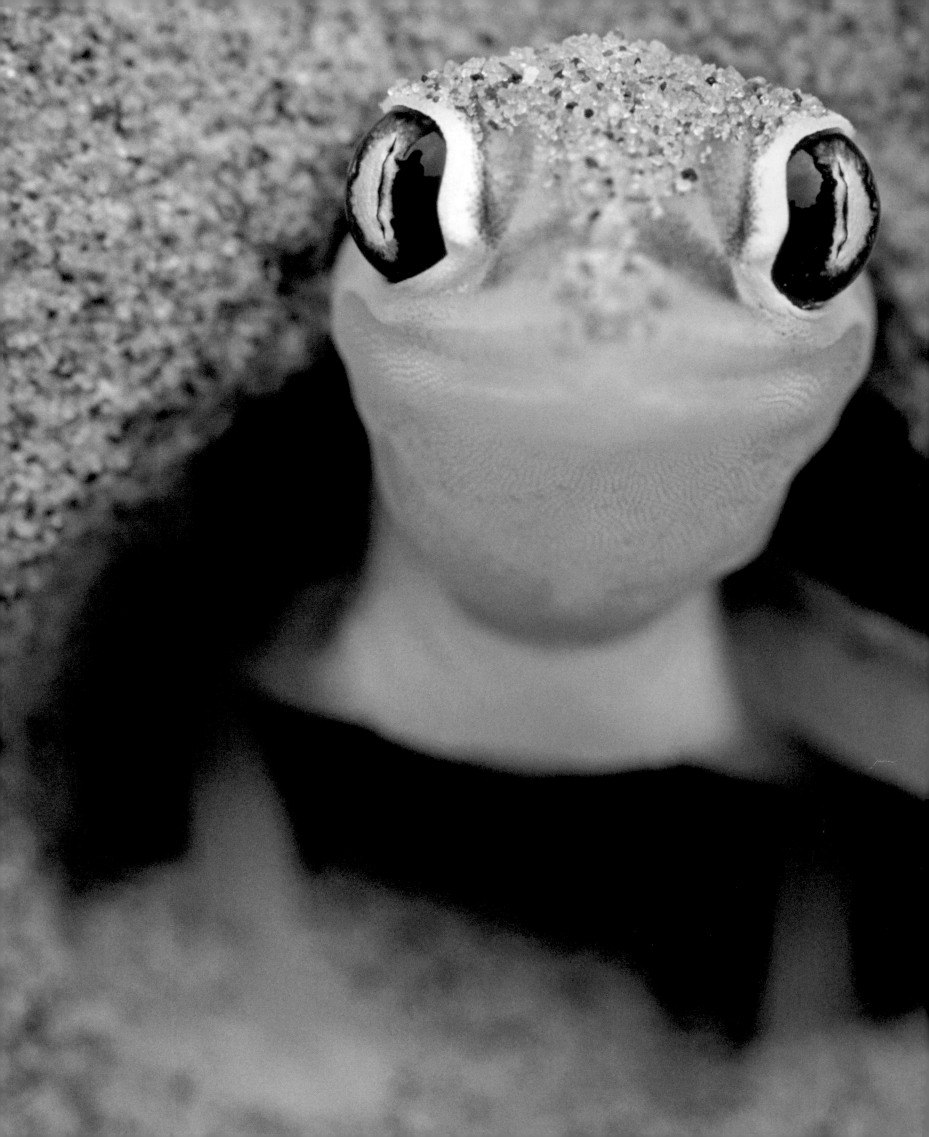

◁ Unlike most geckos, the web-footed gecko (*Palmatogecko rangei*) of southern Africa is not a climber. It burrows in the fine, wind-blown sand of the Namib Desert, and instead of having adhesive pads, its toes are connected by webs of skin. These stop it sinking into the sand as it scuttles across the dunes, and make very effective scoops for digging. Like most small desert animals, it hides from the hot sun by day, emerging to hunt insects just after sundown when the dunes start to cool. Even during the heat of the day, however, it is always ready to rush out of its burrow, snatch a passing insect and drag it back into the shade to be eaten.

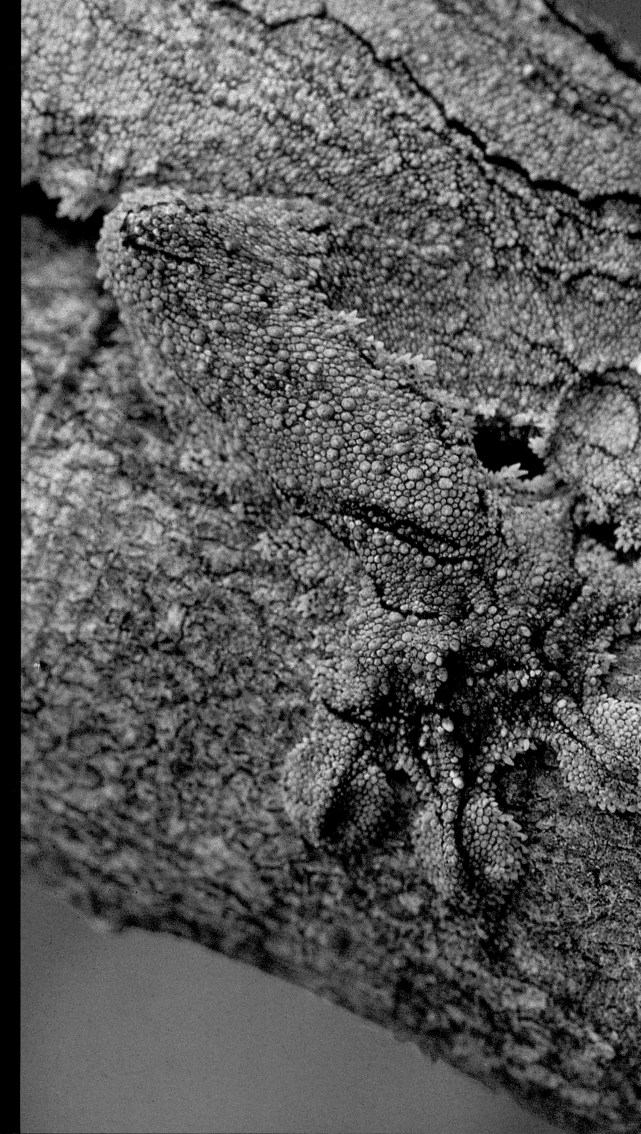

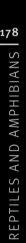

▷ The geckos are masters of camouflage. The cryptic coloration of this leaf-tailed gecko (*Uroplatus sikorae*) is made even more effective by fringes of skin along its lower jaw, body, and limbs, which lie against the tree bark and eliminate its telltale shadow. This enables the gecko to rest during the day without fear of being spotted by predatory birds. Even its big eyes are camouflaged when their pupils close to narrow slots in the sun, but they open up at night so it can see in the dark to hunt insects. The gecko has no eyelids, and must clean the scales over its eyes with a flick of the tongue.

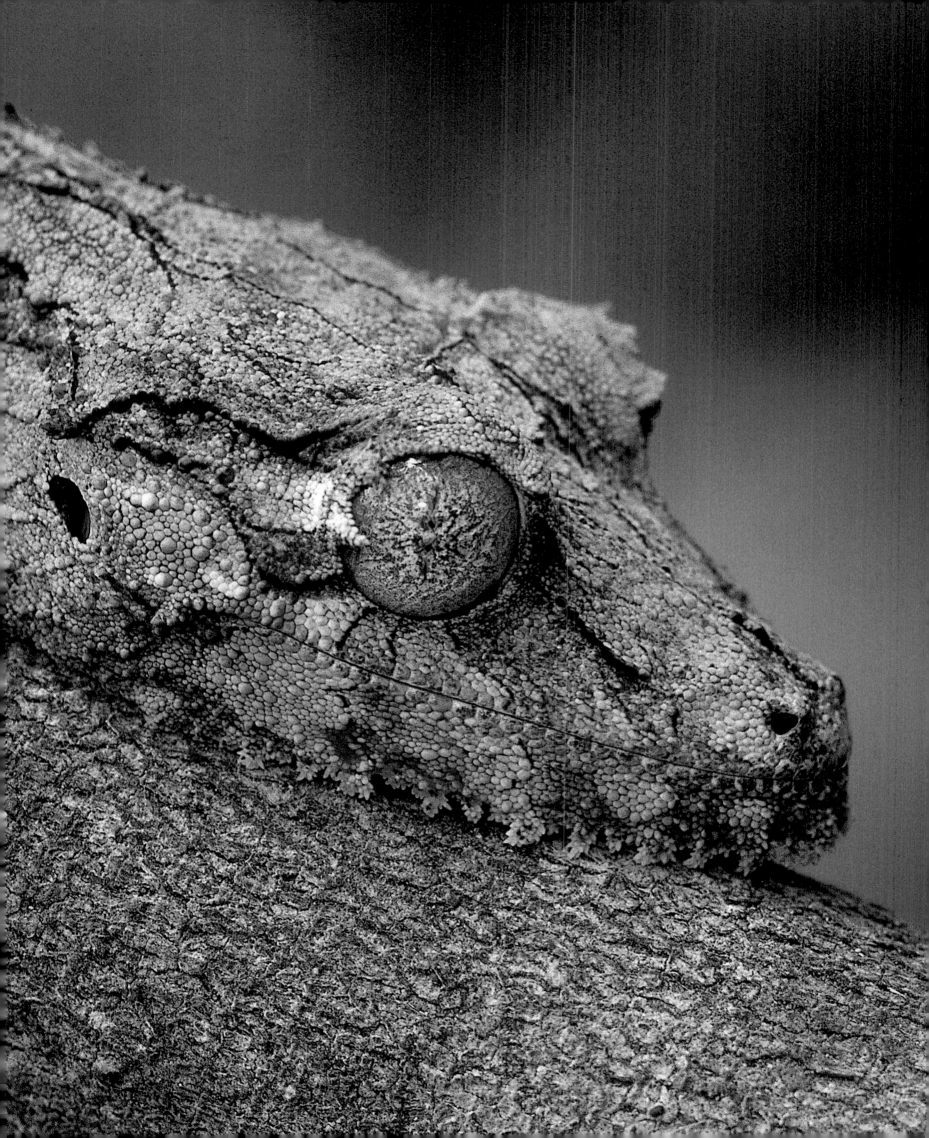

Capable of growing to a length of 90cm (35in) or more, the caiman lizard is named for the big knobbly scales on its back, which resemble those of caimans and alligators. It is a semi-aquatic species of South American forests that feeds almost entirely on large water snails.

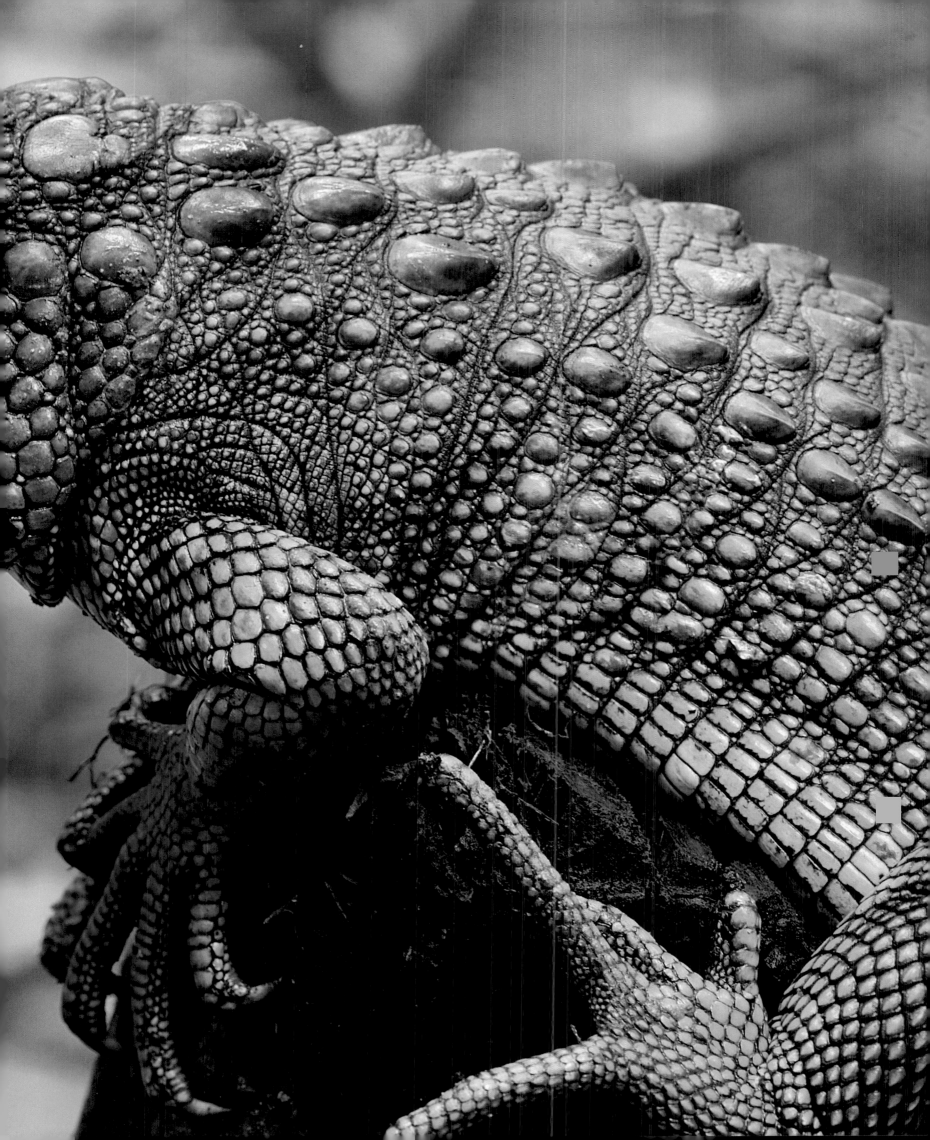

> This young common caiman (*Caiman crocodilus*) may grow to a length of 2.4m (8ft) or more when it is adult. A type of alligator, it lives in the swamps and rivers of Central and South America, from Mexico to Uruguay. It feeds mainly on fish, frogs, turtles, and other animals such as crabs and snails. Like all crocodilians, the caiman has immensely powerful jaw muscles that enable it to crush a turtle shell as if it were an egg, and it can be aggressive in defence of its young. This species is sometimes known as the spectacled caiman, due to the characteristic ridge of bone between its eyes.

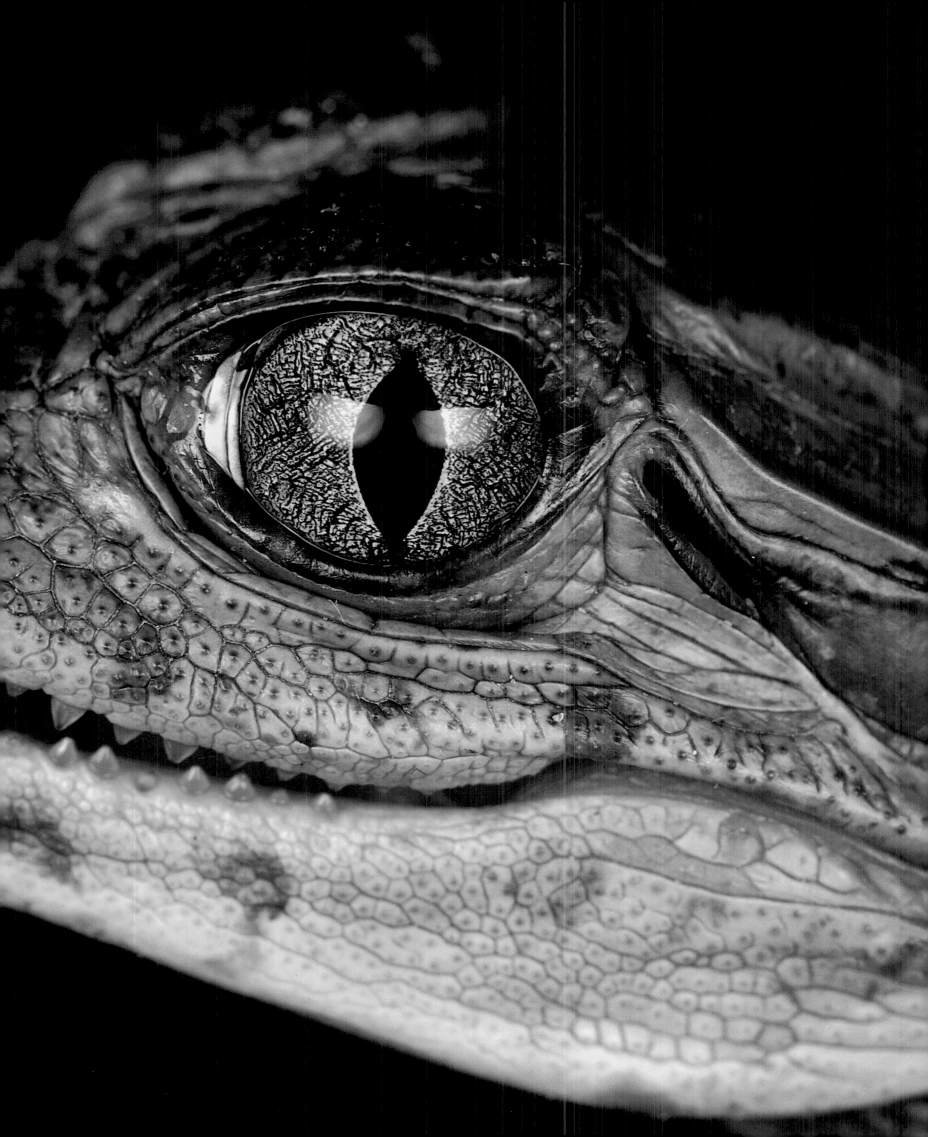

It seems hardly credible that this delicate hatchling will grow into a huge adult Nile crocodile (*Crocodylus niloticus*). Survivors from the age of dinosaurs, crocodiles are among the most powerful predators on Earth.

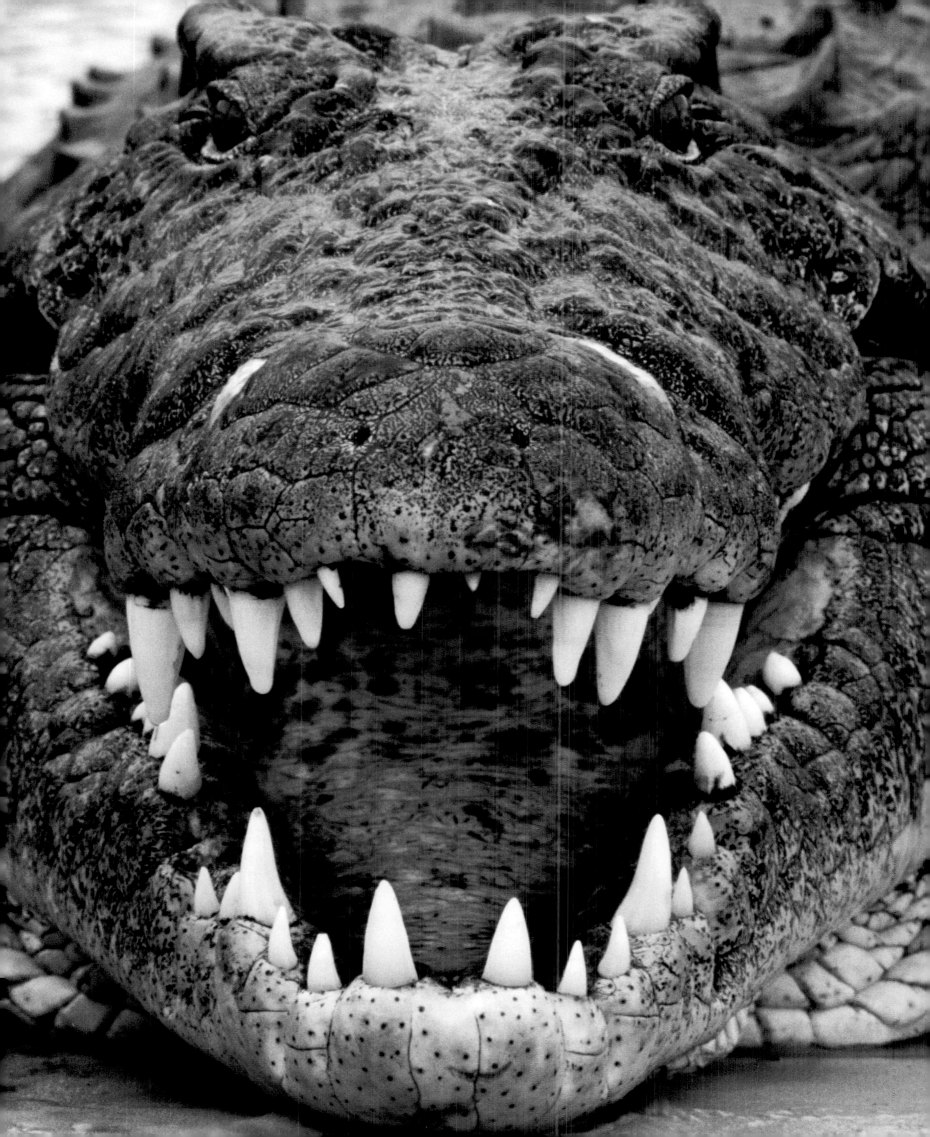

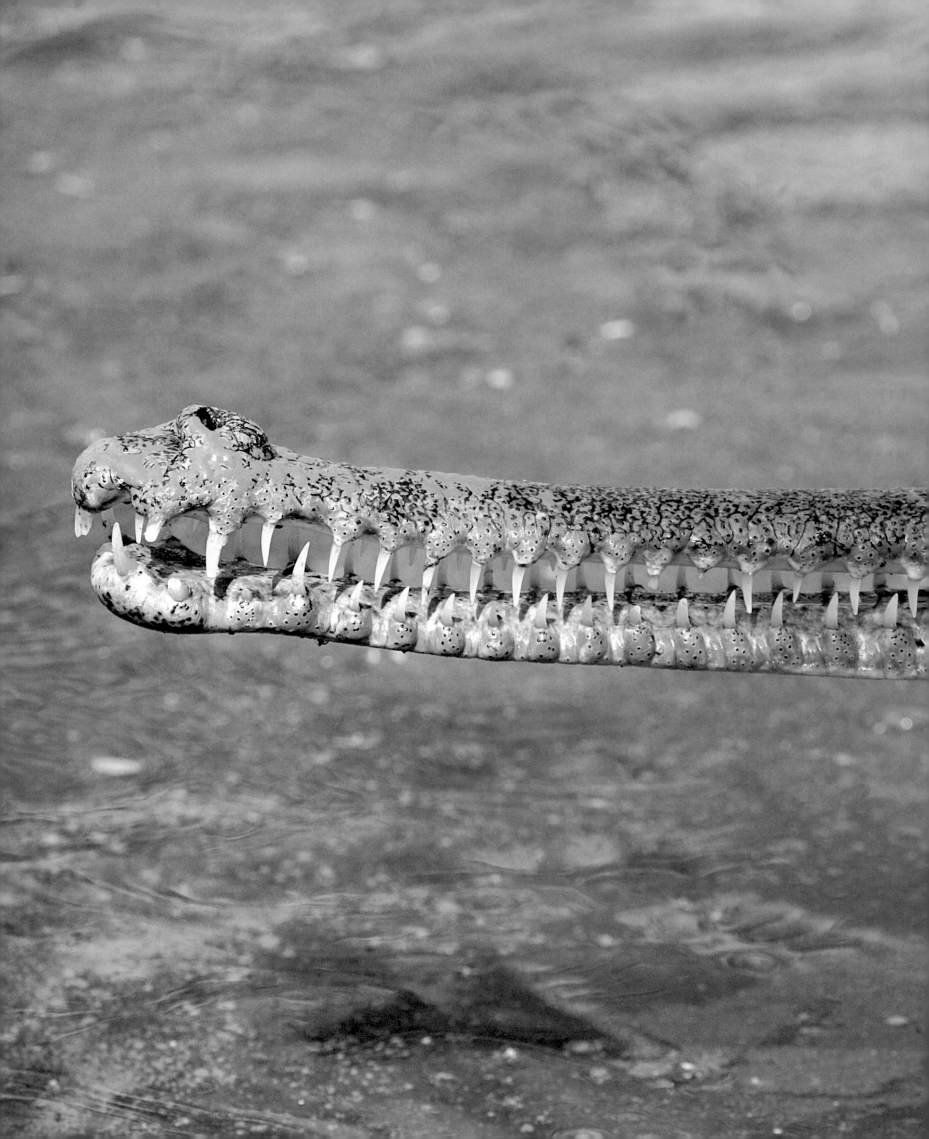

The narrow snout of the Indian gharial (*Gavialis gangeticus*) is adapted for catching fish. Despite its size – it can grow to 6m (20ft) long – the gharial is rarely aggressive towards people. It is now endangered by hunting and water pollution.

▷ Most amphibians spend their early lives in water, then crawl out onto land when they are adults. But some salamanders, such as the Mexican axolotl (*Ambystoma mexicanum*), keep their juvenile form and spend their entire lives underwater. The axolotl retains a set of feathery gills so that it can absorb oxygen from the water. If its pool dries up, the axolotl loses its gills and turns into a land-living form of axolotl called the Mexican salamander. It needs iodine to make a vital growth hormone to metamorphosize, so if there is no iodine in the water it cannot turn into its adult form. However, the axolotl can breed even in its juvenile aquatic form – a phenomenon known as "neotony".

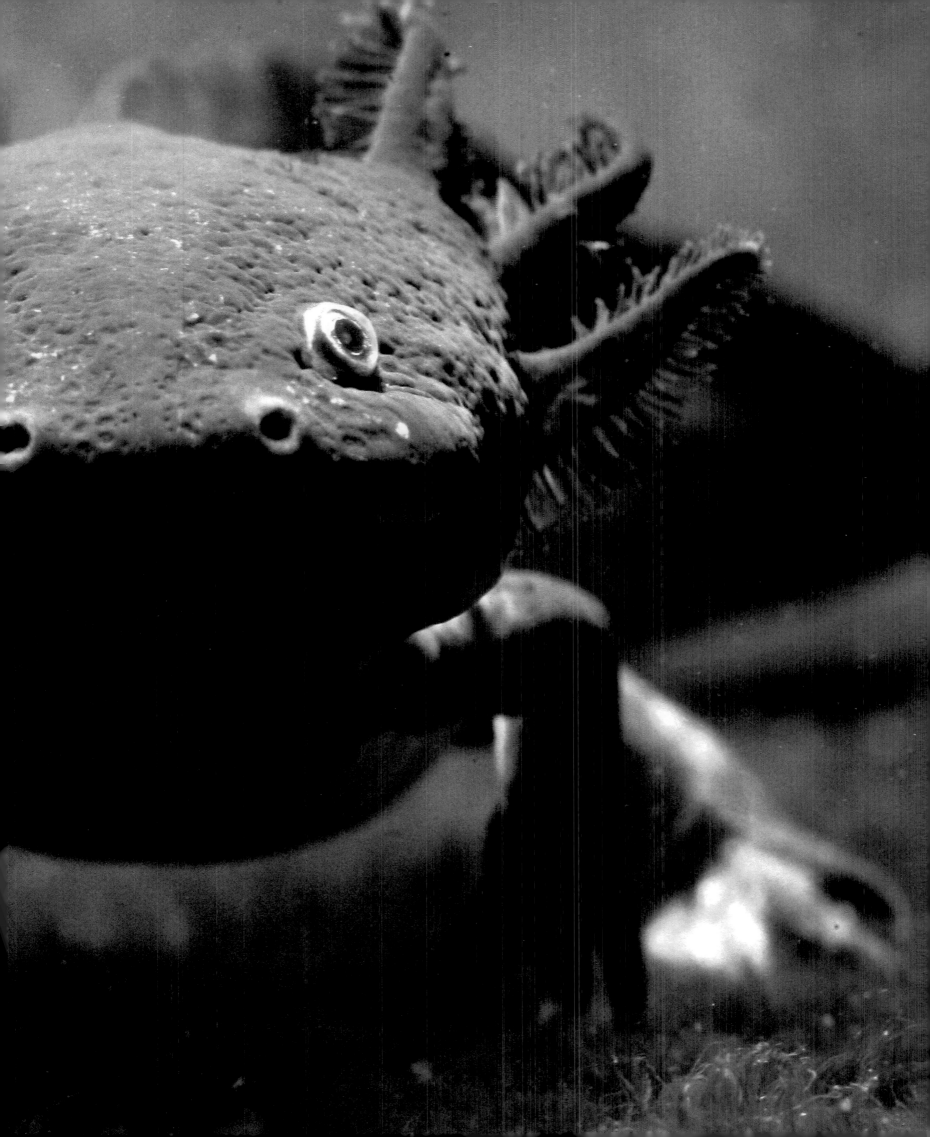

▷ Newts are salamanders that spend much of their lives in the water, and have to return to pools to breed. This European alpine newt (*Triturus alpestris*) is notable for the brilliant courtship colours of the male, with a bright orange belly, boldly spotted flanks fringed with bright blue, and a dorsal crest. He exploits his appearance by dancing before the female underwater, enticing her to pick up the sperm package that he places on the bed of the pool. She attaches her fertilized eggs to pond plants, where they develop into aquatic larvae with feathery gills.

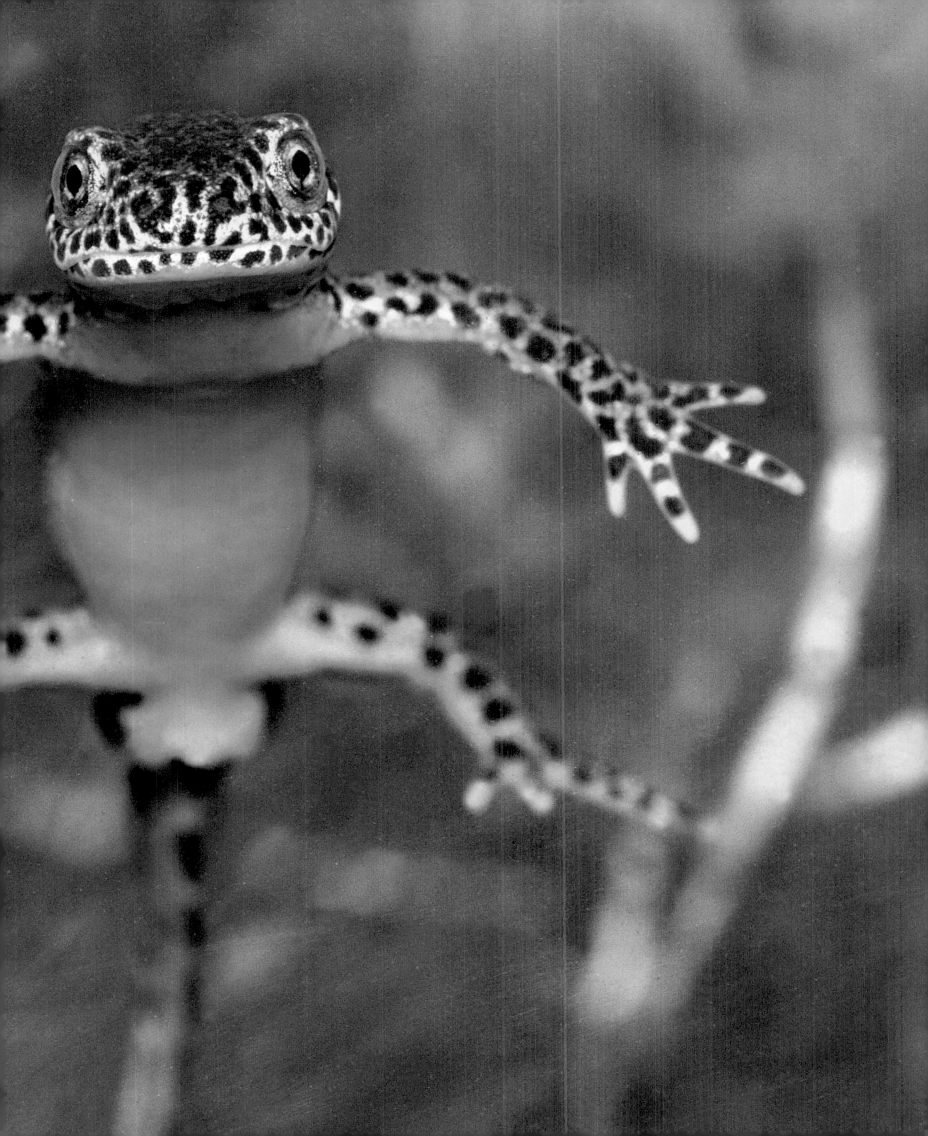

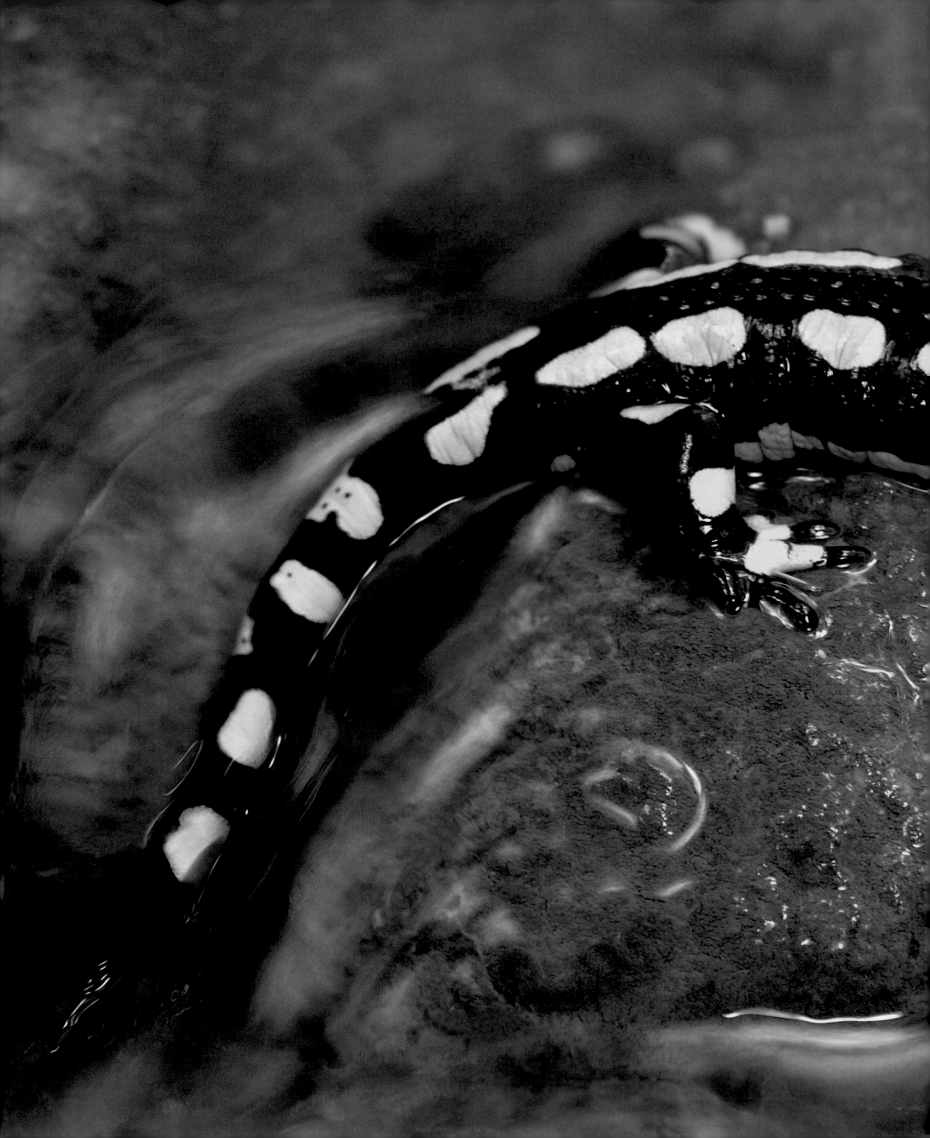

◁ The dramatic yellow and black pattern of the fire salamander (*Salamandra salamandra*) acts as a warning that it can exude a toxic secretion from the swollen, black-spotted glands behind its eyes. Typically up to 20cm (8in) long, the fire salamander lives in damp forests in southern Europe, where it is most active at night after rain. t mates on land, and the female retains her eggs in her body until they are ready to hatch. She then gives birth into a forest stream or pool, and the young salamanders live in the water for about two months until they turn into land-living adults.

◁ Named for its horn-like "eyebrows" and curious projection on the tip of its snout, the long-nosed horned frog (*Megophrys nasuta*) lives in the rainforests of Malaysia. Its body is superbly camouflaged to resemble dead leaves, both by its coloration and its angular form, enabling the frog to sit undetected among the leaf litter of the forest floor. The frogs are most active at night, hunting insects, spiders, and smaller frogs. The males make their presence very evident during tropical rainstorms, when they give loud, resonant calls from shallow pools and streams.

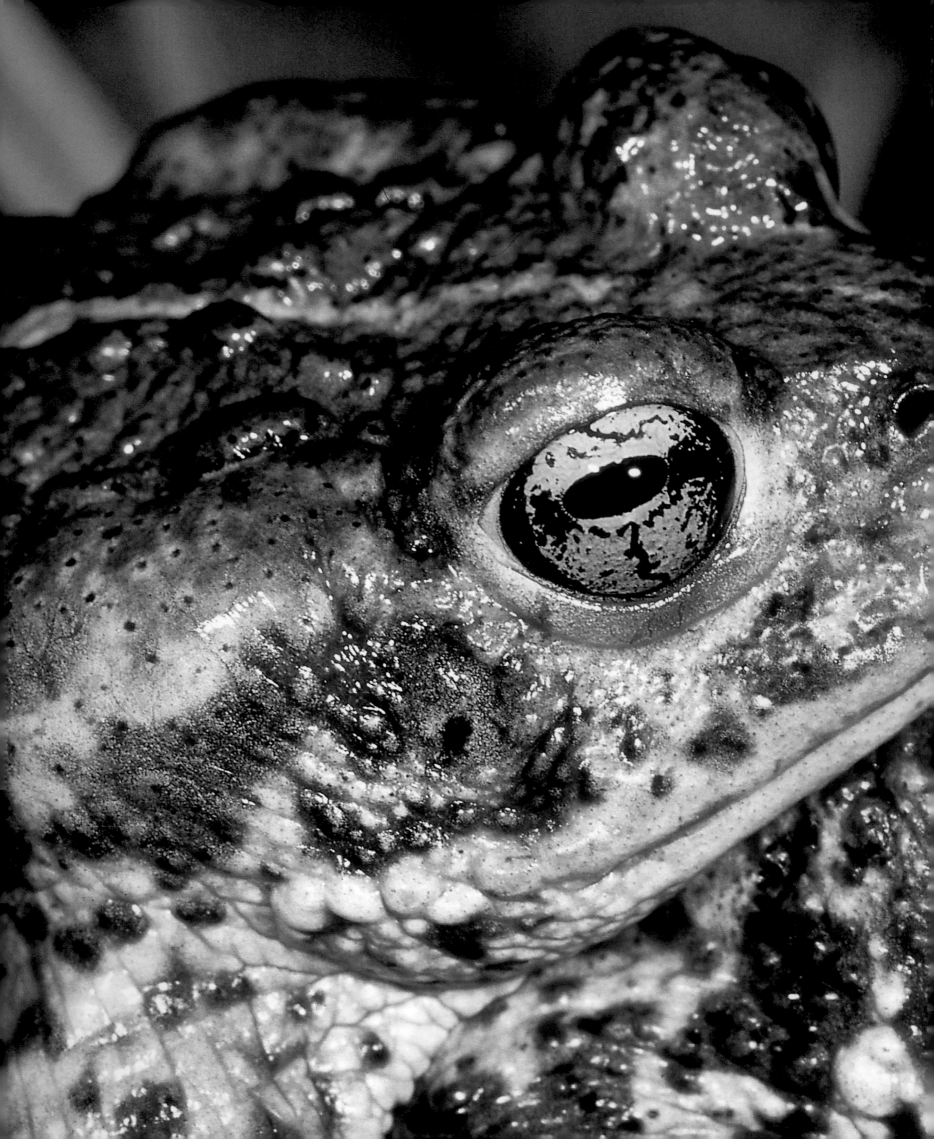

A denizen of coastal dunes and sandy heaths, the natterjack toad (*Bufo calamita*) is famous for the rasping chorus of the males during the spring spawning season. Each male grasps a female to fertilize her eggs as they are laid.

▷ The tiny reticulated poison-dart frog (*Ranitomeya reticulata*) is one of a family of Amazonian tree frogs notorious for the virulent toxins secreted by glands in their skin. These are so toxic that local hunters use the secretions to make deadly blowpipe darts. The vivid colours of this species warn predators to leave it well alone, and are so effective that the frog is often active even in broad daylight. Many of these frogs breed in the miniature pools of water that form in plants growing high in the treetops. They place a single tadpole in each pool, together with some unfertilized eggs for the tadpole to eat.

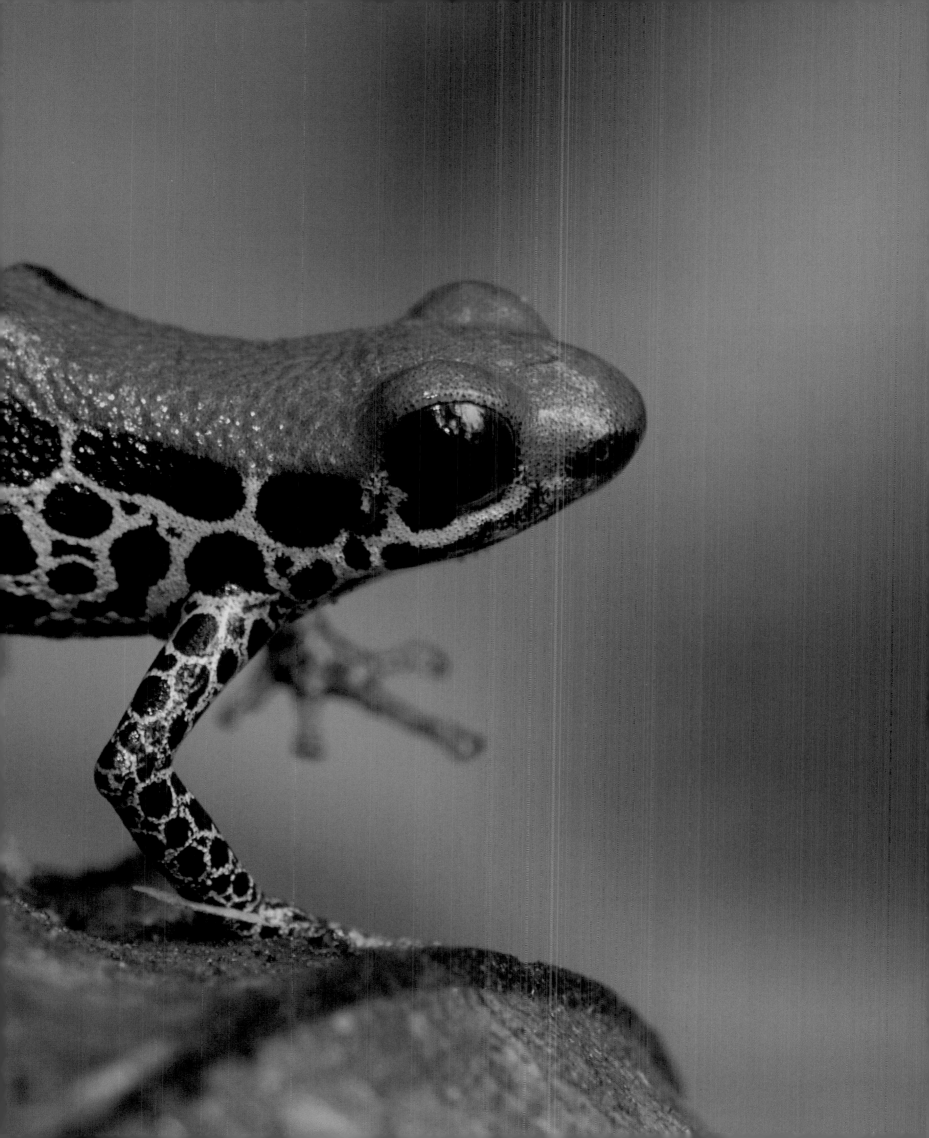

▷ The long limbs of this red-eyed leaf frog (*Agalychnis callidryas*) are typical of the Hylidae – a large family of nearly 800 species of tree frog that live in most of the warmer parts of the world, but mainly in tropical America. This species, found in Costa Rica, is one of the very few with bright red eyes. Although agile and easily able to jump, it is typically slow-moving and prefers to walk along slender branches while clinging on with its elongated, flexible toes. Like most tree frogs, it is active mainly after dark, when its big eyes open up to detect prey in the dim light.

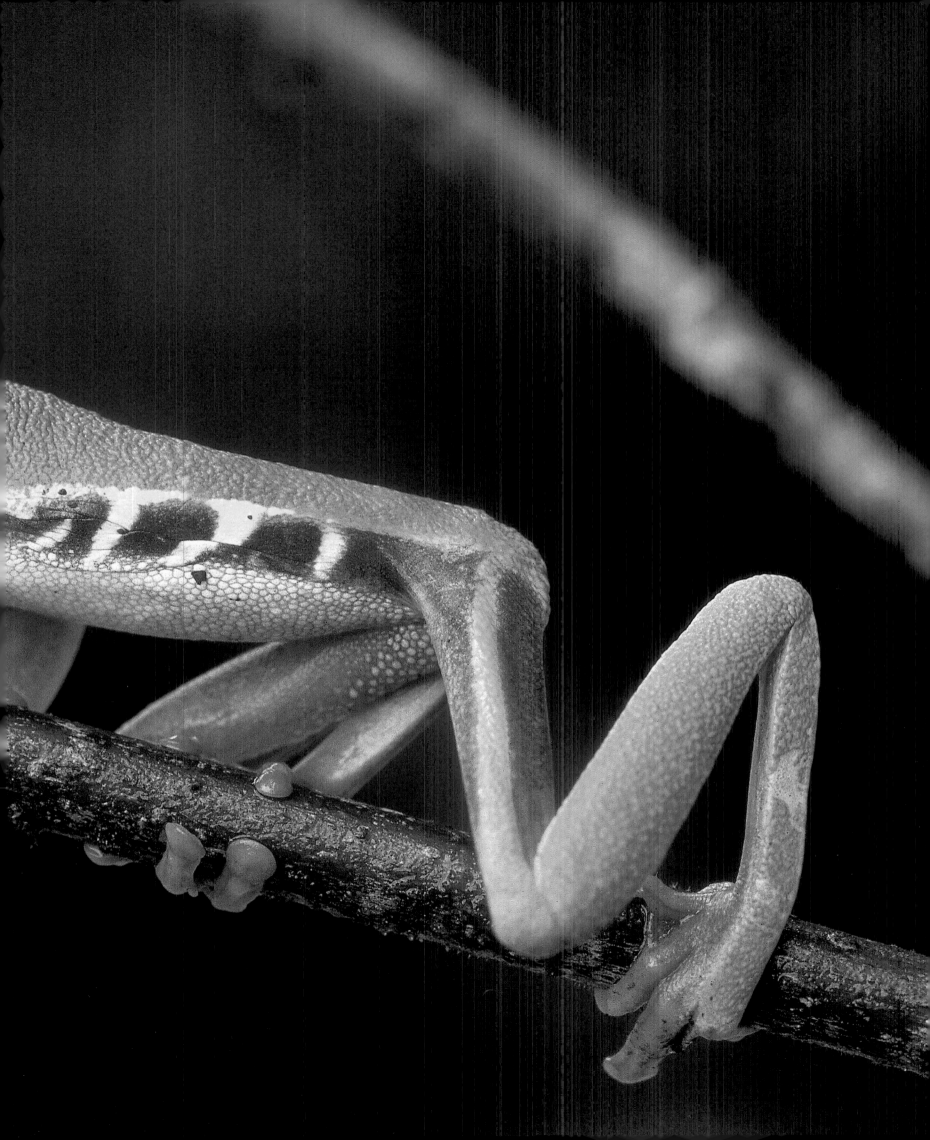

Recently discovered in the tropical forests of Colombia, this tree frog (*Hyloscirtus tigrinus*) resembles one of the poison-dart frogs, and may gain protection by mimicking a toxic species. Like other frogs it has five hind toes.

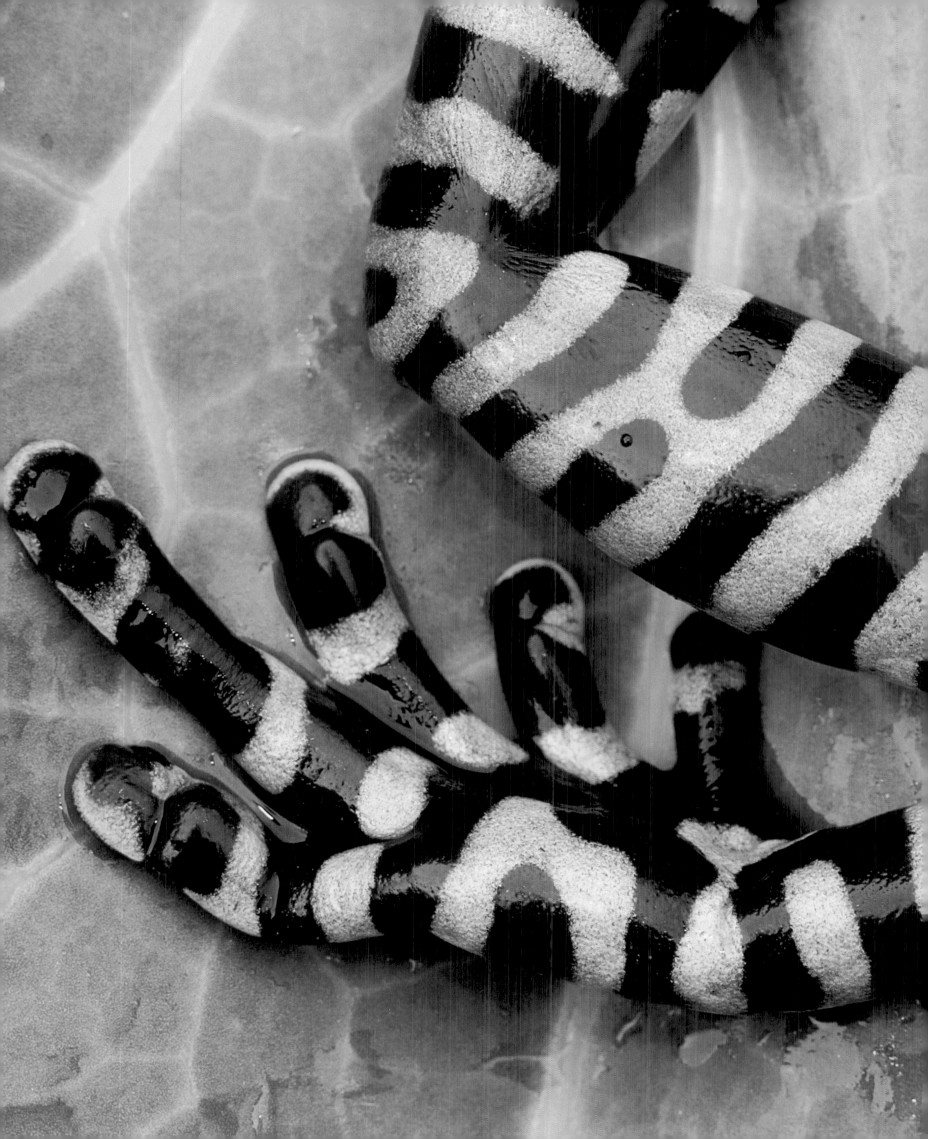

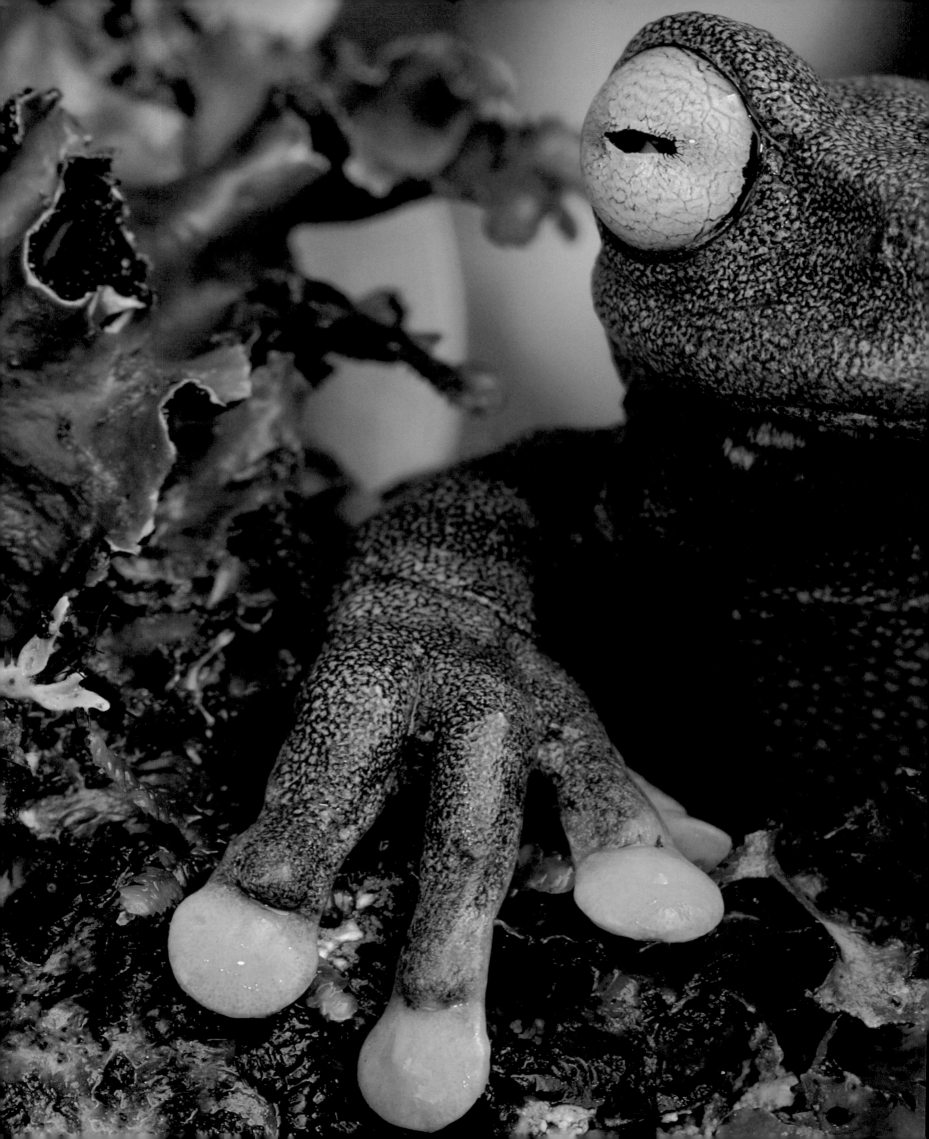

Typical tree frogs such as this Amazonian species (*Hyloscirtus lindae*) have big adhesive pads on the tips of their toes. These enable them to cling to wet leaves and stems as they clamber through the forest canopy at night.

▷ Most male frogs attract females by calling loudly, often in "choruses" that fill the night air. A frog's call is made more resonant by vocal sacs, sometimes in its cheeks but most commonly, as with this Australian Lesueur's frog (*Litiria lesueurii*), in its throat. This species gives a rapidly repeated series of short soft trills, but others generate a wonderful variety of croaks, whistles, grunts, chuckles, squeaks, and warbles. Some sound like metal being struck, or a fingernail being run along the teeth of a comb. Each has its own character, ensuring that it attracts only females of its own species.

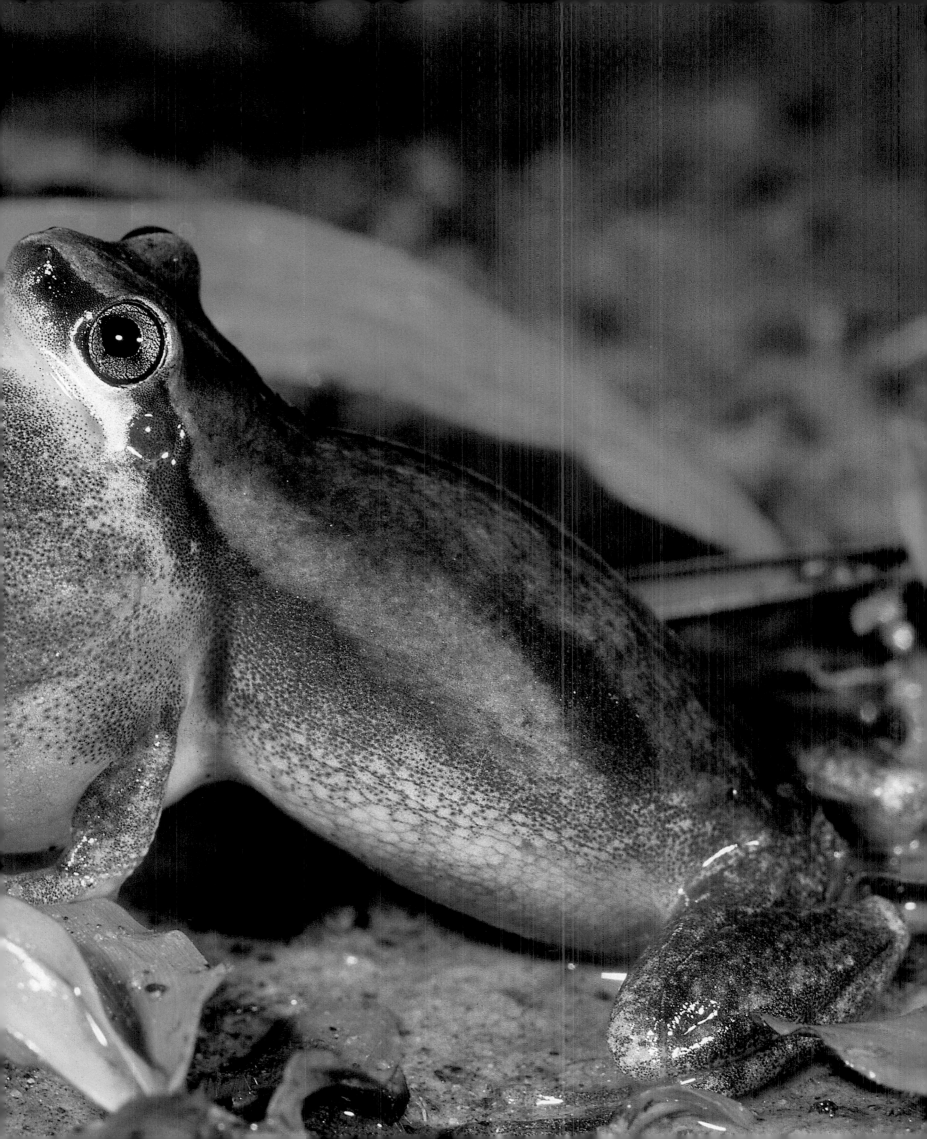

▷ One of several similar species that live in Australia, the magnificent tree frog (*Litoria splendida*) is a very fat, smooth-skinned frog with large poison glands on top of its head and behind its eyes. It has a limited distribution in the tropical northwest of the continent, where it spends the day in caves and crevices and emerges to hunt at night. It was identified as a distinct species as recently as 1977, and was previously thought to be a variant of the more widespread White's tree frog.

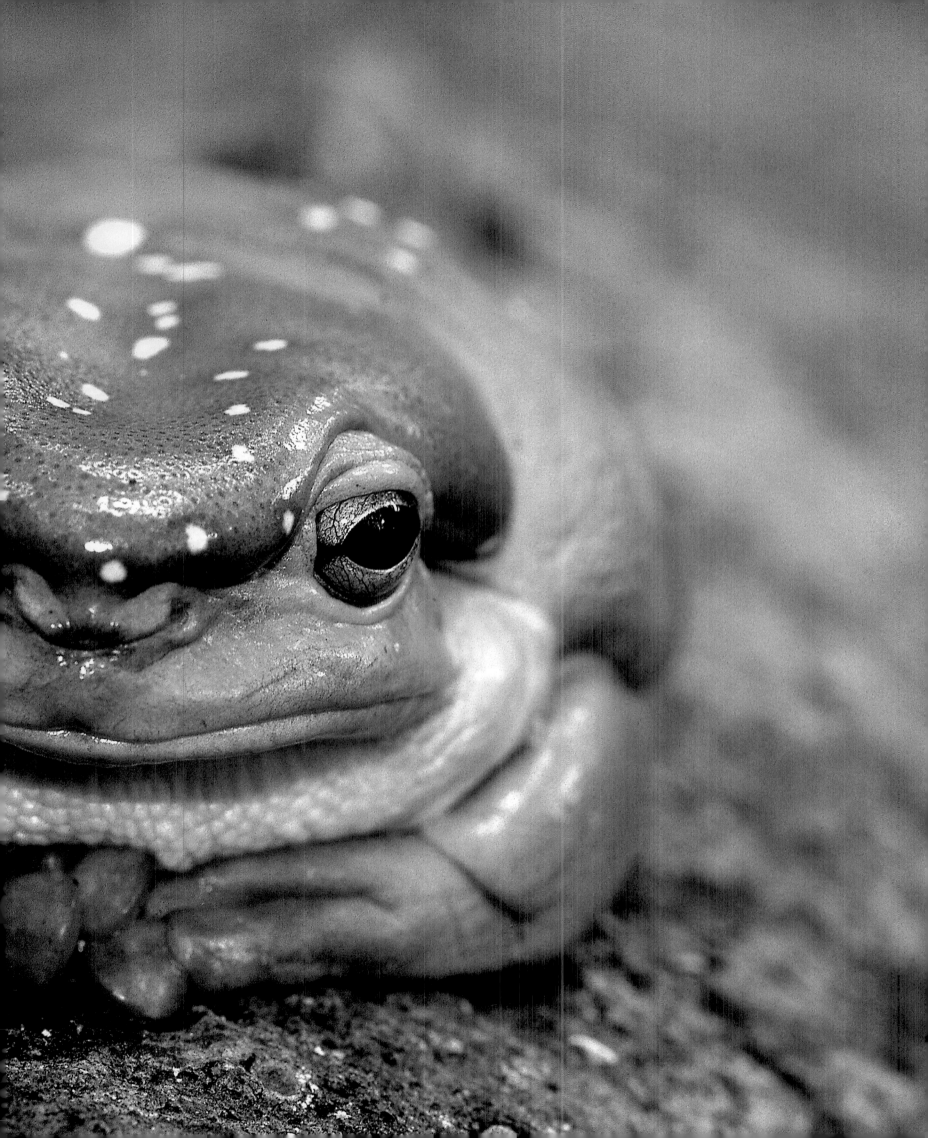

This blue tree frog is almost perfectly camouflaged against a moonlit rock, but the illusion is shattered as soon as the frog raises its head and opens its eyes.

A frog can have excellent camouflage, but a shadow cast beneath its body is enough to highlight its shape and alert predators to its location. This file-eared tree frog (*Polypedates otilopus*) holds its body very close to a tree trunk to ensure that any shadows are kept to a minimum.

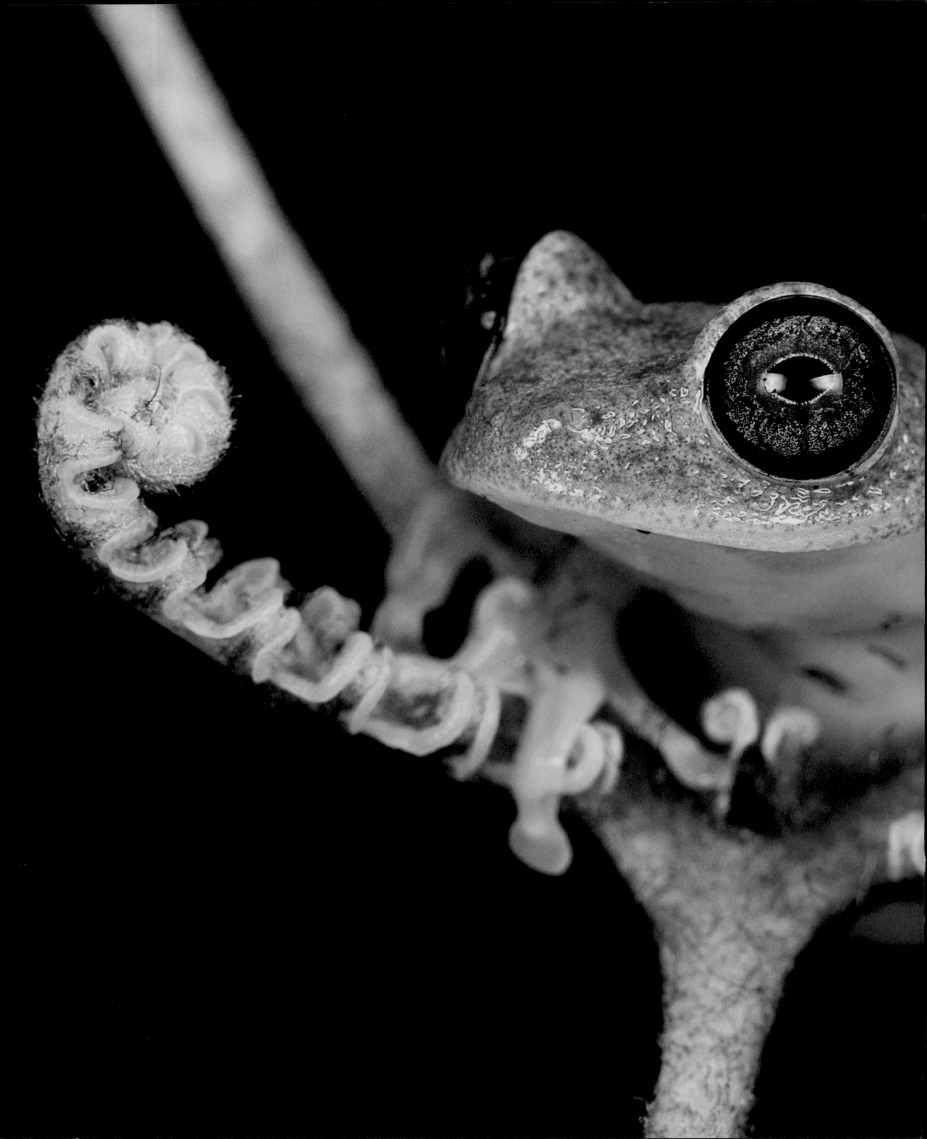

◁ Less than 3cm (1¼in) long, the tiny Andasibe tree frog (*Boophis viridis*) is light enough to perch on the uncurling fronds of a delicate fern. This species is named after the Mantadia Andasibe National Park in Madagascar, where it lives near slow-moving streams in the wet mountain forests of the region. Although usually green with small, reddish dots, it can change colour to become more reddish-brown, especially at night.

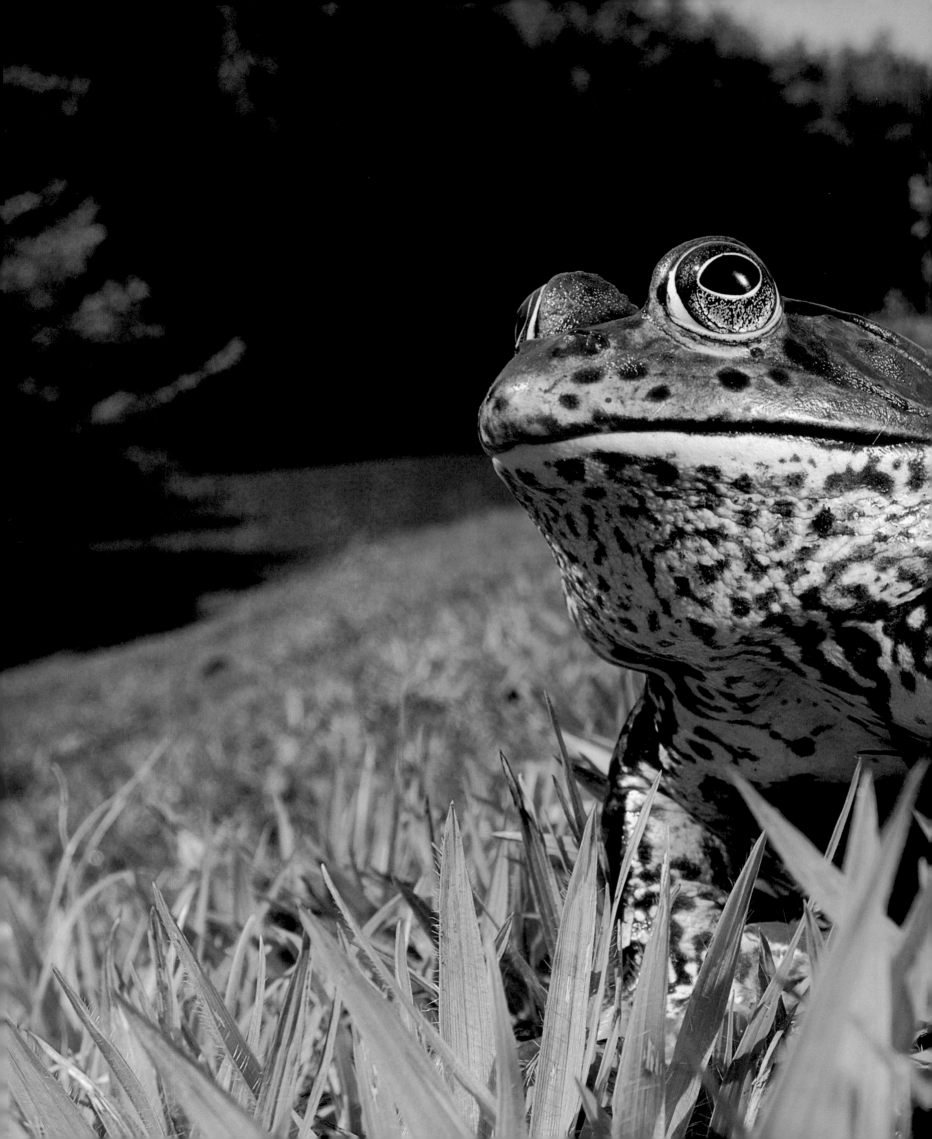

◁ Widespread throughout the United States and southeastern Canada, the American bullfrog (*Rana catesbeiana*) is one of the largest and most familiar of all frog species. It can grow to 20cm (8in) long, and lives around the margins of swamps, lakes, and ditches. Active both by day and night, it is a powerful predator that may devour other frogs, small snakes, and even small birds, although its main victims are aquatic insects and small fish. The resonant "jug-o-rum" call of the breeding males can be heard over long distances on summer evenings.

▷ Like many frogs, the Madagascan tomato frog (*Dyscophus antongilli*) deters predators by secreting toxic slime from glands in its skin. If another animal attempts to eat the frog, the sticky slime tends to gum up its mouth, and may also trigger an allergic reaction. The experience is enough to discourage any predator from repeating the attempt. The deterrent is made more effective by the frog's bright red colour, which literally means "red for danger". As a result, these frogs may live for ten or more years in the wild, provided their threatened forest habitat remains intact.

From sleek, predatory sharks to delicate, entrancing seahorses, fish are among the most efficient and elegant creatures on the planet. They were the first of the vertebrates to evolve, some 480 million years ago, and the ancestry of every land-living mammal, bird, or reptile can be traced back to them. Yet this does not mean that fish are in any way primitive. Their years of evolution have refined their bodies into forms that are superbly adapted to their way of life, enabling many species to move effortlessly through the water, often at very high speed. The sailfish – a relative of the swordfish – can swim at an astonishing 110 kph (68 mph), comfortably outpacing the fastest marine mammal, the common dolphin, which achieves 64 kph (40 mph).

Fish have also evolved an amazing diversity of forms, accounting for more than half of all vertebrate species. These belong to five distinct groups, or classes, which are only distantly related to each other. Three of these groups are quite small: the lampreys, hagfishes, and lobe-finned fishes such as the coelacanth – the last survivor of the group of fish that gave rise to all land-living vertebrates. The other two groups are the ray-finned fish – the biggest class by far, with more than 23,000 species – and the sharks and rays.

The fish with which we are most familiar are the ray-finned fish with bony skeletons. They include species such as goldfish, herring, and salmon, with their translucent fins and scaly bodies. They come in an extraordinary variety of shapes and sizes, from the tiny, vividly coloured tropical fish that swarm over coral reefs to the mighty tuna that can grow to up to 4m (13ft) long and weigh 700kg (2,000lb).

Some, like the sailfish, are high-speed hunters that prey on smaller fish. Many form dense shoals, using their acute sense of proximity to swim in a glittering, co-ordinated formation as they strain tiny planktonic animals from the water. Others are strange-looking – even nightmarish – creatures that live in the dark ocean depths, which, in many cases, glow with eerie light produced by special organs like those of glow-worms or fireflies.

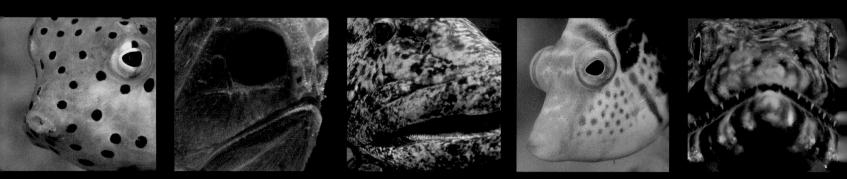

> **The waters of the world are dominated by a dazzling variety of fish, honed to perfection over millennia of evolution.**

The largest fish belong to the group known as the cartilaginous fish because their skeletons are made of pliable cartilage rather than bone. These are the sharks, rays, and their relatives. They include fearsome predators like the tiger shark and the great white shark, as well as the placid, plankton-eating whale shark which, at up to 12m (40ft) long, is the biggest fish in the sea.

These fish are often seen as somehow less advanced than the ray-finned fish, but some sharks have astonishingly acute senses, with a legendary ability to track the source of the tiniest drop of blood in the water. They are even able to detect the electrical tingling of their victims' nerves. They also mate like mammals, rather than spawning into the water, and the females of many species bear live young.

Most of the fish in this chapter inhabit the waters of tropical coral reefs, where the variety of fish is at its most spectacular. The diversity of shapes, sizes, colours, methods of survival, and patterns of behaviour found in these sun-dappled waters is truly remarkable. In fact, few places on Earth offer such an insight into the diversity of the animal world, and the glorious, relentless, flamboyant inventiveness of evolution.

fish

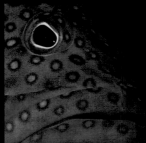
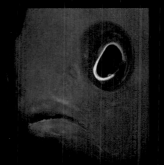
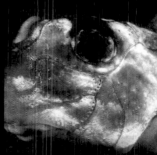

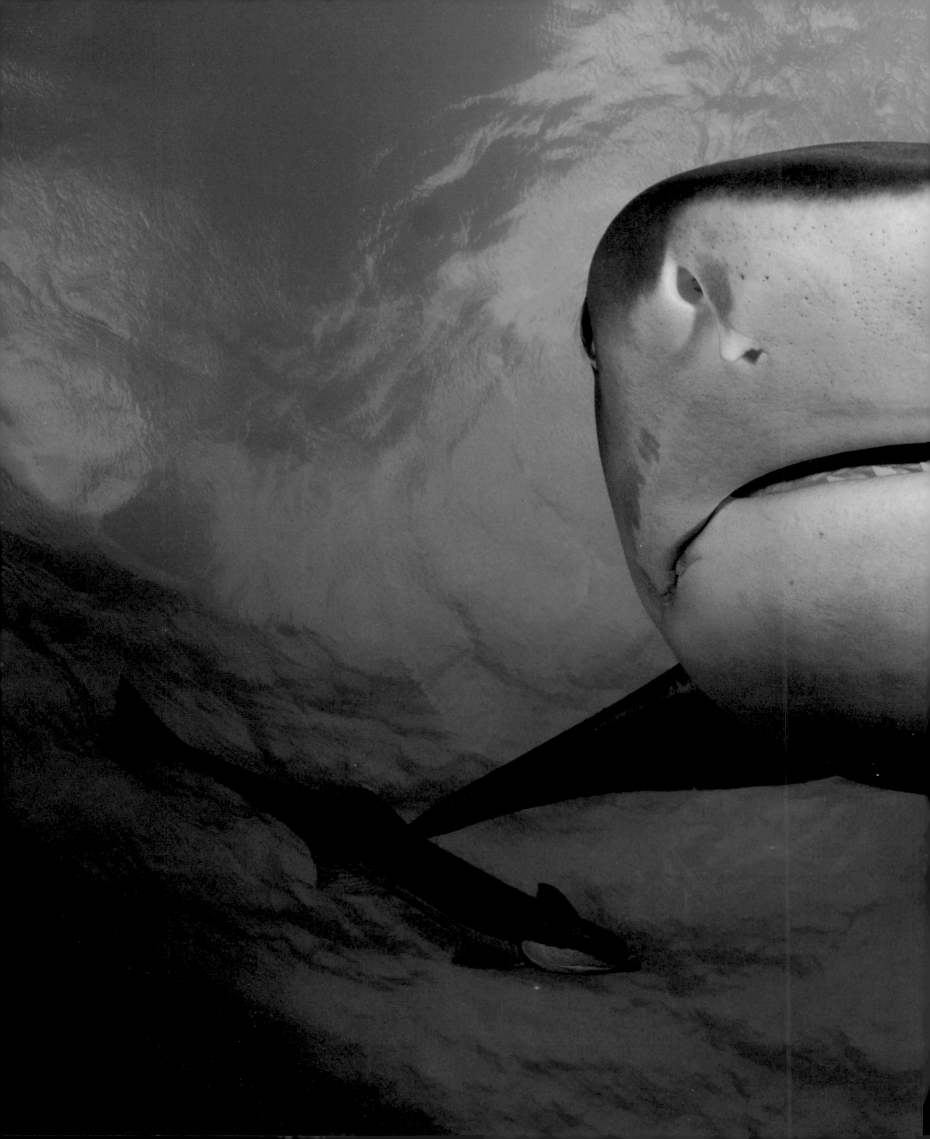

The tiger shark (*Galeocerdo cuvier*) has broad tastes and will feed on anything from birds, turtles, and mammals to fish, lobsters, and even other sharks. With a huge jaw, large nostrils, and lines of electro-sensitive pits on its skin, the tiger shark is a very capable predator.

▷ The largest fish on the planet, the whale shark (*Rhincodon typus*) is present in almost all the oceans of the world and is completely harmless to humans. The whale shark is easily identified by the polka-dot pattern covering its back. Viewed from above, the dark background blends with the deep blue water, and the random spot pattern mimics the patterns of coral growth, jellyfish swarms, schools of fish, or a planktonic haze. Despite its size, the whale shark is rarely encountered, especially as close as this encounter in Baa Atoll, Maldives.

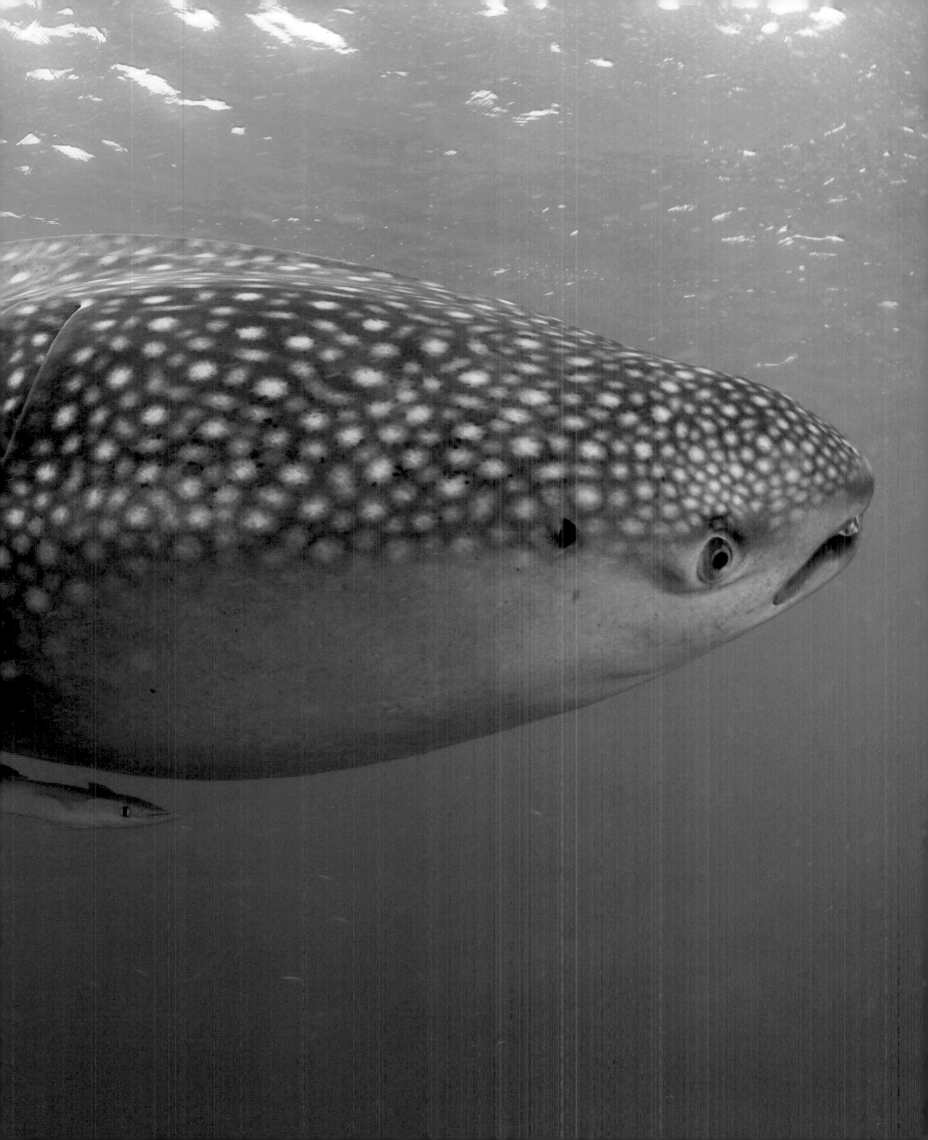

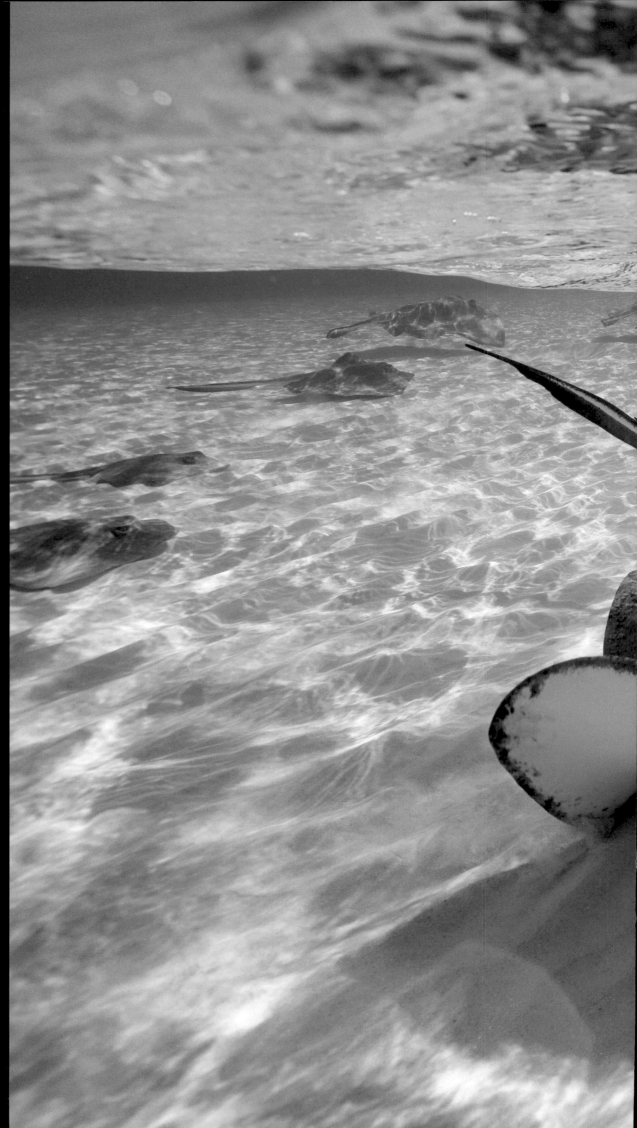

▷ The southern stingray (*Dasyatis americana*) glides over the surface of the sand, using its "wings" to gracefully turn as it hunts for prey. Its protruding eyes have pupils that are protected by an extensible strip of skin. As well as regulating the amount of available light, these strips help to camouflage the eyes. The southern stingray is a shy, inquisitive creature. However, like all stingrays, if it is disturbed or threatened it is capable of inflicting painful wounds with the sharp barb in its tail.

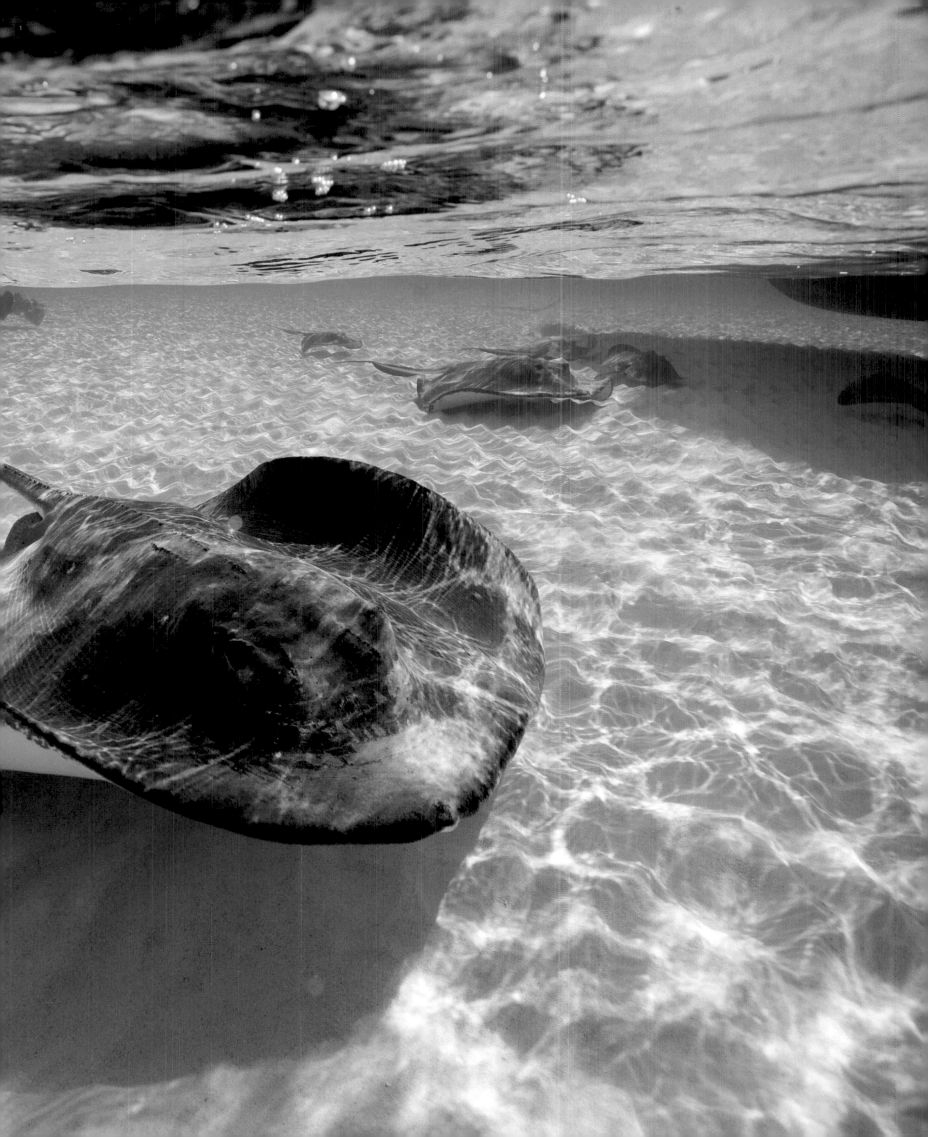

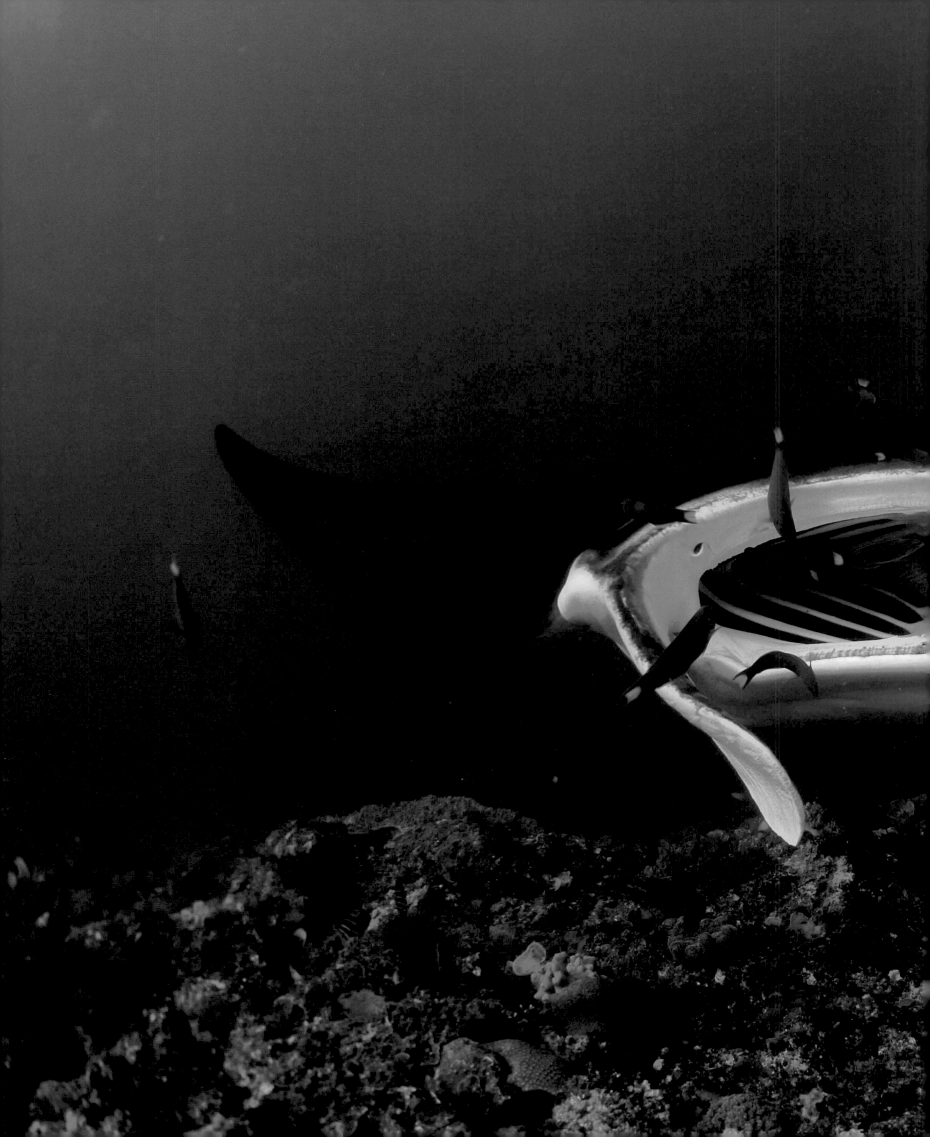

A manta ray (*Manta birostris*) exposes its delicate gills, trusting the masses of crescent wrasse (*Thalassoma lunare*) to safely remove any parasites. The manta rays are the largest of the rays and can grow to approximately 7m (23ft) wide.

▷ The spotted chimaera
(*Hydrolagus colliei*) is a distant
relative of sharks and rays; it too
has a cartilaginous skeleton and
looks like a strange mixture of the
two. The numerous names given
to the chimaera confirm that it is
considered a bizarre-looking fish –
ratfish, elephantfish, ghost shark –
even the name chimaera itself refers
to a creature of Greek mythology.
Although it spends most of its
time in very deep waters, it can
sometimes be found in more
shallow waters along Victoria Island,
British Columbia, Canada.

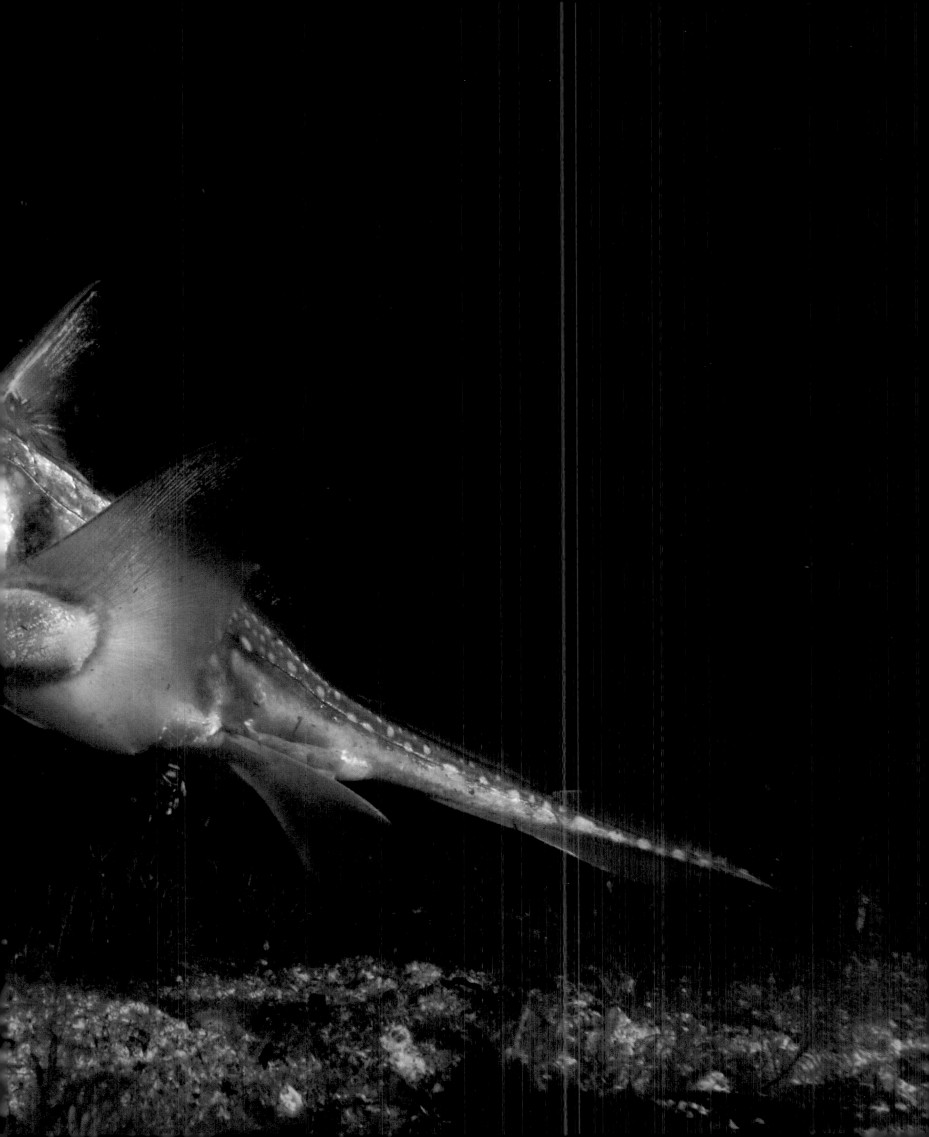

The honeycomb moray eel (*Gymnothorax favagineus*) has an elongated, scaleless body, which is covered with a clear, protective layer of mucus. Like all moray eels, it has a single, long continuous fin that begins behind its head, encircles its tail and ends midway down its belly. The moray eel continuously opens and closes its mouth, a behaviour often perceived as a threat, however the action simply moves water through its gills for respiration. This honeycomb moray, in Sodwana Bay, South Africa, is employing the services of a cleaner wrasse (*Labroides dimidiatus*), allowing the smaller fish to enter its mouth to pick at the bits of food between its teeth.

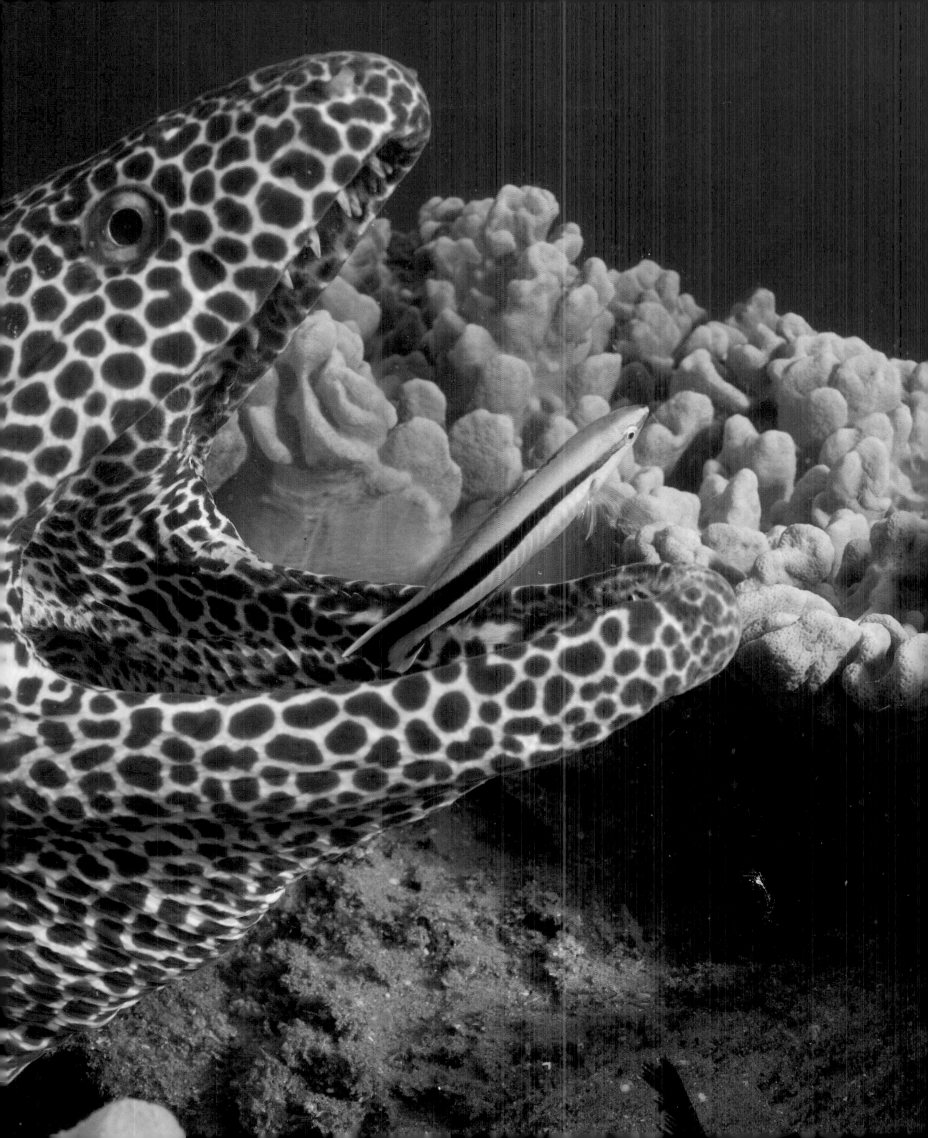

▷ Usually found among coral or
rocks, the reef lizardfish (*Synodus
variegatus*) is a voracious predator,
relying on a combination of stealth,
camouflage, speed, and deception
to capture its prey. It has a long,
cylindrical body and a pointed
snout with a large, tooth-filled
mouth. Some lizardfish bury
themselves in the sand with only
their heads protruding as they wait
for unsuspecting prey, sometimes
taking fish several metres above
the reef with lightning-fast strikes.
Lizardfish are found in tropical
and subtropical marine waters
throughout the world.

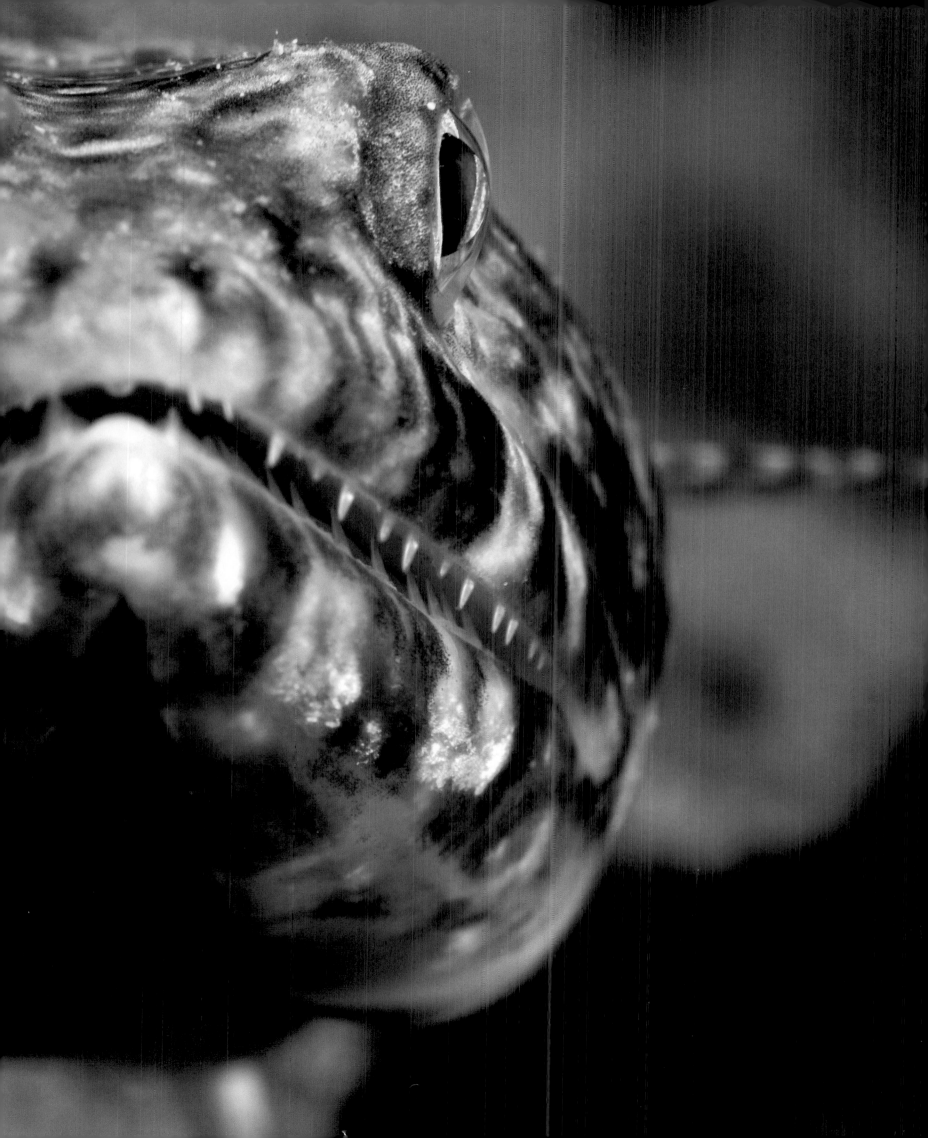

▷ The fangtooth (*Anoplogaster cornuta*) is a deep-sea species that can be found at depths of around 5,000m (3 miles). At its larval stage, as seen here, it swims in much shallower waters, where it feeds on zooplankton. As it develops it will grow huge fangs – the largest teeth in relation to body size of any fish – and will descend to deeper waters to prey on squid and any other unfortunate fish that stray too close to its deadly jaws.

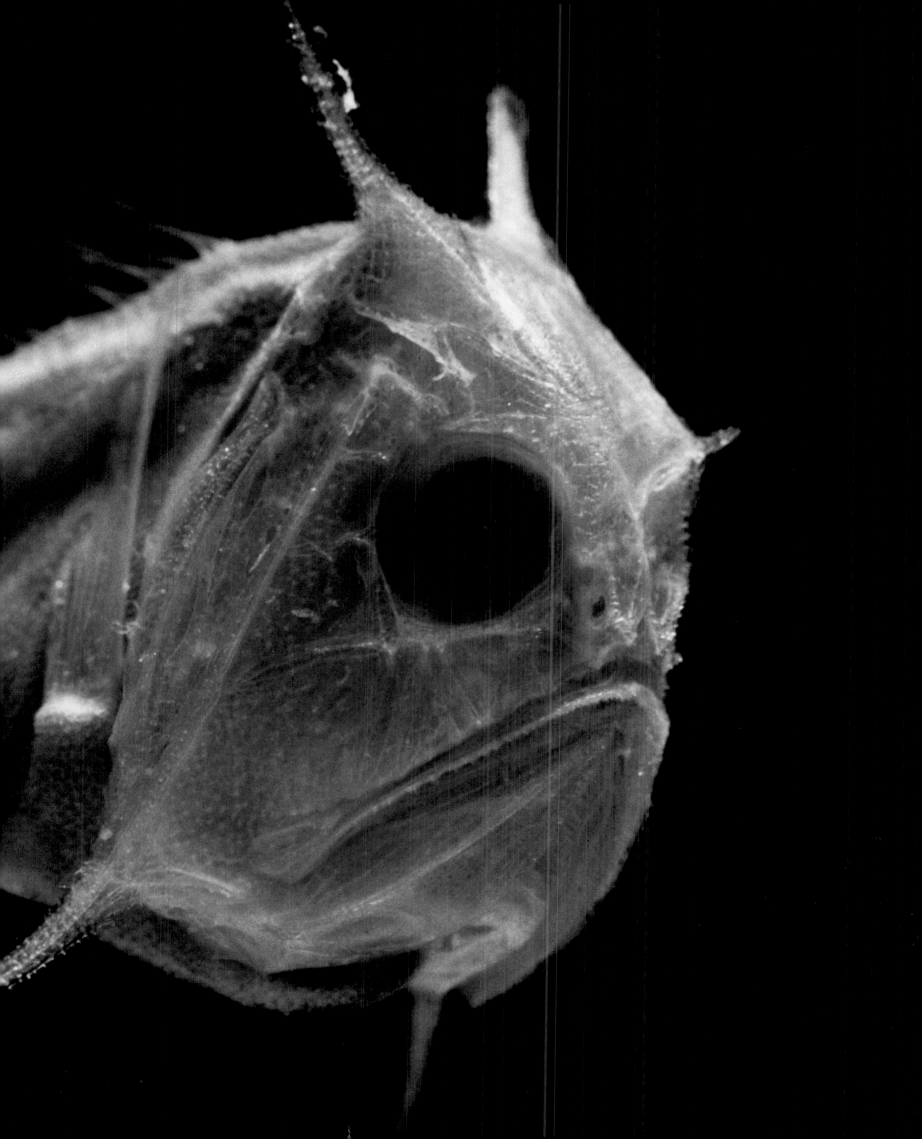

▷ The leafy sea dragon
(*Phycodurus eques*) is a rare and
stunning animal named after the
leaf-like projections that cover its
body. This remarkable camouflage
means it has no natural enemies –
except man. It has a long, pipe-like
snout for feeding, primarily eating
crustaceans, including plankton
and mysids. However, although it
will also eat shrimp and other small
fish, it has no teeth, which is rare
among animals with this diet.
Leafy seadragons are found only
in the waters of Australia from the
southern to the western shoreline.

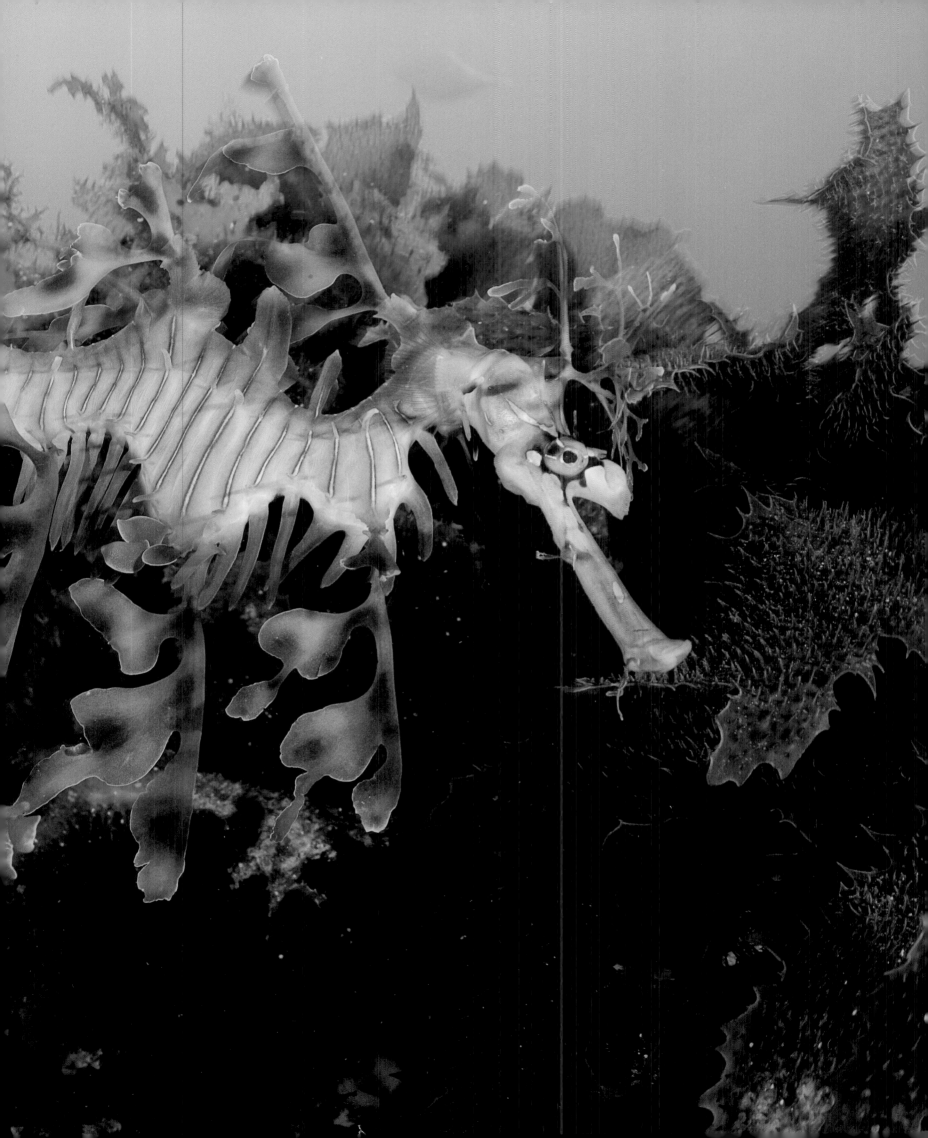

Like all sea horses, the thorny sea horse (*Hippocampus histrix*) has a tough armour made up of dense, bony segments that encircle its body.

This wonderfully camouflaged pygmy sea horse (*Hippocampus bargibanti*) is no bigger than a little fingernail. Most species have yet to be scientifically described and it is likely that more are just waiting to be found.

The colours of an adult ornate ghost pipefish (*Solenostomus paradoxus*) are determined by the environment in which it finally settles, be it a red sea fan or a yellow crinoid.

Seen head-on, the long, slender body of the trumpetfish (*Aulostomus chinensis*) appears much smaller than it really is – an illusion that allows it to drift close to its prey as it hunts among the corals.

◁ This juvenile mimic filefish (*Paraluteres prionurus*) resembles the toxic saddled toby – a tactic that allows it to warn off predators without having to go to the trouble of actually producing any toxins for itself. Other members of the filefish family that do not resemble toxic fish have the alternative defensive tactic of altering their colour and pattern to match their surroundings.

◁ This spiny devilfish (*Inimicus didactylus*) uses camouflage to move stealthily across the seabed. If it finds a patch of coral with fish nearby, this venomous predator will bury itself and wait for its prey to approach, before striking and sucking the fish into its mouth. Barren sandy seabeds with occasional coral outcrops, such as those found in Lembeh Strait, Indonesia, are ideal hunting grounds for these masters of disguise.

▷ The dwarf lionfish (*Dendrochirus brachypterus*) is very variable in both its colour, which may be red, brown, or purple, and its banding, which may be very strong or not present at all. It is usually perfectly camouflaged against the silty substrate and reefs that it inhabits, but, when disturbed, it will flare its large, colourful pectoral fins in an impressive warning display that advertises its venomous spines.

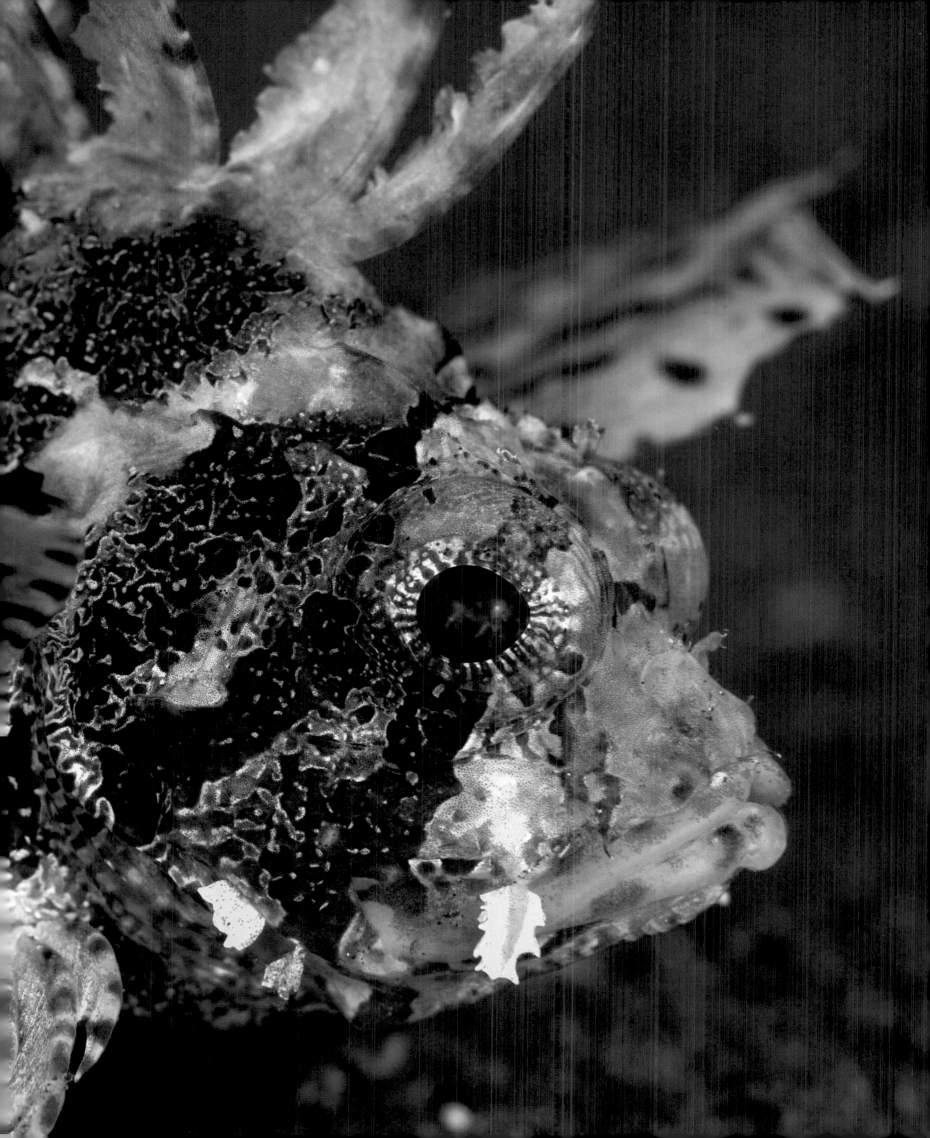

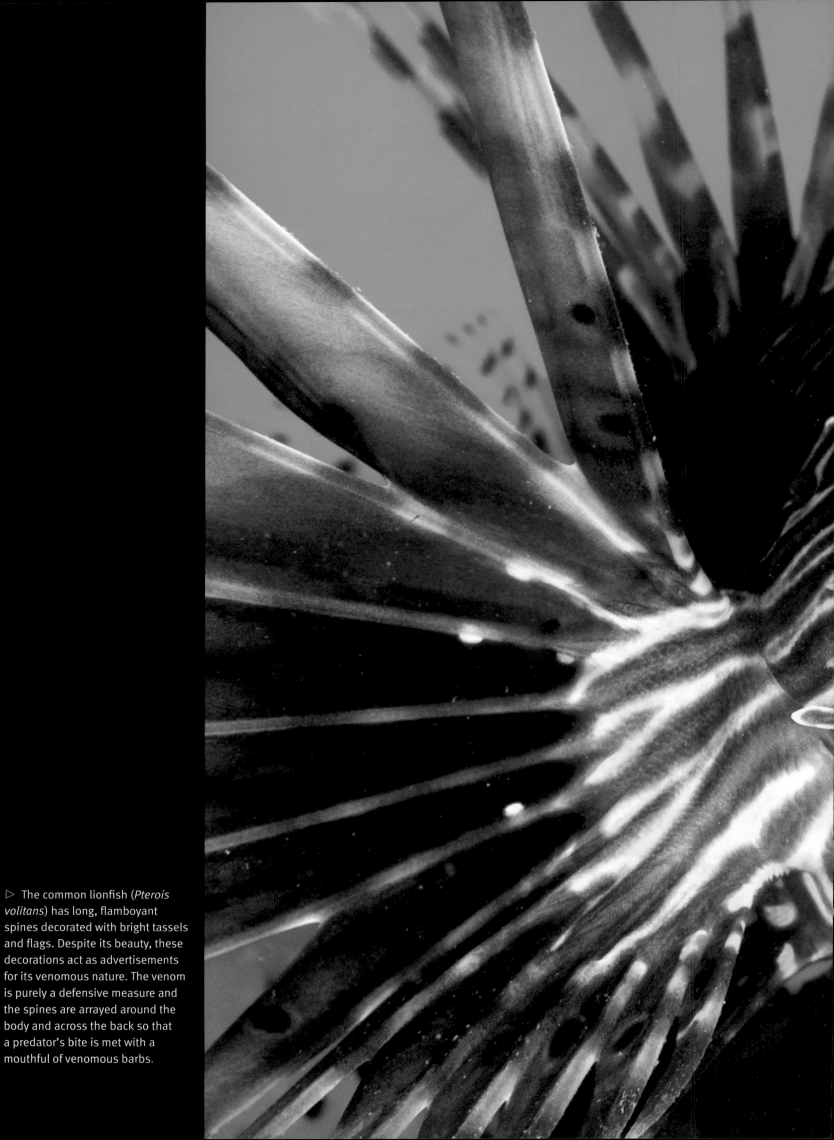

▷ The common lionfish (*Pterois volitans*) has long, flamboyant spines decorated with bright tassels and flags. Despite its beauty, these decorations act as advertisements for its venomous nature. The venom is purely a defensive measure and the spines are arrayed around the body and across the back so that a predator's bite is met with a mouthful of venomous barbs.

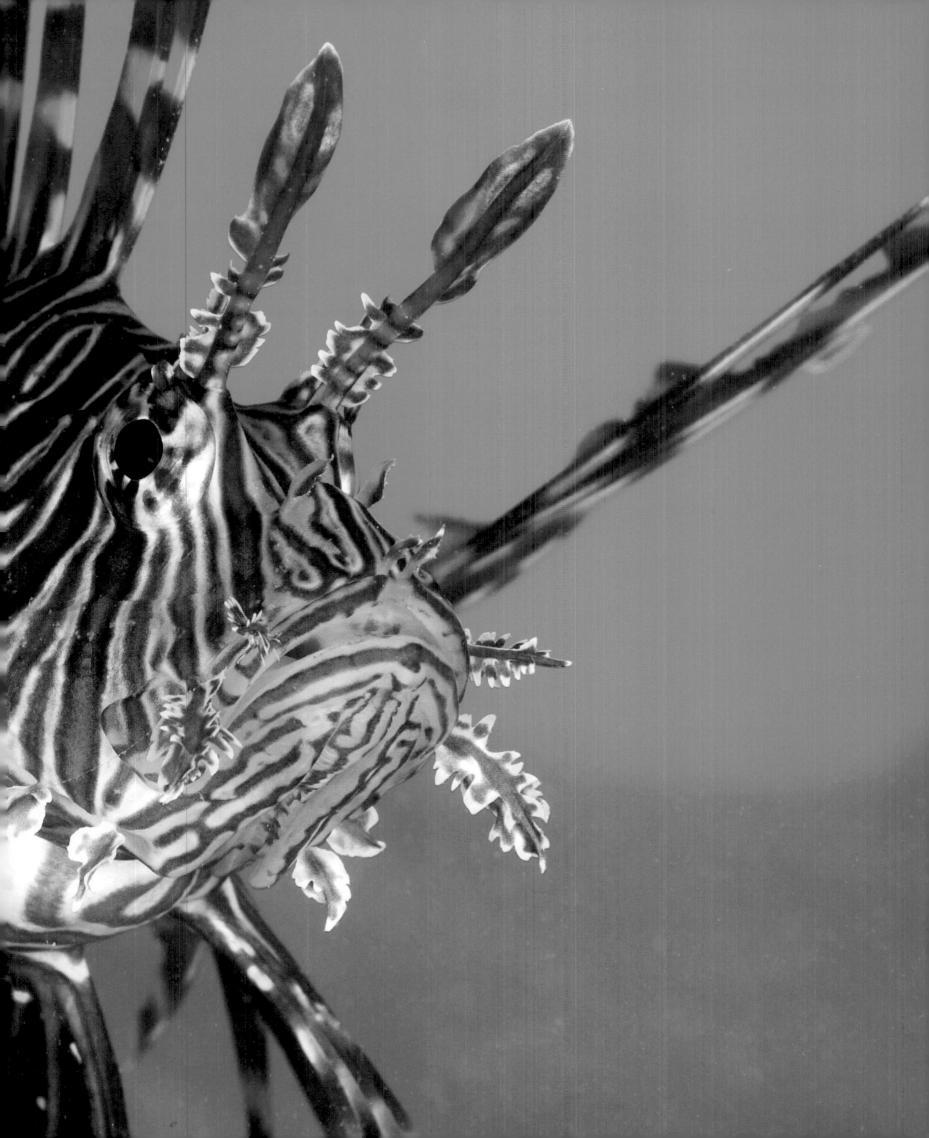

▷ Found in tropical waters throughout the Indo-Pacific, the coral grouper (*Cephalopholis miniata*) is one of the most commonly seen reef fish. Its diet consists of fish, octopus, crab, and other crustaceans, which it will lie in wait for, rather than chasing in open water. It does not have many teeth on the edges of its jaws, but is equipped with heavy crushing tooth plates inside the pharynx. Coral groupers form harems comprising a single male and several females. They are a territorial species, with each harem defending areas of reef of around 400 square metres (approximately 1,300 square feet). Within this area, territories may be sub-divided and defended by individual females from the harem.

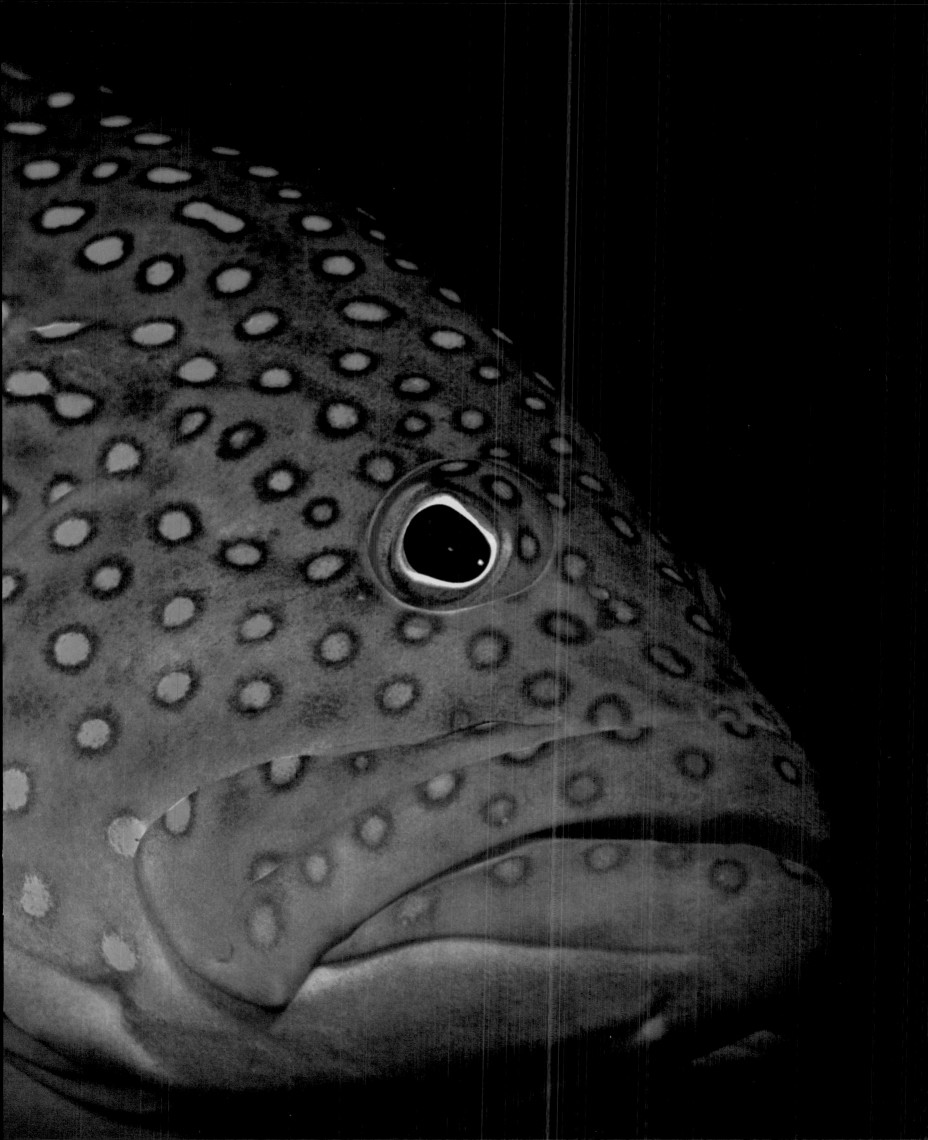

▷ One of the most fascinating events in the marine world is the mating of the mandarinfish (*Synchiropus splendidus*). The mandarinfish is a small, brightly coloured member of the dragonet family, which can be seen during the day foraging amongst reef rubble for food. At dusk, between 3 and 5 females will make their way to a particular region of the reef where males gather and display courtship behaviour in an effort to attract a female. Once paired, the female will rest on the male's pelvic fin, and they align themselves belly-to-belly. Then together they slowly rise about 1m (3ft) above the reef. When they are at the peak of their ascent, they release sperm and a cloud of up to 200 eggs. The fish then disappear in a flash. From that moment until they hatch 18 to 24 hours later, the fertilized eggs are at the mercy of the current.

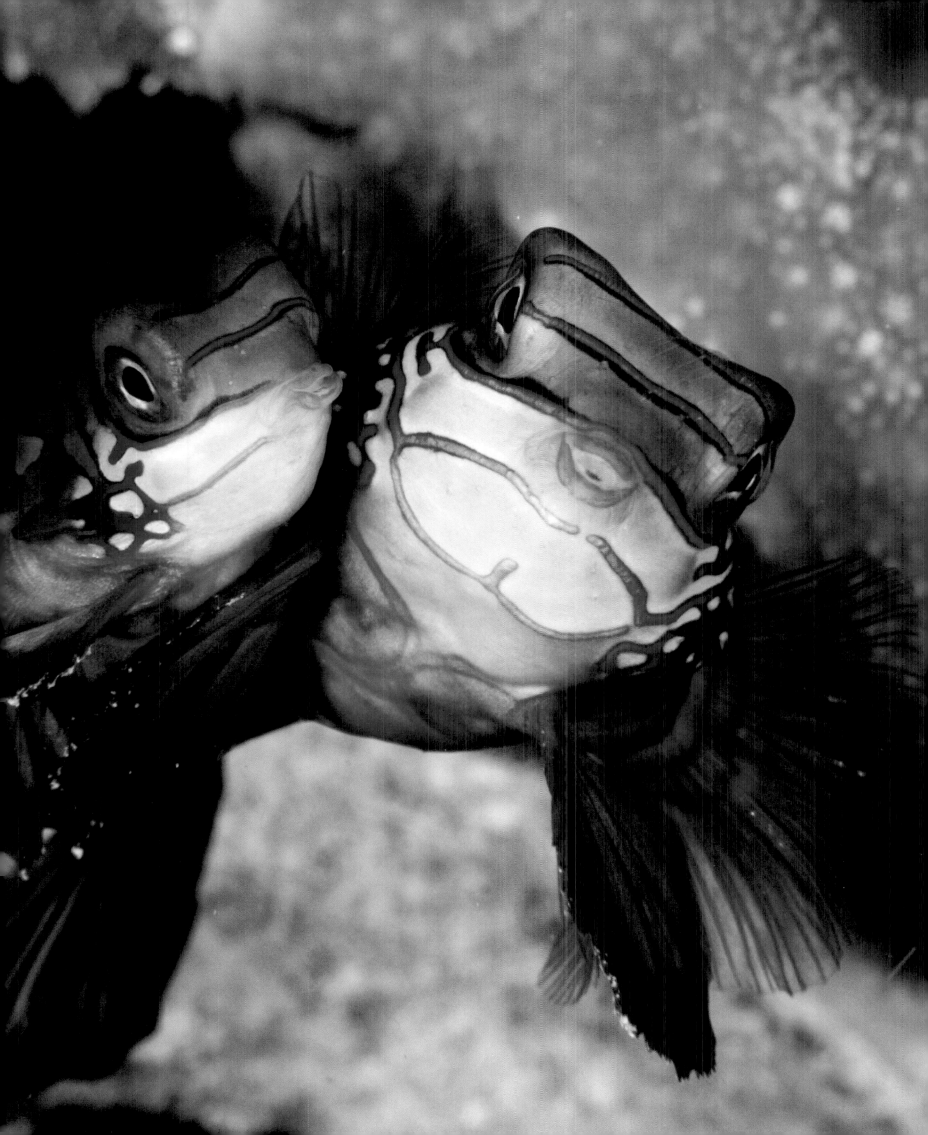

This juvenile cube boxfish (*Ostracion cubicus*) has a coating of toxic mucus as well as tough scales to protect it. Cube boxfish are common in tropical waters throughout the world.

The thornback cowfish (*Lactoria fornasini*) has a host of defences based around modifications of its skin and scales, including tough armour and poisonous mucus. These come into play if a predator ignores the warning colours and spikes.

▷ The hairy frogfish (*Antennarius striatus*) is also known as the anglerfish, because the first dorsal spine on its snout has evolved into a thin stalk-like structure (*illicium*) tipped with a lure. The frogfish wiggles the lure, much like an angler casting a rod, to attract prey. A master of camouflage, the hairy frogfish looks like soft coral or a clump of algae, which makes this stationary, ambush predator difficult to spot. It is only when the frogfish "yawns" – a threat display used when its hiding place among the soft corals is disturbed – that the full extent of its mouth is revealed. The mouth can open to the full width of the fish and this, combined with a strong sucking motion, gives the frogfish one of the fastest strikes known in the animal kingdom.

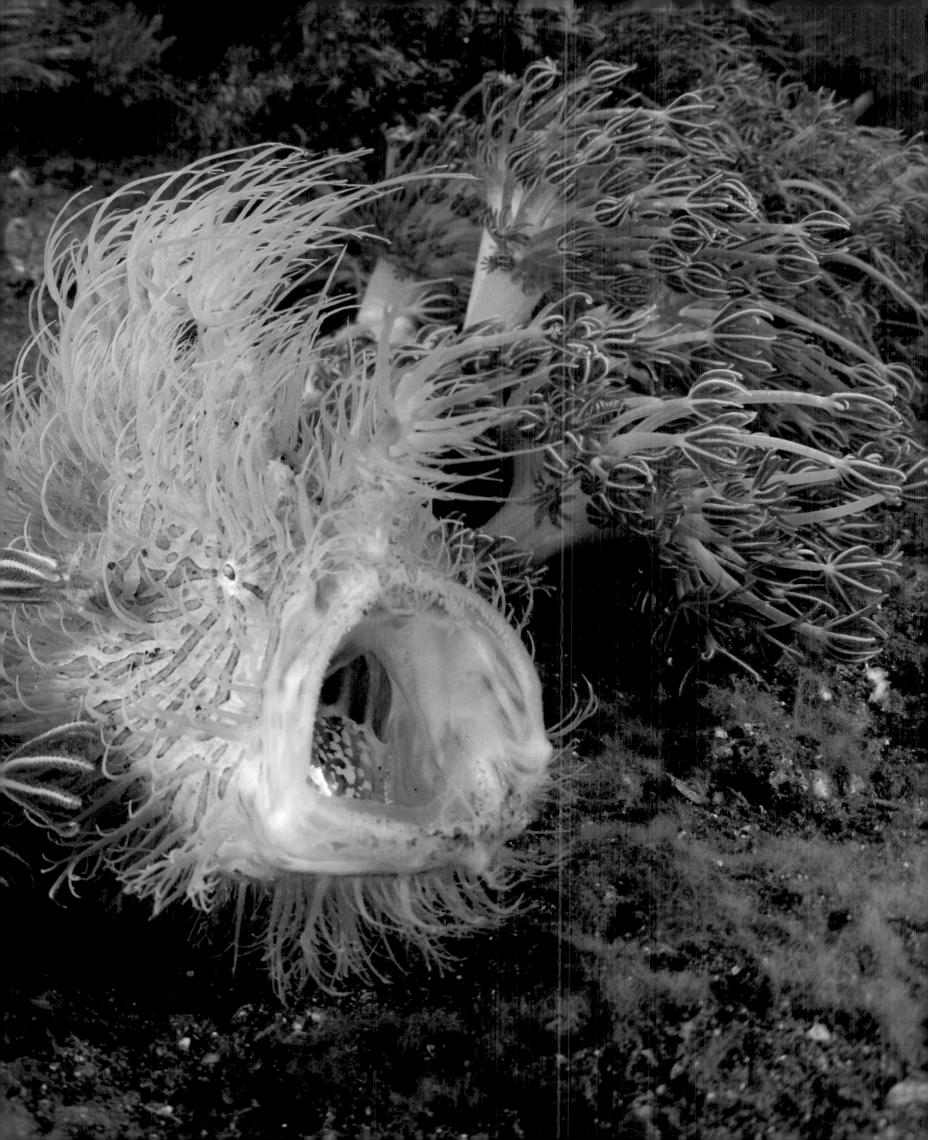

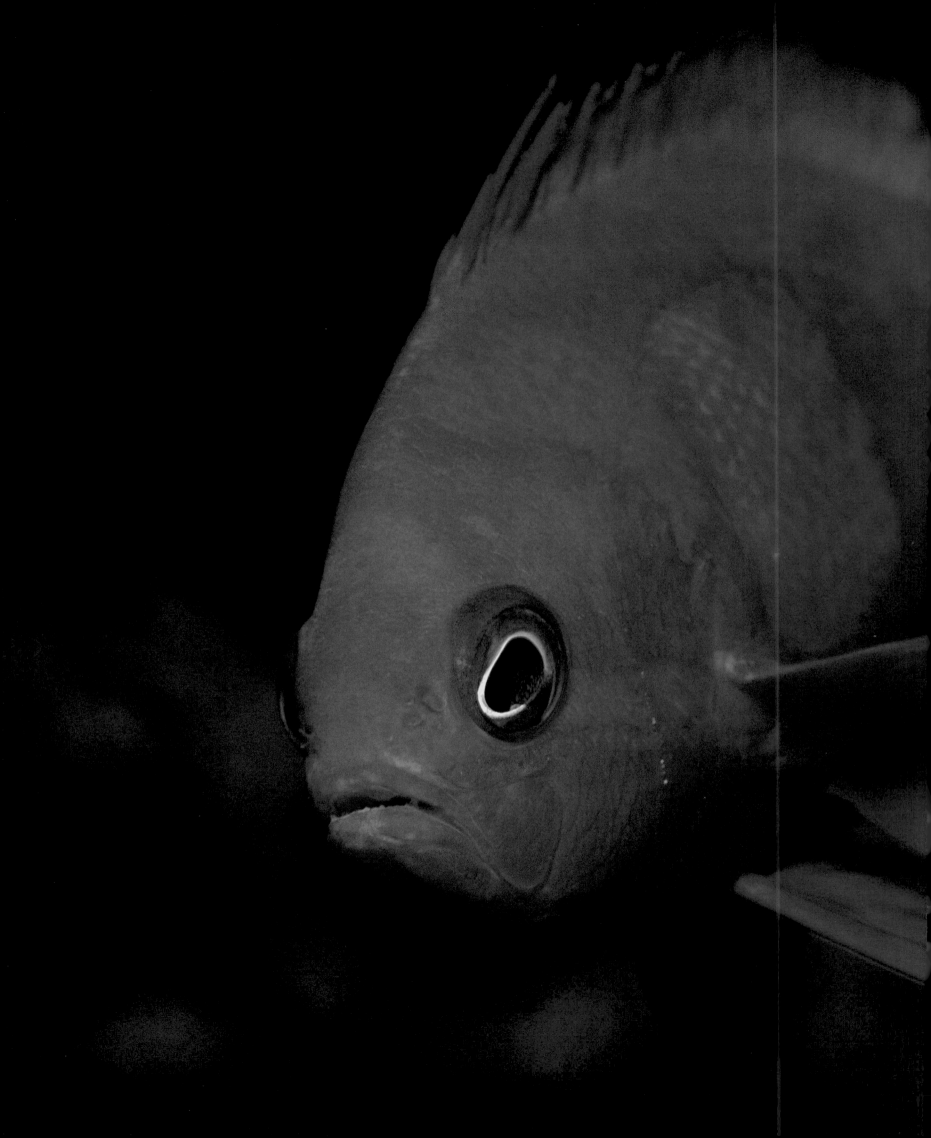

◁ The squarespot anthia
(*Pseudanthias pleurotaenia*) is also
known as the square-back, purple-
blotch basslet, squareblock, square,
or mirror anthias – the names
reflecting its unique colour variation.
The male, as seen here, is
predominantly pink with a lavender
belly and has a light rectangular
shape on its side. The body of a
female is predominantly yellow with
a lavender belly. Found throughout
the Indo-Pacific region, squarespot
anthias are usually seen in large
groups on steep seaward slopes.
A single male has a large harem
of females but, like all anthias,
it is hermaphroditic – if a dominant
male perishes, the largest female
of the group will often morph to
take its place.

▷ The whitemargin stargazer (*Uranoscopus sulphureus*) is found in coastal waters from the Red Sea to Samoa. It is one of the ultimate ambush predators, spending much of its time hiding in the sand with only the tooth-lined slit of its huge mouth visible. With a wriggling, worm-like lure, it attracts passing fish – which are engulfed in a fraction of a second.

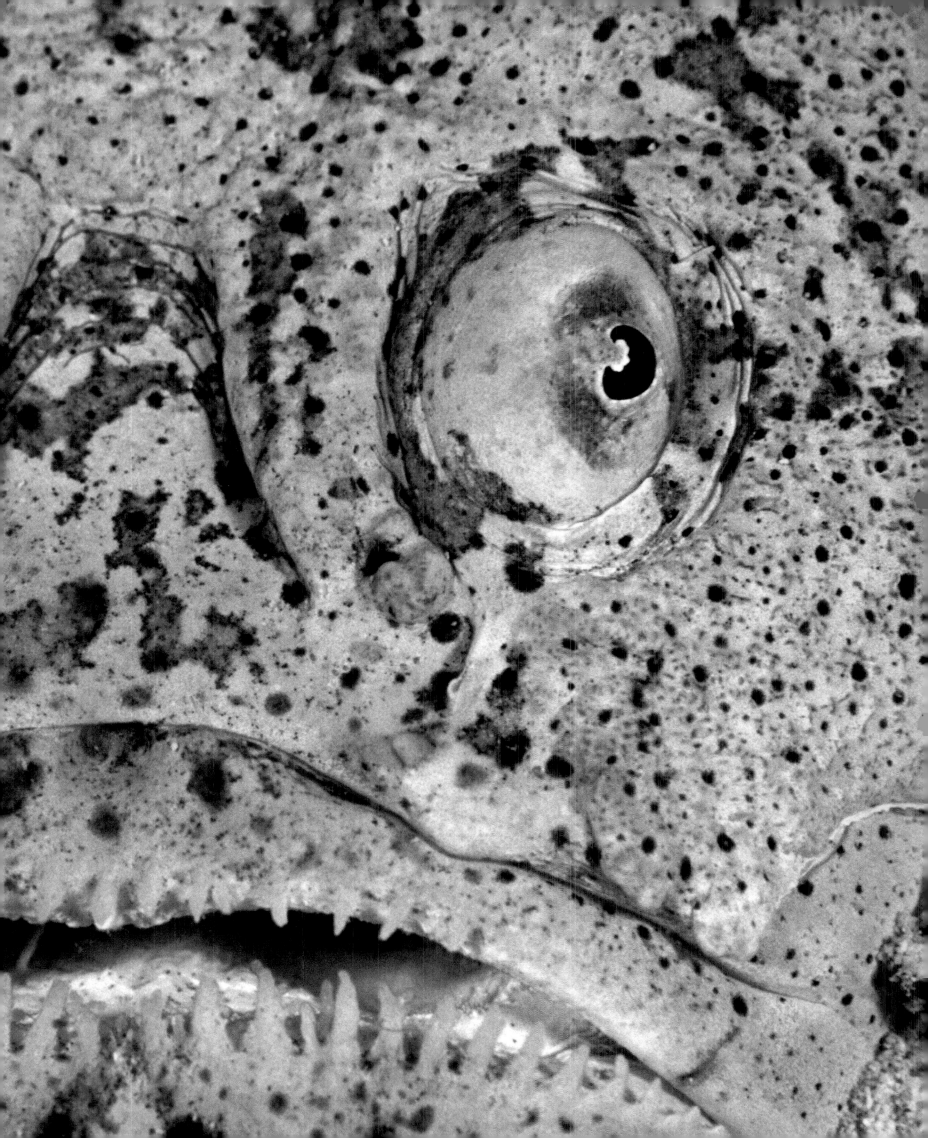

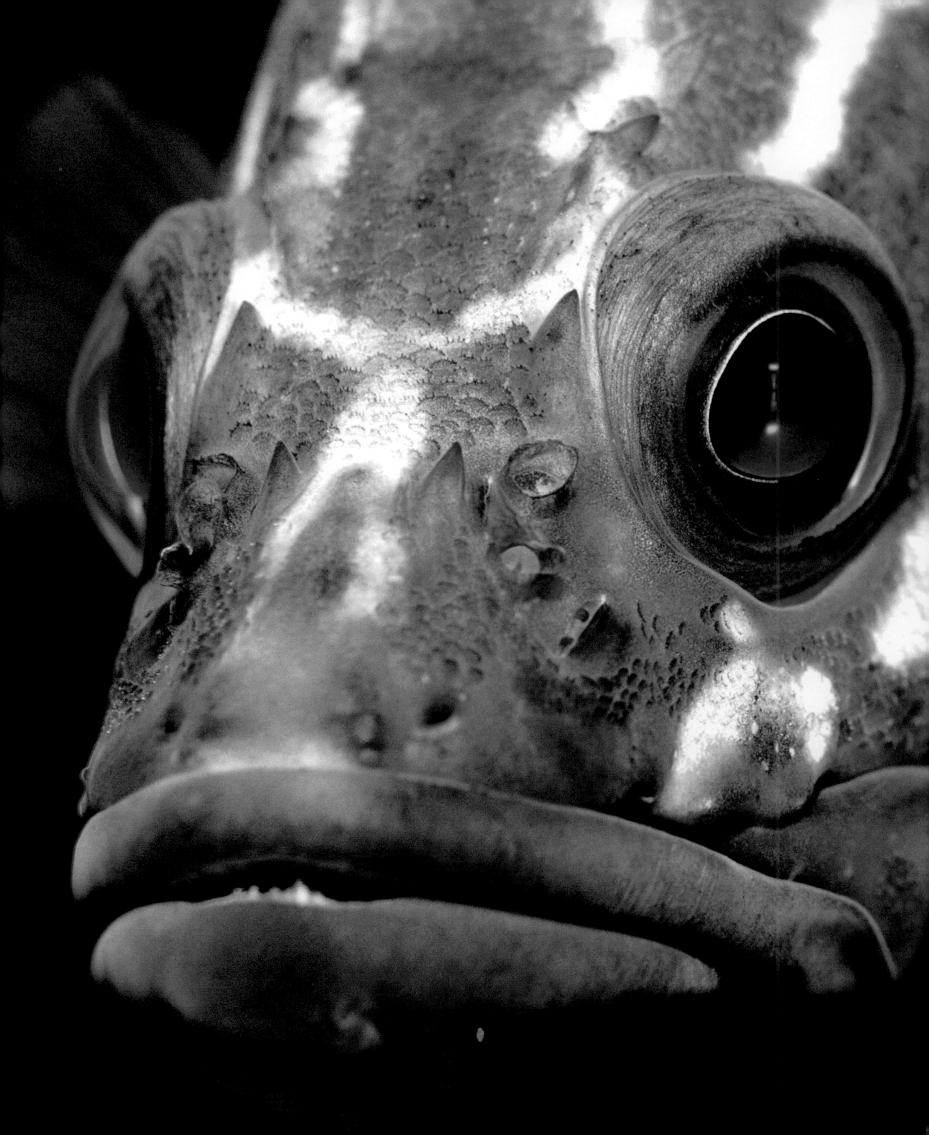

◁ Once found off the Pacific coast in huge numbers, the canary rockfish (*Sebastes pinniger*) has been an important commercial food species for some time, which has resulted in dwindling numbers – they are officially classed as "overfished". The canary rockfish is so named because of its bright coloration, ranging from yellow to orange with a grey mottling underneath.

▷ This regal angelfish (*Pygoplites diacanthus*) epitomizes the classic reef fish – large, colourful, and graceful. Angelfish are greatly dependent on the shelter of boulders, caves, and coral crevices and so traditionally inhabit areas with heavy coral growth or substantial rock formations. Although some of the smaller angelfish feed primarily on algae, regal angelfish prefer sponges and tunicates, such as sea squirts.

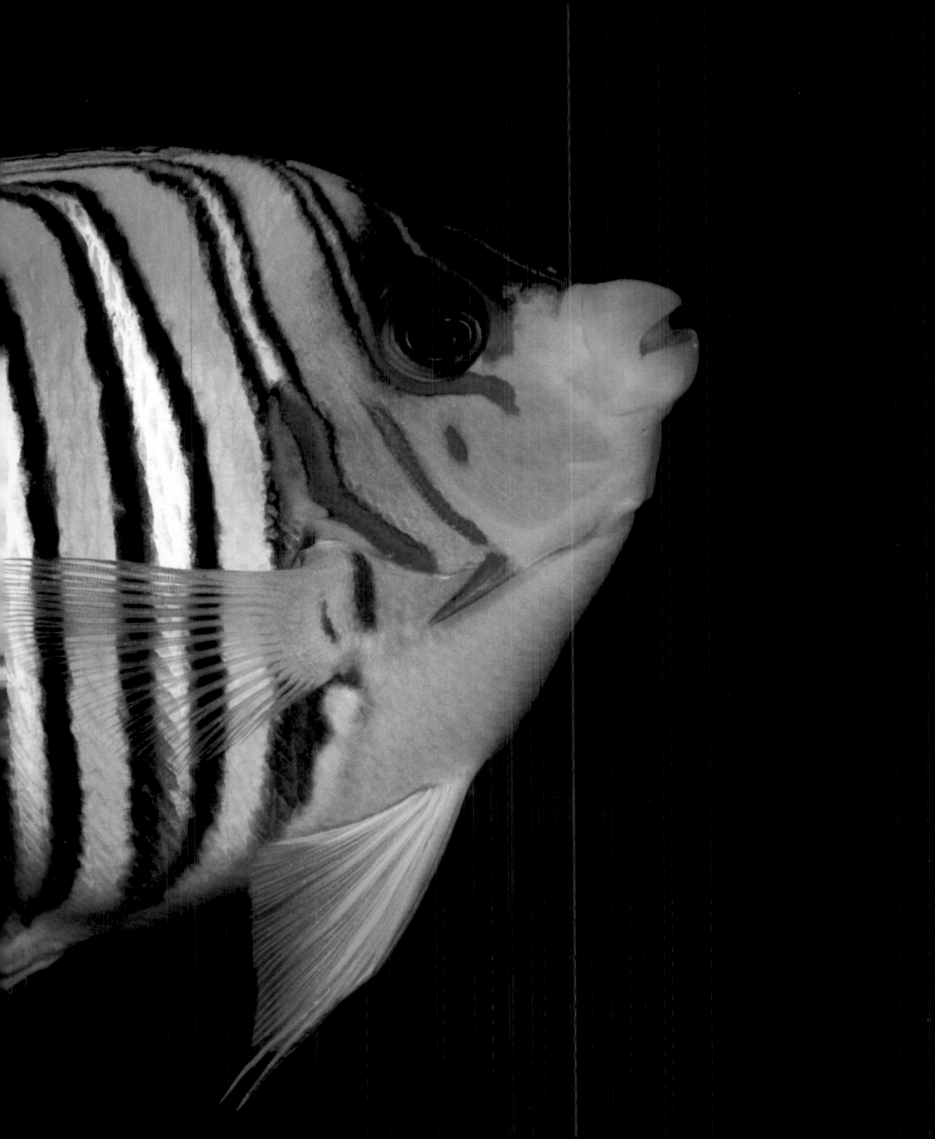

▷ The colours and patterns of the blueface angelfish (*Pomacanthus xanthometopon*) are thought to help it recognize potential mates, but at a price – its bright markings also attract predators. It is also known as the yellow masked angelfish because of the yellow bar across its face. Its body has scales of blue with yellow margins and the breast, pectoral fin, and caudal fin are all yellow. The blueface is one of the larger members of the angelfish family, growing to a maximum length of 38cm (15in), and is found on coral reefs and in tropical inshore waters of the eastern Indian and western Pacific Oceans.

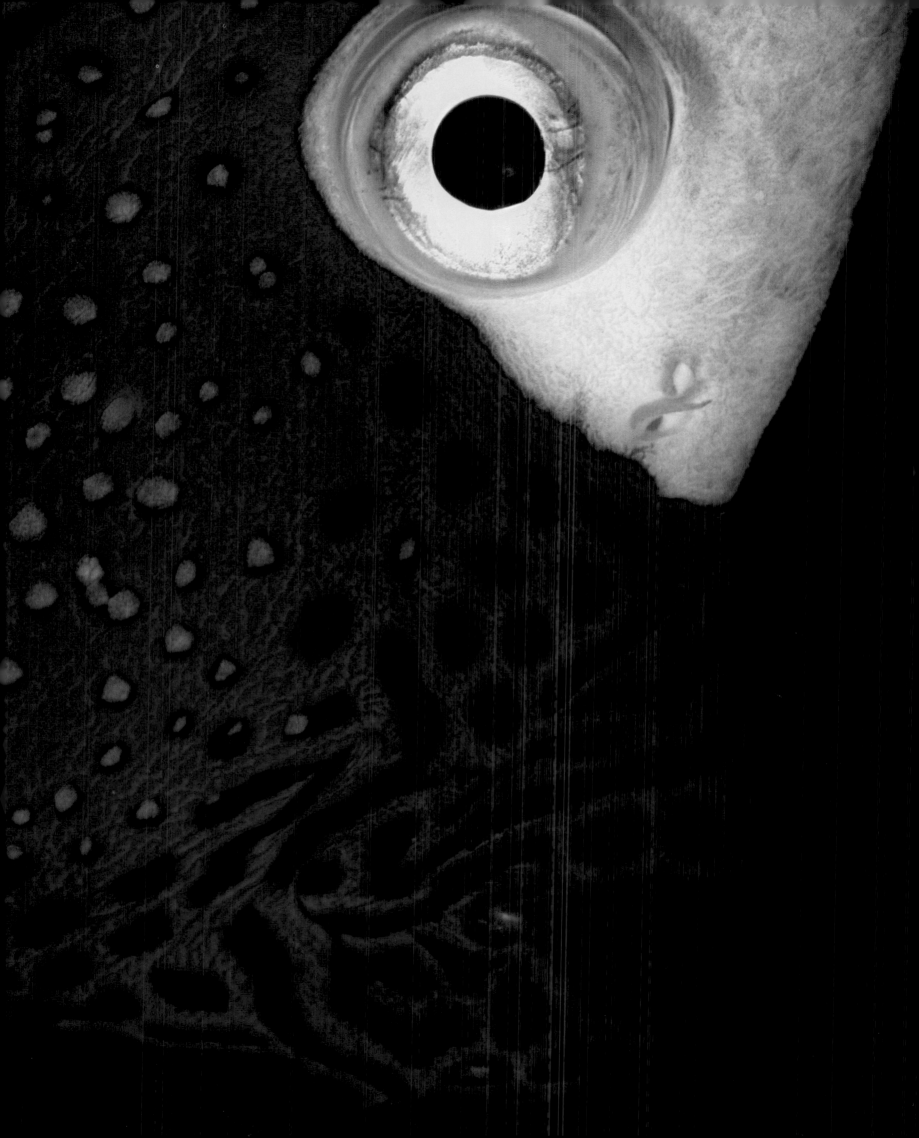

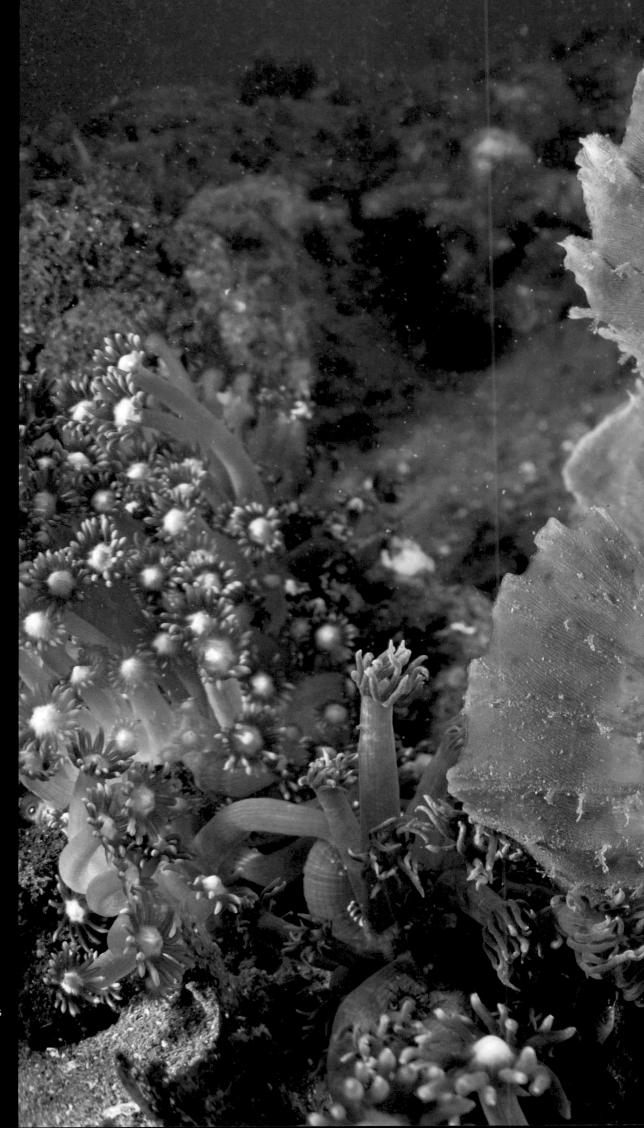

▷ The weedy scorpionfish
(*Rhinopias frondosa*) is one
of the most beautiful fish found
on tropical reefs, although its
stunning colours show up only
under the lights of a camera strobe.
In natural light, it blends into the
background perfectly, relying on
camouflage to get close to the
small fish that make up its diet.
The weedy scorpionfish can be
found in many different colour
variations and mottled shades,
often with dark outlined spots and
numerous short branched skin flaps
and filaments that help it to blend
in with the coral environment.

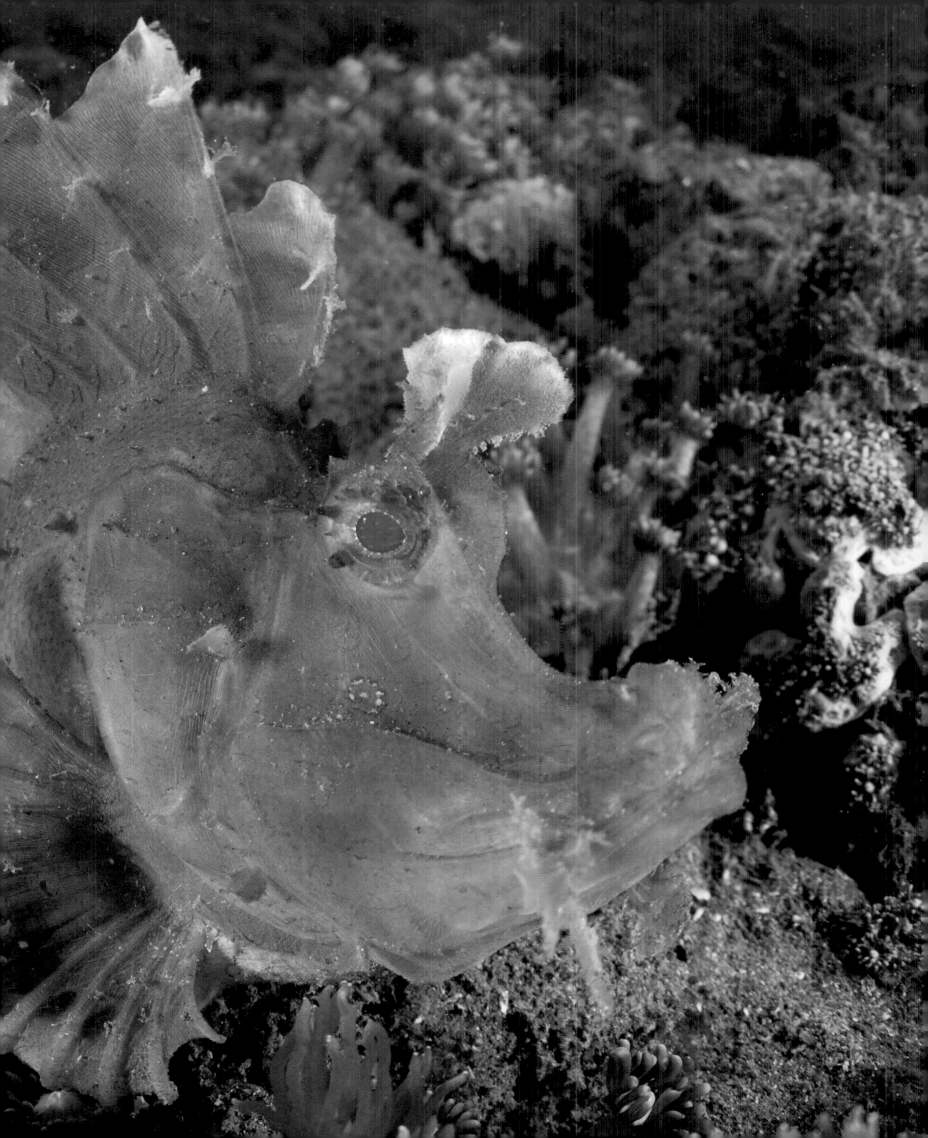

◁ A tiny many-host goby (*Pleurosicya mossambica*) hides in its forest of polyps, only exposing itself to predators when darting out to grab particles of food. As the name suggests, it can be found on a wide variety of hosts, including gorgonian fans, sea whips, and soft tree corals. The goby spends its entire life on its host, even mating and laying its eggs there.

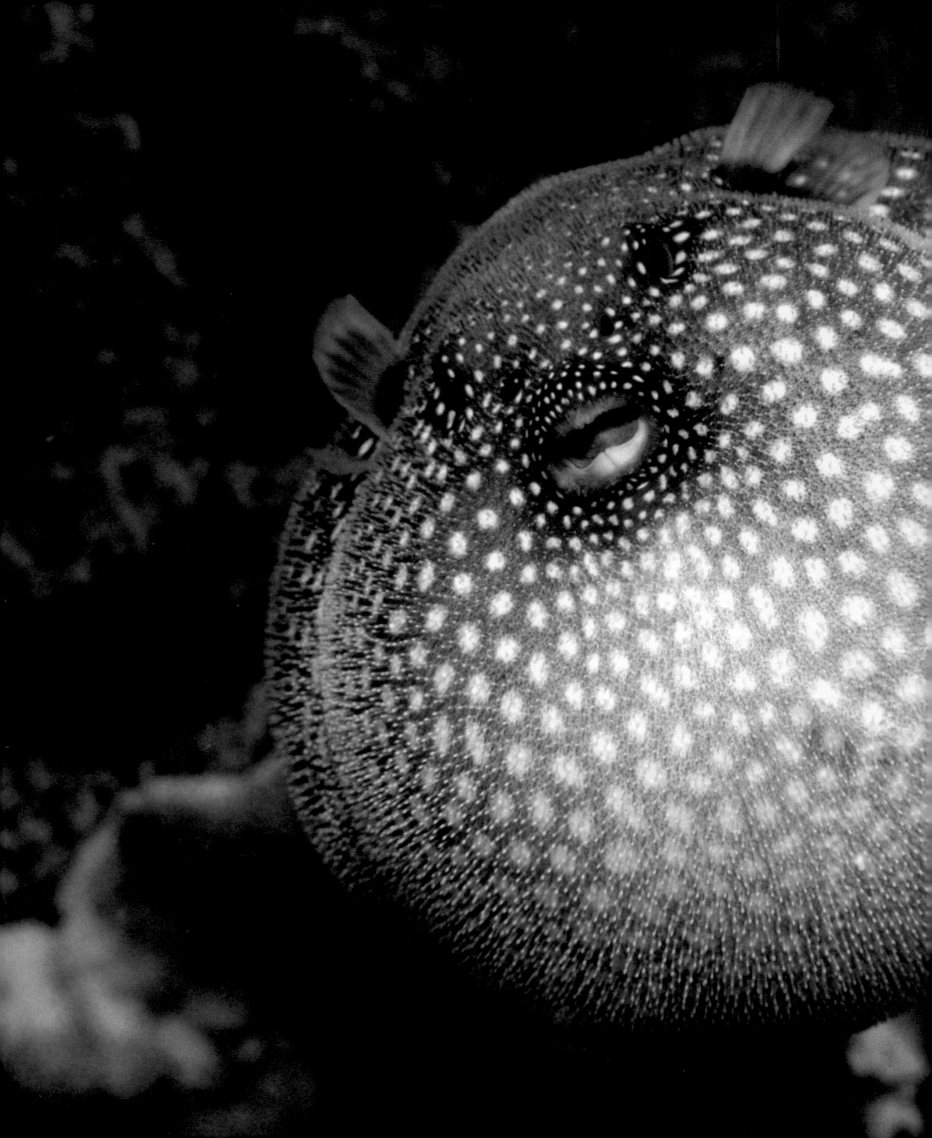

◁ Like all puffers, the guineafowl puffer (*Arothron meleagris*) has tough, scaleless skin, and when disturbed has the ability to greatly expand the size of its body by drawing water into the ventral portion of its stomach. This has the effect of deterring potential predators. In addition to this defence mechanism, the puffer also produces a potent poison (textrodotoxin) in its tissues that is potentially deadly if ingested.

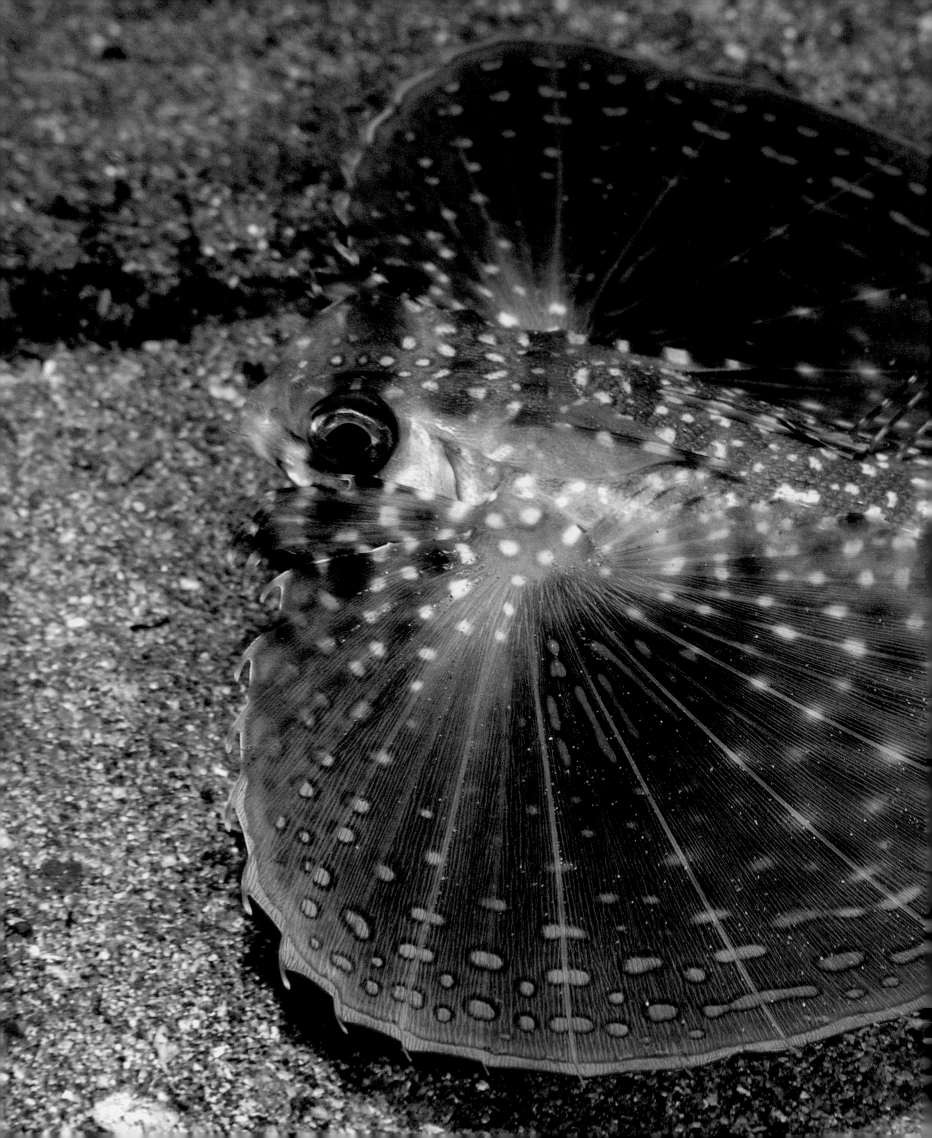

◁ The flying gurnard (*Dactyloptena orientalis*) is found in the sandy areas fringing tropical coral reefs. It has an elongated rigid body with an antenna-like dorsal fin on top of its head and large pectoral fins with protruding filamentous tips that resemble wings. It uses its finger-like pelvic rays to "walk" over the seabed, occasionally stopping to scratch at the sand in search of small crustaceans. When alarmed it will fully extend its pectoral fins and rapidly swim away.

All porcupinefish can inflate their bodies with water when threatened. This blacklip porcupinefish (*Lophodion calori*) is also covered with short spines, some standing permanently erect and others lying flat until its body is inflated.

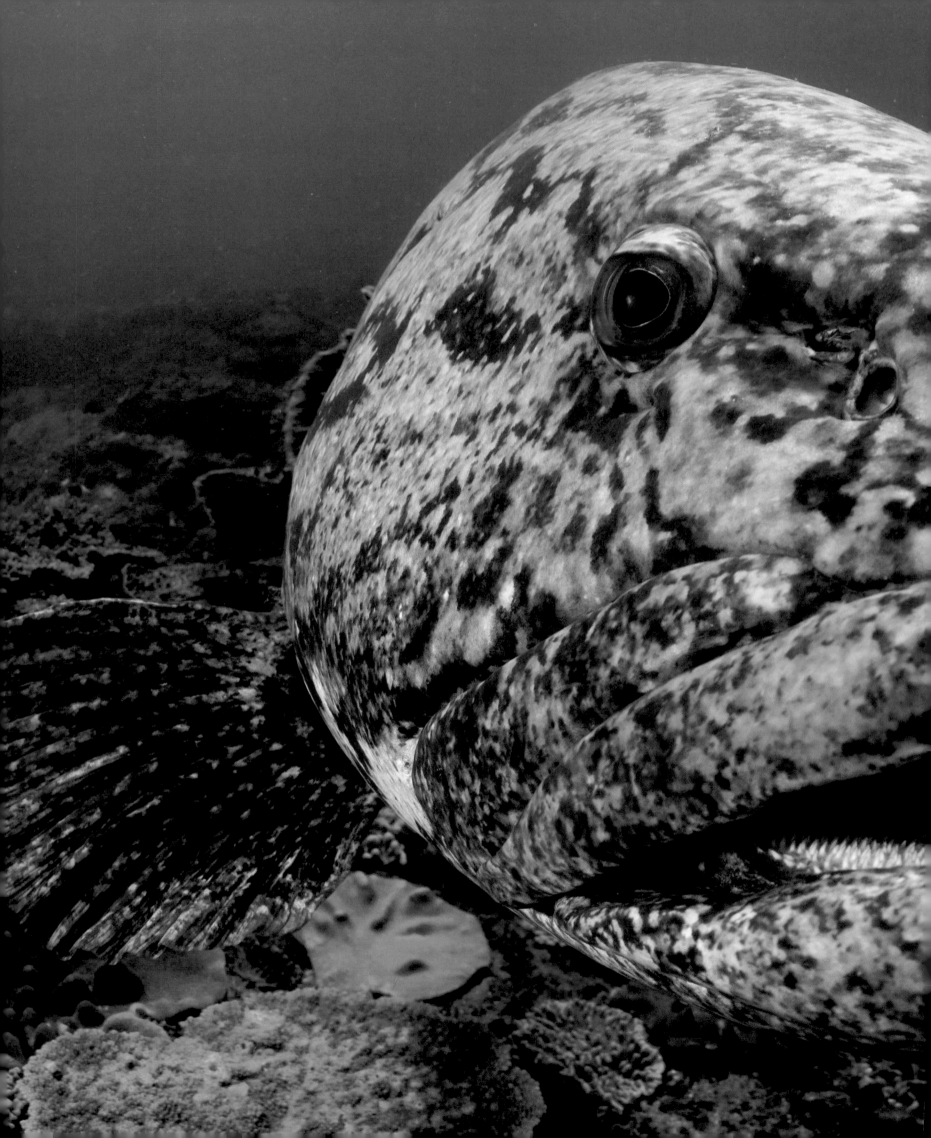

◁ The potato grouper (*Epinephelus tukula*), so named because of the shape of its head, is found in deep reef channels and seamounts from the Indo-Pacific to the western Pacific. It is an exceedingly territorial predator, controlling the populations of smaller fish, skate, crabs, and lobsters that make up its diet. It hunts by hiding in large crevices and ambushing prey that passes by, sucking it in with its huge mouth. The potato grouper is among the largest of all bony fish, growing to more than 2m (6½ft) in length and 100kg (220½lb) in weight.

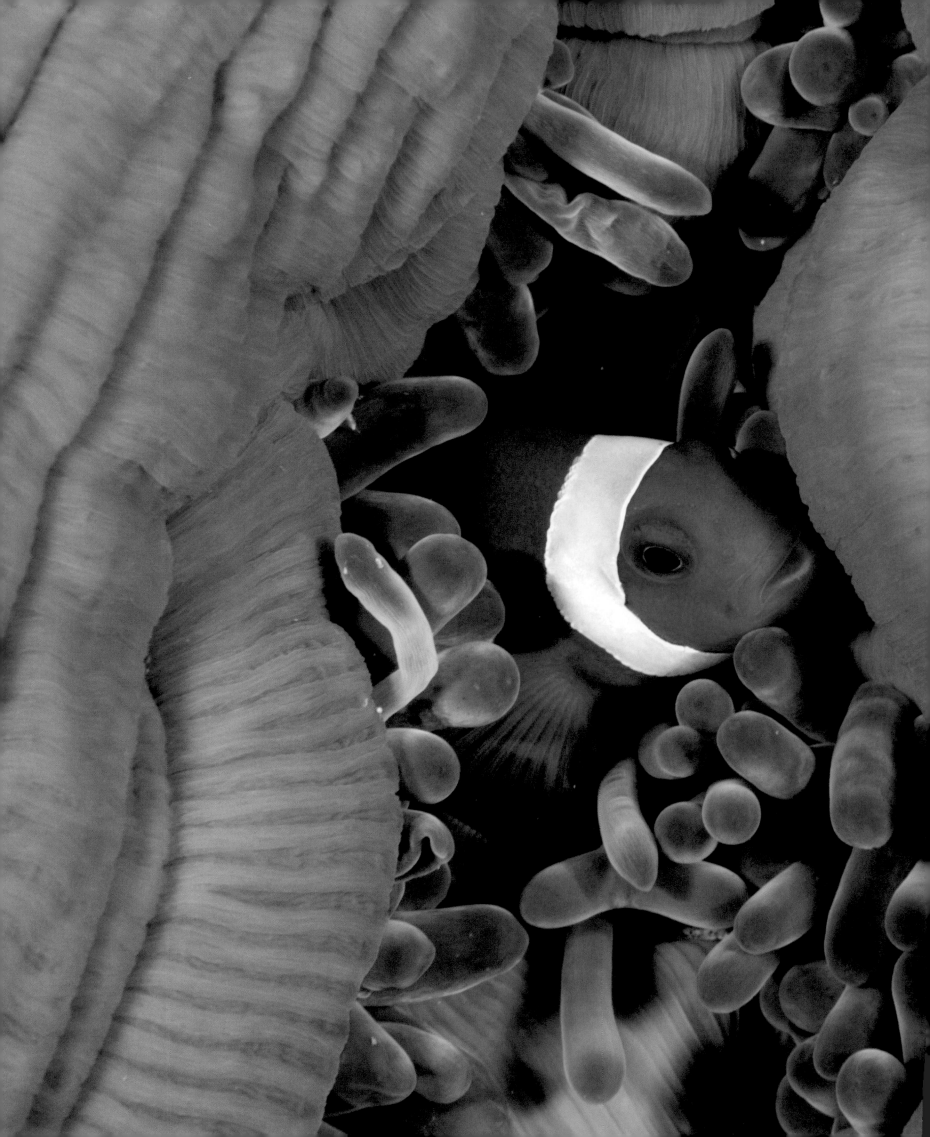

◁ A western clown anemonefish (*Amphiprion ocellaris*) hides among the protective arms of a magnificent anemone (*Heteractis magnifica*), without which it would not be able to survive among the corals. These stunning fish live in permanent harems sheltered by their host anemone, feeding, fighting, and even raising their eggs among its stinging arms. In return for this much-needed shelter, the anemonefish attack and drive away potential predators

▷ The Banggai cardinalfish
(*Pterapogon kauderni*) spends its
entire life around sea urchins and
anemones. Juveniles such as this
are small enough to shelter in the
shorter spines of vivid *Astropyga*
urchins, while adults favour the
black *Diadema*, with its long
needle-like spines. The Banggai
cardinalfish is what is known as a
"paternal mouthbrooder", meaning
that the male cares for his offspring
by holding the eggs in his mouth for
prolonged periods of time. Females
play an active role in courtship and
pair formation, which occurs between
a few hours and a few days before
spawning. Mating pairs of Banggai
cardinalfish establish spawning
territories several metres away
from the main group and vigorously
defend these territories. The species
is found only around the Banggai
Islands of Indonesia.

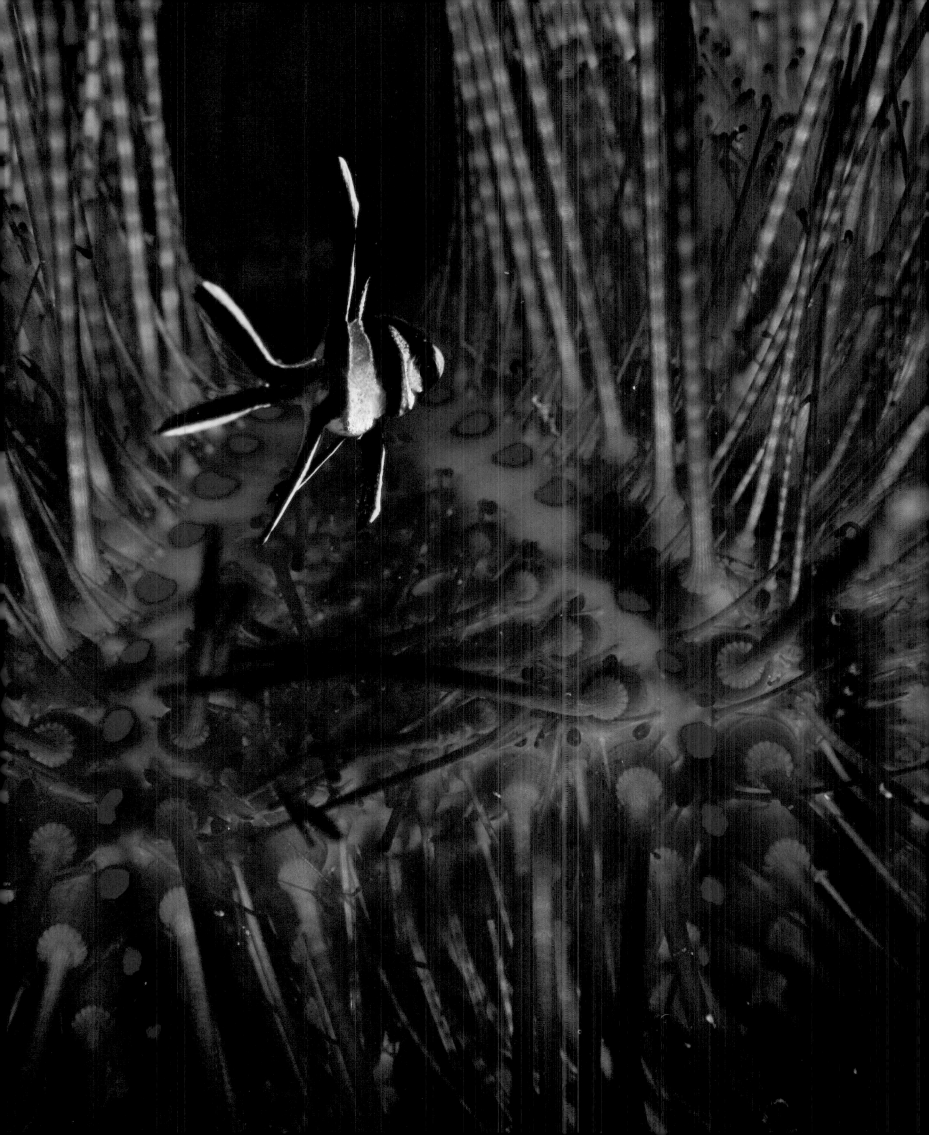

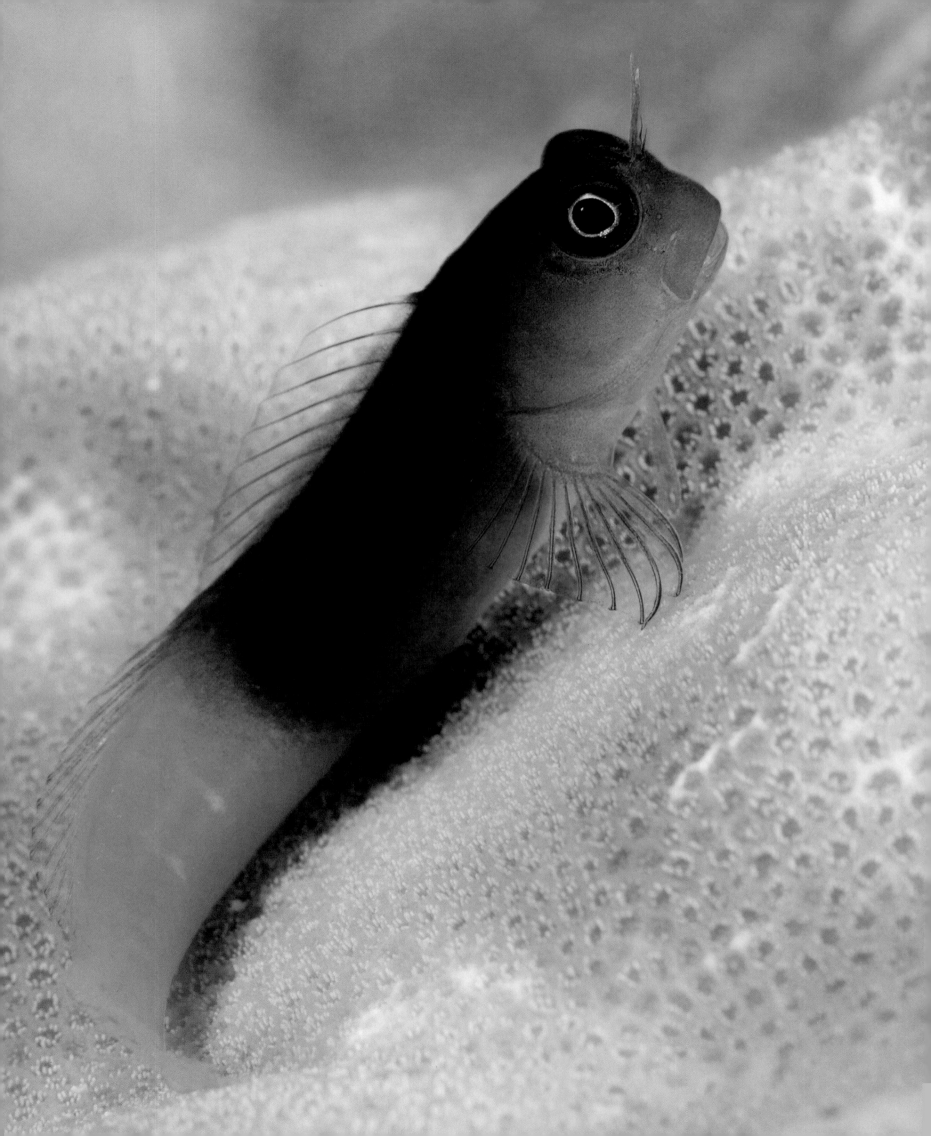

The bicolour blenny (*Ecsenius bicolor*) likes to sit in shallow sunny areas, but will quickly retreat to a nearby tube-worm burrow if it feels threatened. Like most blennies it is territorial and will fiercely defend its patch from intruders.

invertebrates

Animal life is dazzling in its diversity. Scientists believe that there may be more than ten million different species of animals, even though fewer than two million have been scientifically described and named. Of these, less than three per cent are vertebrates – the mammals, birds, reptiles, amphibians, and fish that most people think of as "animals". The other 97 per cent are invertebrates – animals that do not have internal skeletons based on flexible, jointed backbones. They include creatures such as insects, spiders, worms, and snails, as well as oceanic starfish, clams, and corals. These animals are quite unlike the vertebrates. Their bodies are built in very different ways. Some are alarming-looking and even dangerous, but they are all fascinating and often breathtakingly beautiful.

Anyone who is lucky enough to dive a coral reef knows all about the beauty of invertebrate life. The reef is a monument to the industry of simple colonial creatures that, at first glance, seem more like plants than animals. They even live rather like plants, rooted to the spot and drawing most of their energy from the sun. These corals have evolved a spectacular variety of forms, each adapted to its own particular niche in the reef system, and forming a community of living things that resembles an underwater garden. The whole reef is also alive with other invertebrates such as molluscs with their sculptured shells, delicate transparent shrimps, armoured crabs, and drifting, diaphanous jellyfish.

Yet you do not have to visit a coral reef to marvel at the beauty of invertebrate life. Take a walk in the park and you may see an unusual bird or two. But set your sights much closer and you will see wonders. Iridescent, jewel-like beetles, glittering hoverflies with astonishing powers of flight, exquisite butterflies with their glorious, improbably vivid colours, and spiders weaving silken webs of amazing sophistication. Watch carefully, and you will see how these animals live, sipping nectar from flowers, displaying their finery to potential mates, or falling prey to the many tiny hunters that teem in the undergrowth.

> **Invertebrates account for most of the animal species on Earth – an astonishing diversity of weird and wonderful creatures.**

Most of these land-living invertebrates are arthropods of some kind: animals such as insects, spiders, and centipedes that have external skeletons with jointed legs like suits of medieval armour, often wonderfully ornamented and coloured. Others such as worms and slugs have soft bodies that can stretch and squeeze into unlikely shapes. Insects such as butterflies, moths, beetles, and flies are also soft-bodied when young, living as caterpillars, grubs, and maggots that spend nearly all their time eating. Many pass most of their lives like this, and the mature stage is just the last phase of their existence when they are completely transformed into winged adults with one agenda – to mate and reproduce their kind. Some cannot even eat in their mature stage, and they survive for just a few brief days in their adult form.

For many people, such creatures are bugs or even pests, yet they are an essential part of the web of life, pollinating the plants that we rely upon for food, feeding other animals, and clearing up the remains of the dead. They could probably survive without us, but we could not survive without them. They deserve our respect and, when you look at them closely, it is hard not to be impressed by their sheer variety and miniature perfection.

invertebrates

▷ Jellyfish are among the simplest of animals, with no head or brain and only the most basic of senses. The transparent "bell" of this Atlantic moon jellyfish of the genus Aurelia is made of jelly reinforced by elastic fibres. Muscles in the bell contract it and push water out, and when the muscles relax the elastic fibres make the bell spring back into shape. This propels the animal through the water in a series of graceful pulsating movements, but usually it drifts with the current.

▷ Rhizostome jellyfish such
as this Indo-Pacific *Nemopilema*
species have bulky "arms"
surrounding the central mouth
that trap and ingest tiny drifting
crustaceans. By contrast, most
other jellyfish have long stinging
tentacles equipped with thousands
of microscopic stinging cells. These
act like tiny harpoons, piercing the
victim's body to inject a paralyzing
dose of venom. Some species such
as the box jellyfish or sea wasps
of Australian waters are notorious
for the potency of their venom,
which can kill human swimmers.

Although they resemble underwater plants, sea anemones such as this beaded anemone (*Heteractis aurora*) are simple animals related to jellyfish. They attach themselves to rocks and other submerged objects and use their stinging tentacles to snare other animals.

Like other sea anemones, the giant disc anemone *(Amplexidiscus fenestrafer)* has a central mouth, but, unusually, no crown of mobile tentacles. Instead it has a broad fleshy disc up to 45cm (18in) across, which it uses to enfold and trap prey such as small fish.

The tissues of tropical corals such as this mushroom coral contain microscopic algae that use the energy of light to make sugar from water and carbon dioxide. This supplies the coral with most of the food it needs, but it also traps small floating animals.

▷ The constant warmth of the tropics enables rainforest spiders to live longer and grow much bigger than their temperate relatives. They include the big, hairy spiders known as tarantulas, the largest of which can achieve a formidable 25cm (10in) legspan. Despite their size they are not dangerous – they rely on strength to subdue their victims and their venom is relatively weak. However, this tarantula is rearing up in a threat posture to display its venomous fangs to a potential enemy.

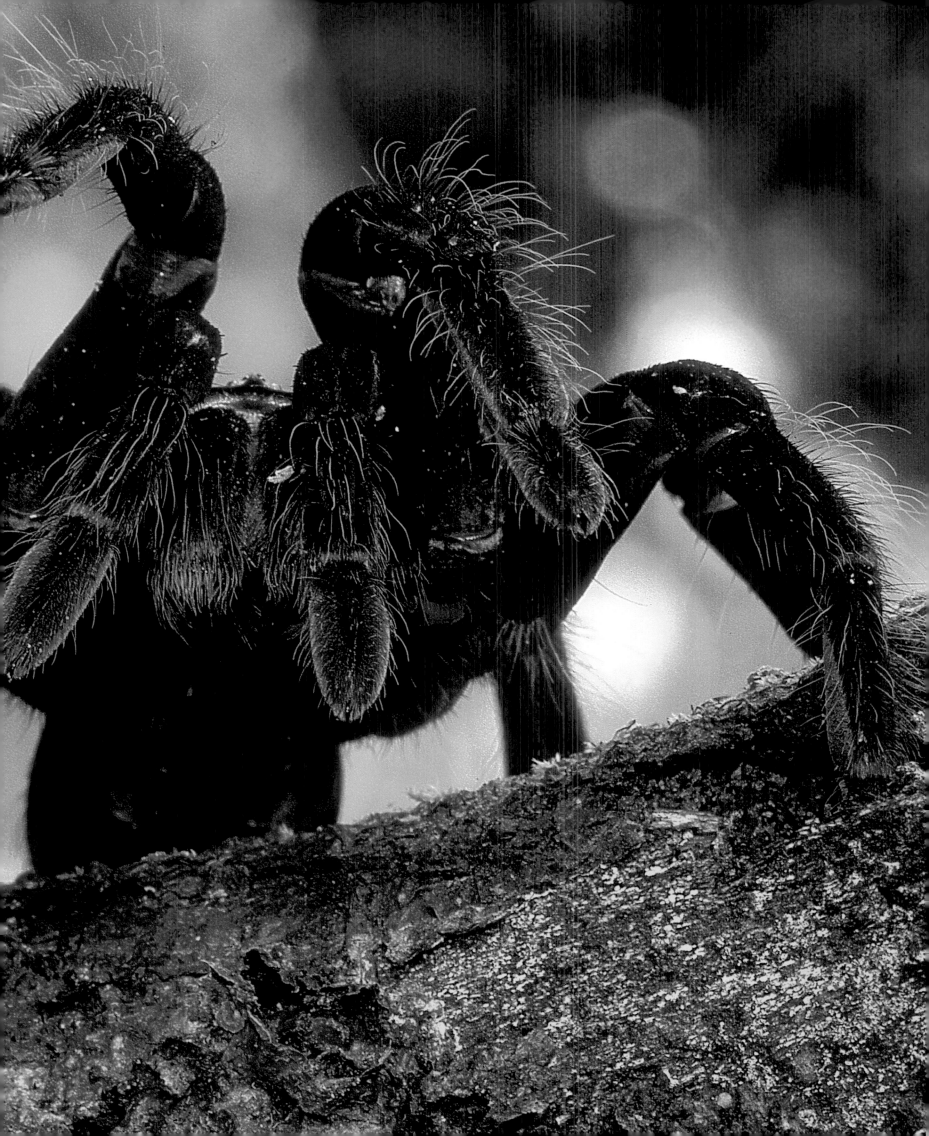

▷ Although related to spiders, scorpions such as this *Grosphus ankarana* from Madagascar have a very different body plan, with powerful pincers and a long, jointed tail. Instead of venomous fangs, the scorpion has a sting on the end of its tail, which it uses mainly for self-defence rather than hunting. The venom of some species is extremely potent and can be fatal to humans, but they usually sting only as a last resort.

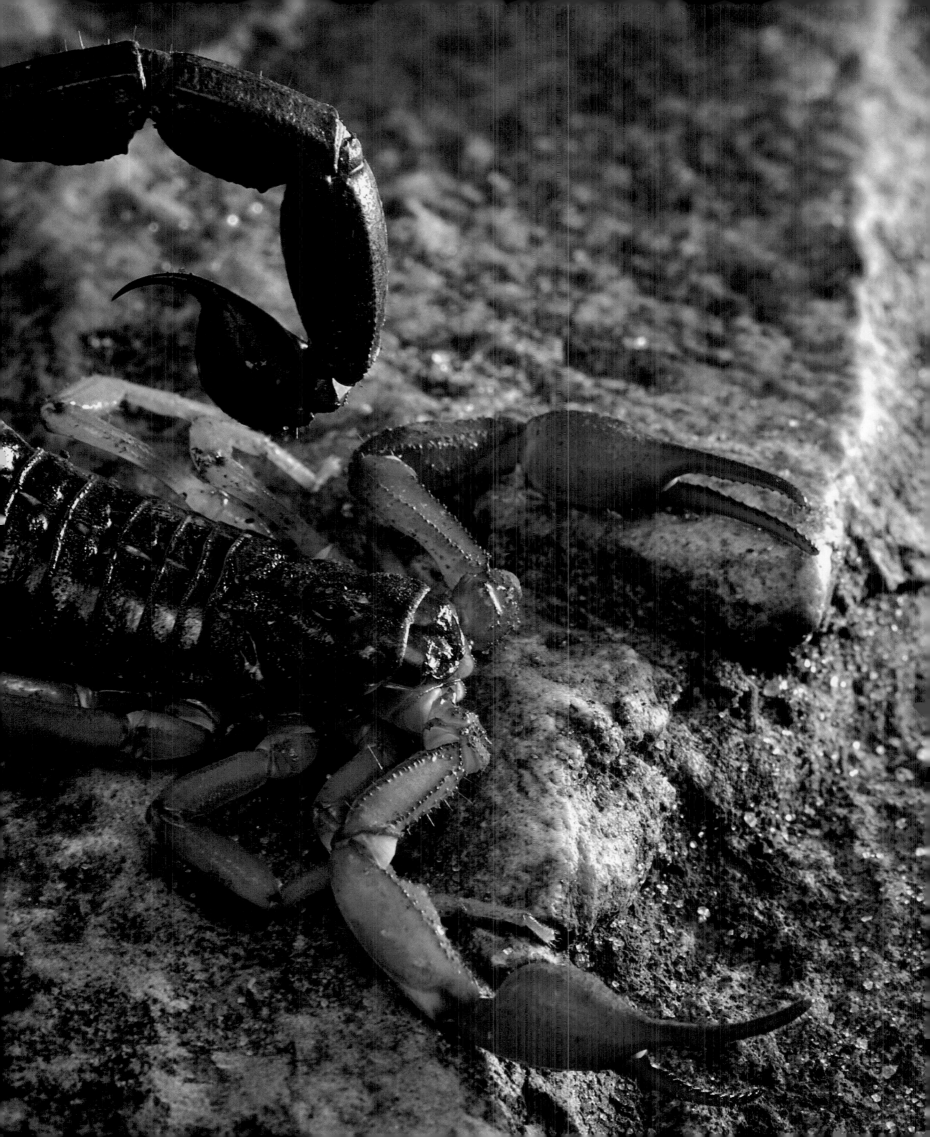

▷ Resembling a creature from another world, the orchid mantis (*Hymenopus coronatus*) of the southeast Asian rainforests is an ambush predator that lurks in the flower of a forest orchid, papaya, or frangipani tree. It is superbly camouflaged with petal-like flanges on its limbs, and as it grows its colour changes to match that of its favoured flower. Any insect that visits the flower to sip nectar is instantly seized in the powerful, spiny forelimbs and devoured.

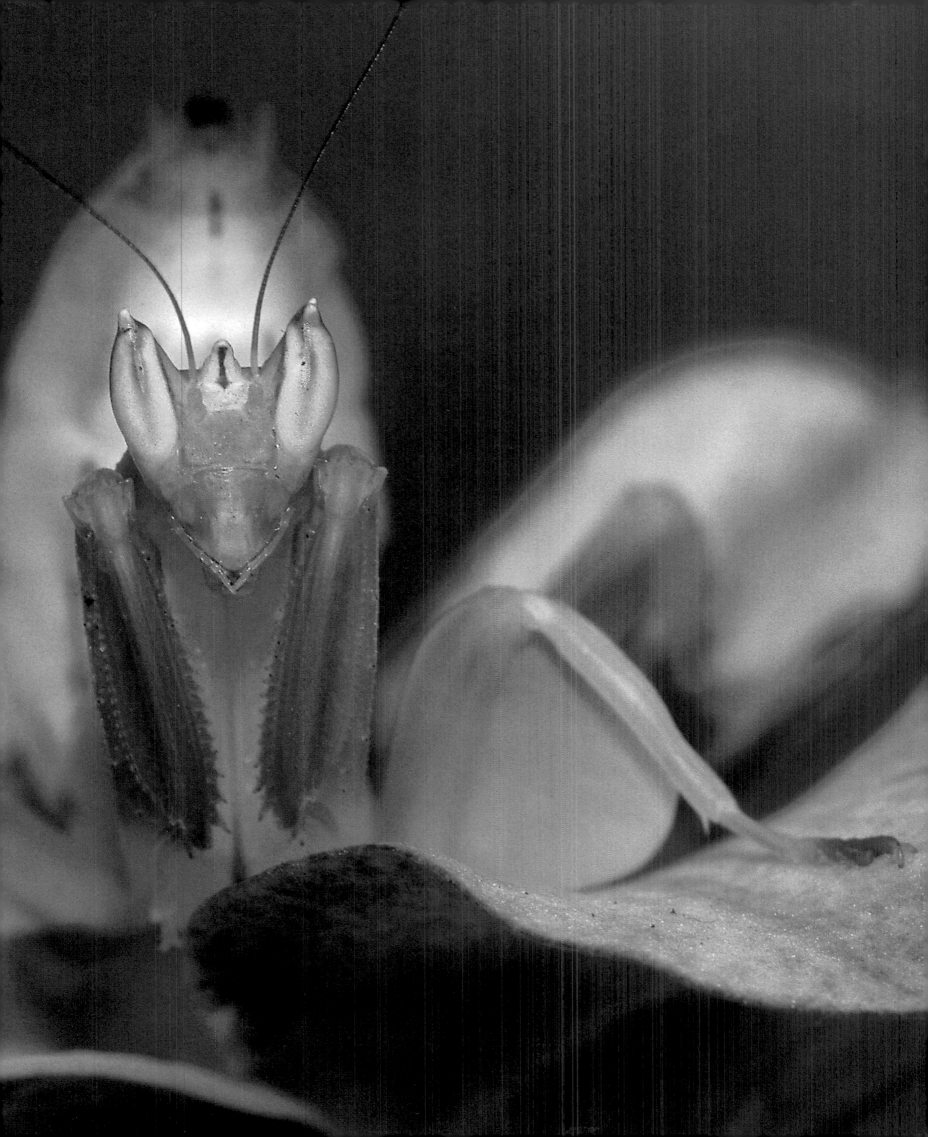

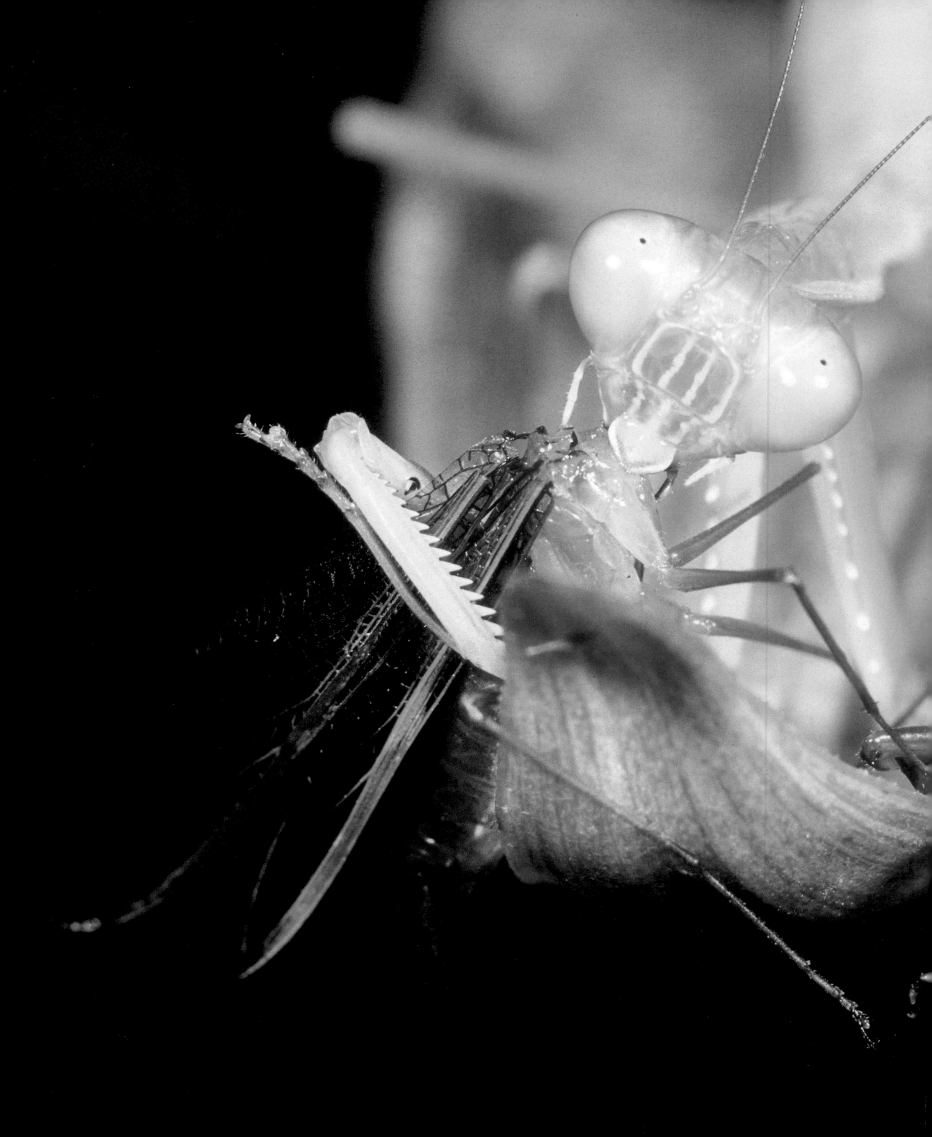

◁ The trap-like forelimbs of this large yellow-green mantis maintain a deadly grip on its prey – another, smaller mantis. These insects are often cannibalistic, with a large female occasionally eating her own mate. Its jaws are small but sharp, and make short work of biting through the armoured bodies of other insects. This mantis has severed the head, neck, and front legs of its victim, which it holds in one forelimb while it feeds on the flesh of the decapitated body.

▷ Many insects are concealed by cryptic coloration, but a few have far more elaborate camouflage that involves their entire body structure. Such creatures include this *Schizocephala bicornis* mantis from the Western Ghat mountains of India, which has evolved a body that is almost indistinguishable in colour and form from stems of dry grass. It uses its camouflage to conceal itself from other insects so it can spring a surprise attack – but the camouflage also hides the mantis from its own enemies.

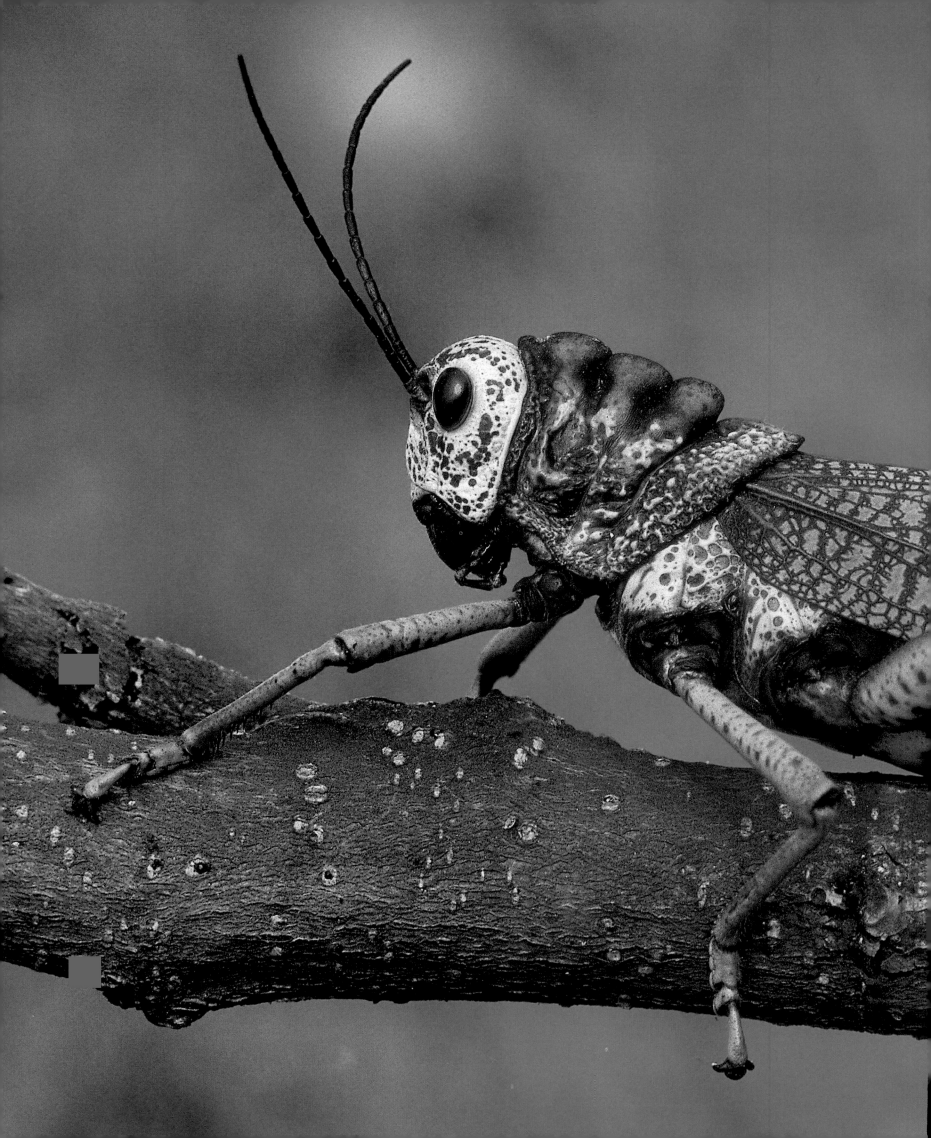

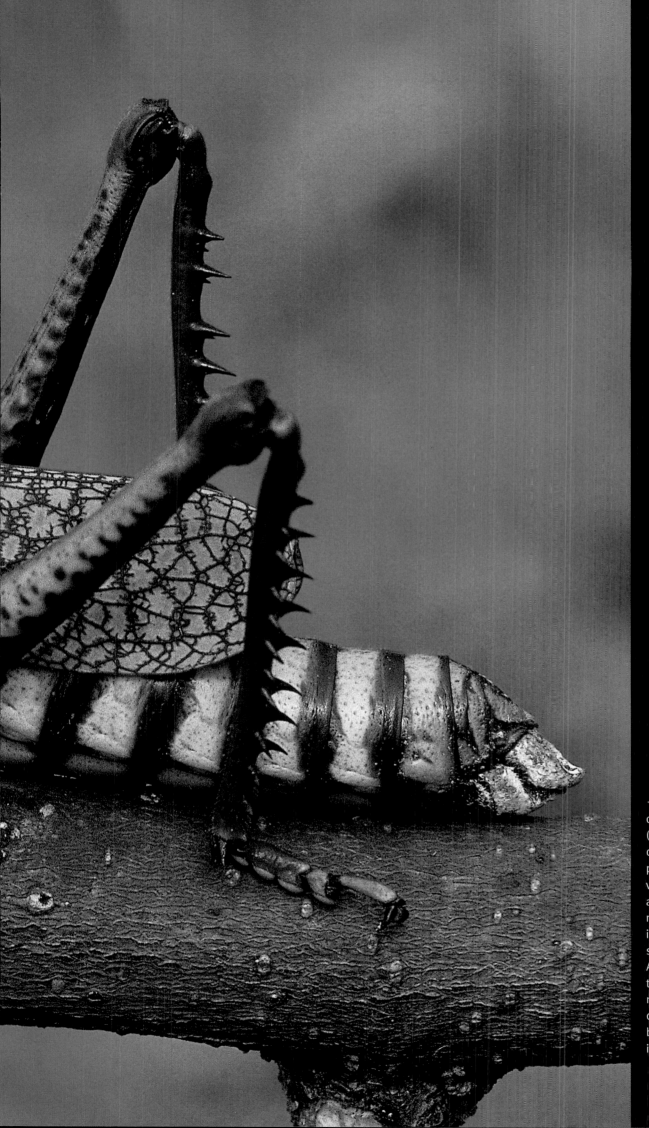

◁ Acrid chemicals in the body of this Peruvian grasshopper (*Aplatacris colorata*) act as a defence against insect-eating predators. The grasshopper's vivid pattern of warning colours advertises the fact that it has a noxious taste and, since most of its enemies are birds that hunt by sight, the warning is very effective Any bird that tries to eat one of these grasshoppers is unlikely to make the same mistake twice. The concentrated toxins in the insect's body are made from chemicals in its food plants.

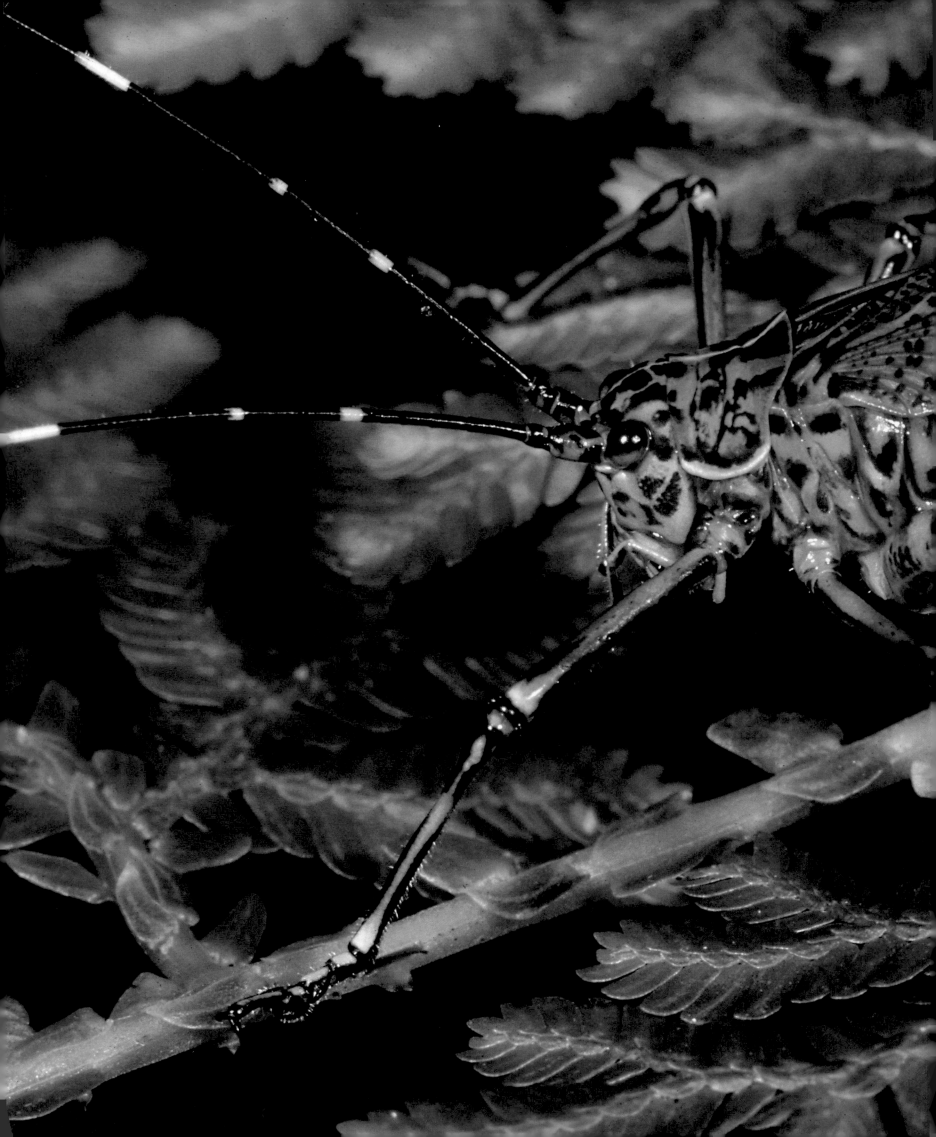

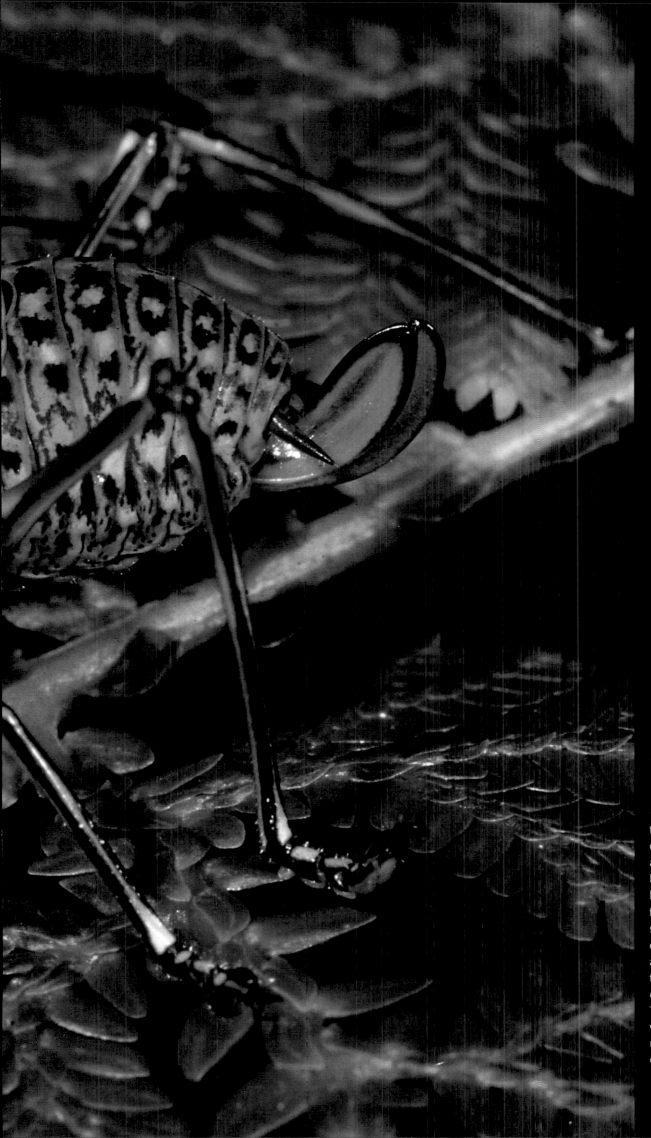

◁ Also known as "bush crickets", the katydids are a very large family of more than 6,000 species. They are related to the grasshoppers, but unlike them they have very long, slender antennae. A mature female, such as this colourful species from Sumatra, has a conspicuous, blade-like ovipositor at the tip of her tail, which she uses to lay her eggs, slipping it into crevices or sawing into plant tissue. The young hatch as miniature versions of their parents, unlike many insects, which have very different larval stages.

Many insects are most active after sunset, and rarely move during the day. Some have evolved amazingly effective camouflage that conceals them from hungry birds. This katydid from Costa Rica is virtually invisible against its mossy tree-trunk perch.

This Costa Rican katydid favours perching on lichen, for obvious reasons. Its net-veined wings and bristly legs are an almost perfect match for the lichen foliage, and it would take a sharp-eyed bird to pick it out – provided it stays perfectly still.

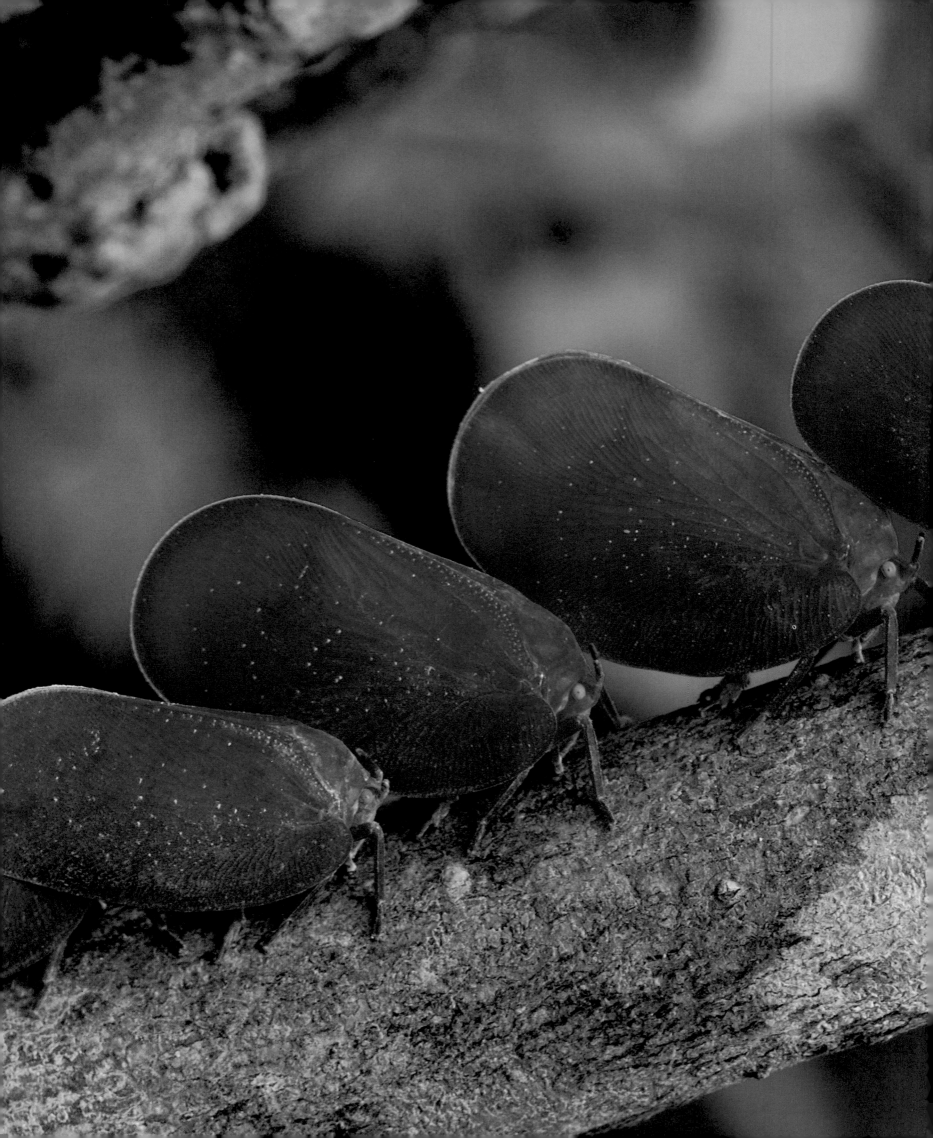

Strictly speaking, a "bug" is a particular type of insect that uses piercing, needle-like mouthparts to drink liquid food. These colourful Madagascan flower-spike bugs (*Phromnia rosea*) cling to the stems of plants and drill into them to suck their sugary sap.

▷ Many insects have adaptations that distract predators from attacking the most vulnerable parts of their bodies. This leaf-footed bug (*Anisoscelis foliacea*) from Peru has eye-catching flaps on its hind legs, and if it feels threatened by a hungry bird it waves one or both legs in the air. This diverts the bird's attention away from the bug's head. The predator may peck at a leg and even pull it off, but the insect can survive this – leaf-footed bugs are often seen with one or both of their hind legs missing.

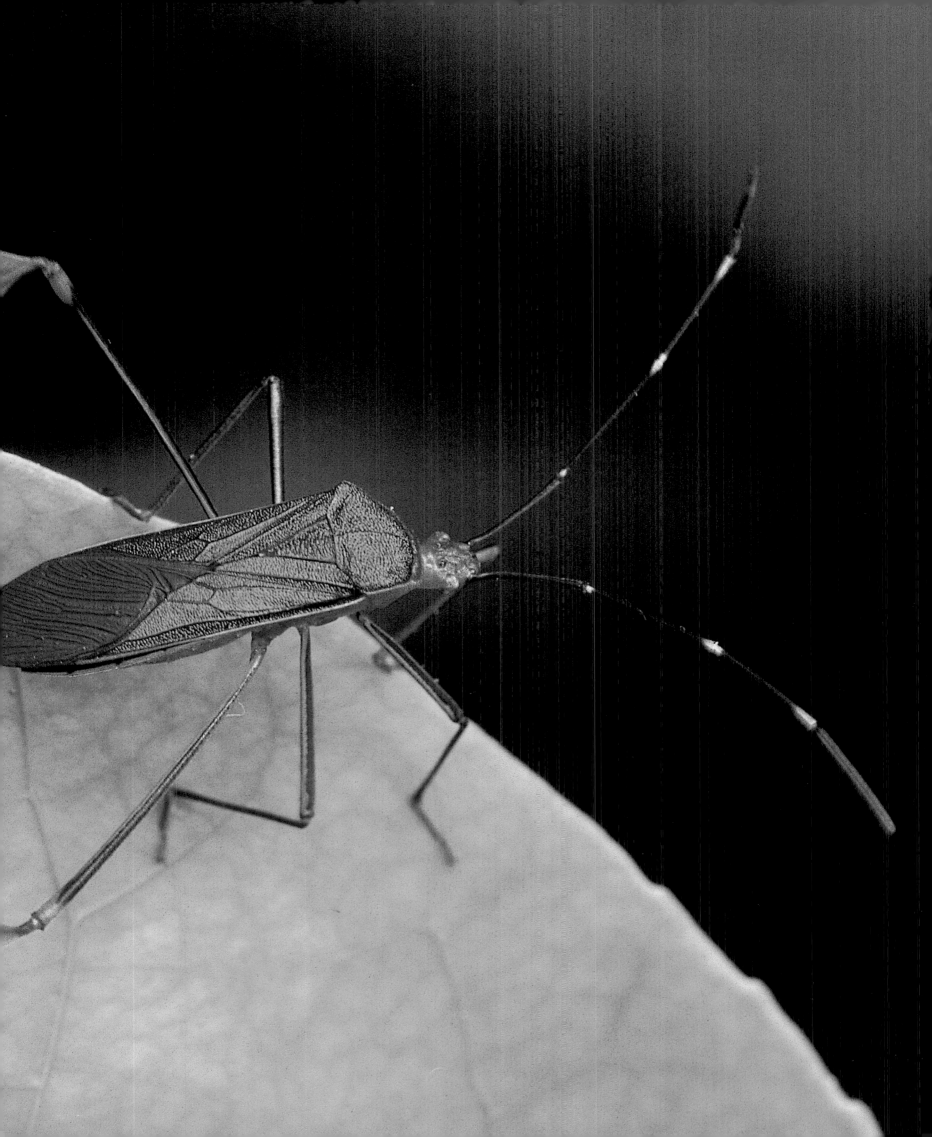

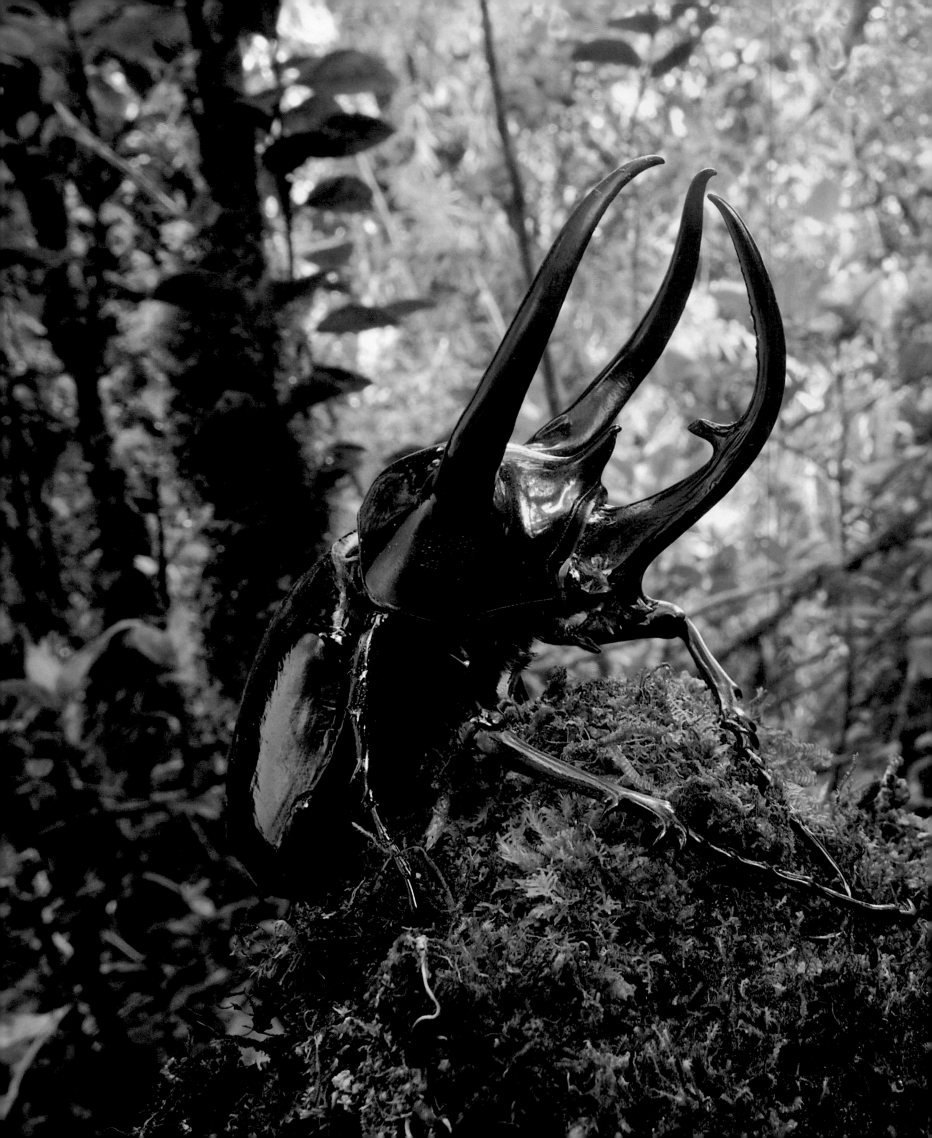

◁ This magnificent male rhinoceros beetle (*Chalcosoma caucasus*) from the tropical forests of Malaysia is one of the largest of all insects, growing to an impressive 12cm (4¾in) long. It is equipped with three long, sharp horns – two on its body and one on its head. The beetle uses these in combat with rival males, each trying to overpower the other by grasping it around the body and tossing it aside. The winner gets the chance to mate with the female, which has no horns and is far smaller.

INVERTEBRATES

▷ Adult insects have tough
external skeletons made of chitin –
a strong yet flexible protein rather
like the keratin in fingernails and
hair. It lends itself to forming
intricate shapes, and is often
beautifully tinted with vivid or even
iridescent colours, as in this green
rose chafer (*Cetonia aurata*).
However, chitin cannot stretch, so
many insects in their young stages
have softer, more flexible skins
that can be discarded easily as
they grow. Many of these larvae
also have simpler body shapes,
which makes it easier for them
to shed their skin.

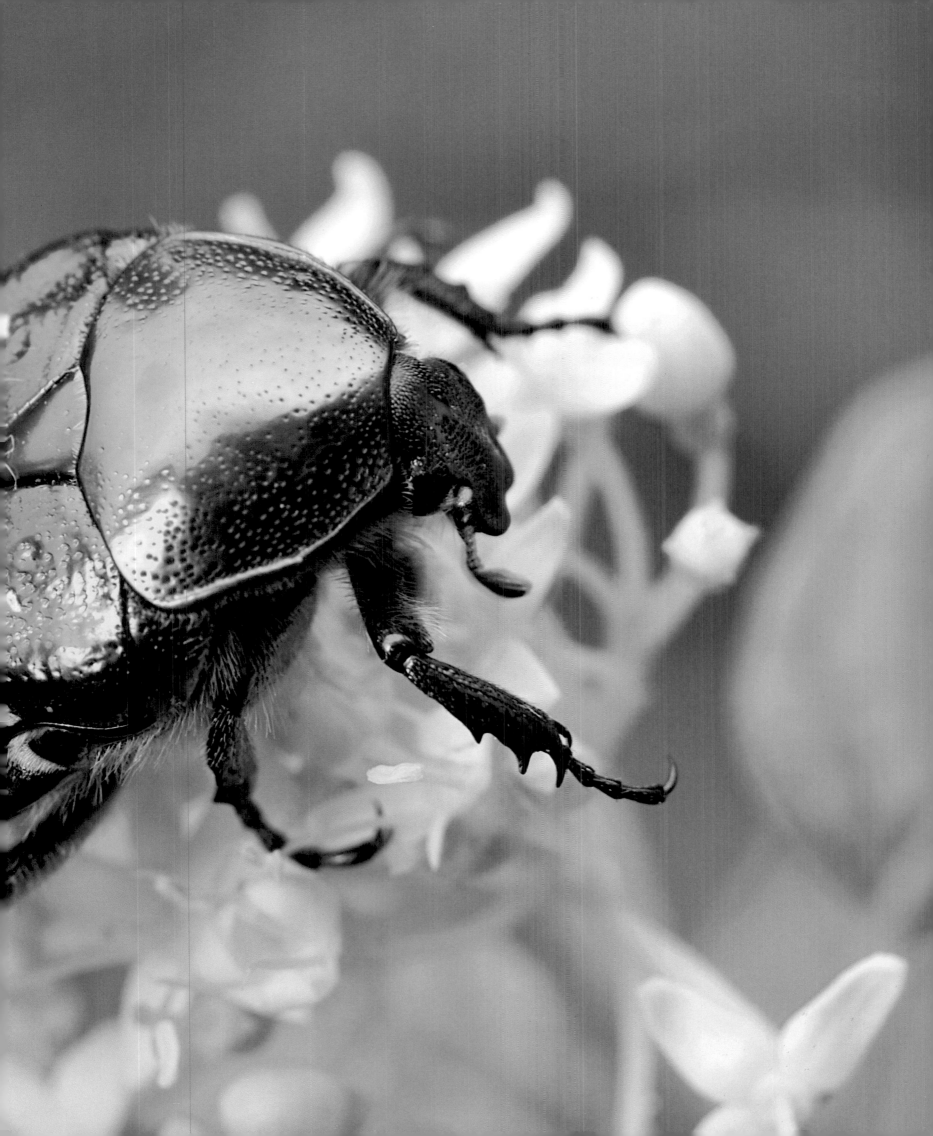

▷ The weevils are a distinctive family of beetles with long snouts ending in small biting jaws. Some have very strange body forms: the body of this Madagascan bearded weevil (*Lixus barbiger*) is covered with tufts of bristles that give it the appearance of having fur. Like all weevils it eats plant material, and as a result it is considered a pest because of its attacks on crops such as cotton and maize.

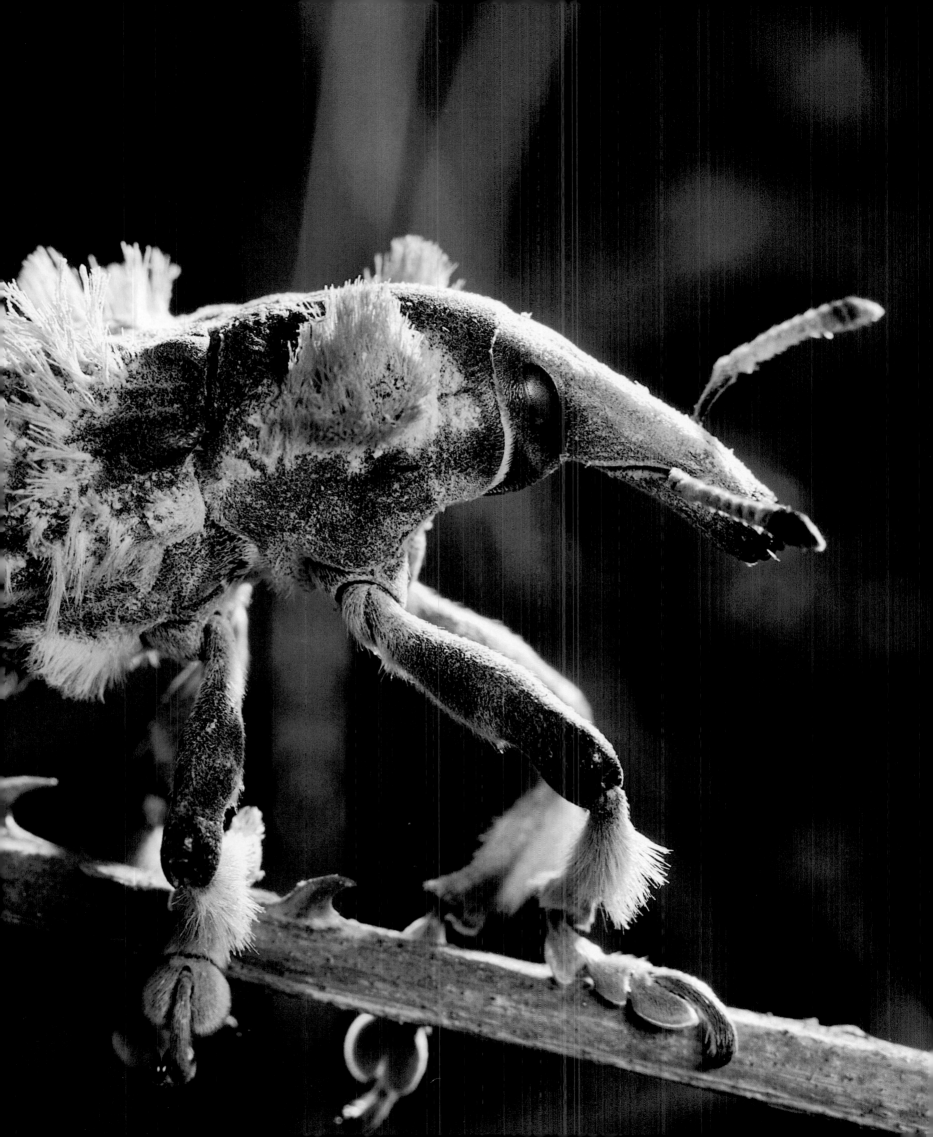

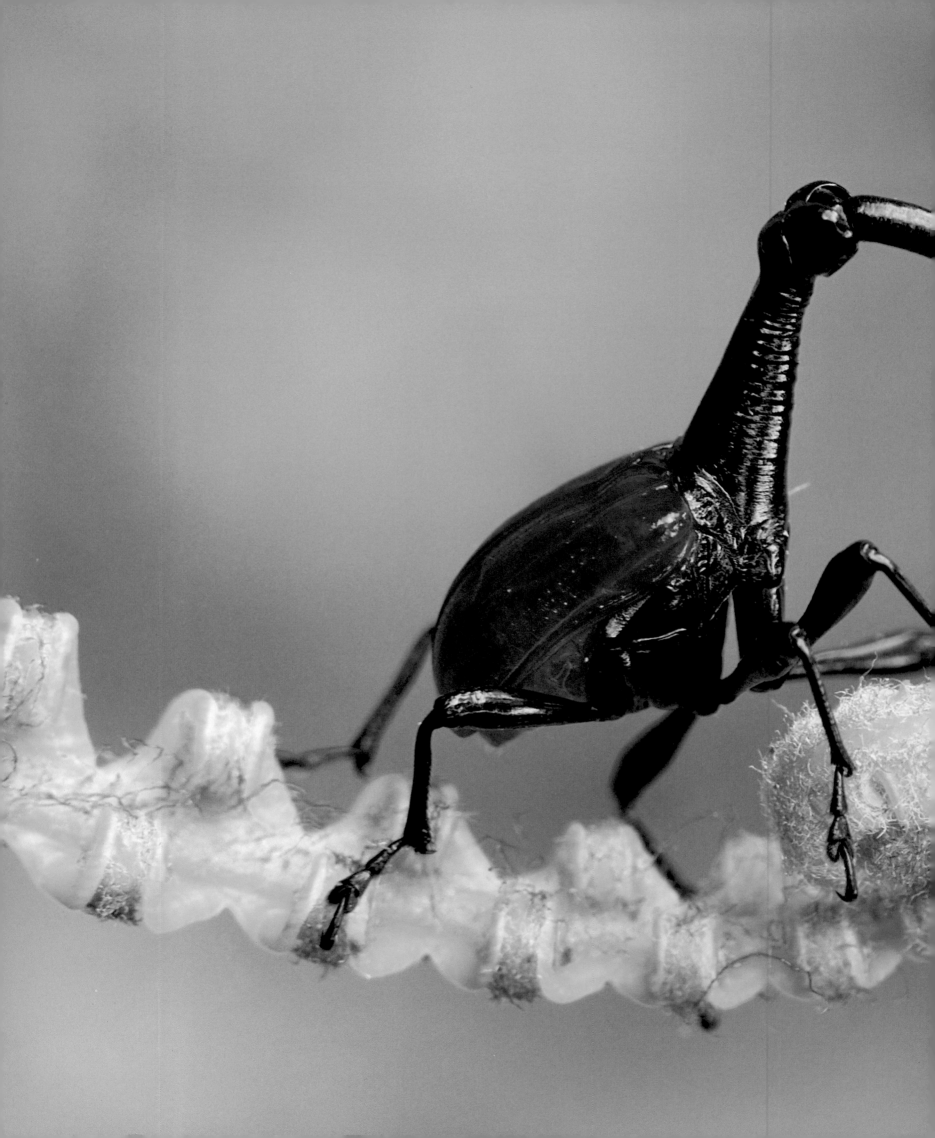

The males of several beetle species have evolved bizarre body forms. This male giraffe-necked weevil (*Trachelophorus giraffa*) is one of the strangest, with a dramatically elongated head hinged to an extended "neck". The function of this adaptation is a mystery.

▷ Nearly all adult insects – including this hoverfly (*Rhingia campestris*) – have large compound eyes made up of many hundreds, or even thousands of tiny lenses. Each lens focuses a dot of coloured light on a cluster of nerve cells. These respond by sending a pulse of electronic data to the fly's brain, where the data is decoded to form an image of the fly's surroundings. Compound eyes probably do not resolve very fine detail but, as with sensors of cigital cameras, the bigger they are – and the more sensory elements they have – the better they perform.

◁ The Madagascan comet moth (*Argema mittrei*) is one of the world's biggest silk moths, with a wingspan of up to 20cm (8in) and very long "tails" on its hindwings. The male seen here has broad feathery antennae that are very sensitive scent organs, tuned to pick up the characteristic perfume released by the female. He must find her within a few hours of hatching, for, like many moths, the breeding adults cannot eat, and survive for only a few days on the energy they store up during their early life as caterpillars.

▷ All moth and butterfly caterpillars have six true legs near their heads, supplemented by a variable number of jointless, fleshy "prolegs". This *Automeris* moth caterpillar has ten prolegs, which support its body while it uses its true legs to grasp its leafy food. It is defended by a formidable array of irritating barbed hairs and stinging spines, picked out in bright warning colours. These deter most predators from trying to eat it, especially if they have already suffered the painful consequences of one attempt.

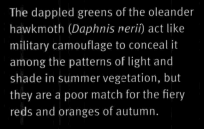

The dappled greens of the oleander hawkmoth (*Daphnis nerii*) act like military camouflage to conceal it among the patterns of light and shade in summer vegetation, but they are a poor match for the fiery reds and oranges of autumn.

To aid his nocturnal hunt for females, this male lobster moth (*Stauropus fagi*) is equipped with huge, comb-shaped antennae, and dense hair to keep his flight muscles warm.

◁ Most caterpillars shuffle along on their thick, fleshy "prolegs", but this caterpillar of the African dice moth *Rhanidophora ridens* moves by looping its body up, then releasing the grip of the true legs near its head so it can extend itself forward before looping again. The ornamented hairs on its body probably provide some protection against insect-eating birds and other potential predators.

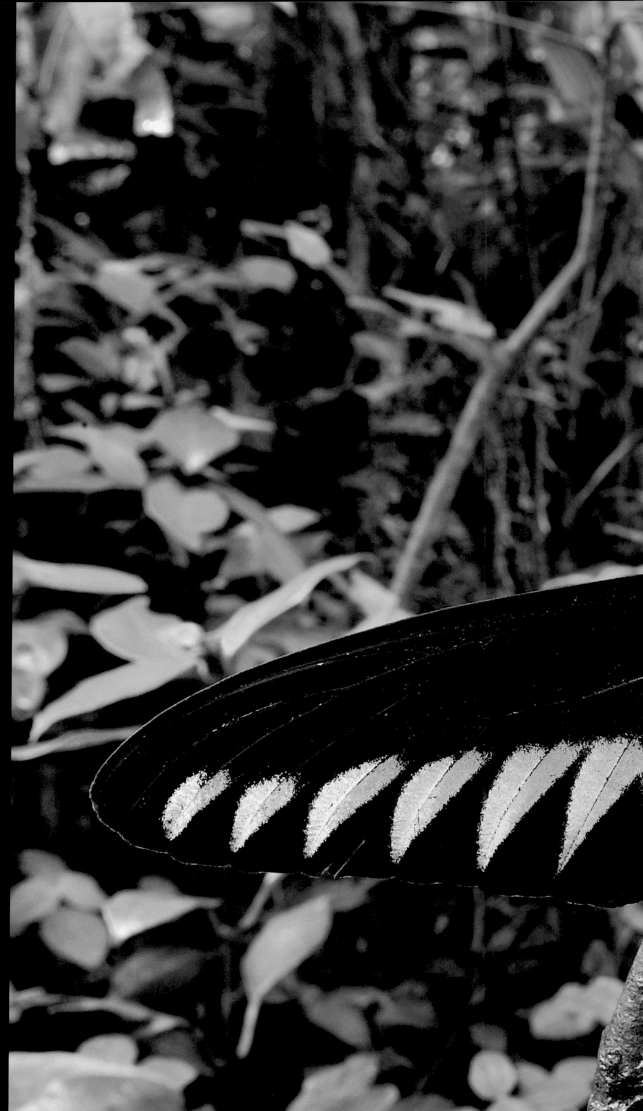

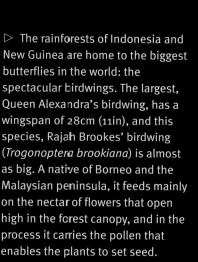

▷ The rainforests of Indonesia and New Guinea are home to the biggest butterflies in the world: the spectacular birdwings. The largest, Queen Alexandra's birdwing, has a wingspan of 28cm (11in), and this species, Rajah Brookes' birdwing (*Trogonoptera brookiana*) is almost as big. A native of Borneo and the Malaysian peninsula, it feeds mainly on the nectar of flowers that open high in the forest canopy, and in the process it carries the pollen that enables the plants to set seed.

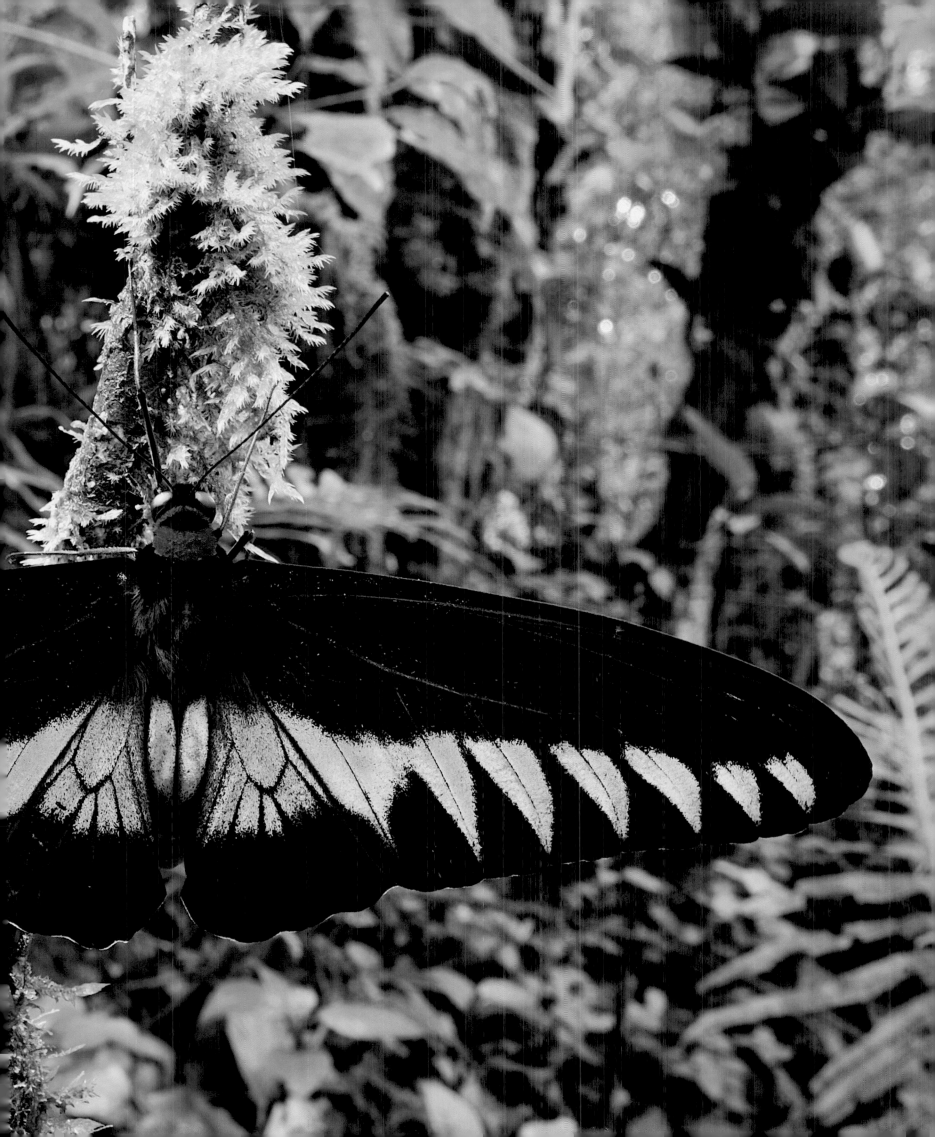

> The wings of all butterflies are broad plates of transparent chitin. Those of most species are covered with coloured scales arranged like tiles on a roof, but the wings of glasswing butterflies such as this Peruvian species of *Ithomia* have large areas with no scales, so they resemble thin sheets of glass. Some glasswing species deter predators by drinking poisonous nectar and concentrating the poisons in their bodies to make themselves inedible.

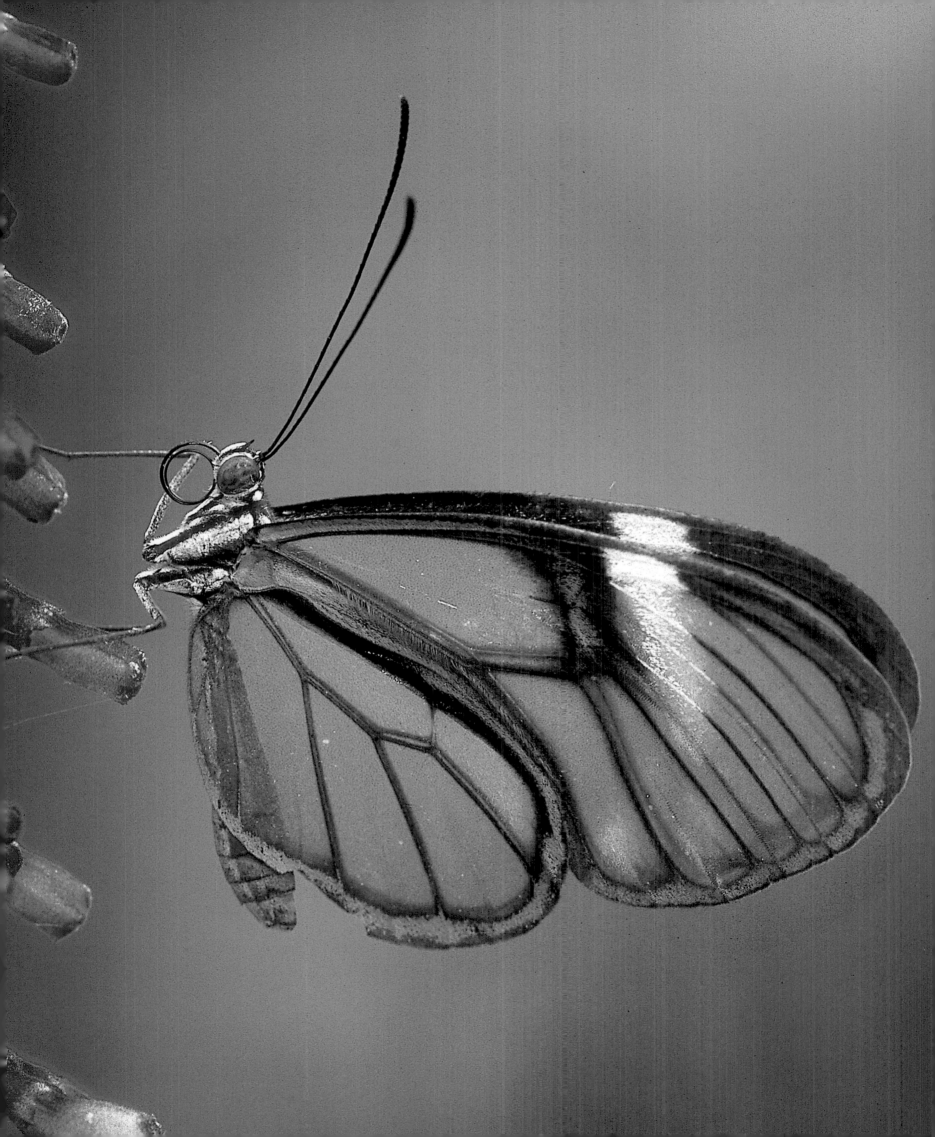

Magnifying the wings of this malachite butterfly (*Siproeta stelenes*) from tropical America reveals the scales that give it its glorious colour. This is one of the nymphalid butterflies, which have tiny brush-like front legs that they fold up beneath their eyes.

Lurking at its burrow entrance on a coral reef, this mantis shrimp (*Lysiosquilla maculata*) waits for prey. Like the insects that share its name, it uses its powerful spined forelimbs to seize any unwary victims that stray within range.

Some coral reef shrimps, such as this *Urocaridella* species from the tropical Indo-Pacific, feed on the parasites that infest reef fish. The fish – which may normally eat shrimps and similar animals – appreciate the attentions of these "cleaners" and never harm them.

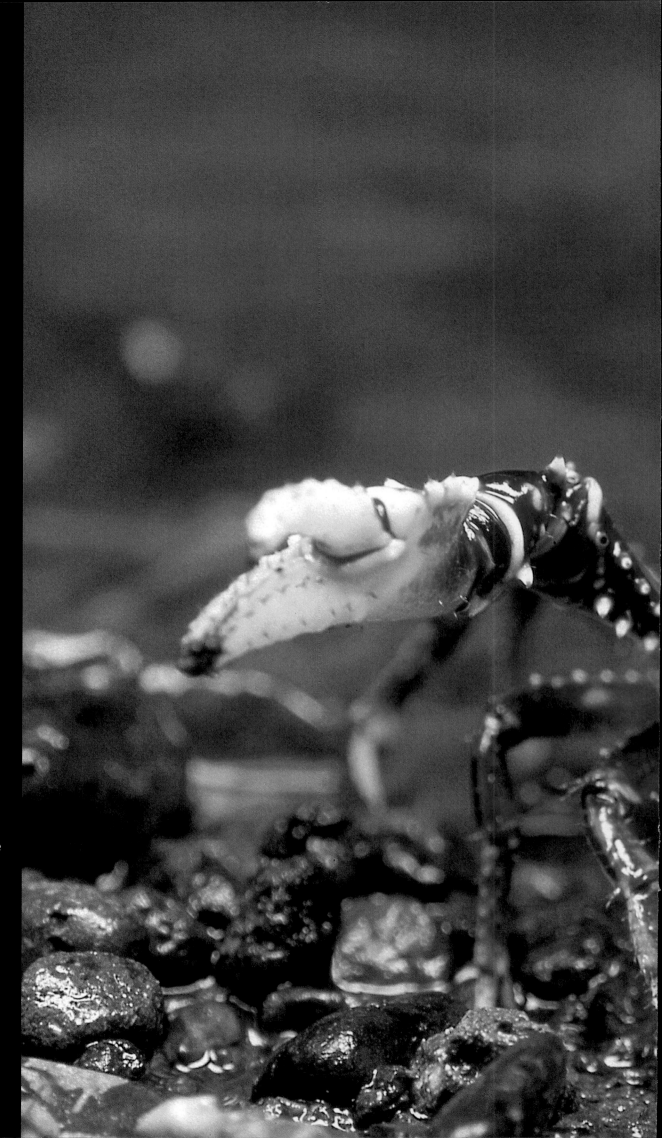

▷ Claws at the ready, a bright blue spiny crayfish (*Euastacus sulcatus*) prepares to defend itself from a possible attacker. Found only among the tropical rainforests of the Lamington Plateau region of Queensland in northern Australia, this freshwater crayfish leaves the creeks after heavy rain and roams over the forest floor to find food. It can breathe because it carries a supply of oxygenated water in its gill cavity, and the water absorbs more oxygen from the air.

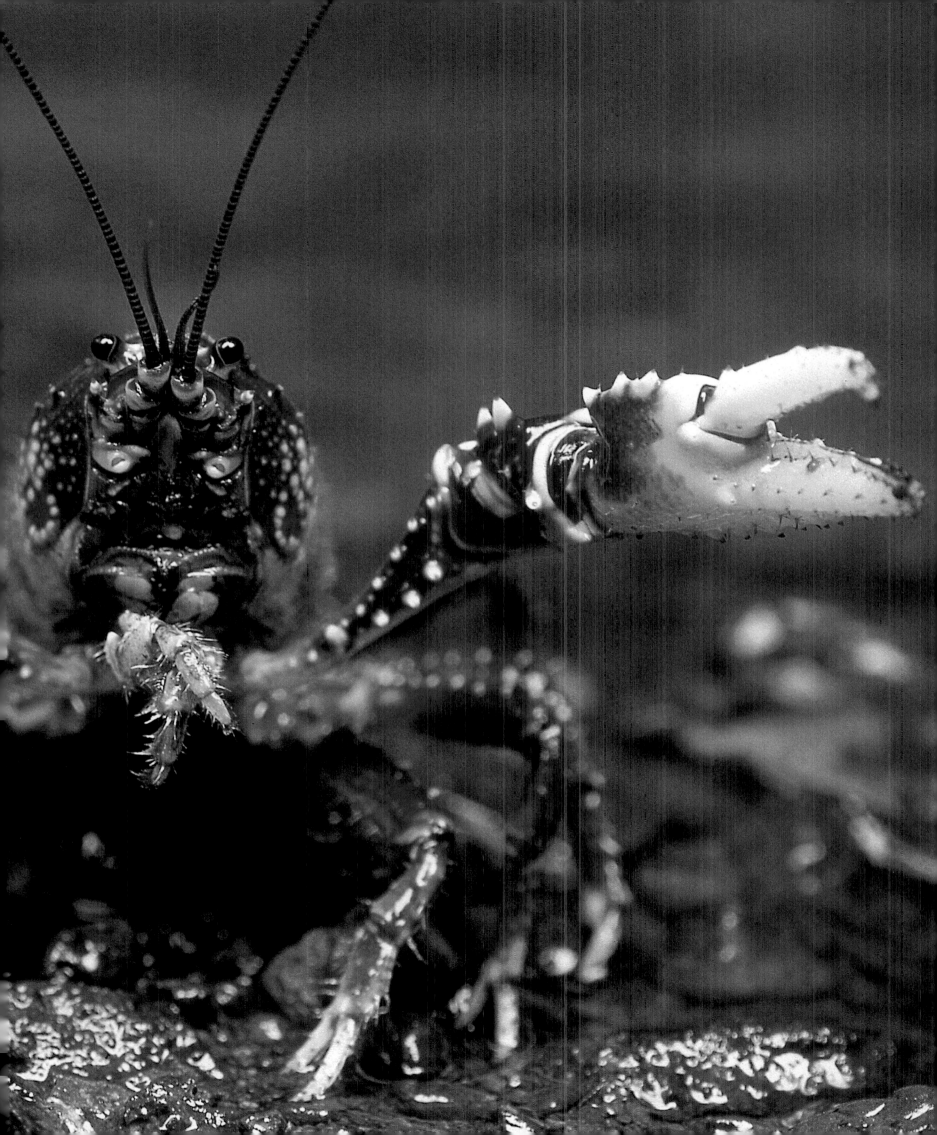

▷ Hermit crabs are known for the way they adopt the empty shells of sea snails and other molluscs as protective "homes". These hermit crabs (*Dardanus pedunculatus*) from the tropical coral reefs of Indonesia sometimes place small anemones on their borrowed shells. The stinging tentacles of the anemones provide the crabs with both defence and protective camouflage. In return, the anemones are carried to new locations on the reef, which often offer better feeding opportunities.

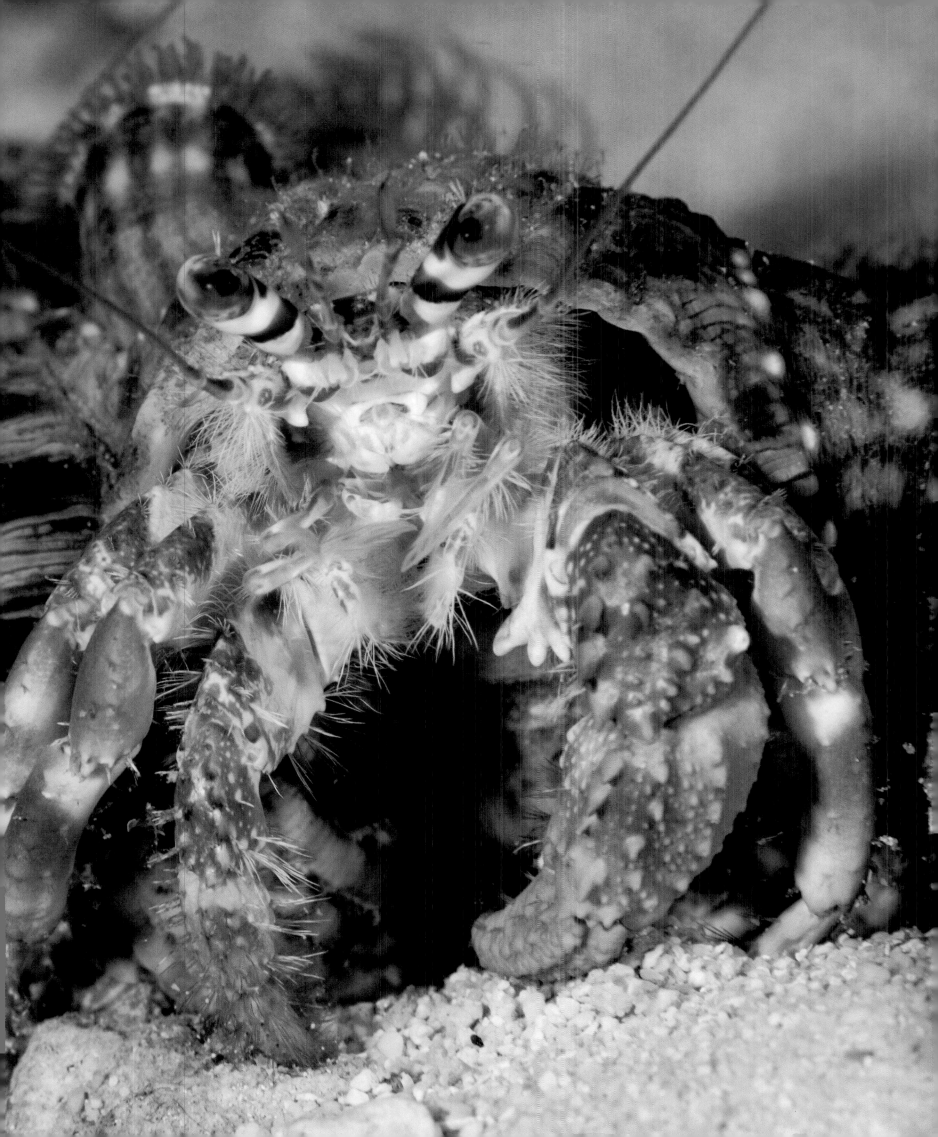

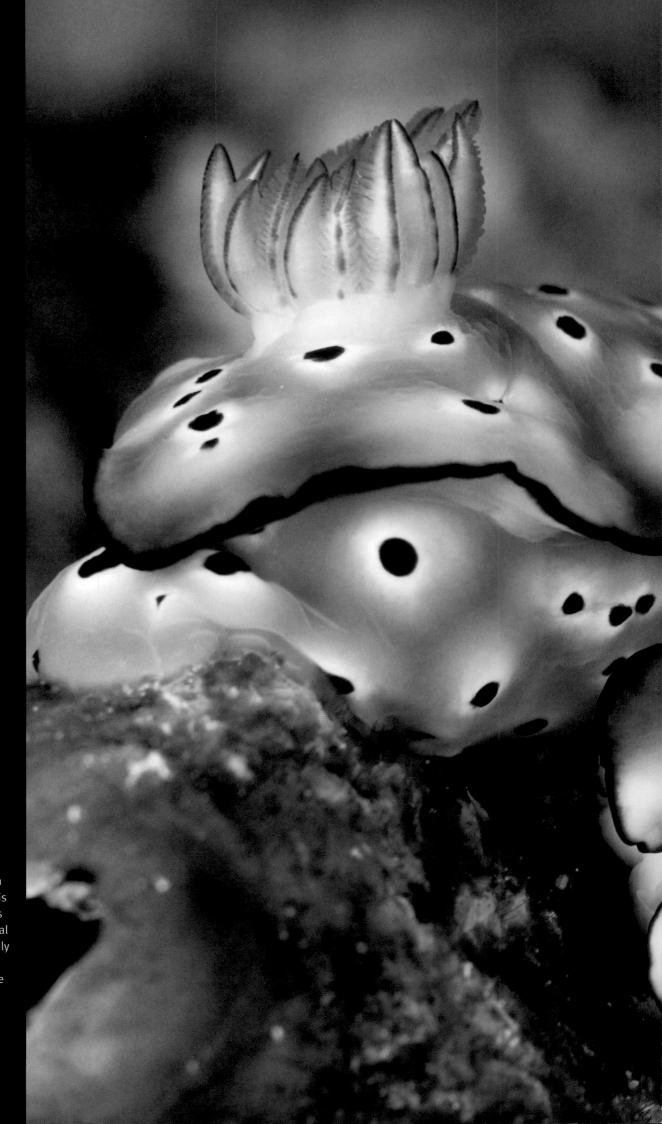

▷ The nudibranchs are marine molluscs that do not have shells. Instead, many are defended by stinging cells that they obtain from prey such as stinging hydroids. This may be why many species, such as these *Risbecia tryoni* from a tropical coral reef off Malaysia, are so vividly coloured. The colours may act as a warning to potential predators. The nudibranchs are among the most beautiful and diverse of all marine animals, with more than 3,000 species known to science.

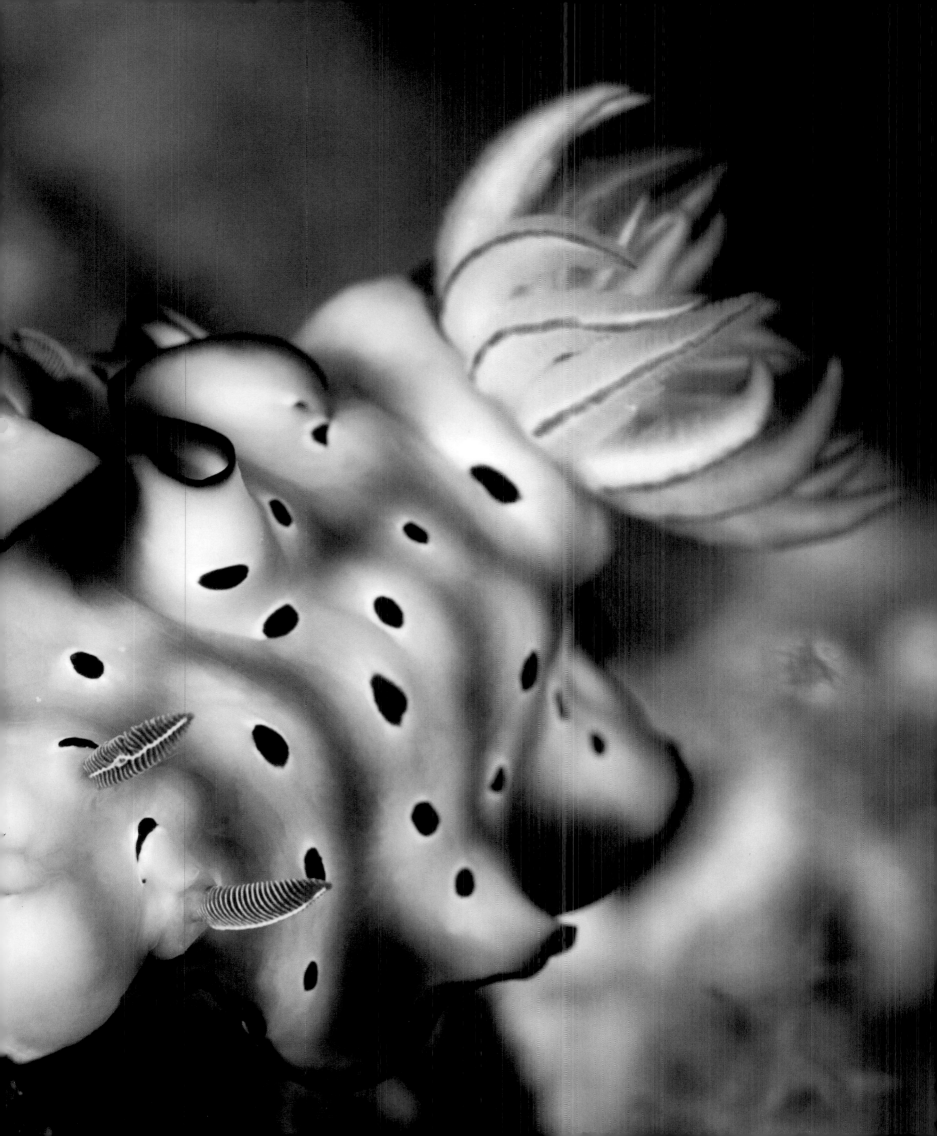

> The pretty little blue-ringed octopus (*Hapalochlaena lunulata*) of the tropical Pacific is only 15cm (6in) long, but it is one of the most dangerous animals on the planet. This is because it is armed with one of the natural world's most powerful venoms. Similar to that of a cobra, but stronger, it is lethal to humans because it attacks the central nervous system, causing fatal breathing failure within a few minutes of being bitten. Luckily it would rather slip away into a crevice than launch an attack.

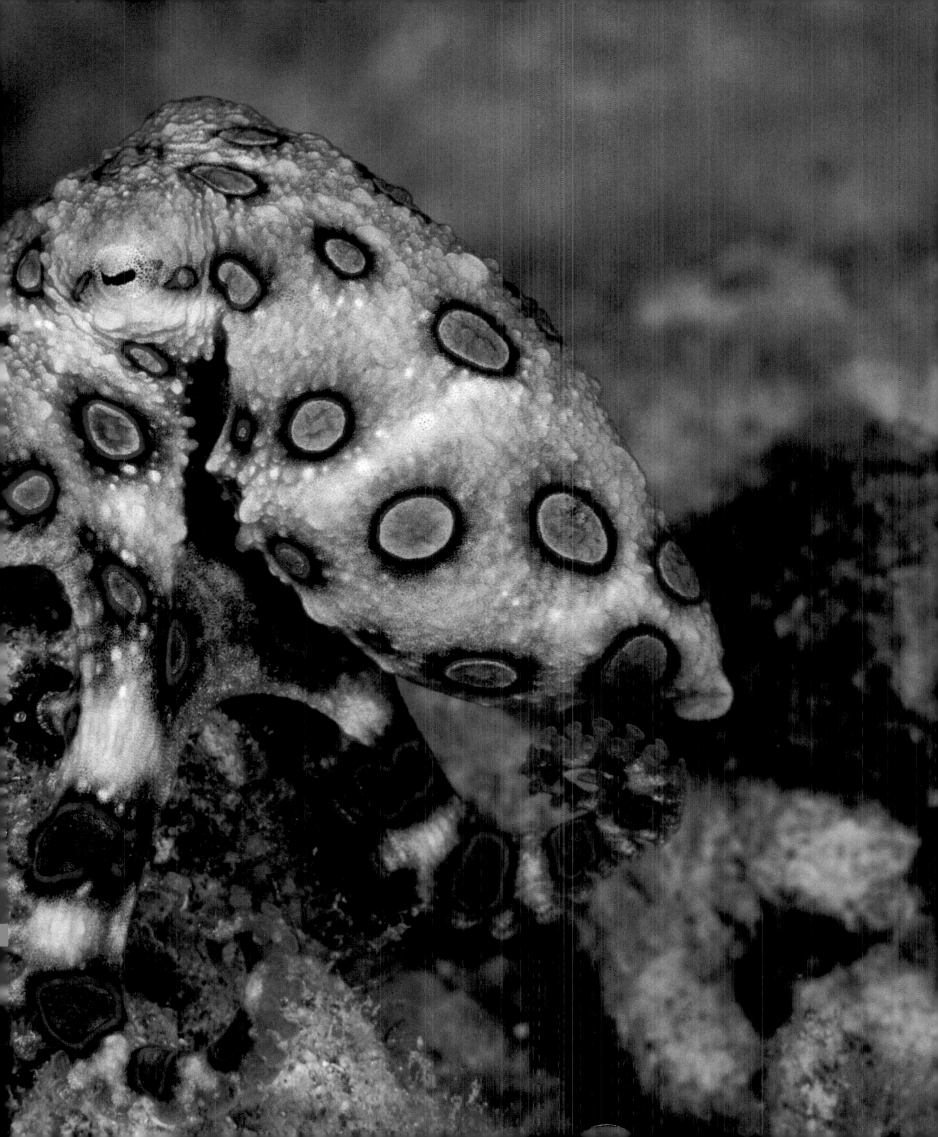

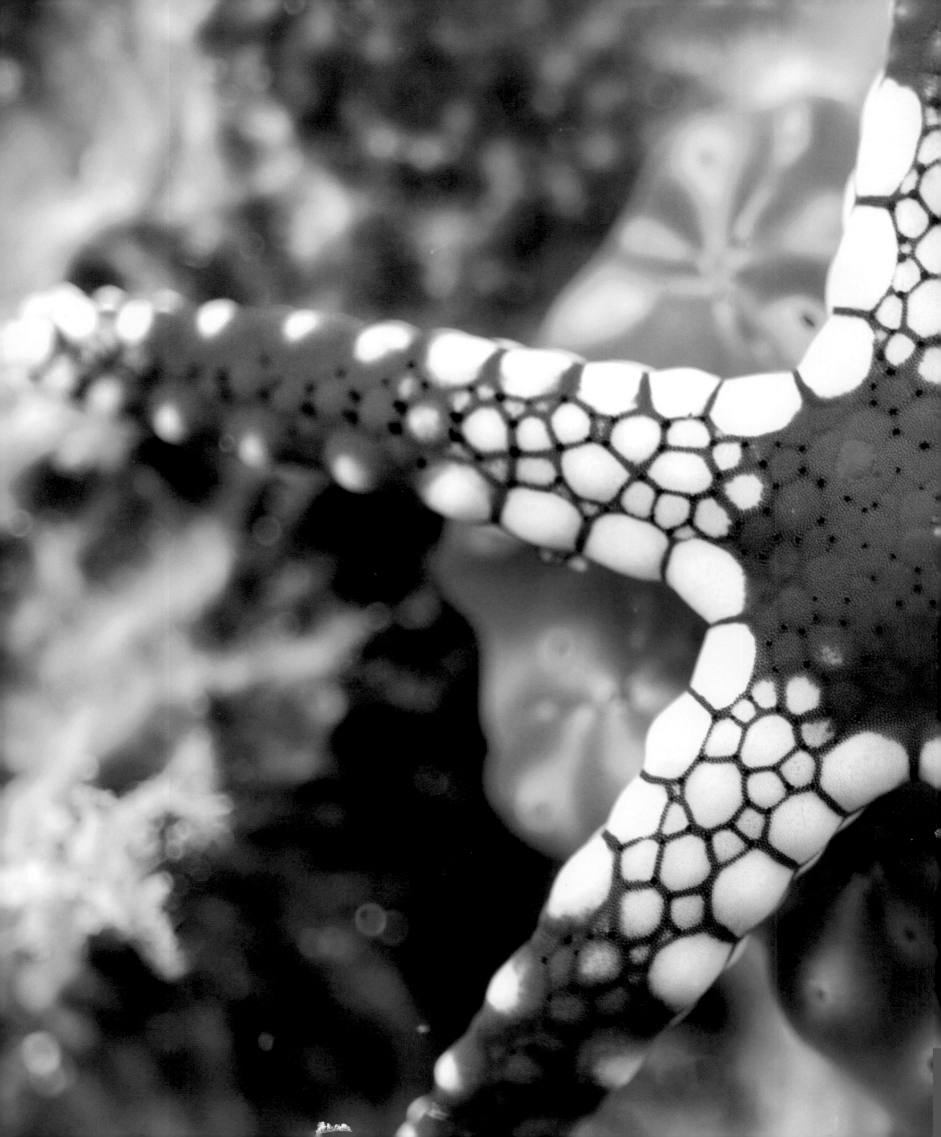

Starfish and their relatives are unique because their bodies have five-sided symmetry. This is evident with species such as this tropical red tile starfish (*Fromia monilis*), with its five long "arms". It feeds on microscopic algae and grows to approximately 13cm (5in) across.

index

For indexing purposes, only common species names have been used, except where no common name is used in the caption text.

acknowledgments

Publisher's acknowledgments

Dorling Kindersley would like to thank the following: John Woodward for the reptiles and amphibians and invertebrates captions and the introductions; Jason Isley and Gilbert Woolley for the fish captions; David Chandler for the mammals and birds captions; Sarah Arnold, Jill Burr, and Katie Eke for design assistance; Adam Brackenbury for image retouching; Mark Cavanagh for jacket design; Jenny Baskaya for picture research; Angie Hipkin for compiling the index; and Thomas Marent and the Scubazoo team for all their patience and valuable assistance throughout the project.

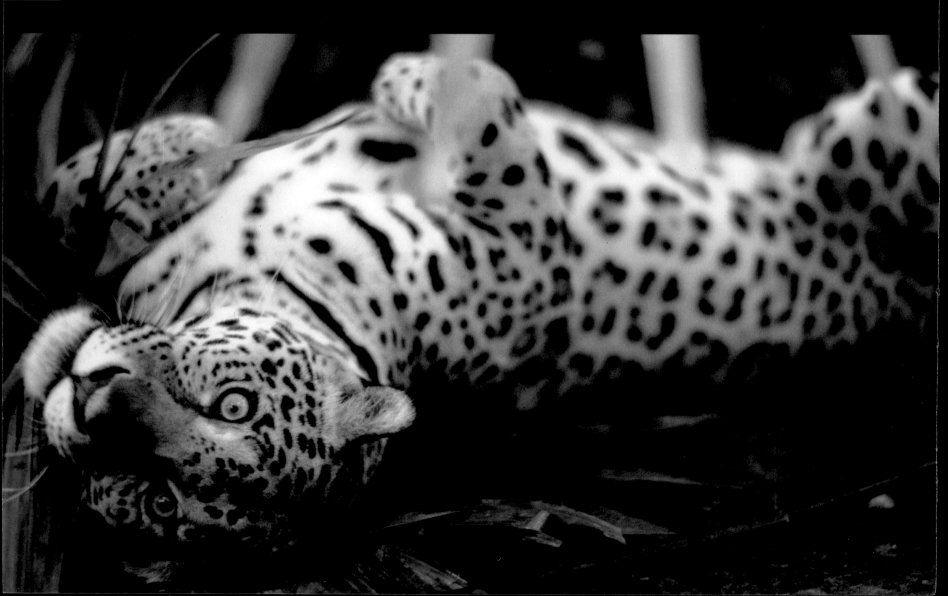

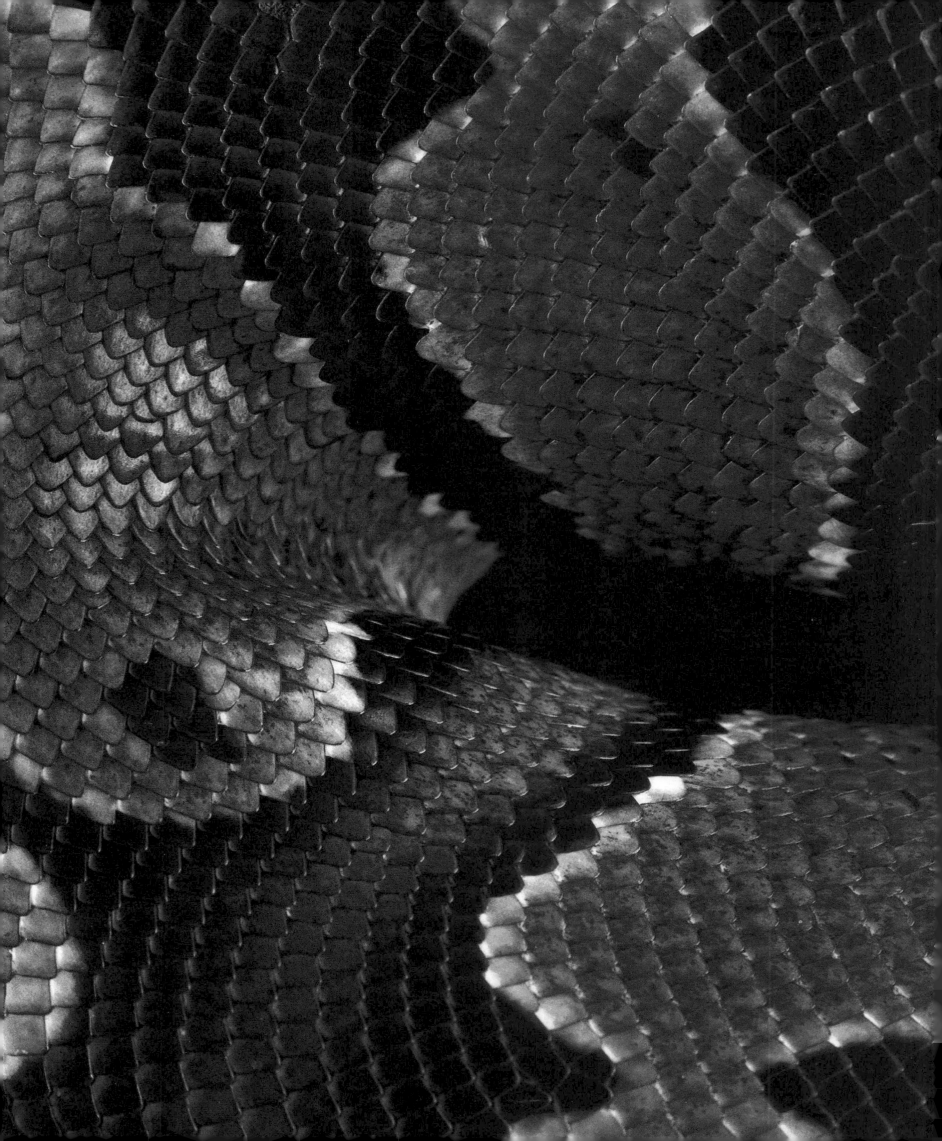